The complete paintings of

Mantegna

Introduction by **Andrew Martindale**

Notes and catalogue by **Niny Garavaglia**

Harry N. Abrams, Inc. *Publishers* New York

Classics of the World's Great Art

Editor
Paolo Lecaldano

International Advisory Board
Gian Alberto dell'Acqua
André Chastel
Douglas Cooper
Lorenz Eitner
Enrique Lafuente Ferrari
Bruno Molajoli
Carlo L. Ragghianti
Xavier de Salas
David Talbot Rice
Jacques Thuillier
Rudolf Wittkower

This series of books is published in Italy by Rizzoli Editore, in France by Flammarion, in the United Kingdom by Weidenfeld and Nicolson, in the United States by Harry N. Abrams, Inc., in Spain by Editorial Noguer and in Switzerland by Kunstkreis

Standard Book Number
8109 5510 5
Library of Congress Catalogue
Card Number 72 92259
© Copyright in Italy by
Rizzoli Editore, 1967
Printed and bound in Italy

Table of contents

Photographic sources

Colour plates: Domínguez Ramos, Madrid; Haase, Bergen-Enkheim; Mercurio, Milan; Meyer, Vienna; Pinacoteca di Brera, Milan; Scala, Florence; Staatliche Museen, Gemäldegalerie, Berlin-Dahlem; Statens Museum for Kunst, Copenhagen; Witty, Sunbury-on-Thames.
Black and white illustrations: Rizzoli Archives, Milan; Bulloz, Paris; British Museum, London; Calzolari, Mantua; Dudley, Oxford; Ministry of Public Buildings and Works, London; Wallace Collection, London.
Drawings and sketches by Gino Alessi, Sergio Coradeschi and Sergio Tragni.

Introduction

Mantegna's life from the age of about thirty was spent as court painter to the Gonzaga marquesses of Mantua. For some forty-six years he served under three successive rulers, Ludovico (died 1578), Federico (died 1484) and Francesco. As the result of the survival of a large proportion of the Gonzaga archives, much, by fifteenth-century standards, is known about his life in Mantua (one can effectively contrast the little that is known about Leonardo's life at the court of Milan during much the same period). For instance, there exists in Mantua a file of autograph letters, beautifully written in a fine italic hand (see p. 84). As a result of these insights, it is possible in Mantegna's case to give some account of what he was like as a person, an account based on contemporary evidence rather than subsequent legend. For a fifteenth-century artist this is uncommon.

His own vision of himself was not ingratiating. One of the heads in the so-called "Camera degli Sposi" (see pp. 100–8) has been reasonably identified as a self-portrait. It presents us with a rather broad face with a somewhat large nose and firm projecting cheekbones. There is no suggestion of refinement or humour and the general impression is solemn and stern, even morose. Mantegna's letters do not in general dispel these impressions. Many of them are anxious in tone, reflecting financial problems or the procurement of favours. Some are about quarrels with his neighbours who appear to have thought him a tiresome and bitter person. The tone is in general depressingly ordinary and serves only to remind one that the letters of the great can be very disappointing for those expecting an uplifting experience.

Yet, with Mantegna, one must admit important qualifications. He belonged for instance to the Marquess' household (that is to say, he was not merely regarded as a city craftsman); and throughout his life he seems, as a painter, to have received somewhat specialised treatment. If one were to hunt for a modern parallel one might say that he was treated less as a salaried employee and more as the "family librarian" or "keeper of the collections". The reason for this is not obscure. Mantegna had academic aspirations, as a student and connoisseur of Antiquity. It is difficult to say how profound his knowledge was and, for instance, how fluently he read Latin, but he certainly had a keen and perceptive eye for antique remains; he collected antique sculpture; he cultivated humanist scholars and antiquarians as friends; and there seems little doubt that on his chosen subject he was probably extremely interesting. It is worth noting that when Cardinal Francesco Gonzaga visited the baths at Porretta, Mantegna was one of those asked to accompany him (1472). The other men were apparently the scholar Angelo Poliziano, the scholar-architect Alberti and the musician Malagiste. Mantegna was asked to discuss and examine the Cardinal's antiques.

There are a few other indications that Mantegna's character had a more congenial side to it. There is the account (1464) of a boating expedition on Lake Garda, in the company of three humanist friends. One was dubbed "emperor" and two became "consuls" and they sailed across the lake to visit antique remains and to copy inscriptions. It is difficult to know what to make of this charade, but at least a large part of its purpose seems to have been sheer pleasure. Then again, one of Mantegna's letters from Rome (1489) gives a curious account of the strange Turkish prince Djem, brother of the Sultan and at that point prisoner of the Pope. However this may be, Mantegna maintained good personal relations with the Gonzaga family who treated him with courtesy and respect.

This respect was, of course, due to his stature as an artist as well as a person. There can be no doubt that from the very first, the Gonzagas realised that they had acquired a court artist with few equals in Italy. Numerous testimonies to his excellence exist from

Mantegna's own lifetime (see p. 11); and, in recommending him to the Pope (1488), the Marquess Francesco called him "a most distinguished painter, the like of whom our age has never seen". Certainly by 1492, the fame of the Camera degli Sposi is known to have attracted sightseers. By the time of his Roman visit (1488–90) Mantegna's personal status had been buttressed by the titles of Knight and Count Palatine.

Although much is known about Mantegna's life, there is still a great deal of obscurity about his art. The German scholar Kristeller, in what is still the fundamental work on Mantegna, wrote: "It is very remarkable what difficulties the attempt to fix the chronology of Mantegna's work has encountered, although large works, which may be exactly dated, are preserved from all periods in his life." The position has not really improved since Kristeller's time, and the reader will find plenty of evidence of this in the Catalogue. The Louvre St Sebastian (No. 56), it will be observed, has had three general dates suggested for it by historians. The first, "before the S. Zeno altarpiece" or c. 1455, places the painting among Mantegna's juvenilia. The second "the period of the Camera degli Sposi" or c. 1470, makes it a product of his maturity. The third, c. 1480, places it on the threshold of his latest period. The possibility of confusion on this scale with an important and first class work of art may seem surprising, suggesting as it does that Mantegna's painting hardly changed throughout his life.

In a very limited sense, this is true. During a long working life, Mantegna's technique changed surprisingly little since he appears to have continued to employ the dry, meticulous precision of tempera painting at a time when most artists were experimenting in oil. This means that a detail, for instance, of mantegnesque foliage or drapery painted c. 1490 will probably not be especially different from such details painted c. 1460. Vasari, writing in the sixteenth century of the now destroyed frescoes in the Vatican, compared them to manuscript illustrations; and an extreme attention to detail was one of Mantegna's most striking technical characteristics throughout his life.

Certain things did change, however, and in a manner not difficult to see. A comparison of the frescoes of the Camera degli Sposi (c. 1470–43, Nos. 46–52) with the canvases of The Triumph of Caesar (c. 1486–93, No. 63) will show that a radical change has overtaken the figure style. When all due allowance

has been made for the change in subject matter, the vivid triumphal procession contains figures constructed with an assurance, vitality and movement which has no real precedent in Mantegna's work. The same impression of vitality combined with grace is to be found in the two paintings which he executed for Isabella d'Este (No. 91, A–B). Here, it will also be seen that the style of landscape painting has changed. The background is laid out with more delicacy in the colour transitions; and Mantegna's late work looks, in this respect, appreciably closer to Venetian painting of the early sixteenth century.

The crucial period for these changes, c. 1475, is unfortunately uncharted in terms of dated works, and there is nothing, therefore, to give an insight into what was happening. To the historians, it is of considerable interest that the change in figure style coincides with something similar in Florence, to be seen in the work of Antonio Pollaiuolo and the young Leonardo. Pollaiuolo was a contemporary of Mantegna, and it is difficult to believe that the developments were independent. It is, however, possible that the common factor was the work of Donatello, who was, without question, the most exciting and disturbing genius of fifteenth-century Italian art. The shadow of his influence falls right across the second half of the century and well into the sixteenth century. The almost prophetic quality of much of his work has never ceased to amaze critics, just as the immense variety of his invention has been a constant source of inspiration for artists. Perhaps then the excitement and vigour of the Triumph of Caesar represent some sort of response on the part of Mantegna to these aspects of Donatello's sculpture.

Mantegna was, of course, very well acquainted with an important part of Donatello's work at Padua. Donatello was working there c. 1443–53 at the very same period as Mantegna was beginning his career as an artist. At this stage in his career, it is true, the breathless vitality of Donatello's narrative style clearly meant very little to him. Nevertheless, even at this stage, elements of Donatello's art can be detected. One or two odd compositional devices and types of perspective projection probably originate with him. But the chief monument to Donatello's influence is the S. Zeno altarpiece itself which certainly took as its starting point the great sculptured bronze tableau devised by Donatello for the High Altar of the church of St Anthony at Padua.

This early work exhibits two particular interests

superficially only loosely connected with Donatello. There is an almost obsessive concern for the third dimension; and a passionate interest in the general and detailed appearance of antique remains. The origin of these interests presents one of the most disputed problems of Mantegna's career and introduces the obscure and enigmatic figure of Francesco Squarcione, who was Mantegna's master when he began as a painter.

It is generally recognised that Squarcione himself was an indifferent artist. Born probably in 1394, he began life apparently as a tailor, but had switched to painting by 1426. Nevertheless, he was already taking pupils in the 1420s, and some of his subsequent pupils were extremely skilled (for instance Marco Zoppo or Giorgio Schiavone). Mantegna himself spent four years in the workshop. By the sixteenth century a complete legend had grown up round Squarcione, suggesting a famous teacher, with large numbers of students (137 according to one account) flocking to his house. It was said they went to learn from him the theory of art and to study his collection of antiques, amassed, it was alleged, during extensive journeys in Greece and Italy.

Although the sixteenth-century legend created precisely the right setting for the emergence of Mantegna, at no point is it unequivocally supported by the contemporary evidence. Direct access to a private collection of antiques might certainly have fired Mantegna's interest in classical remains; and it may be that his somewhat lapidary figure style may have been influenced by the appearance of marble sculpture. Nevertheless, it can reasonably be argued that much of the appearance of his first great frescoes in the Eremitani chapel owes far more to painters such as Uccello and Castagno, both of whom visited Padua and Venice. Mantegna was probably also acquainted with the work of Piero della Francesca in the castle at Ferrara (paintings unfortunately now lost). In any case, it is more likely to have been to exemplars of this *quality* that an artist of Mantegna's ability turned, rather than to the decidedly second-rate talents of Squarcione. In fact, exactly what Squarcione taught and what facilities his household and workshop offered are likely to remain a matter of speculation.

Mantegna's reputation survived his death in a somewhat diminished form. It was in particular as a manipulator of perspective that he was regularly mentioned, and, in this respect, the Eremitani frescoes were frequently praised. But, in general, sixteenth-century artists and critics were reserved about his pictorial style and, indeed, there was little in it for the generation of Raphael or Titian to imitate. By contrast, however, Mantegna had an immense following early in his career; and the style of the Eremitani frescoes and the S. Zeno altarpiece made a deep impression. The hard and meticulously defined character of these works was widely imitated, not only by other pupils of Squarcione, but also by more eccentric artists such as Cosma Tura or Carlo Crivelli. Mantegna also exercised an important influence on the Bellini family, into which he married in 1453.

In the long term, it was probably Mantegna's ideas which have exercised the most influence. His reputation as a perspectivist was amply justified, and he had the most extraordinary skill in devising illusionistic schemes of painting (as witness the Camera degli Sposi). But it was also his perceptive care as an antiquarian and student of classical remains that helped to open a new chapter in the history of Renaissance painting. Mantegna's work brought others, artists and patrons alike, to a far more complete and critical awareness of what the classical remains actually looked like, and what the Romans and Greeks might have looked like. Mantegna put classical and mythological scenes into antique costume; and his *Triumph of Caesar* is also a triumph of archaeological reconstruction combined with artistic sensitivity.

And in the end, of course, this artistic sensitivity was of the very first importance. Mantegna has occasionally been criticised for being over-intellectual, but his interests as an antiquarian were balanced by his skill and instinct as a painter, so that his art never descended to mechanical revivalism. It is, indeed, this peculiar combination of imagination, intellect, and manual dexterity which gives Mantegna's work its special quality and fascination, and which is amply illustrated in the following pages.

ANDREW MARTINDALE

An outline of the artist's critical history

The art of drawing used as a means of naturalistic portrayal, exercised with sureness of touch and elegance of line; manual skill and "charm" (by which is meant a combination of grace and the use of the right colour in the right place) in painting; above all, a gift for handling perspective, in the sense of an ability to create an illusion: these were the aspects of Mantegna's art extolled by Giovanni Santi (c. 1485), the father of Raphael. They were celebrated, too, by Spagnuoli (1502), Leonardi (1502), Biondo (1549) and a number of others writing at the same period or not long afterwards, all of whom stressed the element of "truth". These others included such writers as Lomazzo (1584, 1587 and 1590) and Scannelli (1657), who dwelt in particular on the precision of Mantegna's foreshortening, while Lorenzo da Pavia (1506) reserved his praise for the wealth of ideas and Summonte (1524) appears to have been impressed chiefly by the artist's love of archaeology. All these points were touched on by Vasari in his *Vite* (1550 and 1568) and again by Scardeone (1560) who followed in Vasari's footsteps but who, in the heat of his enthusiasm for his subject, omitted Vasari's reference to the stony "hardness" of Mantegna's style, even though this must to a great extent have puzzled the critics. Indeed, it had already been discussed in the preface (1532) to Dürer's *De Symmetria* by J. Cammermeister, who concluded that it denoted a lack of any real ability. The theme was further developed by Ridolfi (1648), Scaramuccia (1674) and the very few writers from then until almost the end of the eighteenth century who referred to Mantegna, who had sunk to being little more than a local celebrity in Padua and Mantua. There are, however, three exceptions and it will not be out of place to quote them here for the insights which they shared with their age: Montesquieu (1728–29) had a genuine admiration for the frescoes in the Ovetari chapel: Goethe (1786) thought he saw in the cycle (but may well have been mistaken) presages of the work of Titian; finally, Abbot Lanzi (1789) vigorously denied the suggestion that Mantegna's style was "hard".

In spite of the quality of Cavalcaselle's philological work, his contention (1871) that Andrea was the necessary forerunner to Carpaccio did not really advance Mantegna studies to any great extent. About the same time, Charles Blanc (c. 1860) and others were still imputing to him a frank and unseemly "primitive" quality.

When Mesnil wrote (1914) he thought he could reinstate Mantegna by demonstrating with compass and ruler that the parallel lines do all meet at the required vanishing point and that the figures are correctly positioned in relation to the surface on which they rest. However, by that time, Berenson (1897) had already pointed out that Mantegna's fanatical, "uncritical" and "undiscriminating" passion for Antiquity had limited his inspiration and accounted for the weakness, or even total lack, of passion in his work. This view was rejected by Fiocco (1926 and 1937) who held that there was nothing inhuman about Mantegna's abstraction and that it was precisely his cult of the world of classical antiquity which enabled him to achieve "artistic equilibrium" in a realm "beyond reality" and to do so with a vigour hitherto undisplayed by even the greatest of the Tuscan artists. Thoughts along these lines, which had earlier been aired by Venturi (1914), were further developed by Coletti (1953 and 1959) and a number of lesser critics, who presented Mantegna in an increasingly "antique" and even "imperial" light but who at the same time managed between them to impute to him a wide range of heterogeneous sentimental, psychological, stylistic and cultural qualities ranging from the heroic to the tender, from aloofness to cordiality, from frigidity to white heat, classicism to romanticism, from nostalgia for the communal and imperial glories of the past to a condemnation of the feudal system, from the most tenacious Gothic leanings to the most precocious humanism, from the most unbridled of fancies to the most unbending logic.

Mantegna's fame was at its zenith: and it was crowned by the exhibition in Mantua in 1961 which aimed, among other things, at illustrating the importance of the "lesson" which the considerable and distinguished band of his pupils, disciples and followers had learnt from him. These included the little known lesser (artistic) lights in Mantua itself (Andrea's own sons, particularly Bernardino who died in 1480, Samuele da Tradate, Raffaello Albarati, the brothers Gerolamo and Francesco Corradi, who were included in Mantegna's will; Bartolomeo Sacchi, the artist known as "Il Tondo", Luca Liombene and others who seem even more phantom-like in our eyes). But there were others: Liberale, Francesco Bonsignori, Gianfrancesco Caroto, Domenico Morone of Verona, Lorenzo Costa, Francesco Raibolini nicknamed "Il Francia", Boccaccio Boccaccino, Dosso Dossi and Correggio in Emilia. Moreover, Correggio was not the only giant of the group for it included Giovanni Bellini and Raphael as well as Titian, not to mention Melozzo da Forlì, Benvenuto Tisi known as "Il Garofalo" and Paolo Veronese. Yet others were particularly attracted by Mantegna's drawings: such were Dürer, Michael Pacher and Hubert Goltzius, Andrea Briosco nicknamed "Il Riccio", and Peter Vischer the Younger (so we see that the Master's influence was not restricted to painters but extended to sculptors as well). The list does not really stop there, for it covers also the late sixteenth-century French orna-

mentalists and reaches on down through time to the Pre-Raphaelites and symbolists of the last century, headed by Edward Burne-Jones and Gustave Moreau.

The Mantegna Exhibition in Mantua produced a crop of Mantegna literature with, at times, the expression of rash or ill-considered opinions. However, it also provided an opportunity for a series of studies aimed at the kind of rigorous pruning of the corpus of Mantegna's works (accompanied by an occasional addition) which Ragghianti had called for as early as 1937. A further aim of the studies was to determine the real extent of Mantegna's influence by distinguishing between the mere suggestion of themes (to which quite a number of the artists listed above were in fact open) and the provision of a more poetic kind of inspiration (and in this sense, there is little left to say about Mantegna's influence). Finally, the scholars concerned (Longhi; Castelfranco; Camesasca) attempted to pick out the fine and at times sublime pages in the great book of Mantegna's work (these follow closely on one another in the chapters produced in Padua and in the early years in Mantua) from the mannered, somewhat academic and at times even lifeless closing pages, with the occasional example of a more lively work appearing at increasingly rare intervals as the years of the artist's sojourn in the city of the Gonzagas rolled by.

. . . It is quite certain that Andrea endowed nature with so much and such great excellence that I doubt if he could have done more; for he, more than any other man in Italy or abroad, possesses in its fullness the skill to portray its every aspect.

. . . And no man who ever took or used a paintbrush or other similar tool was so clearly the faithful heir to Antiquity or reproduced it with greater beauty; indeed, I would venture to say that he outstrips all the ancients so that, for me, he is the foremost artist of all.

G. SANTI, *Cronaca rimata*, after 1482

. . . Mes. Andrea Mantinea, foremost in the field of drawings or paintings in all the world.

A. CREMA, *Cronaca manoscritta*, 1486

. . . the qualities of Polyclitus are overshadowed and cannot stand comparison with those of Andrea. Oh thou beast of Italy, thou glory of our age . . .; a grateful country must heap high praise on thee, second only to Livy. The gates of painting, proud of thy genius, stand ever open to receive thee; painting offers thee all her riches and admits thee to the innermost recesses of her sanctuary . . BAPTISTA MANTUANUS (G. B. Spagnuoli), *Sylvarum libri* (c. 1499), 1502

This Italy of ours possesses a very famous man, . . . Andrea of Padua, known as Mantegna, who has demonstrated for posterity every rule and kind of painting and who is not only outstanding in the use of a paintbrush but with a pen or charcoal stick can, in the twinkling of an eye, draw the figures of men and animals of every age and kind as also the customs, dress and gestures of various peoples in such a way that they almost seem to move. I think he surpasses not only the artists of our own day but also those of Antiquity . .

C. LEONARDI, *Speculum lapidum*, 1502

I do not know the identity of the painter or sculptor of those things, but it was perhaps the great Apelles of whose stock is our own Mantinea, from whom, as we learn from the writings of Seraffo, will be descended another great painter known as Mantegna to the people of Padua; our city of Mantua will take possession of him while he is still a young man; he will be skilled in drawing and in the application of colour; he will live under the rule of Francesco the Turk [Francesco Gonzaga] and will portray the deeds of the triumphant Caesar, showing forth the perfect art of the painters of Antiquity . . .

T. FOLENGO (Merlin Cocai), *Macaronea XIII*, 1517

. . . Andrea always held that the fine statues of Antiquity were invariably more perfect and possessed finer parts than were to be discovered in nature . . . And we know that he applied this principle in his own work, where we see that the style is a little sharp, so that the figures sometimes seem to be made of stone rather than of flesh and blood . . .

With great skill he showed how it was possible to depict, in painting, figures foreshortened from the bottom upwards, an achievement which was both difficult and fanciful.

G. VASARI, *Le vite*, 1568[2]

Mantegna was the first to open our eyes to that skill [perspective], because he realised that the art of painting was nothing without it. As a result, he showed us how to make everything correspond to its real appearance as we see in his own works, which were executed with extreme care.

G. P. LOMAZZO, *Idea del tempio della pittura*, 1590

. . . although this man's style was somewhat hard and severe, this was simply because he was born and flourished at a time when but scant attention was paid to the quality of tenderness . . . indeed, for this very reason, Andrea is all the more noteworthy in that he excelled, on the other hand, in all that was connected with drawing, symmetry and many other qualities . . .

L. SCARAMUCCIA, *Le finezze de' pennelli italiani*, 1674

. . . This little room [Innocent VIII's private chapel in the Vatican, decorated by Mantegna: demolished in 1780] . . . is nevertheless worth attention because of the fine pictures with which it is covered. Although modern painting is not short of innovations in composition, in drapery and in the harmonising and clashing of colours, it can nevertheless learn from these fine paintings a lesson in extraordinary lightness, precision and grace.

A. TAJA, *Descrizione del Palazzo Apostolico Vaticano* (1712), 1750

In a chapel in the church of the Eremitani (in Padua), there is on one side the Martyrdom of St Christopher and on the other the Martyrdom of St James. Both were executed by Andrea Mantegna of Padua and are excellent on account of the marvels of perspective.

C. DE MONTESQUIEU, *Voyage de Gratz à la Haye*, 1728–29

In the church of the Eremitani, I saw some paintings by Mantegna, one of the ancient artists, which filled me with amazement. What a vivid and convincing presence these pictures achieve! Artists of a later age (I noticed this in the case of Titian's paintings, for example) were schooled by the contemplation of these pictures. Mantegna's portrayal of reality is utterly authentic, never merely showy, cleverly deceptive or appealing to the imagination: it is solid, pure, lucid, minutely executed, conscientious, sensitive – and yet at the same time somewhat severe, earnest, laboured. Inspired by these paintings, later artists were able to progress still further: the vitality of their genius and the

vigour of their nature, enlightened by the spirit of their pre-
decessors and animated by their power, were able to rise to even
greater heights, soar high above the earth and produce works of
art which were both heavenly and yet true to life.

J. W. GOETHE, *Italienische Reise*, 1786

What a marvel it is [in the *Madonna della Vittoria*] to see such
delicate complexions, such glistening armour, such subtle changes
in hue in the garments, such fresh and dew-drenched fruit in
the ornamentation. Every single head is a lesson in vivacity and
the study of character and some afford fine examples, too, of how
to imitate Antiquity; the actual drawing of the figures, whether
naked or clothed, has a mellow quality that gives the lie to the
current view that Mantegna's style and an arid style are one
and the same thing. Moreover, there is an *impasto* of colour, a
fineness of brushwork and an inherent grace which, in my
opinion, mark the last forward movement made by art before
attaining the perfection of Leonardo. L. LANZI, *Storia pittorica della Italia*, 1796

. . . It seems to me that once Mantegna had realized that he
was on a false trail [with the initial frescoes in the Ovetari cycle],
he thereafter endeavoured only to reproduce in his works all that
is true and tender in nature; and although for the most part he
did not succeed in discarding entirely a certain tightness in his
portrayal of garments, with folds that are rather too straight; or in
getting away from a general tendency towards yellow in his use
of colour; or in abandoning that excessive and almost immoderate
austerity of contours which sometimes renders his style somewhat
harsh, these are all faults which may be imputed to his early
training . . . and I think he came so near to perfection in art that
he only just fell short of producing works which were absolutely
right and faultless. F. RANALLI, *Storia delle belle arti in Italia*, 1856²

Mantegna from the first betrays a total absence of that feeling
for tone which is so charming in Giovanni Bellini. He contrasts
his tints on scientific principles, one colour being accurately
balanced by another, in accordance with the laws of harmony,
but he has not the fibre of a colourist, nor does he know how to
produce depth by imperceptible gradations, and in his merciless
severity he is the forerunner of Carpaccio.

J. A. CROWE – G. B. CAVALCASELLE, *A History of Painting in North Italy*, 1871

Antiquity was thus to Mantegna a very different affair both
from what it was to his artist contemporaries in Florence, and
from what it is to us now. If ever there be a just occasion for
applying the word "Romantic" – and it means, I take it, a
longing for a state of things based not upon facts but upon the
evocations of art and literature – then that word should be
applied to Mantegna's attitude towards Antiquity . . .
Subjects like the Crucifixion, the Circumcision, the Ascension,
which again offer rare opportunities for the expression of speci-
fically Christian feeling, Mantegna treated as fitting occasions
for the reproduction of the Antique world . . . as an Illustrator,
he intended to be wholly Roman.
Had he succeeded, we might perhaps afford to forget him, in
spite of the three centuries of admiration bestowed upon him
by an over-Latinised Europe. We do not any longer need his
reconstructions. We know almost scientifically the aspect and
character of the Rome which cast her glamour over his fancy . . .

If Mantegna is still inspiring as an Illustrator, it is because
he failed of his object, and conveyed, instead of an archaeo-
logically correct transcript of ancient Rome, a creation of his own
romantic mood, the Rome of his dreams, his vision of a noble
humanity living nobly in noble surroundings.

B. BERENSON, *North Italian Painters of the Renaissance*. 1897

When handling religious themes, too, the talented artist could
not but discover new and deeper forms of expression. Neverthe-
less, in his inmost experience, he was compelled to move further
and further away from the Christian and religious spirit; as his
passion for Antiquity grew more and more unrestricted, and as
his study of its forms grew more penetrating, his mind and also
perhaps his senses were gradually filled by the forms of the antique
world as it appeared to him. Although the spirit of his early
works may be said to have been akin to that of Aeschylus, his
later works were increasingly stamped with the Euripidean
concept of the tragic: the attitude adopted by the human will
in the face of the inevitability of destiny.

P. KRISTELLER, *Andrea Mantegna*, 1902

. . . Mantegna's drawing is always great, clear, pure, noble and
very skilful. He does not aim at the comfortable seduction of
noble, melting contours, or the facile softness of half tints;
instead he always displays a combination of incisive fidelity and
daring in conveying the artist's thought without any uncertainty
but instead with forcefulness, deep and original lines and a
complete lack of concern about the possibility of seeming dry or
hard. L. TESTI, *La storia della pittura veneziana*, 1909

The originator of humanist painting in northern Italy began
his career imbued with a passion for Antiquity. On the pattern
afforded by the ancients, he Romanised Donatello's forms,
simplified their composition and tempered their movement.
Though he was an unscrupulous naturalist, he nevertheless
wished to enhance nature and to force her to conform to the
pattern of the mighty images of Antiquity. The principal features
of Mantegna's iconography are therefore an iron gravity, a
profound silence and a rigid sense of control . . .
Toward the end of his life, he stretched out his enfeebled
arms towards his own youthful image of beauty . . . From
Antiquity he then took no more than the refinements incor-
porated in the great cameos of the emperors for the decoration
of the Sant'Andrea chapel where, to this day, he gazes from the
bronze image of himself, crowned with the laurel wreath earned
for him by the *Triumph of Caesar*.

A. VENTURI, *Storia dell'arte italiana – Pittura del Quattrocento*, 1914

. . . Mantegna grew up among Squarcione's other protégés.
They must certainly have discussed at length among themselves
the right approach to the art of those subtle and violent Floren-
tines who seemed somehow to model clay with the same careless
assurance with which God the Father had created man in the
beginning; it was the most natural thing in the world for men
of such wild and passionate temperaments to turn the very
material nature of things into a form of idolatry; the difficulty
was to know which things were to be idolised. Mantegna
believed he had found the presumed and much vaunted source,
classical antiquity; from this he quickly devised himself a
desperate and subtle set of principles which were no less imagin-
ary than those which the Venetian Piranesi was to deduce from

the ruins of ancient Rome, but above all from his own imagination, three centuries later. It is not quite clear whether Mantegna was attracted chiefly by the quality of marble itself or rather by the examples known to him of the forms which had been fashioned out of marble in Antiquity. Personally, I am inclined to believe that the former was the case, seeing that he built up round those human beings which he "carved" out of stone a landscape imbued with an archaeological or at least an antiquated quality.

Thus, though he aimed at being classical, the principles Mantegna used were in fact anything but classical.

R. LONGHI, "Vita artistica", 1926

. . . In the frescoes of the Eremitani church the boy of eighteen . . . is the first and the greatest of the pseudo-classicists, and this detachment from humanity, while he looks inward upon a world of his own creation, alone made possible the immaculacy of his design. It is perfect with a rather narrow symmetry, tending towards the idea of a sculptured bas relief, which is frankly adopted in some of his canvases; his drawing is perfectly refined but never plastic to the full relief: his colours stimulate with their subtle clashing rather than move us by their depth. His religious scenes are without compassion, the protagonists distant from us in their proud austerity, though their sufferings are drawn with ghastly precision. And thus it is in the last great series, *The Triumph of Caesar*, at Hampton Court, that his genius swells to full expansion. His own fastidious pride finds its most genial rhythm in the pomp of a victorious procession, and this series of nine great tableaux, one of the most accurate of reconstructions, is perhaps the most moving expression of that dream of Roman grandeur which continued to obsess the artists of Europe for more than three centuries.

P. HENDY, *The Isabella Stewart Gardner Museum. Catalogue of the Exhibited Paintings and Drawings*, 1931

. . . Mantegna, for whom the formal result, art, clearly derived from a series of systematic premises and from a rigorous, selective and firmly-held "poetic", so much so that, apart from poetry, we do not find in his work any passages of uncontrolled passion, any sensual, naturalistic or descriptive flashes which push him beyond his self-imposed "form" . . . is the most logical and restrained artist of the fifteenth century.

C. L. RAGGHIANTI, "Critica d'arte," 1937

. . . [in the frescoes in the Ovetari chapel] Mantegna's control of forms – which he understands plastically – and of the setting – which he understands geometrically – are fused in a mastery which goes beyond any merely scientific solution: he translates, and so goes beyond, simple form by using colour to convey construction; and transcends linear perspective by using aerial perspective. Thus we have the birth of modern art . . .

His was a logical mind, equipped to draw out the fullest implications of the extremely deep experiences of the Renaissance. By means of them he was able, on the one hand, to outgrow in a very short time the tendency to excessive detail and ornamentation left behind by the Gothic tradition so much favoured in his native land; and also, on the other hand, to make full use of the laws of perspective, which he used, as Baudelaire says the true poet uses the rules of rhetoric, for the purpose of obtaining ever broader and more logical rhythms: harmonising first one picture with another, and then entire cycles of paintings . . .

G. FIOCCO, *Mantegna, La cappella Ovetari nella chiesa degli Eremitani*, 1946

. . . Mantegna's genius exploded with a phenomenal violence: if you attempt to study its development on the walls of the Ovetari chapel . . . you get the impression that you are faced with a sensitive nature open to any and every influence, coupled with a precise and clear-cut style: he accepts and makes his own all the achievements of the Renaissance in Tuscany, filtering them all through a humanist awareness bounded by an archaeological severity, while at the same time catching and responding to the first echoes in Ferrara of Piero della Francesca's measured space and Roger van der Weyden's naturalism. The most amazing feature of Mantegna's work is his creation of a plastic language embodying an almost relentless logic . . . Mid-way through the fifteenth century, the Veneto, and with it the whole of northern Italy, was given a landmark, in the shape of the Ovetari chapel, which was to serve as the norm for the development of a rigorously humanistic artistic culture, in a new sense, based on the experience of the Tuscan Renaissance.

R. PALLUCCHINI, *La pittura veneta del Quattrocento*, 1946–47

. . . The marbles of Antiquity represented for him a type of beauty which was noble, incorruptible, eternal; and his passion for them was happily grafted onto the sculptural bent that Donatello had given to the embryonic local school of painting. In fact, without the lessons taught in Tuscany, he would not have had a form in which to express his vision. It was from Tuscany that he derived his vigour of outline and compactness of composition. Moreover, like the Tuscans, he knew how to be both simple and monumental when he looked at nature . . .

L. VERTOVA, *Mantegna*, 1950

. . . Though they differed both in intention and in the results they achieved, a vague sense of an admittedly lofty compromise between the classic and the romantic pervades the work of Mantegna and Dürer.

M. MARANGONI, *Saper vedere*, 1950

. . . What purpose did Mantegna have in mind? To talk about perspective nowadays, when Cézanne and his successors have dissolved its classical structure, seems so lacking in interest that it is difficult for us to understand how it can ever have constituted the principal aim of a young artist . . . Mantegna was one of the small band of such pioneers; indeed, according to Lomazzo, he had it in mind to write a treatise on perspective. Besides, it is thanks to his handling of perspective that all the bystanders portrayed in these frescoes [in the Ovetari chapel] retain in the composition their presence, their beauty and youth, while at the same time assuming a new importance. We may view all this as the outcome of a logical appropriateness, since they occupy the place assigned to them of necessity. There is therefore in them nothing merely adventitious and their presence serves to clarify the rules by which art is governed.

E. TIETZE-CONRAT, *Mantegna*, 1955

It was . . . his search for the equilibrium of the ancients and his nostalgia for an heroic and orderly humanity which caused him to follow a different route from that taken by the artists of Ferrara, and it was his unfaltering sense of the value of the individual within the historicising system that he was trying out, which saved him from the kind of excessive cultural display common in his day and in the circles in which he moved and of which the *Sogno di Polifilo* is a good example. And it was precisely his search for "the real" that provided Mantegna with an

antidote to both erudition and rhetoric: the construction of his imagery is always based on a really minute analytical scrutiny of natural forms. The process of abstracting from the planes and profiles which determine these forms, blocking in their every movement and development, is revealed in the artist's toilsome elaboration; and the image is rendered all the more powerful precisely on account of the pondered clarity of its genesis.

R. CIPRIANI, *Tutta la pittura del Mantegna*, 1956

[The Camera degli Sposi:] this portrait broken up into a number of large panels, or better still this novel told in a series of chapters, in which all the Gonzagas, princes, ladies, teenagers, boys and girls, prelates, feature as persons in their own right, with their political thoughts and their pleasures. We are forced to wonder at the ability of this first-class psychologist, who first gets into their minds and then reveals them in their faces, yet always leaves them intact . . . G. PIOVENE, *Viaggio in Italia*, 1957

. . . A classicism . . . which is rendered immediate by the new laws governing perspective and harmony of composition, in which every dramatic tension is balanced in a serene solemnity and which is cut loose by Mantegna's own passionate nature from the bonds of the formal aridity of marble.

P. LECALDANO, *I grandi maestri della pittura italiana del Quattrocento*, 1957

Mantegna's Paduan period, which coincided with the youthful flowering of his genius, was wholly dominated by his passion for the Renaissance idiom – a novelty in the Po Valley at the time – and by his desire to assimilate it. At that time, he was also carried away by the fascination of discovering the natural truth (particularly from the point of view of shapes and solids) along the lines and following the examples suggested by Antiquity. The promptings of realism and culture complemented one another, resulting in an archaeological realism. Thus, even when archaeology is not directly related to the theme of his paintings, or is not featured in events or decoration which he included in his pictures regardless of the danger of being anachronistic, he aims at "archaeologising" his work precisely by means of what was, at times, an excessive accentuation of the three-dimensional and sculptural element . . . This explains the mysterious fascination exercised by those harsh, imperious and disquieting works.

— COLETTI, *La Camera degli Sposi del Mantegna a Mantova*, 1959

. . . There is . . . the Mantegna who carves his figures out of blocks of stone taken from the quarries which he loves to depict in his pictures to denote his own preference, and this not only in the *Madonna of the Stonecutters* but also in one of the panels in the Camera degli Sposi. But there is also the Mantegna who moves away from every Renaissance form, in the Tuscan sense, and depicts instead foreshortened figures in the foreground of his pictures, almost as if he were pointing out the direction of the scene by means of an illusion, after the manner of the Flemish masters, from whom he also derived the superb representation of cities clustered around a mountain top . . . These architectural structures used by Mantegna in his backgrounds should really be taken in isolation and studied in conjunction with the development in Vicenza (and therefore next door to Padua) of the kind of classical architecture of which Palladio was the greatest exponent but which is excitingly foreshadowed in the work of Mantegna. S. BOTTARI, "*Arte veneta*", 1961

. . . when Mantegna came to decorate the *Camera picta*, he found that there could now be no question of his fusing the work into a single thematic whole (indeed, he stuck to the "panel" technique for the most important parts of the room) and even the experiment in illusion represented by the oculus in the ceiling, which has been so much vaunted as presaging the work of Correggio (though really this is true only of the theme), clearly proved a failure.

This does not mean that, after completing this important work, Mantegna did not again have an occasional flash of inspiration, the odd curious recognition of his own error; nevertheless it is significant that he attempted to express those "insights" by means of a technological expedient. It is clear that he had heard talk of the wonderful chromatic and atmospheric effects which his elderly Venetian brothers-in-law were achieving in the *teleri* at the Palazzo Ducale, and of course he wanted to try his hand, though on a small scale, at the technique of tempera on canvas which, in the Madonnas in Milan (Poldi-Pezzoli), Bergamo and Berlin (all late works) or in the wonderful *Christ the Redeemer Blessing* of 1493 at Correggio, seems to veil (but no more) his underlying obsession with engraving.

R. LONGHI, "Paragone", 1962

. . . To quote Berenson, it is not that Mantegna "romanised Christianity" by setting it in a world which was congenial to him from the point of view both of decoration and inspiration; rather he restored the events of early Christian history to the world which was really theirs, namely the Roman world, the world into which Christianity had been born, so to speak, and in which it had endured the prolonged though spasmodic tragedy of its early centuries. The Roman element does not merely provide a background for the young Mantegna's work, nor is it in itself the ultimate aim of the picture or painting: it is simply one of the two dialectical elements which go into the making of the drama.

. . . His figures are perfectly in accordance with the laws governing the structure of the human body and the movement of human beings, but there is no clue as to their country of origin or the race from which they spring: they are all creatures of Mantegna's own highly individual myth of the athleticism of Antiquity.

His landscapes are generously strewn with geological details but they are devoid of that primary natural element, atmosphere, which Leonardo was to define as "aerial perspective": the tendency of colours towards blue and of forms to become less sharply defined in proportion to their distance from the observer. Mantegna could have noted its use in Flemish paintings and miniatures of the preceding decades, but it is never featured in his own work, or at most merely hinted at, at rare intervals when very great distances were involved.

Finally, the strivings of the young Mantegna were marked by a certain tendency towards the archaic which cannot be readily pinpointed but to which we must not hesitate to draw attention . . .

G. CASTELFRANCO, "Bolletino d'arte", 1962

The free disposition of the figures, in a space no longer restricted by the severity of geometric perspective, as well as the volume of the forms and the brilliant glaze of the color, are characteristics of the late style of Mantegna. . . . The heroic tone of the *Triumph* becomes in the Copenhagen *Christ Seated on a Sarcophagus* an almost Ferrarese hardness of expression; here Mantegna's native sculptural force appears again in full vigor,

and the subject is rendered still more pathetic by the livid landscape and by the static balance of the composition. The inspiration of the *St Sebastian* of the Ca' d'Oro is similar. There the theme of pain without respite is developed to its tragic extreme in the contrast between the internal energy manifested by the strained volumes and tortured outlines of the titanic figure and the inexorable geometric rigidity of the restricted architectural space . . .

<div style="text-align: right">G. Paccagnini, *Mantegna*, "Encyclopedia of World Art", 1964</div>

. . . What really matters is the way in which the archaeological element is portrayed, the process by which the ancient remains, the sloping hillsides with their classical-communal trappings of pyramids, statues, amphitheatres, their towers, barbicans, bridges, gateways and coats of arms, not to speak of the tormented human beings, that process by which the whole conglomeration – marbles, stonework, foliage and flesh – is caught up in the sumptuousness of a single material, harder and more compact than diamond, and is solemnly co-ordinated in a gem-like rigidity. In order to make sure that the result is absolute, the hillocks made of agate, the mineralised foliage, the stony masses are set in a space governed by the rigorous laws of perspective and in a light (there is no question of describing it as air) filtered through highly polished crystal, thus rendering the whole thing even more remote.

It was this control, rationally and constantly exercised by the artist, which necessarily produced his own particular world, so utterly unrelated to life or time. To say this, however, is not to deny that Mantegna was in fact open to natural beauty, to the tenderness of motherhood or the caresses of children, to the powerful grace of a horse or the lively affection of a dog, and even to the constantly changing circumstances of everyday life; nevertheless, all these elements are rendered with astonishing consistency into the density of stony and immutable forms, in which emotions, feelings of nostalgia, anxieties, aggressiveness and the most towering rages are all smoothed down into controlled harmonies.

<div style="text-align: right">E. Camesasca, *Mantegna*, 1964</div>

The paintings in colour

List of plates

The identification of some of the figures in the Camera degli Sposi given here is the traditional or at any rate the more generally accepted one; for details of possible alternatives, see section 50 of the Catalogue.

ST MARK
PLATE I
Whole

FRESCOES IN THE OVETARI CHAPEL
PLATE II
Detail of the *Assumption of the Virgin*: head of the Virgin

PLATE III
Detail of the *Assumption of the Virgin*: apostles on left-hand side

THE ST LUKE POLYPTYCH
PLATE IV
St Scholastica and St Prosdecimus

PLATE V
St Benedict and St Justina of Padua

PLATE VI
Details of: A. *Christ* – B. *St Sebastian* – C. *Mater Dolorosa* – D. *St John the Evangelist*

PLATE VII
Detail of *St Luke*

THE PRESENTATION IN THE TEMPLE
PLATE VIII
Whole

PLATE IX
Detail of Madonna with Child

ST GEORGE
PLATE X
Whole

ST SEBASTIAN
(Vienna, no. 43)

PLATE XI
Whole

PLATE XII
Details: A. Clouds on left with figure on horseback, believed to be King Theodoric – B. Broken arch in centre – C. Capital – D. Allegorical figure beside arch on right

PLATE XIII
Details: landscape and fragments of classical sculpture with signature carved in stone, to left of picture – pilaster strip and landscape to right of picture

THE AGONY IN THE GARDEN
PLATE XIV
Whole and detail of guards led by Judas, to right of picture

PLATE XV
Details: (*top*) rocks to left of picture; (*bottom*) right foreground of picture

PLATE XVI
Detail of landscape with Jerusalem, in upper half of picture

PLATE XVII
Detail of landscape at top right of picture

THE S. ZENO ALTARPIECE
PLATE XVIII
Detail of the *Crucifixion*, with Madonna supported by holy women

PLATE XIX
Detail of the *Crucifixion* with soldiers casting lots for Christ's garments

PLATES XX–XXI
Whole of three main panels

PLATE XXII
Detail of left-hand panel: architecture and festoons

PLATE XXIII
Detail of central panel: Madonna with Child

PLATE XXIV
Detail of central panel: frieze and festoons, top left

PLATE XXV
Detail of central panel: lamp and festoon, top centre

PLATE XXVI
Detail of right-hand panel with St John the Baptist

ST SEBASTIAN
(Paris, no. 56)

PLATE XXVII
Whole

PLATE XXVIII
Detail showing fragments of classical sculpture, bottom left

PLATE XXIX
Detail showing landscape to right of picture

PLATE XXX
Detail showing archer, bottom left

THE DEATH OF THE MADONNA
PLATE XXXI
Whole

PLATE XXXII
Detail of central portion of picture

THE UFFIZI "TRIPTYCH"
PLATE XXXIII
Adoration of the Magi

PLATE XXXIV
The Ascension

PLATE XXXV
The Circumcision

PLATE XXXVI
Details of the *Circumcision*: A. The sacrifice of Isaac, in left-hand tympanum – B. Moses shows the Tablets of the Law to the Jews, in right-hand tympanum – C. Capital in centre – D. Decorative motifs in central portion of picture

PLATE XXXVII
Details of the *Circumcision*: A. St Joseph – B. Women to right of picture – C. The priest Simeon with the Madonna and Child – D. Child to right of picture

PORTRAIT OF CARDINAL CARLO DE' MEDICI
PLATE XXXVIII
Whole

PORTRAIT OF A PRELATE OF THE GONZAGA FAMILY
PLATE XXXIX
Whole

CAMERA DEGLI SPOSI
PLATE XL
The Meeting

PLATE XLI
Detail of *The Meeting* showing Marquess Ludovico, Gianfrancesco and Cardinal Francesco Gonzaga

PLATE XLII
Detail of panel depicting *Servants with Horse and Dogs*: upper portion

PLATE XLIII
Detail of panel depicting *Servants with Horse and Dogs*: lower portion

PLATES XLIV–XLV
Court Scene: left and central portions of picture

PLATE XLVI
Details of *Court Scene*: A. Paola Gonzaga (?) – B. The dwarf – C. Marsiglio Andreasi, secretary, and Marquess Ludovico Gonzaga

PLATE XLVII
Detail of *Court Scene*: Barbara Gonzaga and governess (?)

PLATE XLVIII
Oculus in ceiling

PLATE XLIX
Detail of oculus in ceiling

MADONNA OF THE STONECUTTERS
PLATE L
Whole

MADONNA WITH CHILD AND CHERUBIM
PLATE LI
Whole

MADONNA DELLA VITTORIA
PLATE LII
Details of upper portion of picture

PLATE LIII
Central and lower portions of picture

CHRIST ON TOMB
PLATE LIV
Whole

TRIVULZIO MADONNA
PLATE LV
Whole

PLATE LVI
Detail of angels singing at base of picture

SAMSON AND DELILAH
PLATE LVII
Whole

THE TRIUMPH OF SCIPIO
PLATE LVIII
Detail of soldier and bystander, to right of picture

PLATE LIX
Detail of musician on extreme right of picture

DEAD CHRIST
PLATES LX–LXI
Whole

PARNASSUS
PLATE LXII
Detail of Vulcan, to left of picture

PLATE LXIII
Detail of nymphs with landscape, at centre of picture

THE TRIUMPH OF VIRTUE
PLATE LXIV
Detail of olive tree with features of a man on left of picture

COVER
Detail of *The Agony in the Garden*

In the captions at the foot of the colour plates, the number placed in square brackets after the title of each work refers to the numbering of the paintings followed in the Catalogue of Works *(pages 86–123). The actual size (width) of the painting, or of the detail reproduced is given in centimetres on each plate.*

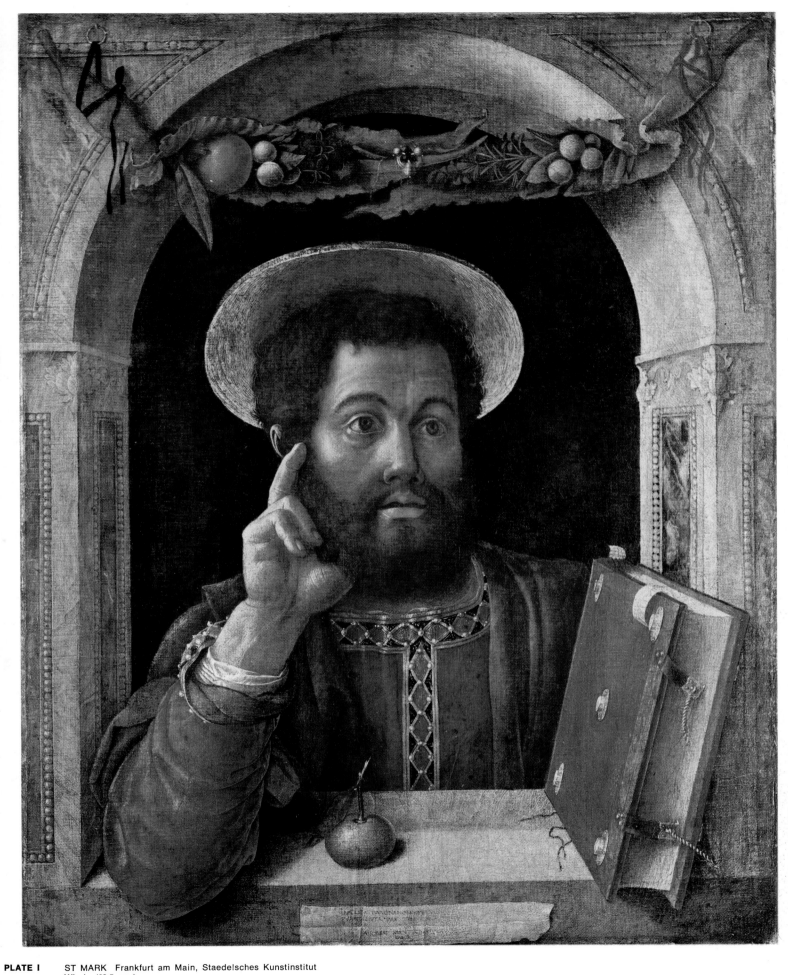

PLATE I ST MARK Frankfurt am Main, Staedelsches Kunstinstitut
Whole (63,5 cm.)

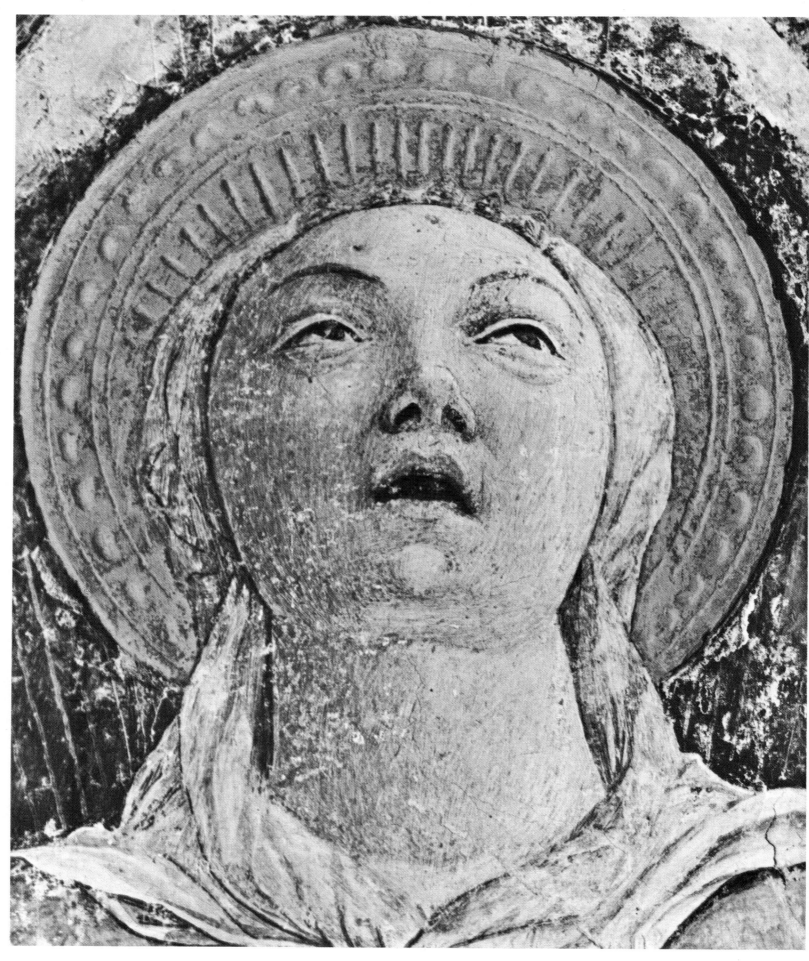

PLATE II FRESCOES IN THE OVETARI CHAPEL Padua, Eremitani Church
Detail of the *Assumption of the Virgin* (actual size)

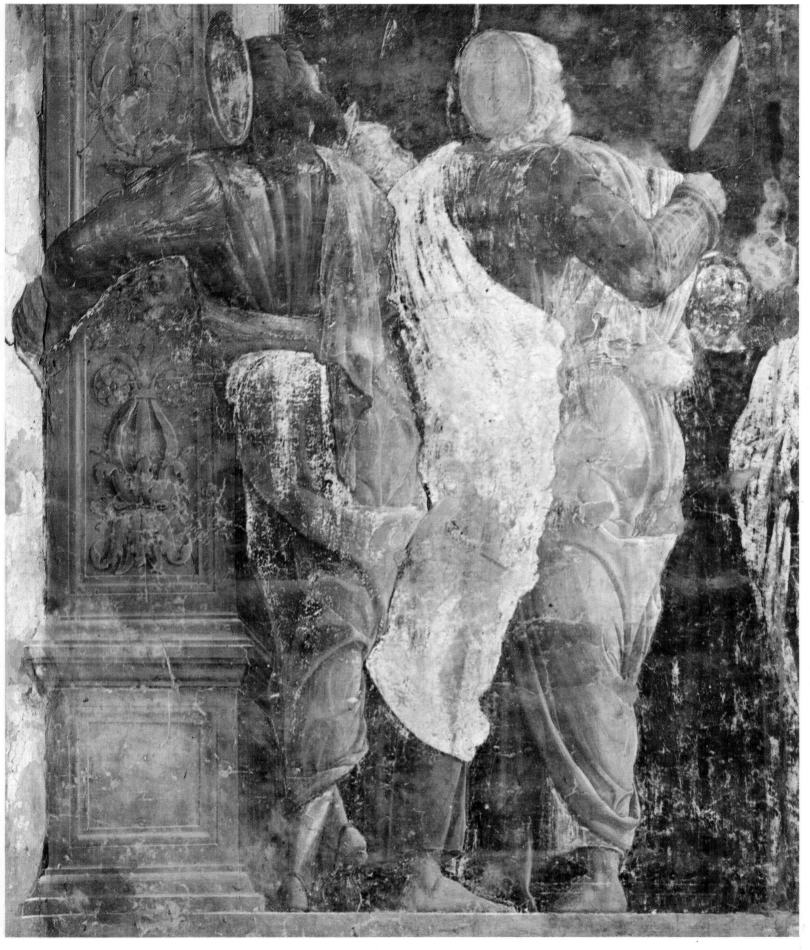

PLATE III FRESCOES IN THE OVETARI CHAPEL Padua, Eremitani Church
Detail of the *Assumption of the Virgin* (135 cm.)

PLATE IV ST LUKE POLYPTYCH Milan, Pinacoteca di Brera
St Scholastica and *St Prosdecimus* (37 cm. each)

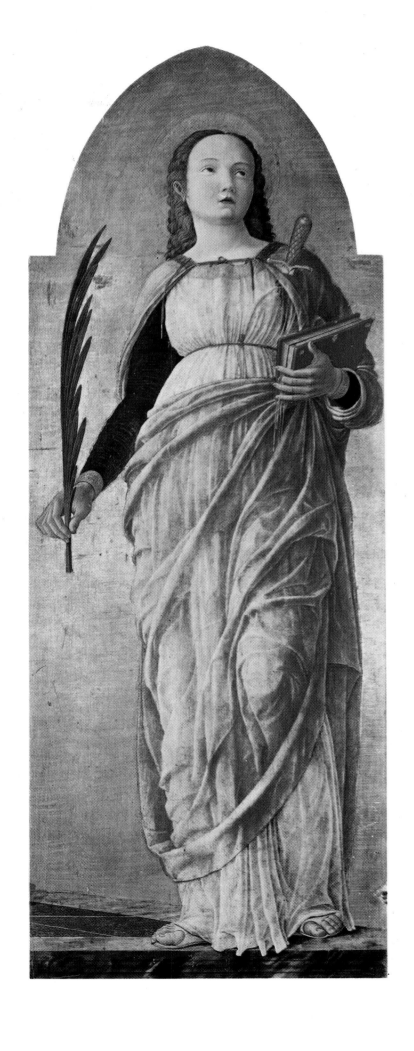

PLATE V ST LUKE POLYPTYCH Milan, Pinacoteca di Brera
St Benedict and *St Justina of Padua* (37 cm. each)

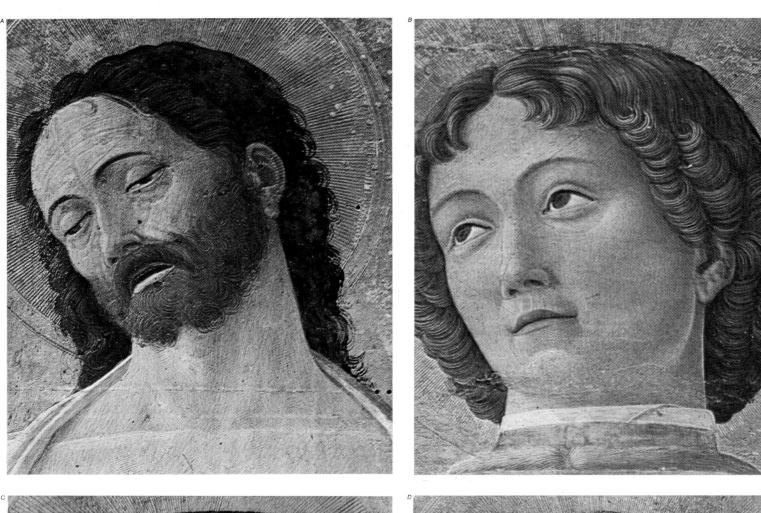

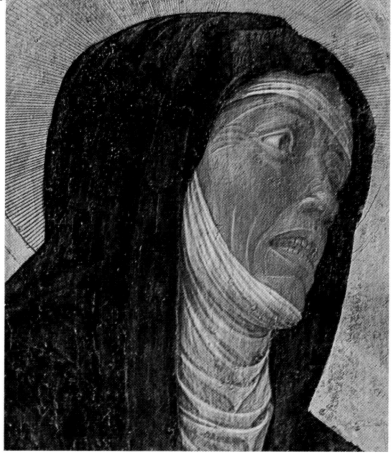
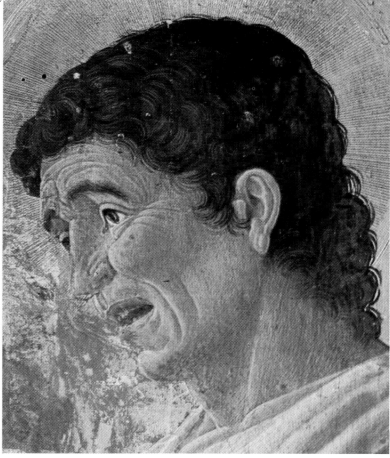

PLATE VI ST LUKE POLYPTYCH Milan, Pinacoteca di Brera
Details of *Christ*, *St Sebastian*, *Madonna Addolorata* and *St John the Evangelist* (each actual size)

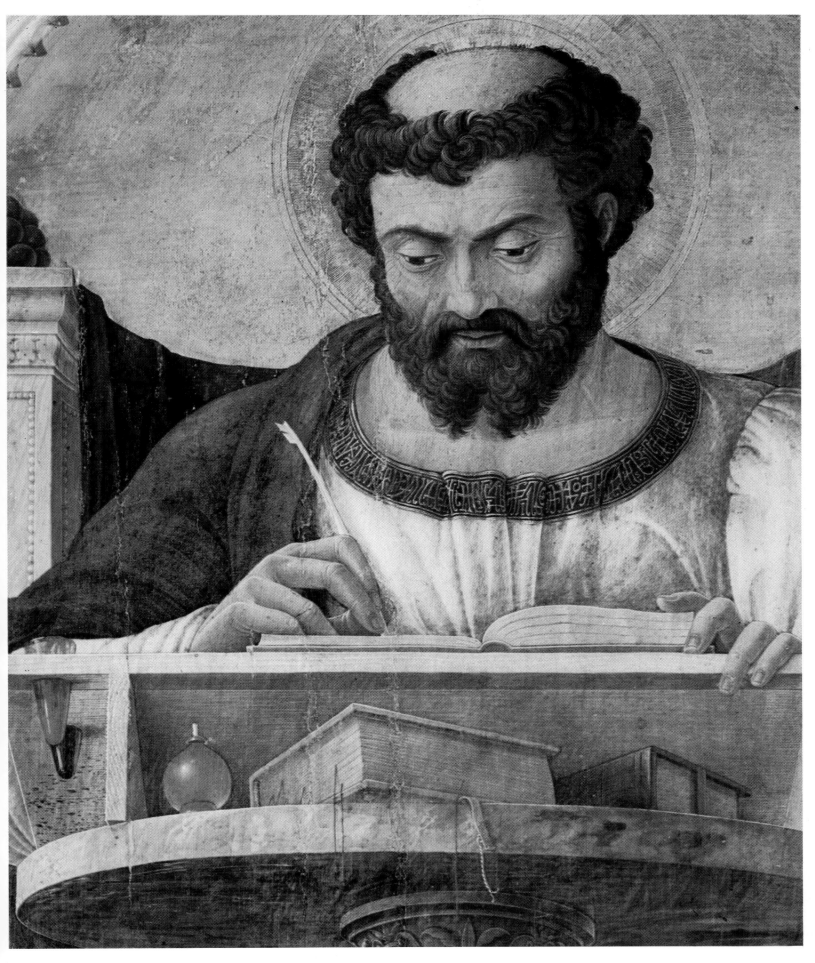

PLATE VII ST LUKE POLYPTYCH Milan, Pinacoteca di Brera
Detail of *St Luke* (33 cm.)

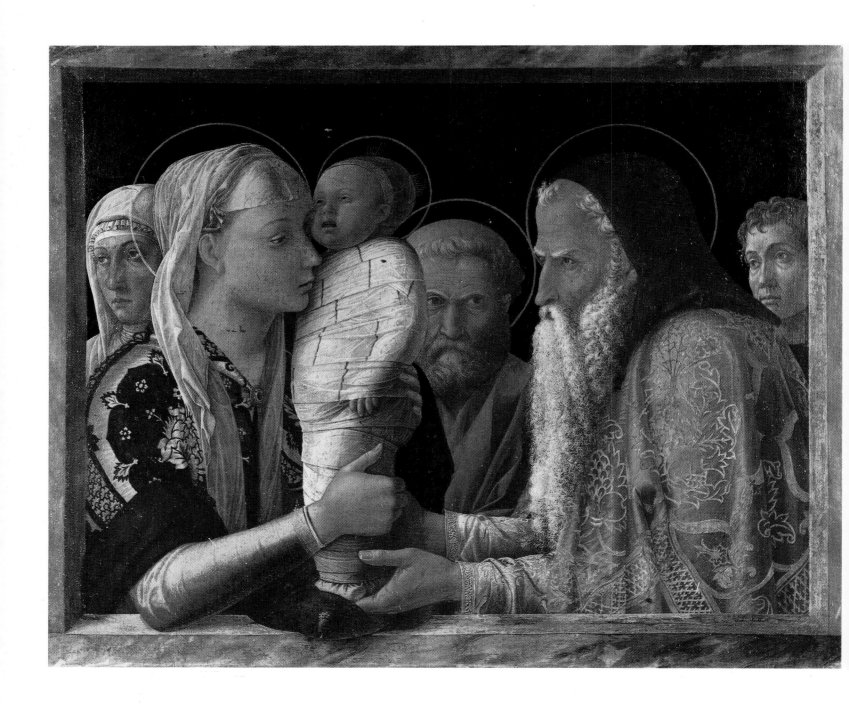

PLATE VIII THE PRESENTATION IN THE TEMPLE Berlin, Staatliche Museen
Whole (86 cm.)

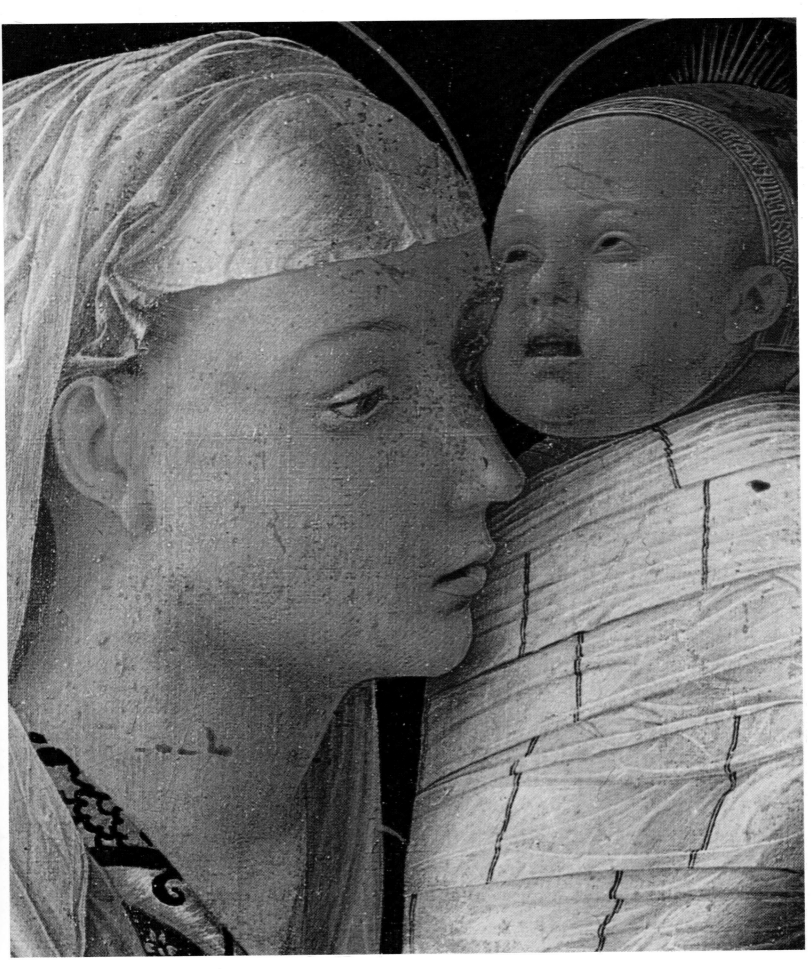

PLATE IX THE PRESENTATION IN THE TEMPLE Berlin, Staatliche Museen
Detail (actual size)

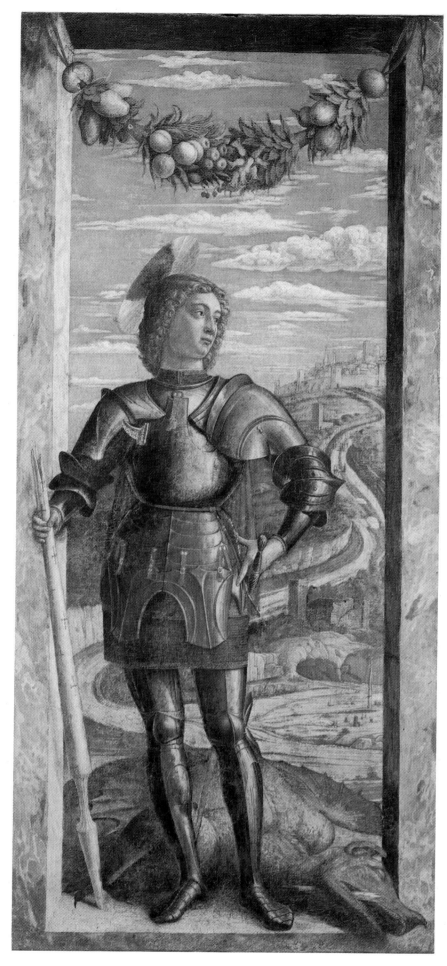

PLATE X

ST GEORGE Venice, Gallerie dell'Accademia
Whole (32 cm.)

PLATE XI

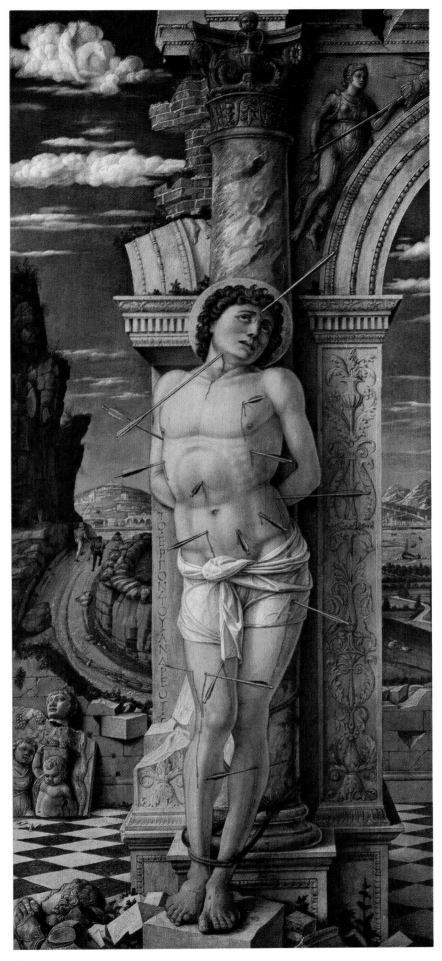

ST SEBASTIAN Vienna, Kunsthistorisches Museum
Whole (30 cm.)

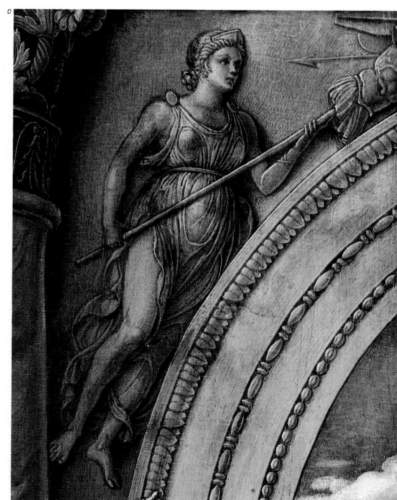

PLATE XII ST SEBASTIAN Vienna, Kunsthistorisches Museum
Details (each actual size)

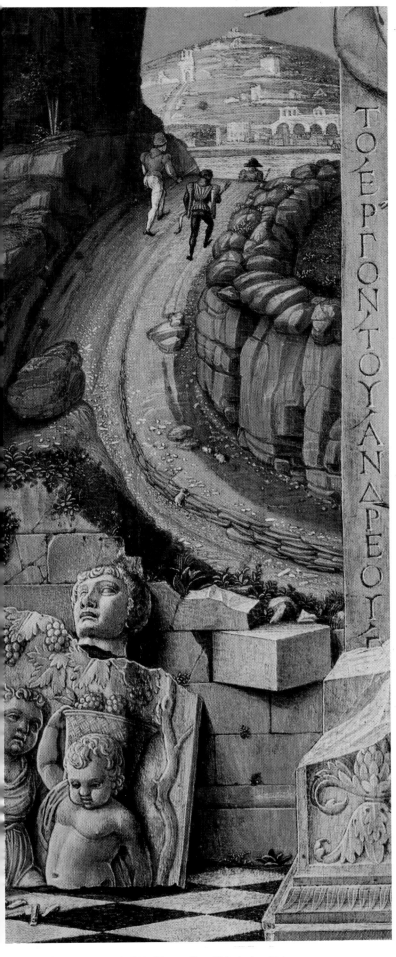

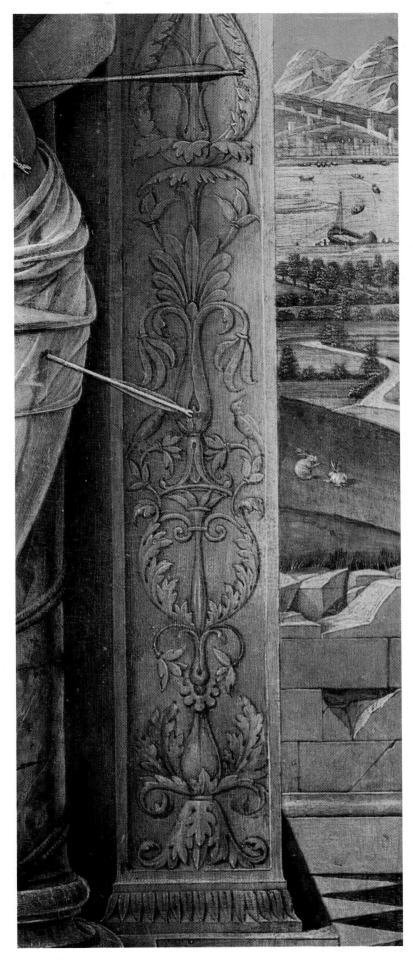

PLATE XIII ST SEBASTIAN Vienna, Kunsthistorisches Museum
Details (each actual size)

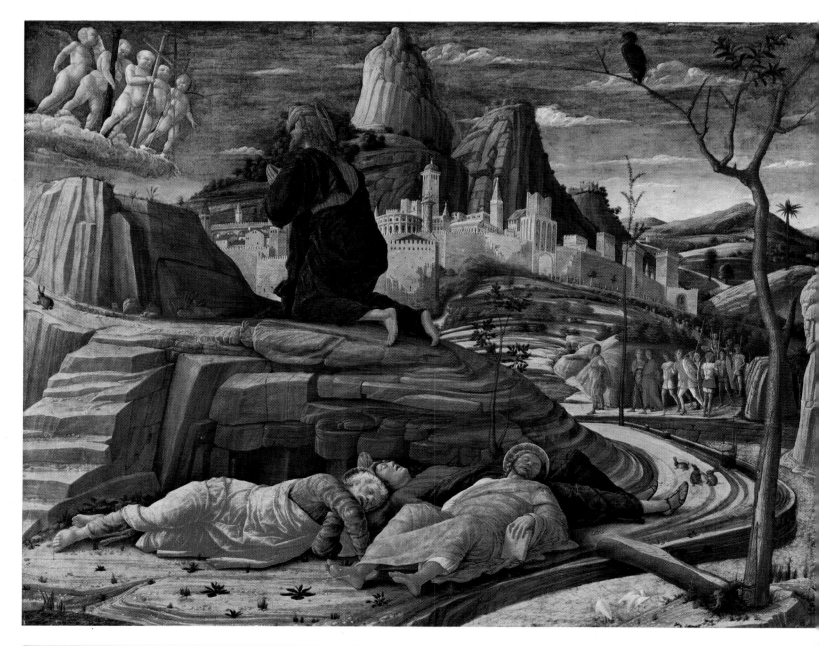

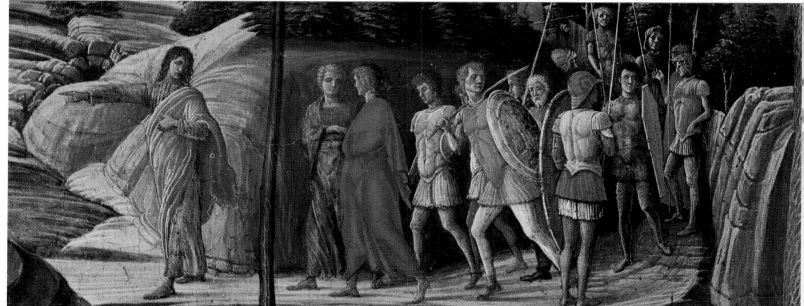

PLATE XIV THE AGONY IN THE GARDEN London, National Gallery
Whole (80 cm.) and detail (actual size)

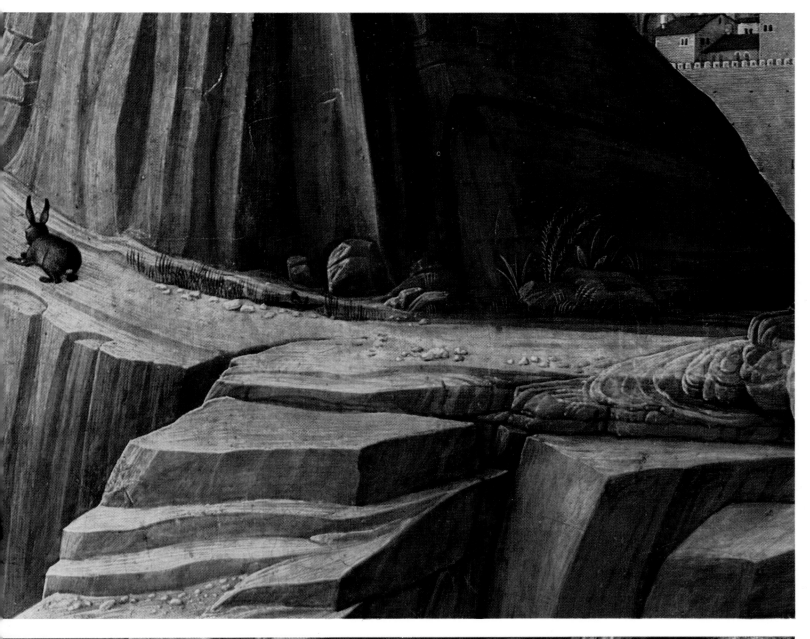

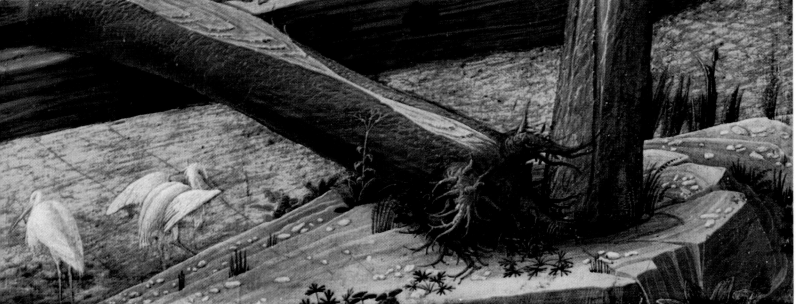

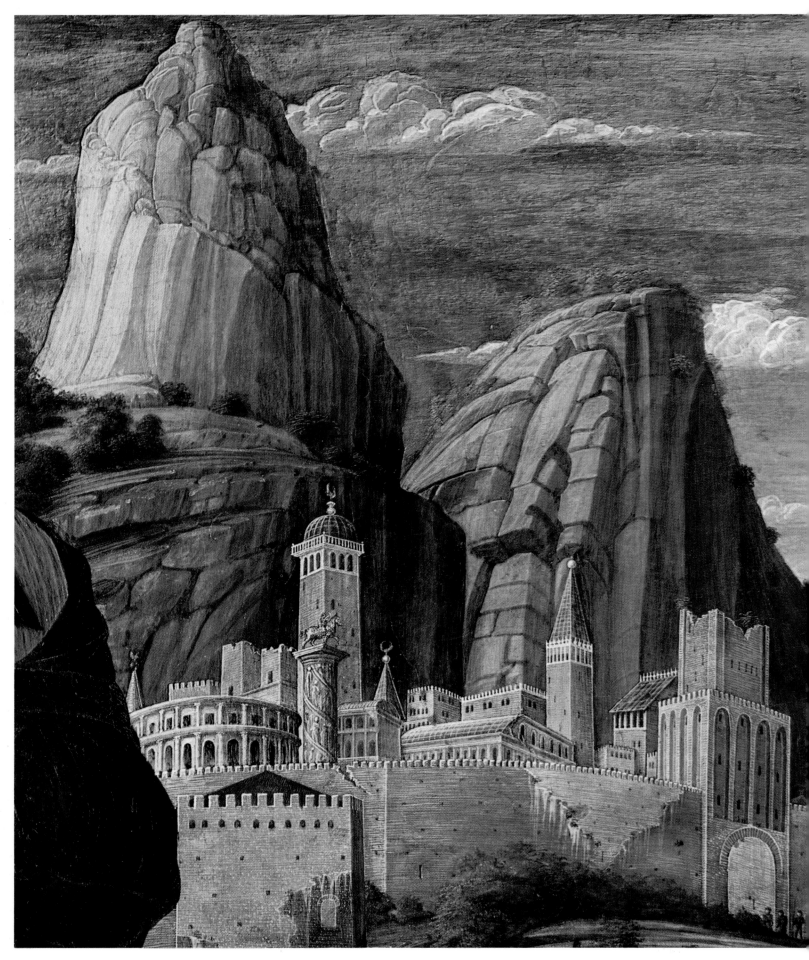

PLATE XVI THE AGONY IN THE GARDEN London, National Gallery
Detail (actual size)

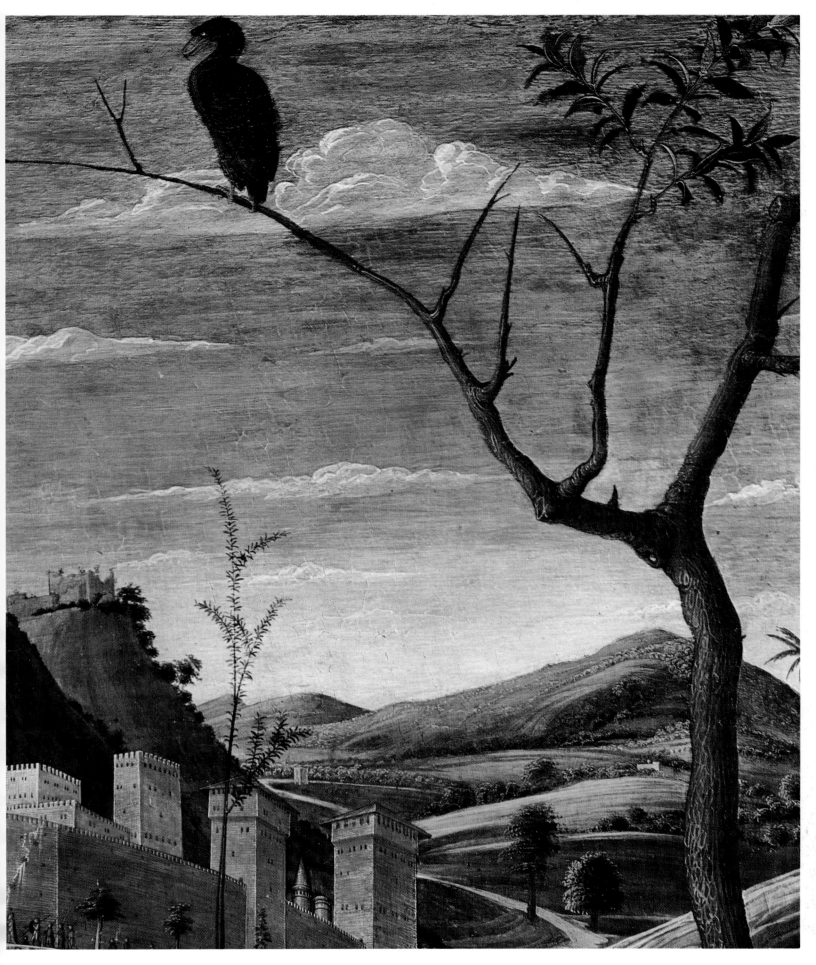

PLATE XVII THE AGONY IN THE GARDEN London, National Gallery
Detail (actual size)

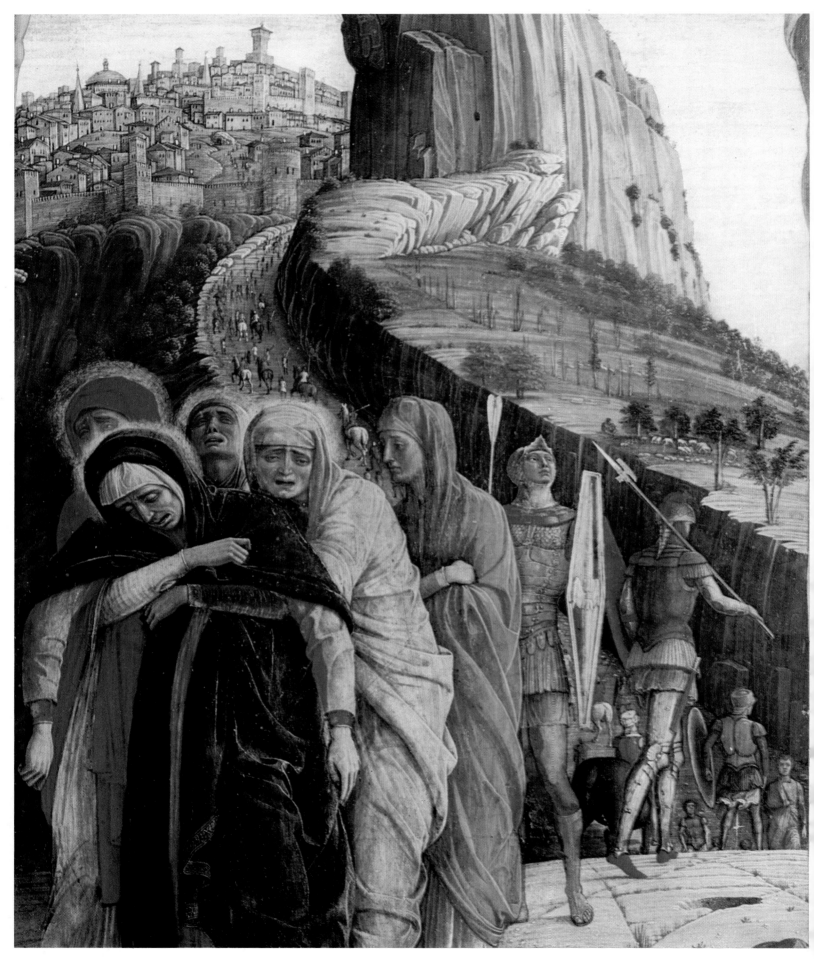

PLATE XVIII *Predella* of the S. ZENO ALTARPIECE Paris, Louvre
Detail of the *Crucifixion* (30 cm.)

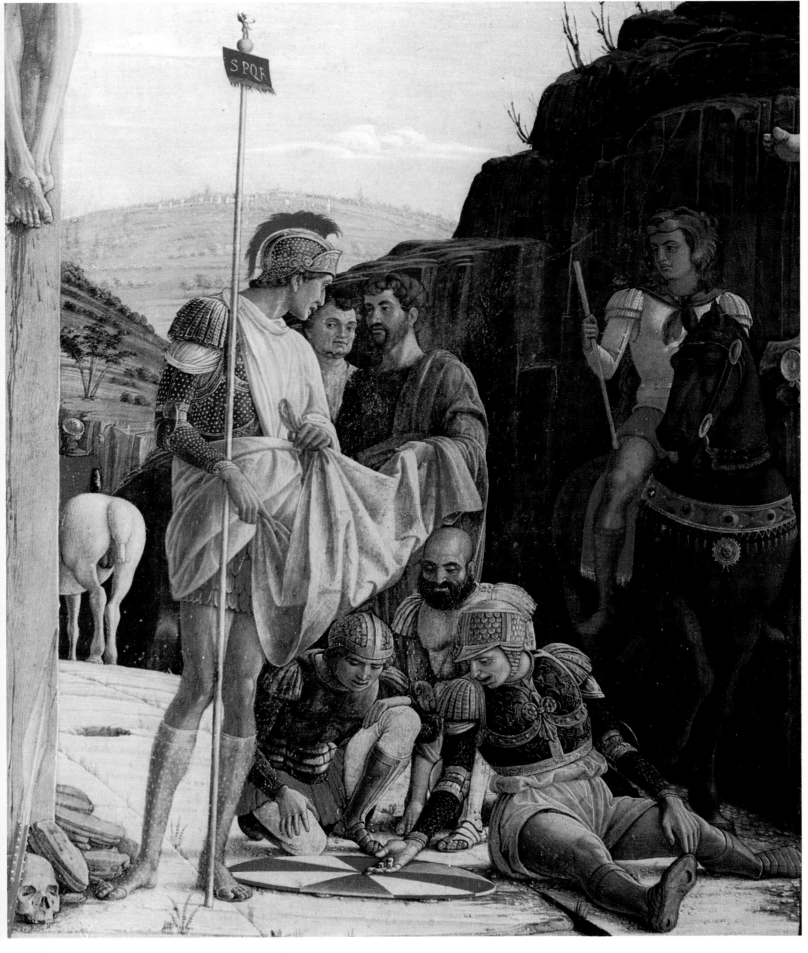

PLATE XIX *Predella* of the S. ZENO ALTARPIECE Paris, Louvre
Detail of the *Crucifixion* (30 cm.)

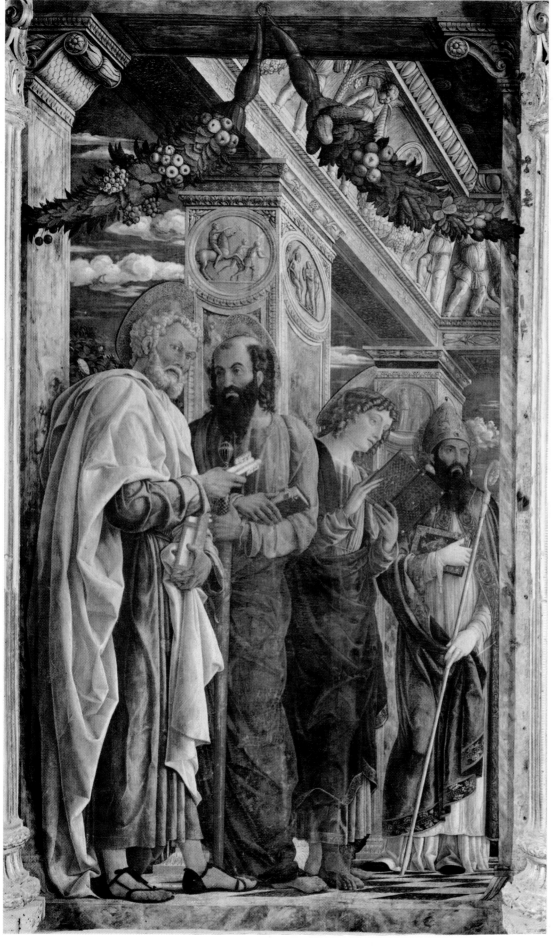

PLATES XX-XXI THE S. ZENO ALTARPIECE Verona, S. Zeno
The three main panels (115 cm. each)

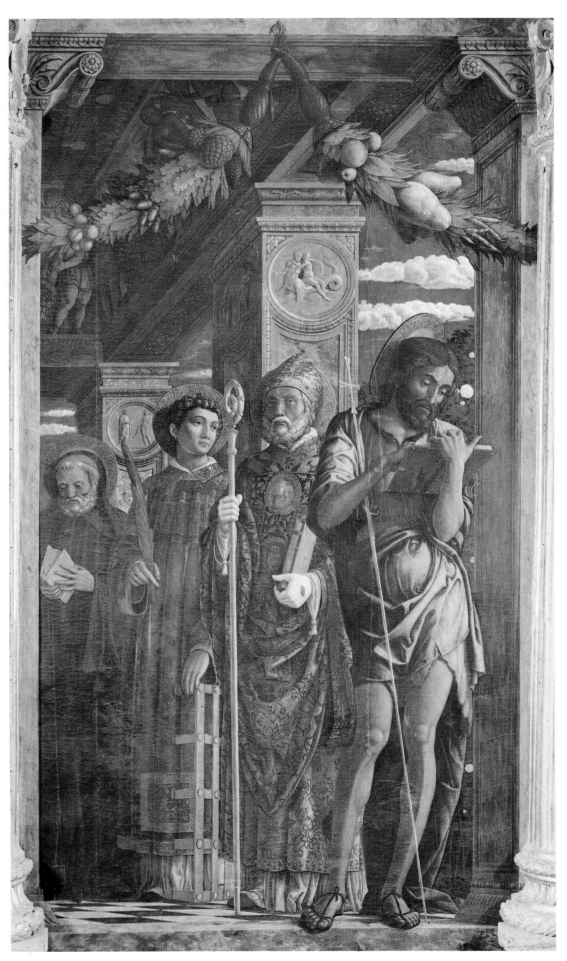

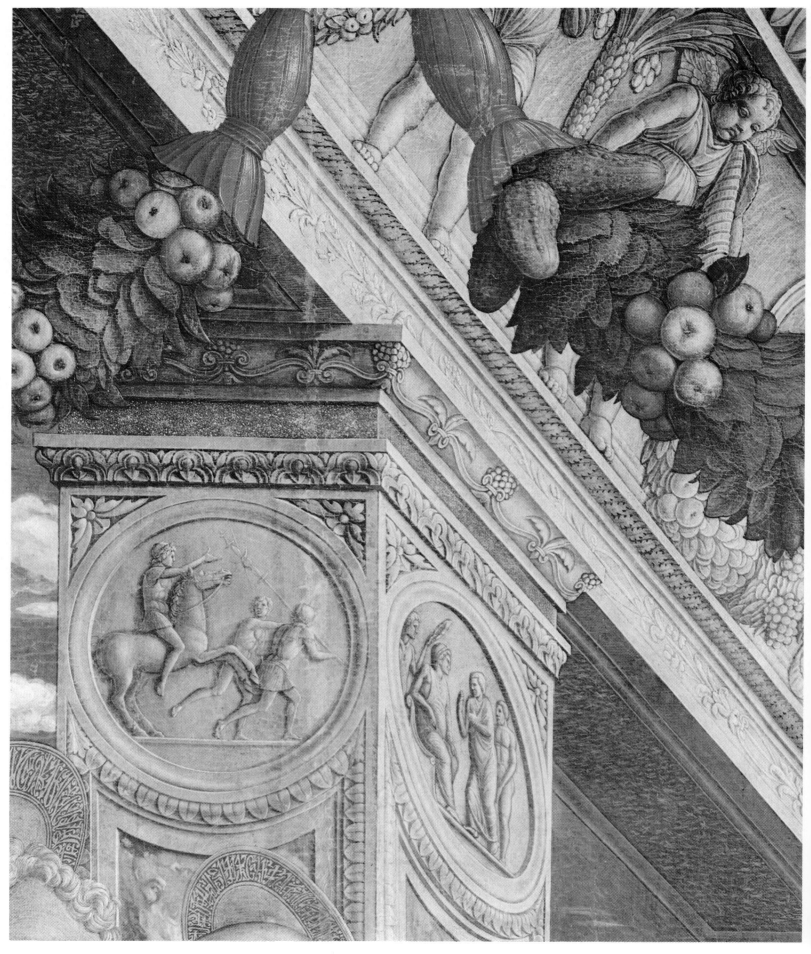

PLATE XXII THE S. ZENO ALTARPIECE Verona, S. Zeno
Detail of the left panel (53 cm.)

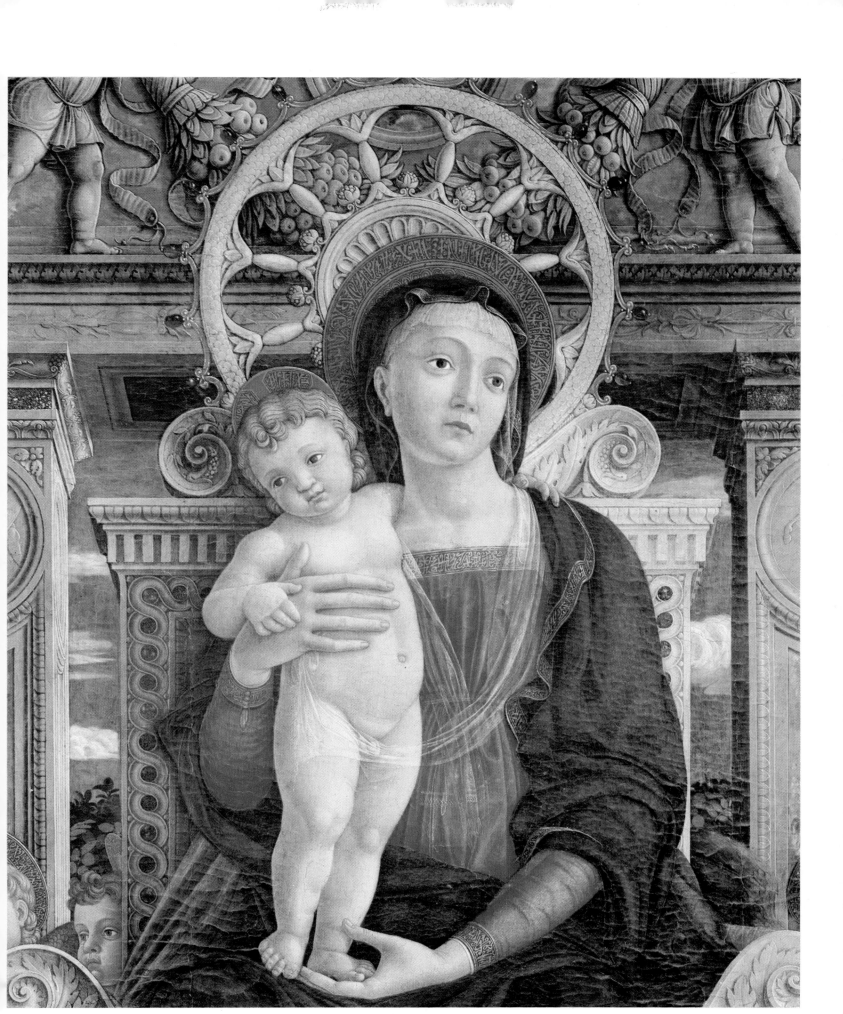

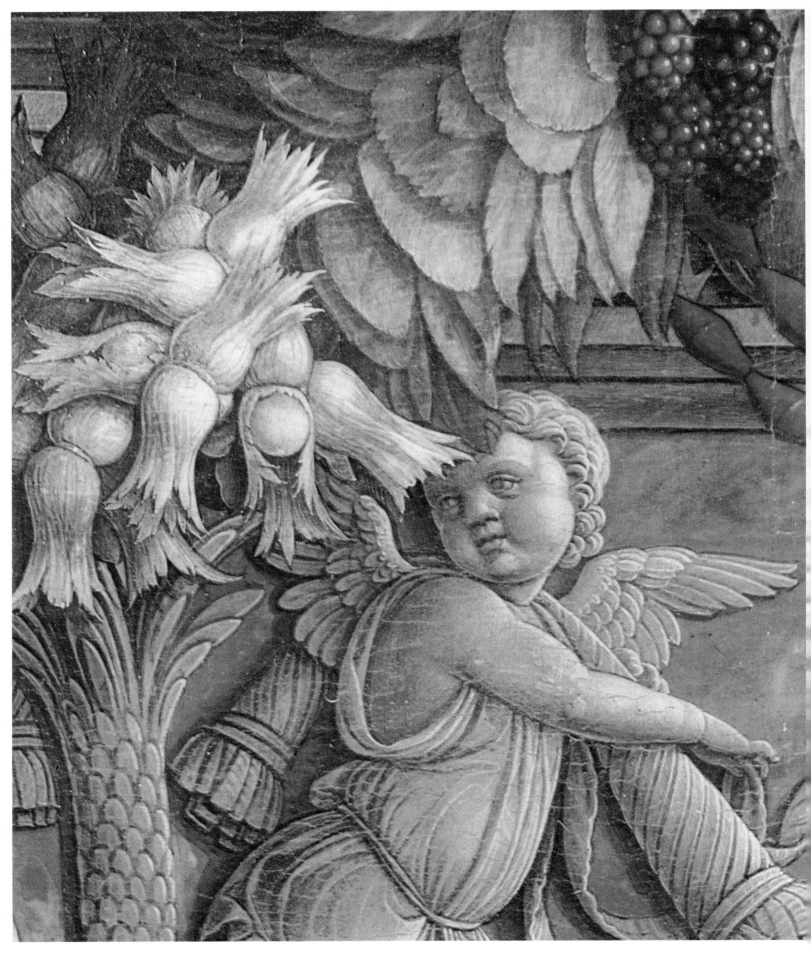

PLATE XXIV THE S. ZENO ALTARPIECE Verona, S. Zeno
Detail of central panel (actual size)

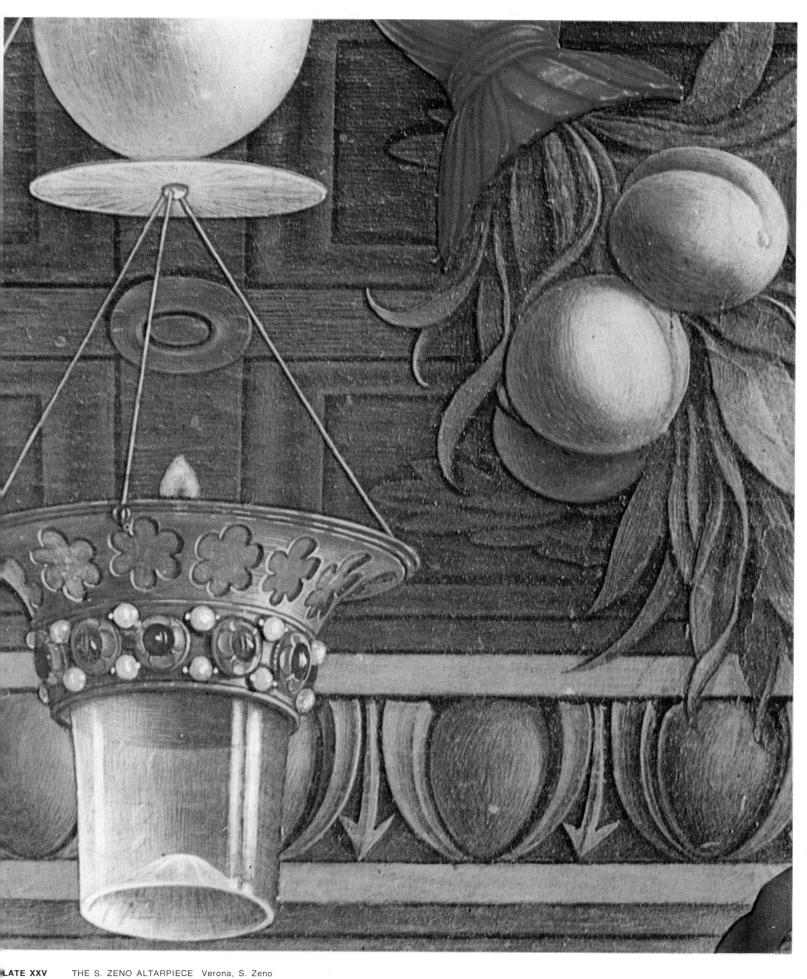

THE S. ZENO ALTARPIECE Verona, S. Zeno
Detail of central panel (actual size)

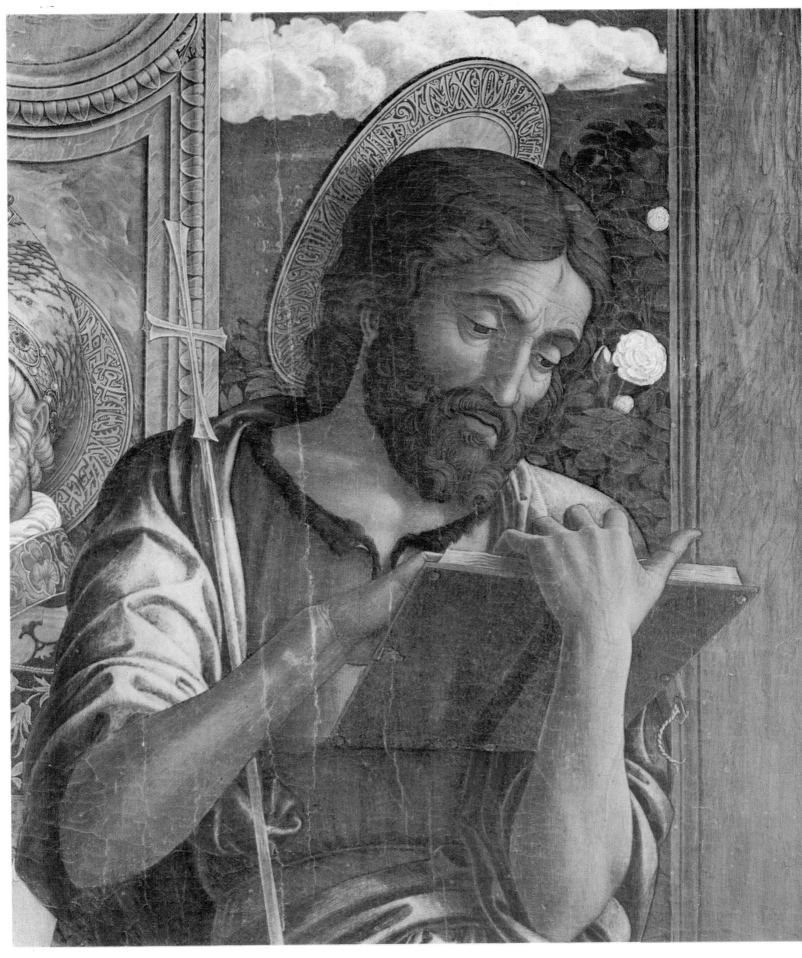

PLATE XXVI THE S. ZENO ALTARPIECE Verona, S. Zeno
Detail of the right panel (48 cm.)

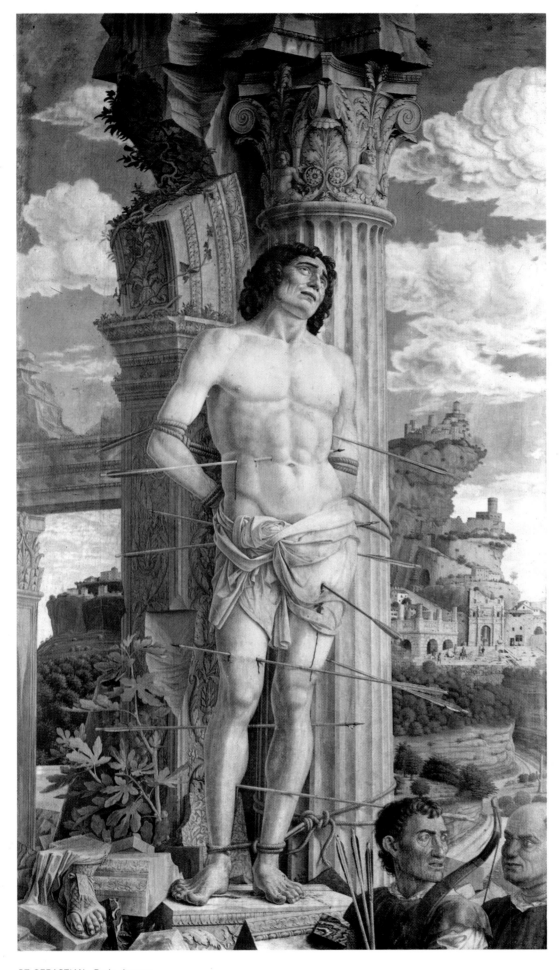

PLATE XXVII ST SEBASTIAN Paris, Louvre
Whole (142 cm.)

PLATE XXVIII ST SEBASTIAN Paris, Louvre
Detail (41 cm.)

PLATE XXIX ST SEBASTIAN Paris, Louvre
Detail (41 cm.)

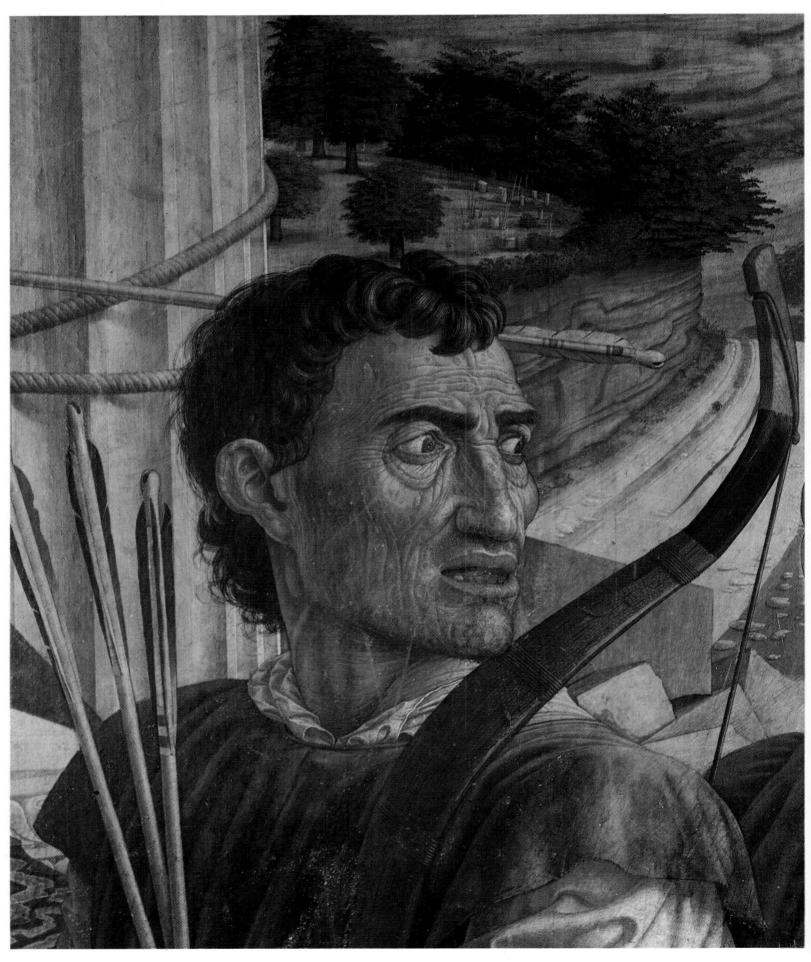

PLATE XXX ST SEBASTIAN Paris, Louvre
Detail (41 cm.)

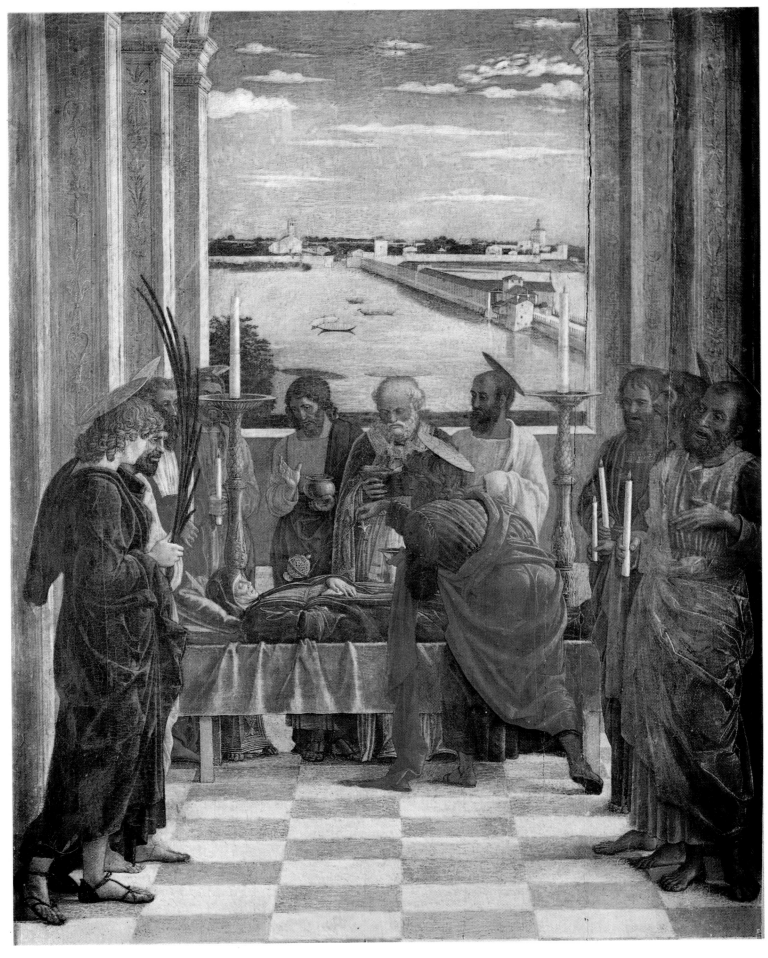

PLATE XXXI DEATH OF THE VIRGIN Madrid, Prado
Whole (42 cm.)

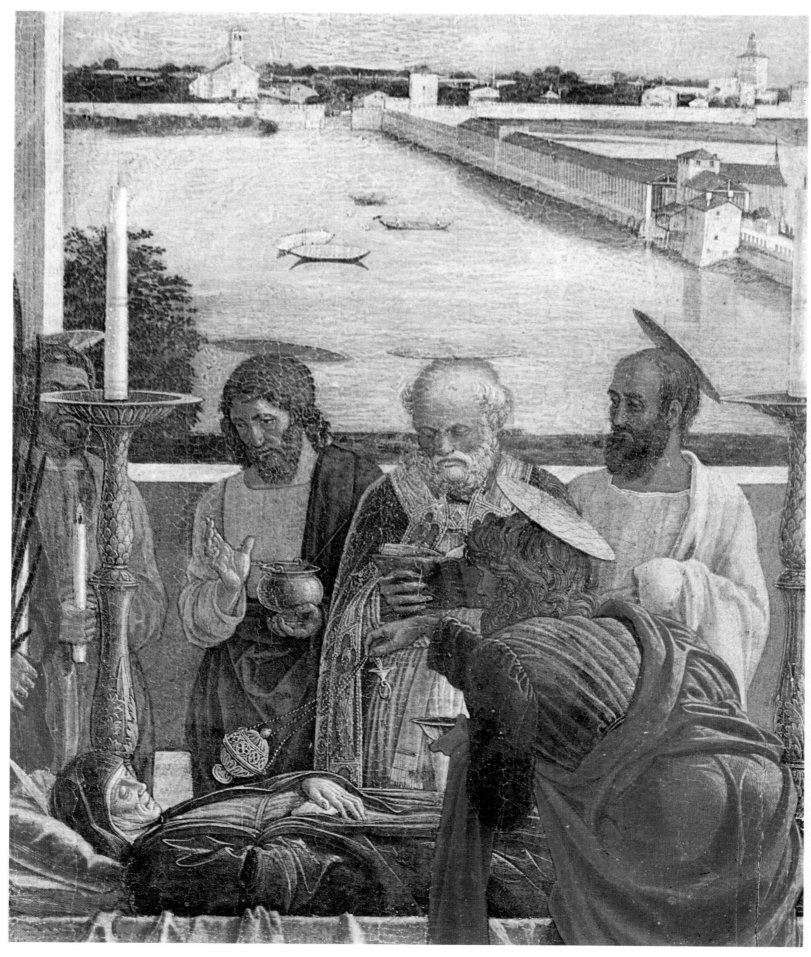

PLATE XXXII DEATH OF THE VIRGIN Madrid, Prado
Detail (actual size)

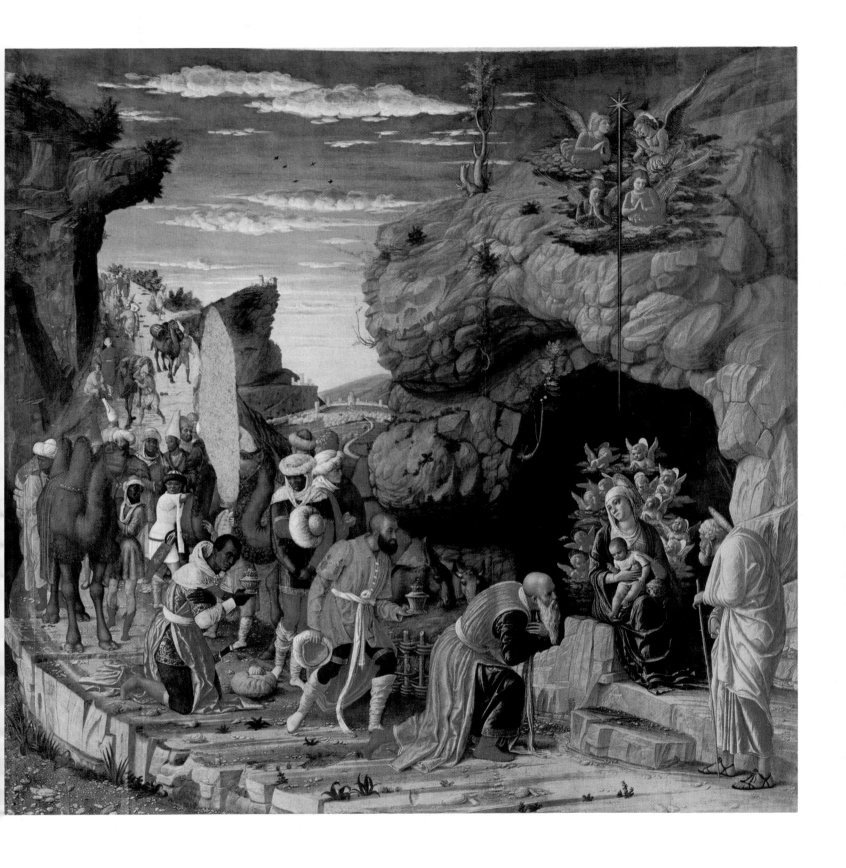

PLATE XXXIII THE UFFIZI "TRIPTYCH" Florence, Uffizi
The Adoration of the Magi (76,5 cm.)

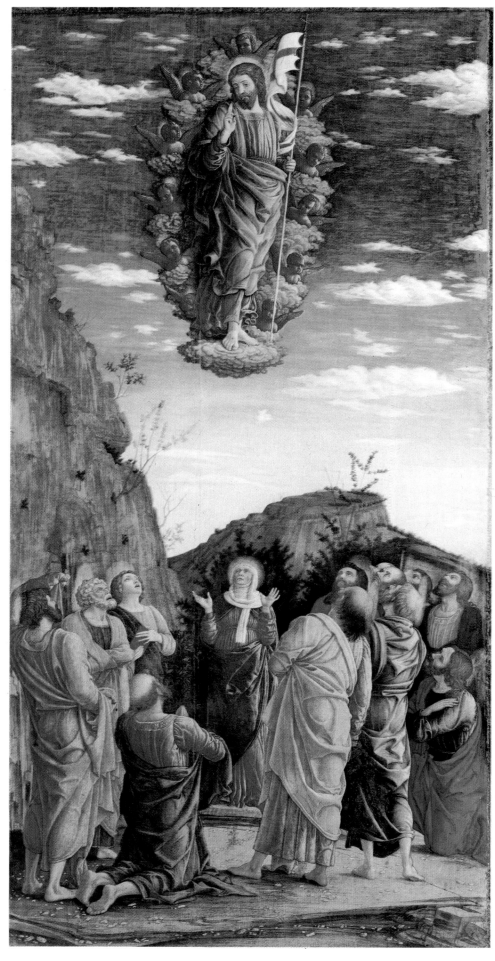

PLATE XXXIV THE UFFIZI "TRIPTYCH" Florence, Uffizi
The Ascension (42,5 cm.)

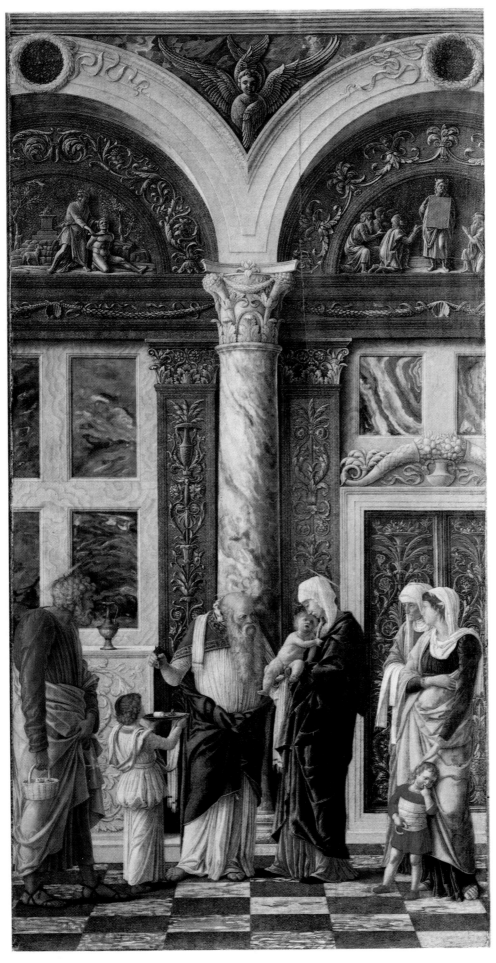

PLATE XXXV

THE UFFIZI "TRIPTYCH" Florence, Uffizi
The Circumcision (42,5 cm.)

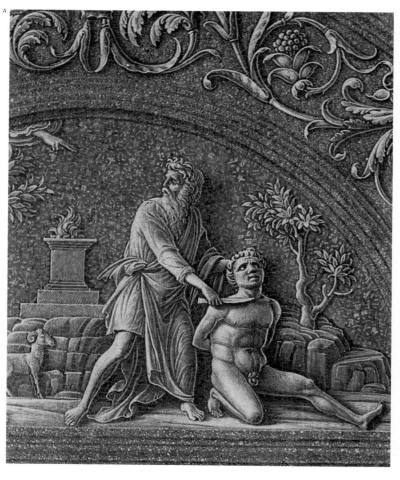

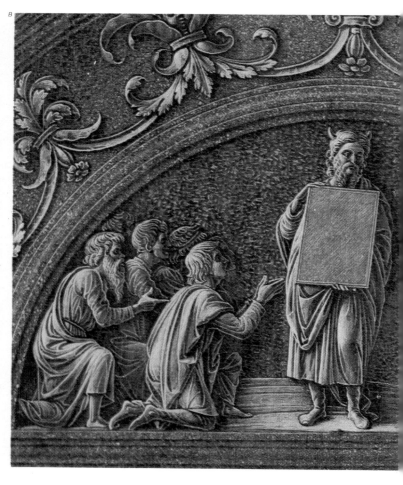

PLATE XXXVI THE UFFIZI "TRIPTYCH" Florence, Uffizi
Details of the *Circumcision* (each actual size)

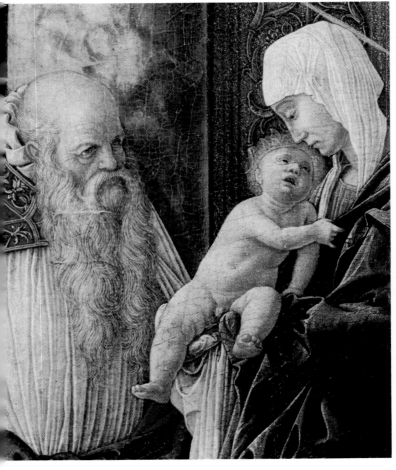

PLATE XXXVII THE UFFIZI "TRIPTYCH" Florence, Uffizi
Details of the *Circumcision* (each actual size)

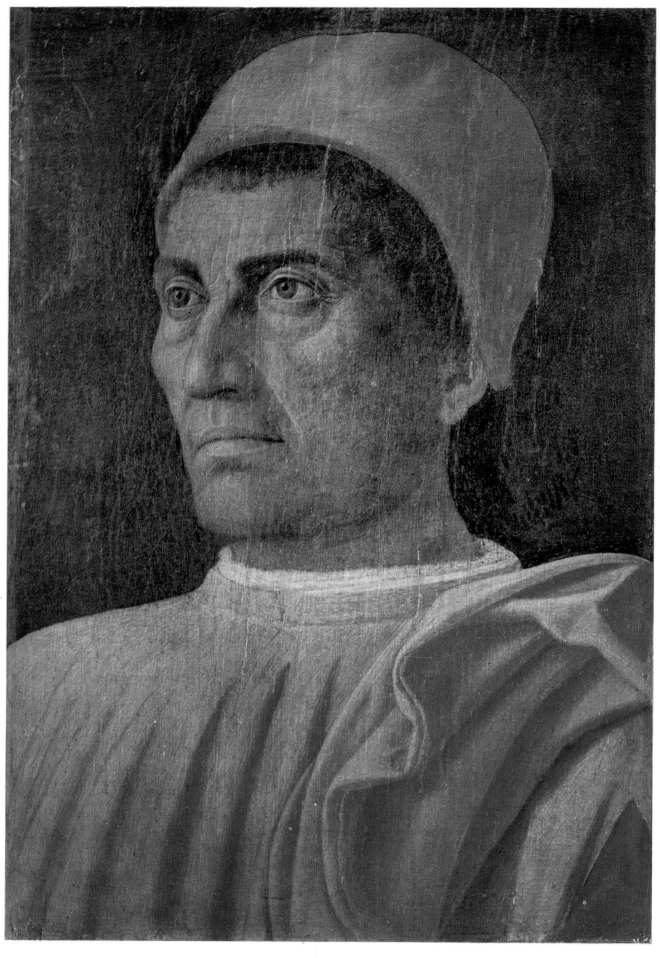

PLATE XXXVIII PORTRAIT OF CARDINAL CARLO DE' MEDICI Florence, Uffizi
Whole (29,5 cm.)

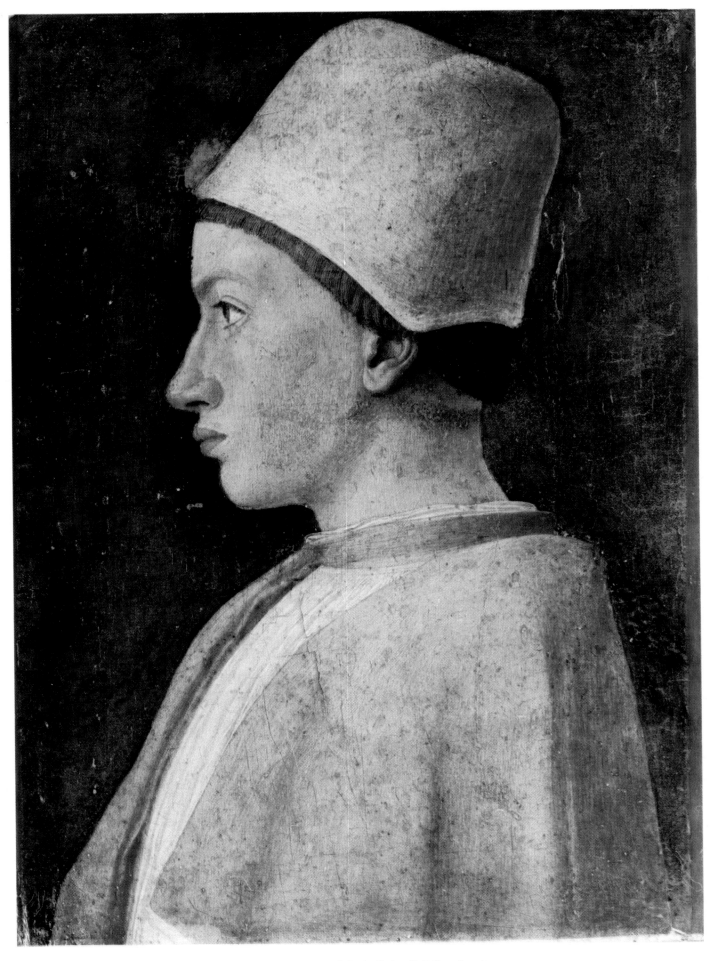

PLATE XXXIX PORTRAIT OF A PRELATE OF THE GONZAGA FAMILY Naples, Gallerie Nazionali di Capodimonte
Whole (actual size)

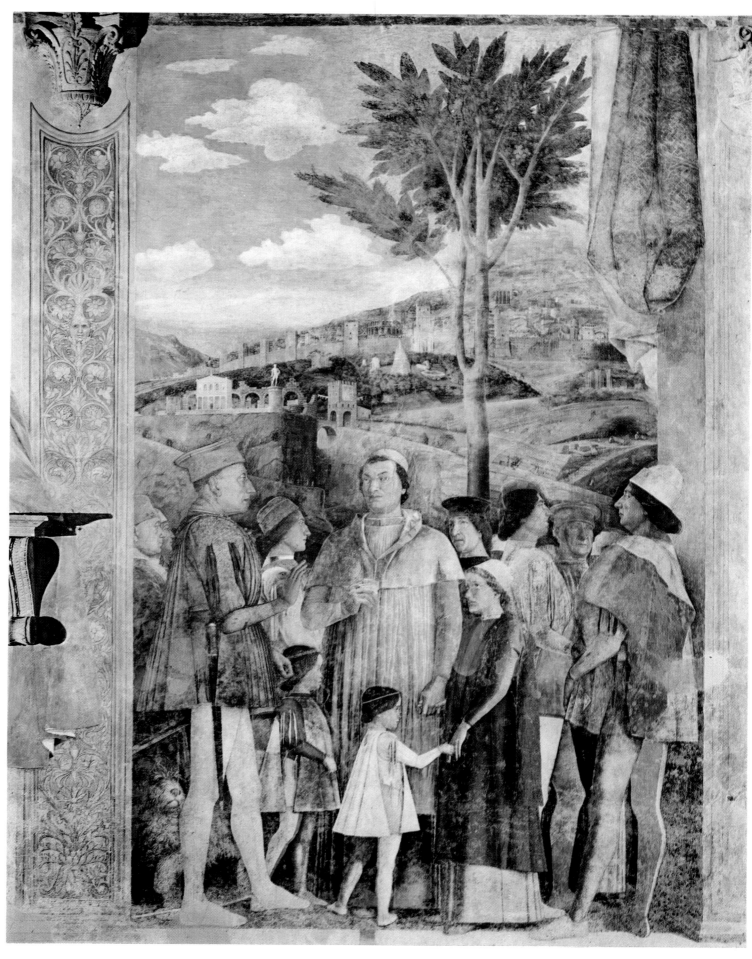

PLATE XL CAMERA DEGLI SPOSI Mantua, Palazzo Ducale
The Meeting (300 cm.)

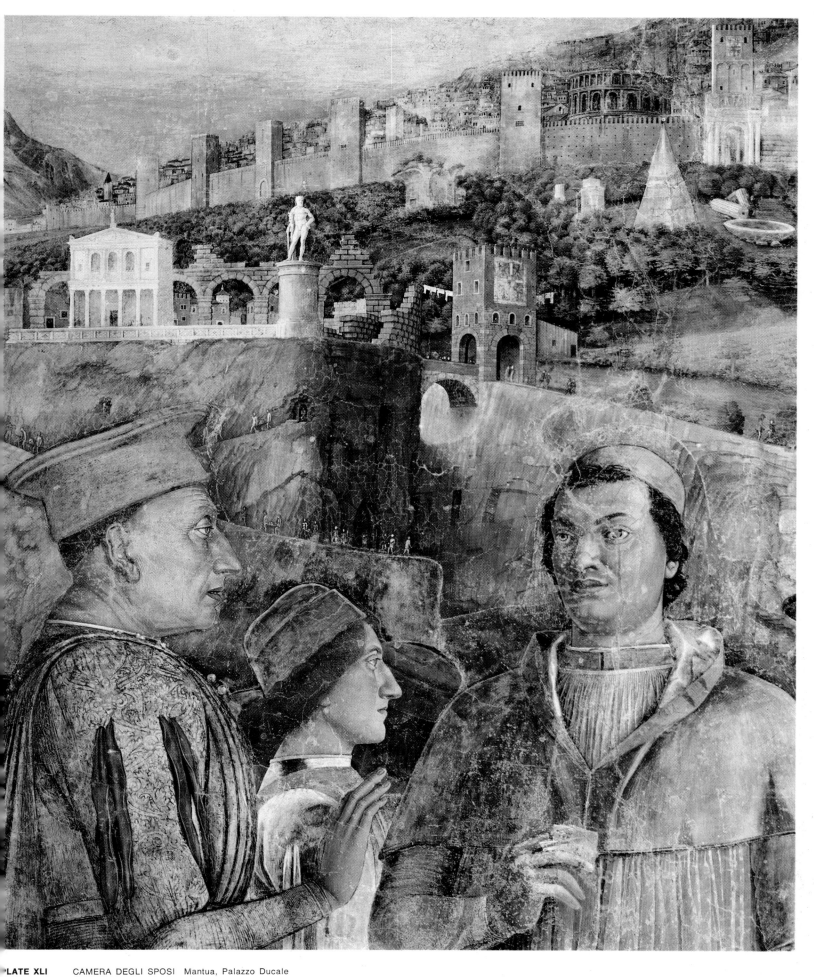

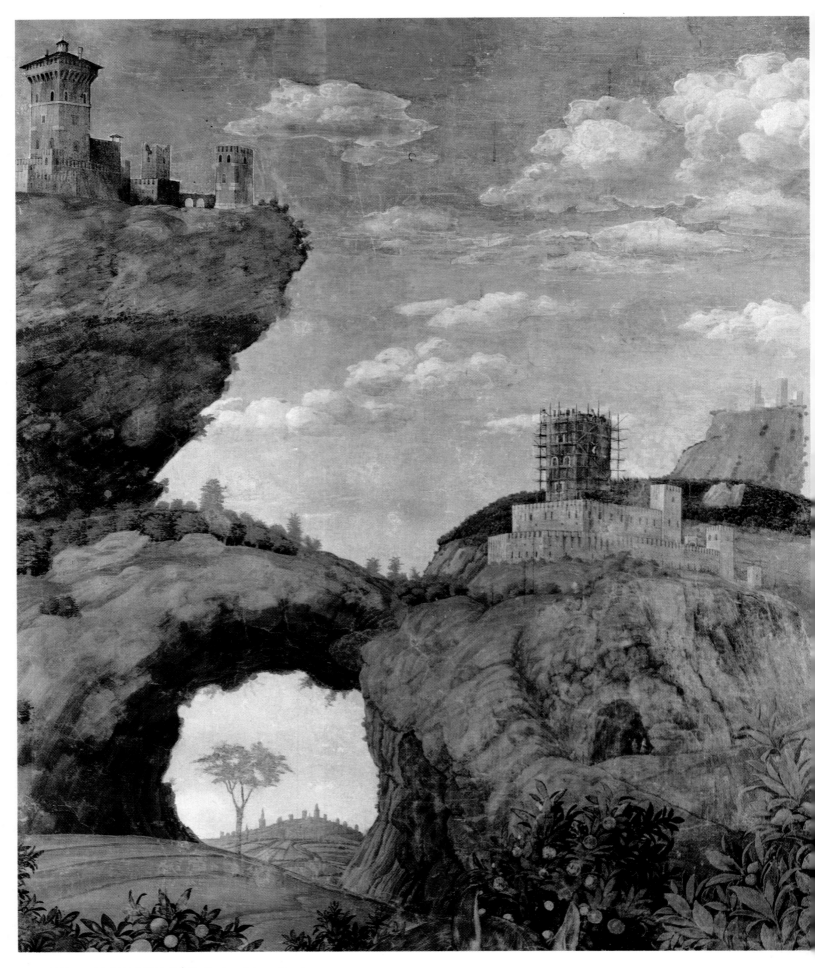

PLATE XLII CAMERA DEGLI SPOSI Mantua, Palazzo Ducale
Detail of *Servants with Horse and Dogs* (160 cm.)

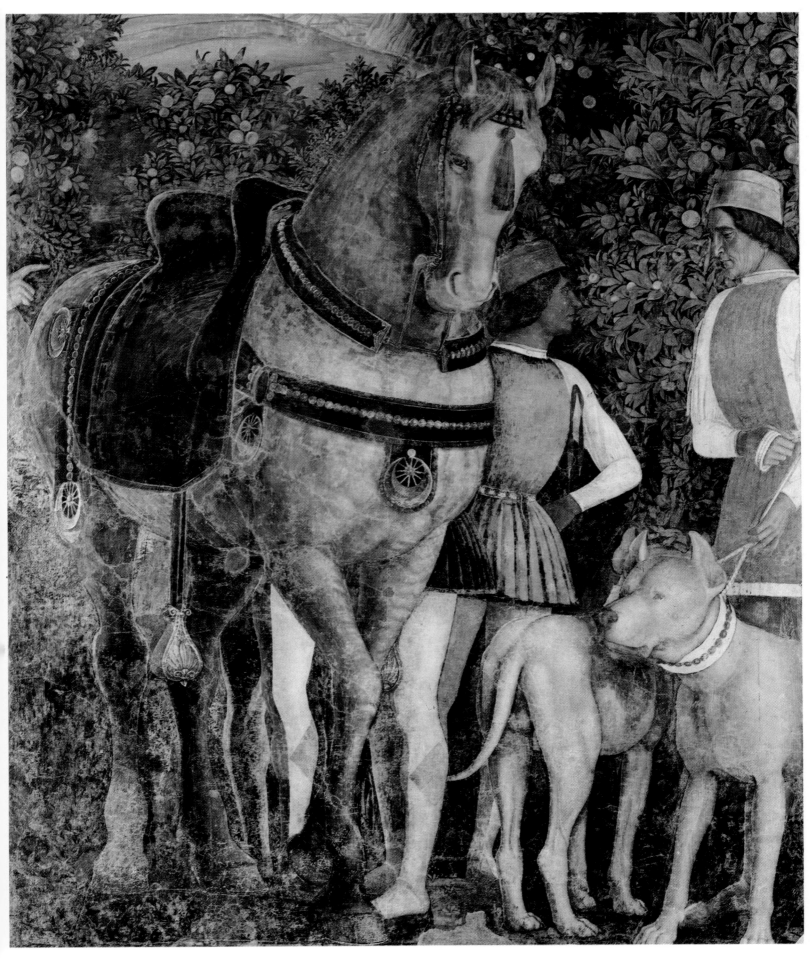

PLATE XLIII CAMERA DEGLI SPOSI Mantua, Palazzo Ducale
Detail of *Servants with Horse and Dogs* (160 cm.)

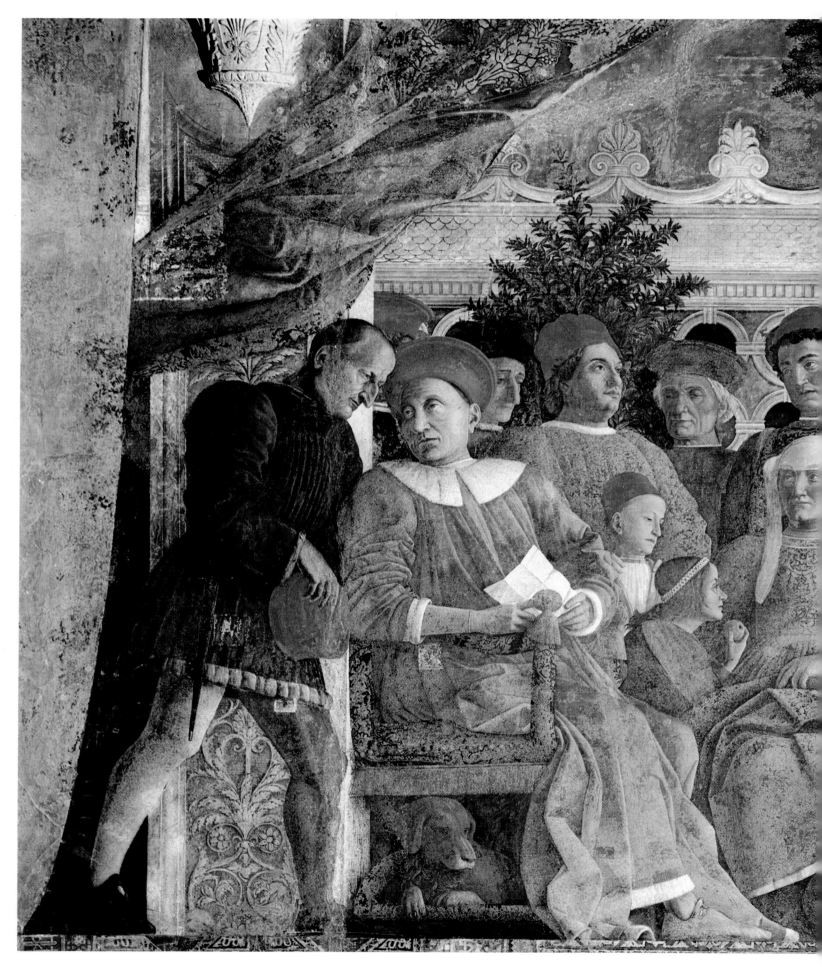

PLATES XLIV-XLV CAMERA DEGLI SPOSI Mantua, Palazzo Ducale
Detail of the *Court Scene* (410 cm.)

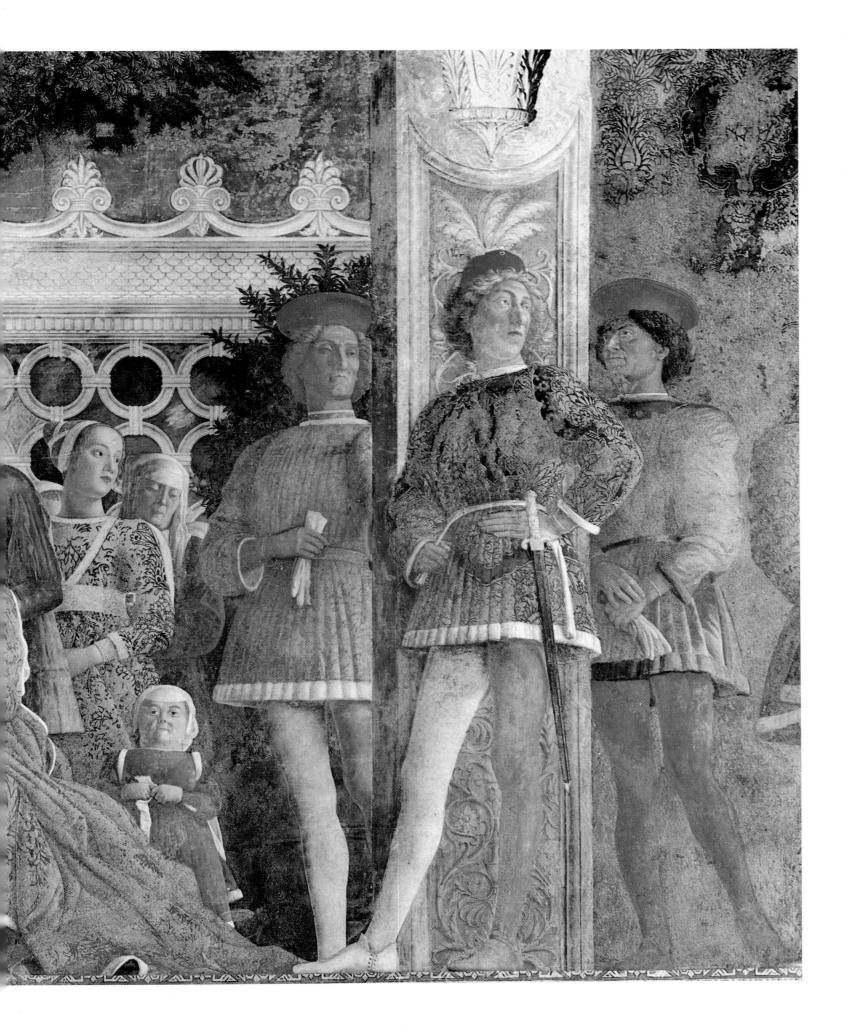

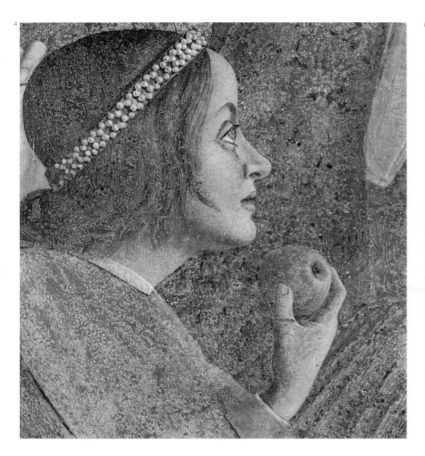

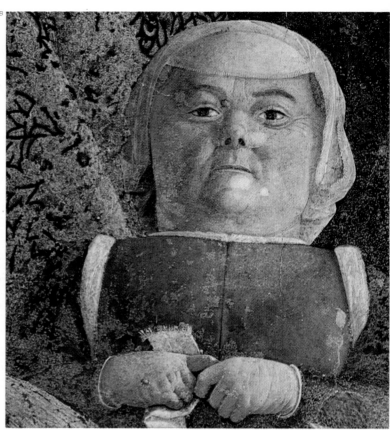

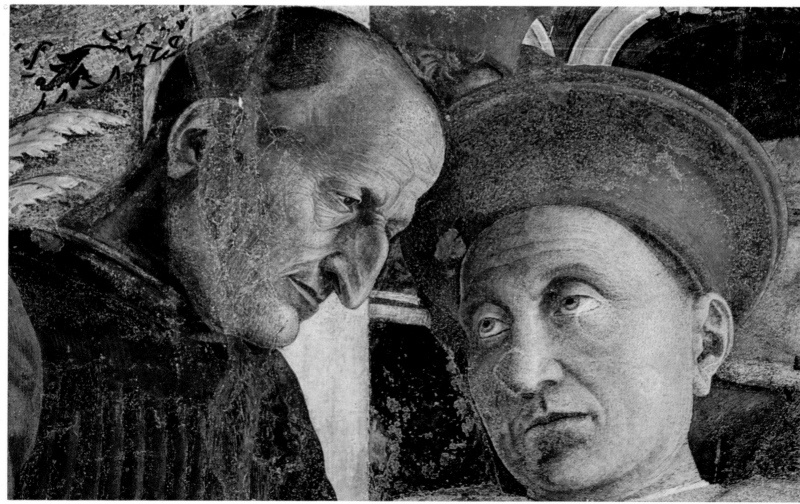

PLATE XLVI CAMERA DEGLI SPOSI Mantua, Palazzo Ducale
Details of the *Court Scene* (respectively 30, 25 and 60 cm.)

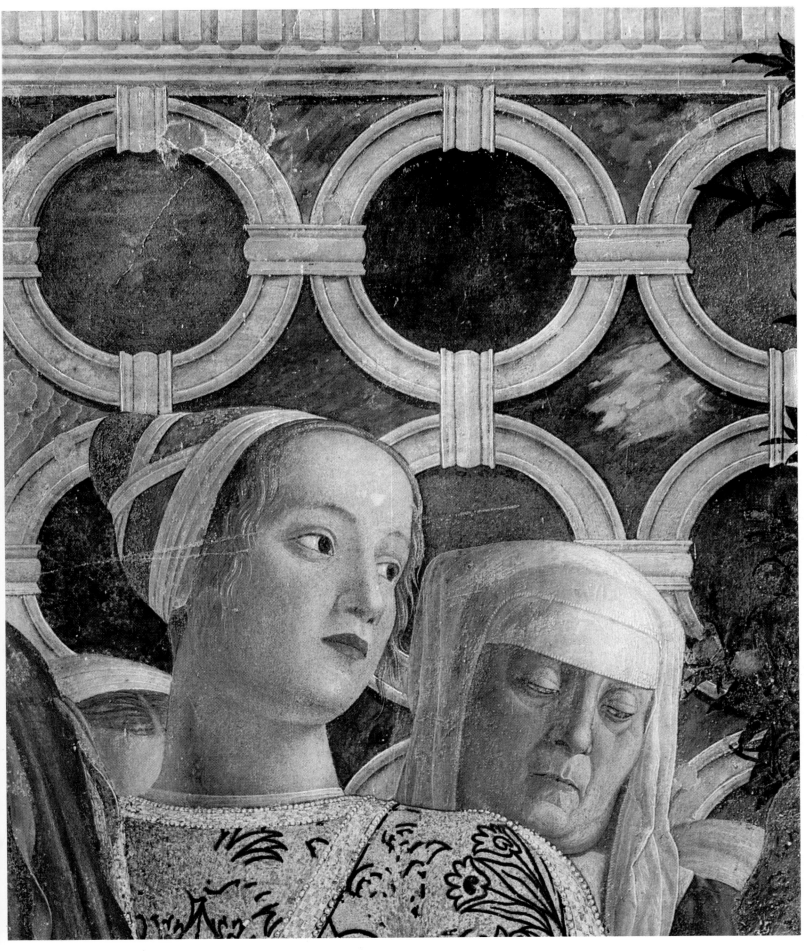

PLATE XLVII CAMERA DEGLI SPOSI Mantua, Palazzo Ducale
Detail of the *Court Scene* (50 cm.)

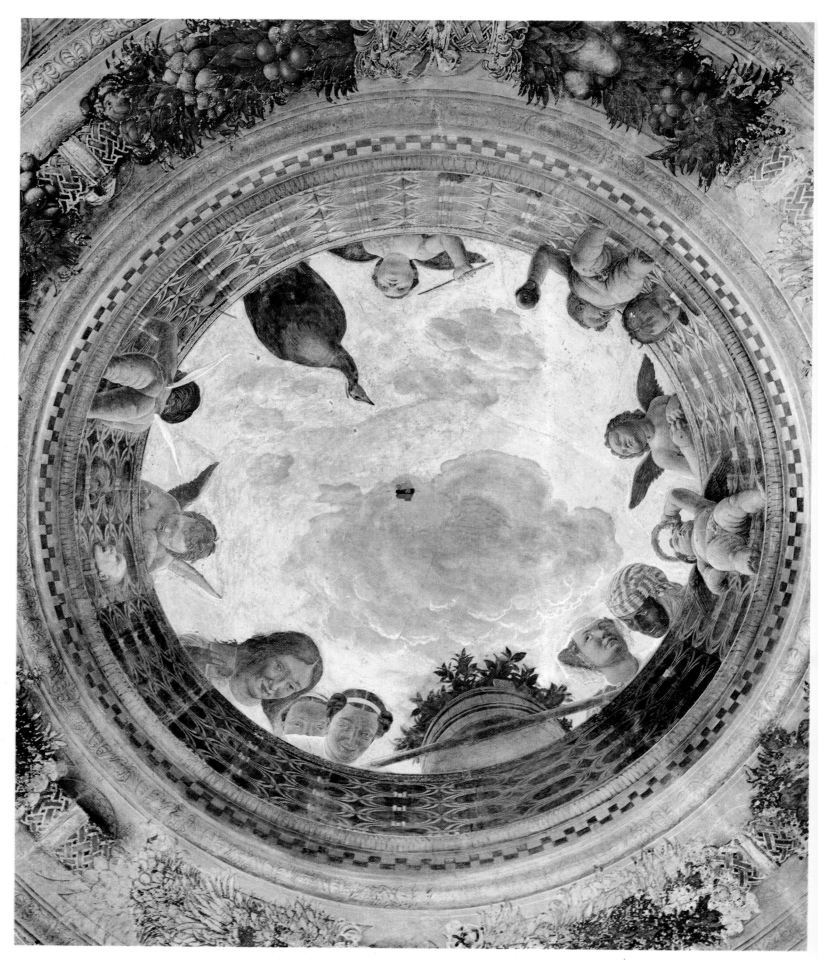

PLATE XLVIII CAMERA DEGLI SPOSI Mantua, Palazzo Ducale
The *Oculus* on the ceiling (270 cm. in diameter)

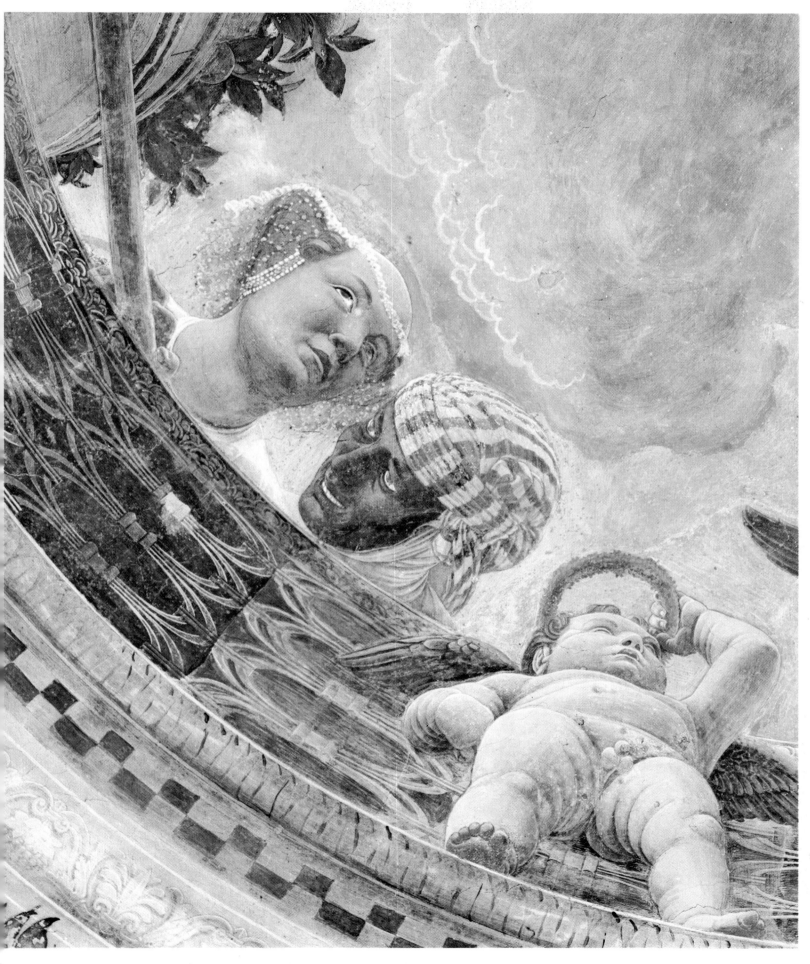

PLATE XLIX CAMERA DEGLI SPOSI Mantua, Palazzo Ducale
Detail of the *Oculus* on the ceiling (95 cm.)

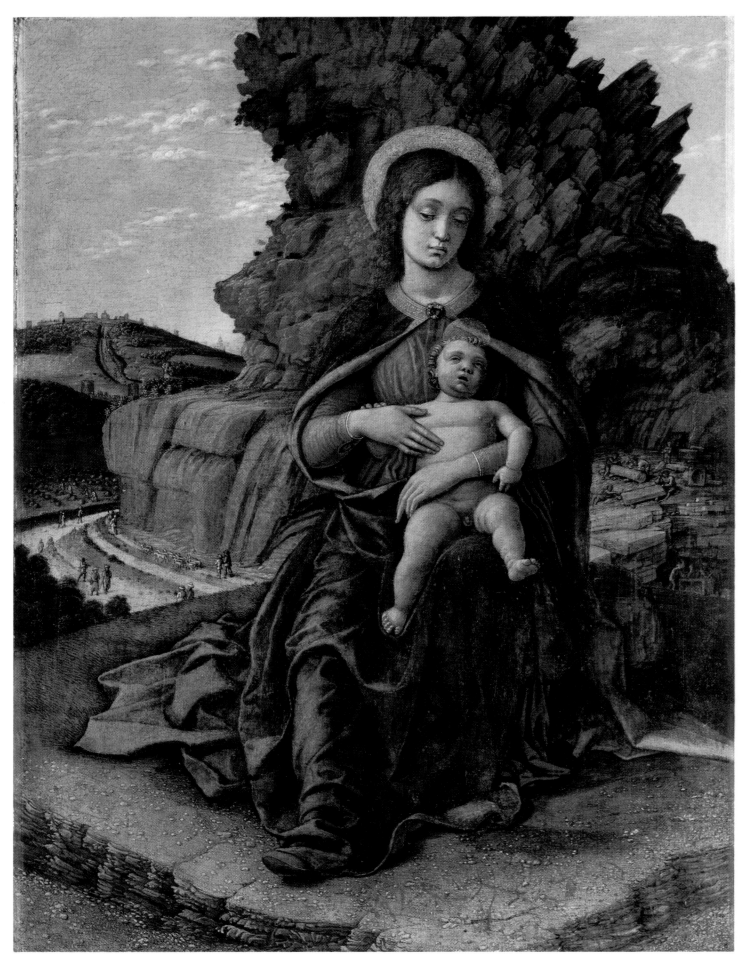

PLATE L MADONNA OF THE STONECUTTERS Florence, Uffizi
Whole (21,5 cm.)

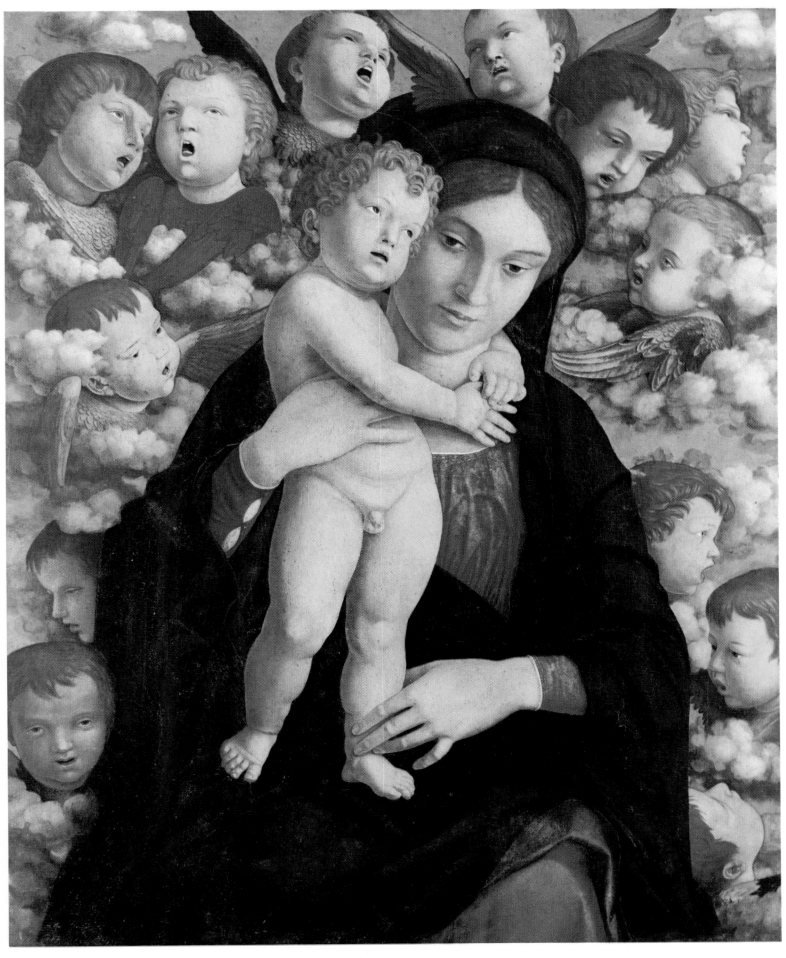

PLATE LI MADONNA WITH CHILD AND CHERUBIM Milan, Pinacoteca di Brera
Whole (71 cm.)

PLATE LII SACRA CONVERSAZIONE (MADONNA DELLA VITTORIA) Paris, Louvre
Details of upper part (40 cm each)

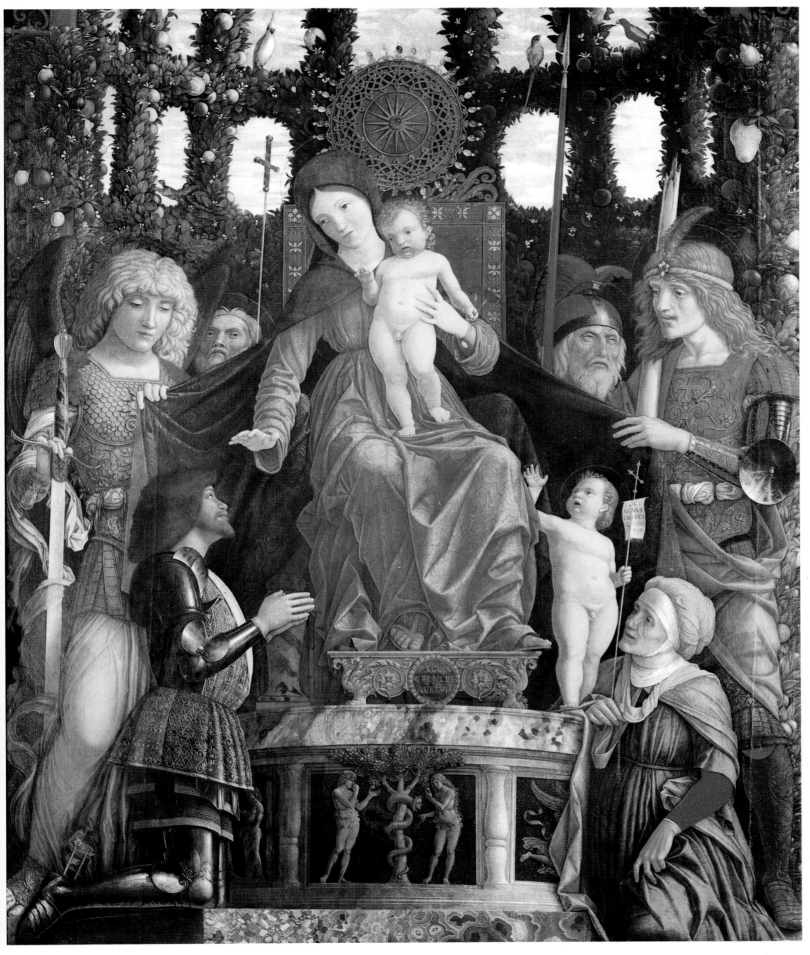

PLATE LIII SACRA CONVERSAZIONE (MADONNA DELLA VITTORIA) Paris, Louvre
Middle and lower parts (160 cm.)

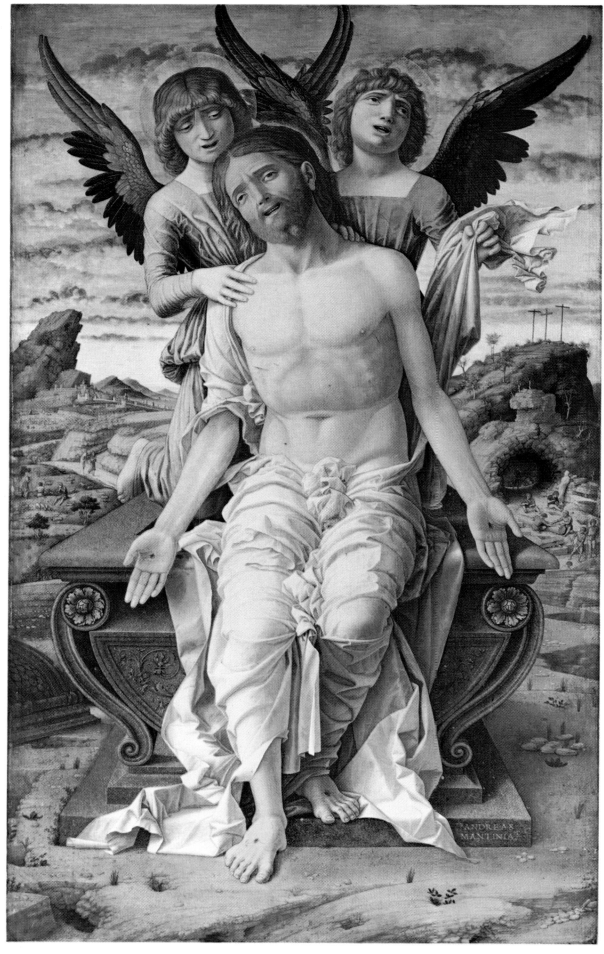

PLATE LIV CHRIST ON TOMB SUPPORTED BY TWO ANGELS (PIETÀ) Copenhagen, Statens Museum for Kunst
Whole (51 cm.)

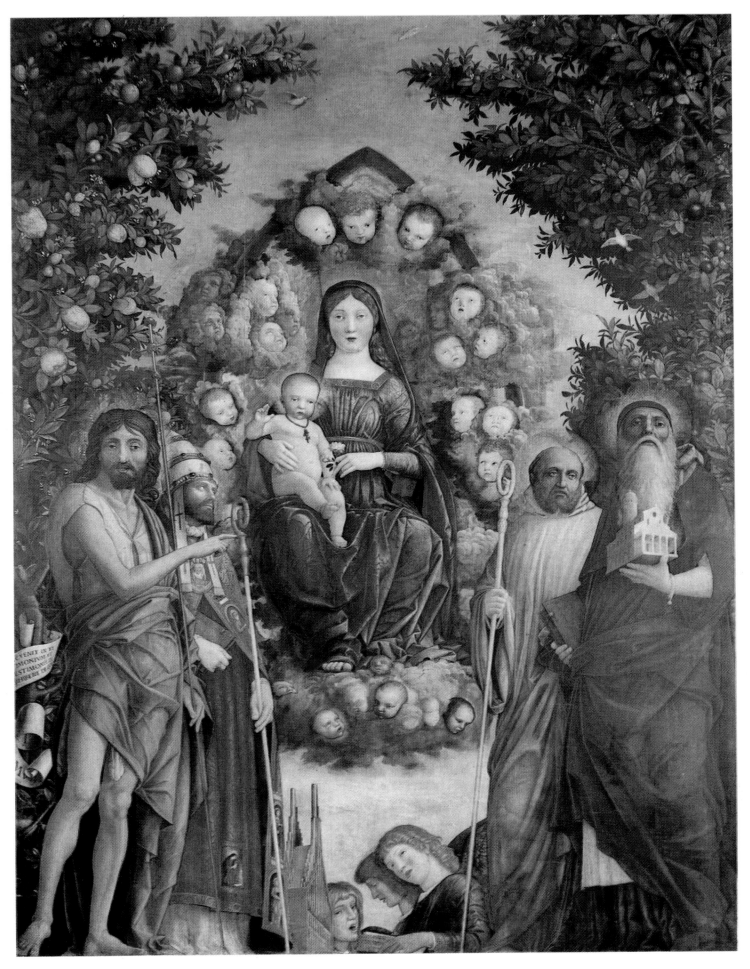

PLATE LV SACRA CONVERSAZIONE (TRIVULZIO MADONNA) Milan, Castello Sforzesco
Whole (214 cm.)

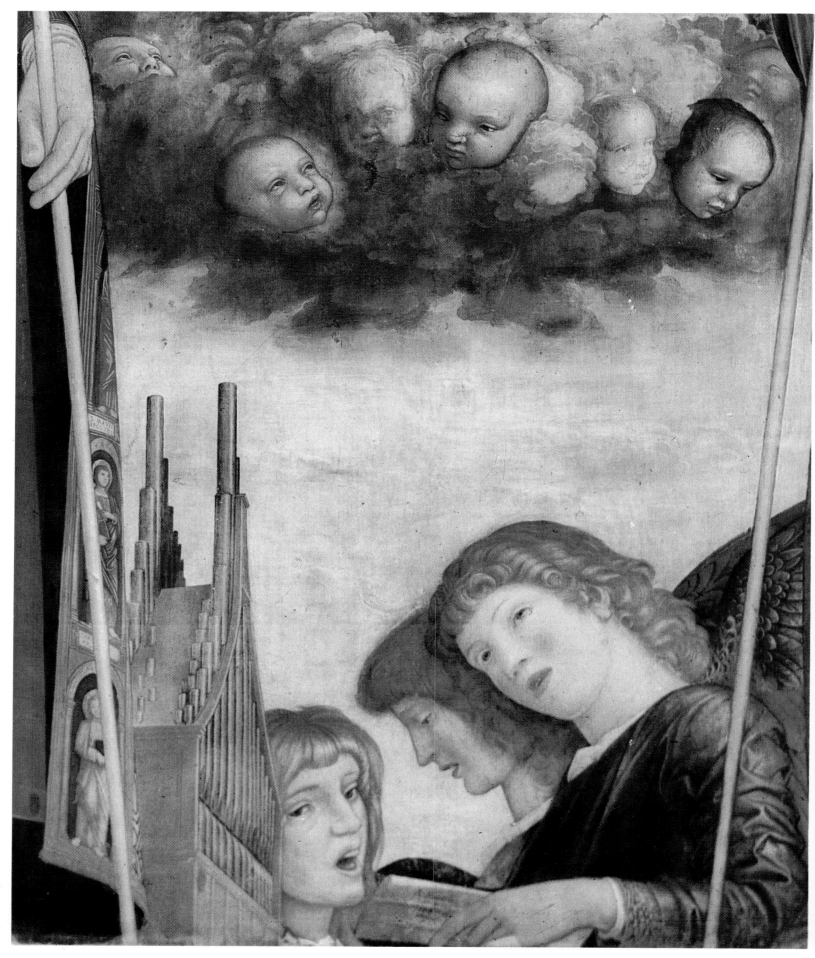

PLATE LVI SACRA CONVERSAZIONE (TRIVULZIO MADONNA) Milan. Castello Sforzesco
Detail (68 cm.)

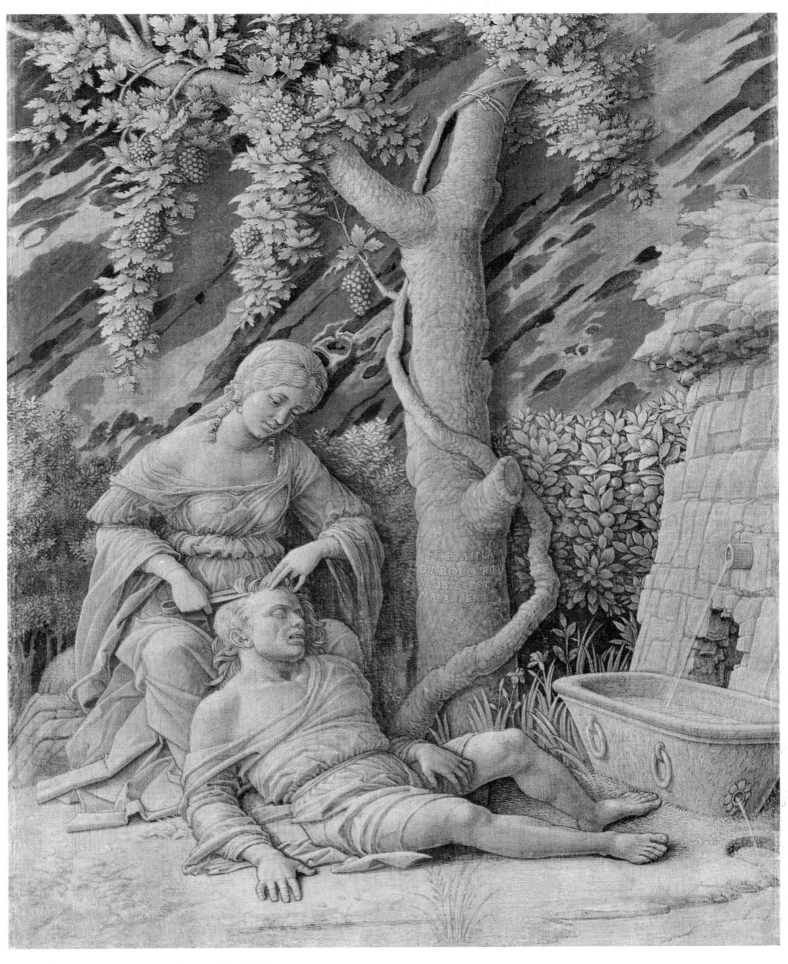

PLATE LVII SAMSON AND DELILAH London, National Gallery
Whole (37 cm.)

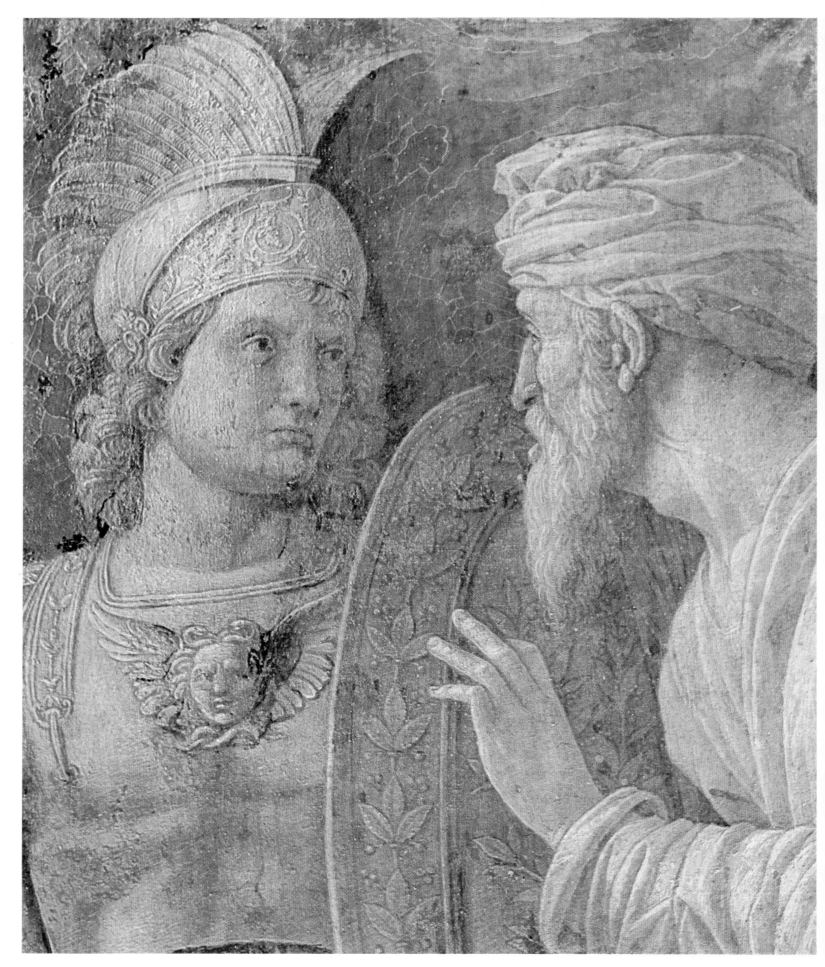

PLATE LVIII THE TRIUMPH OF SCIPIO London, National Gallery
Detail (actual size)

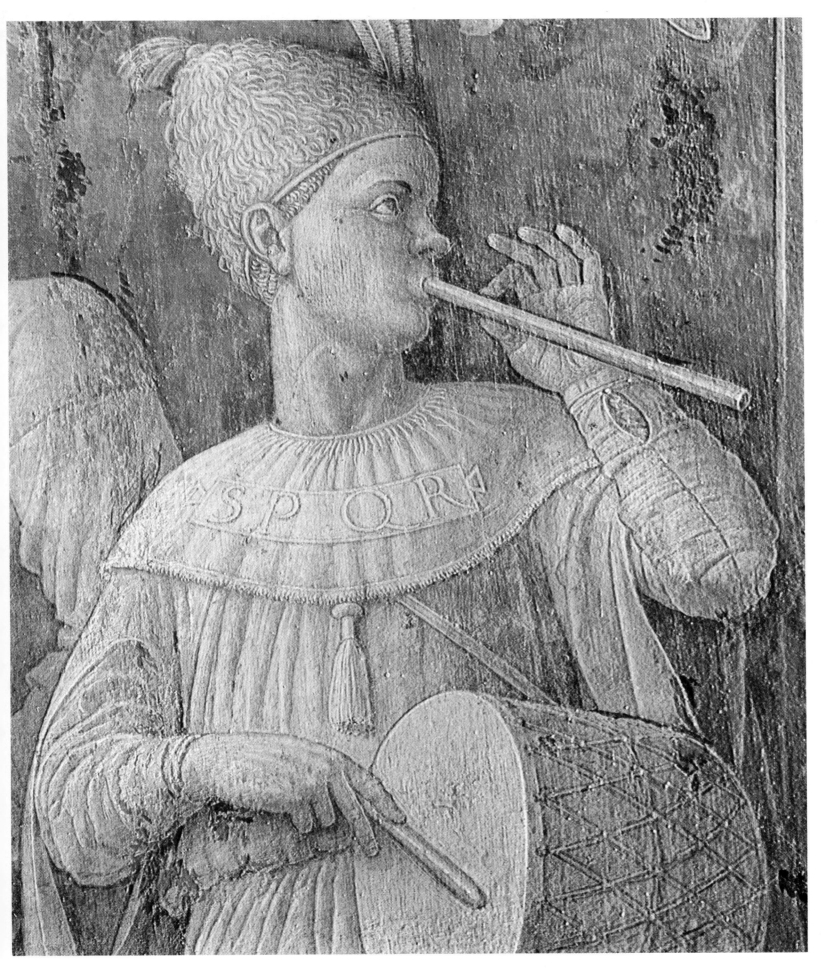

PLATE LIX THE TRIUMPH OF SCIPIO London, National Gallery
Detail (actual size)

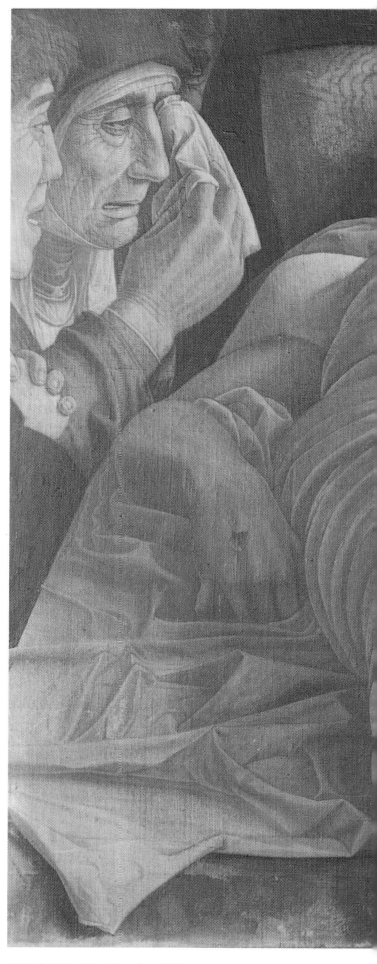

DEAD CHRIST Milan, Pinacoteca di Brera
Whole (81 cm.)

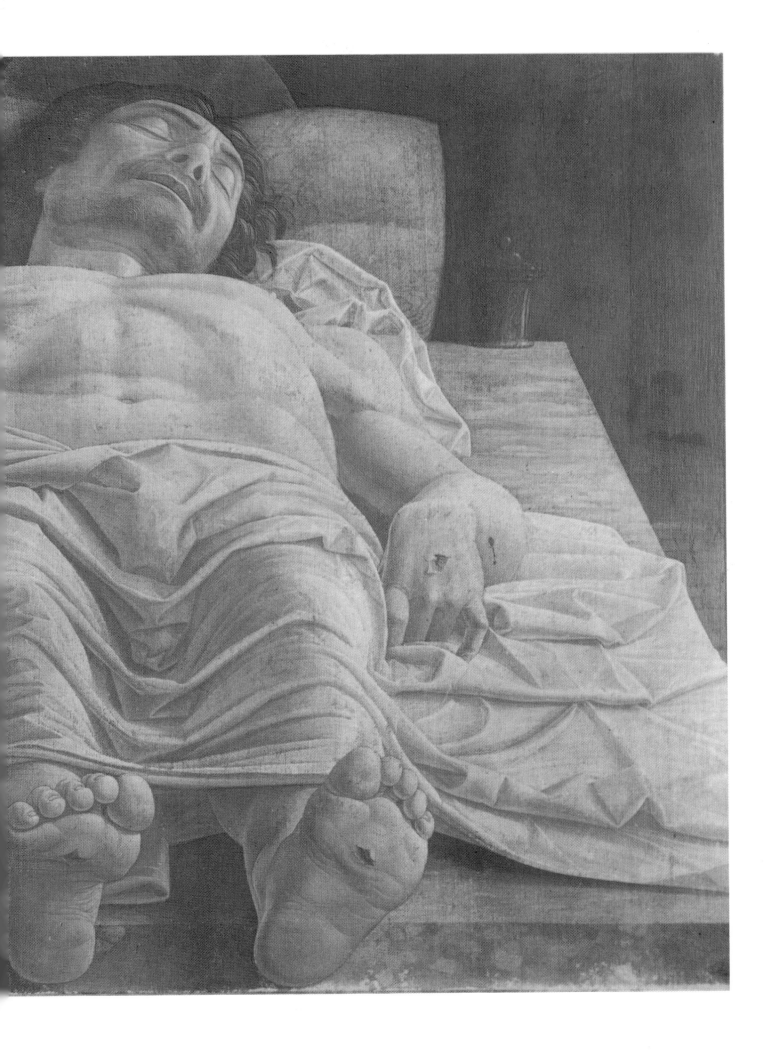

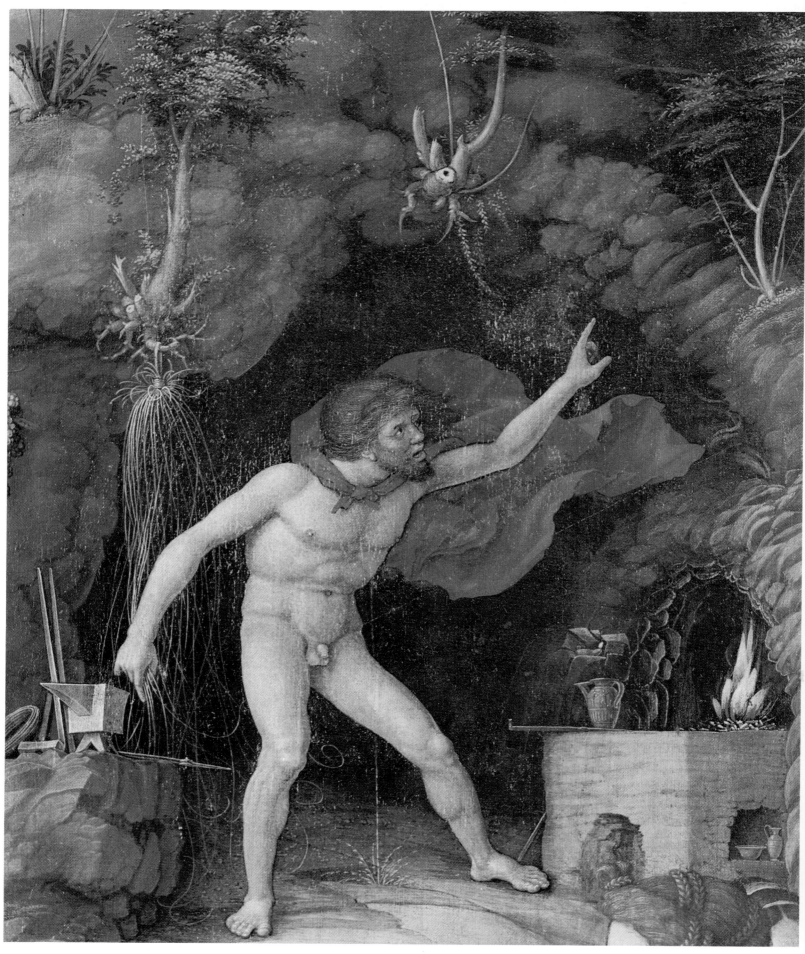

PLATE LXII PARNASSUS Paris, Louvre
Detail (31 cm.)

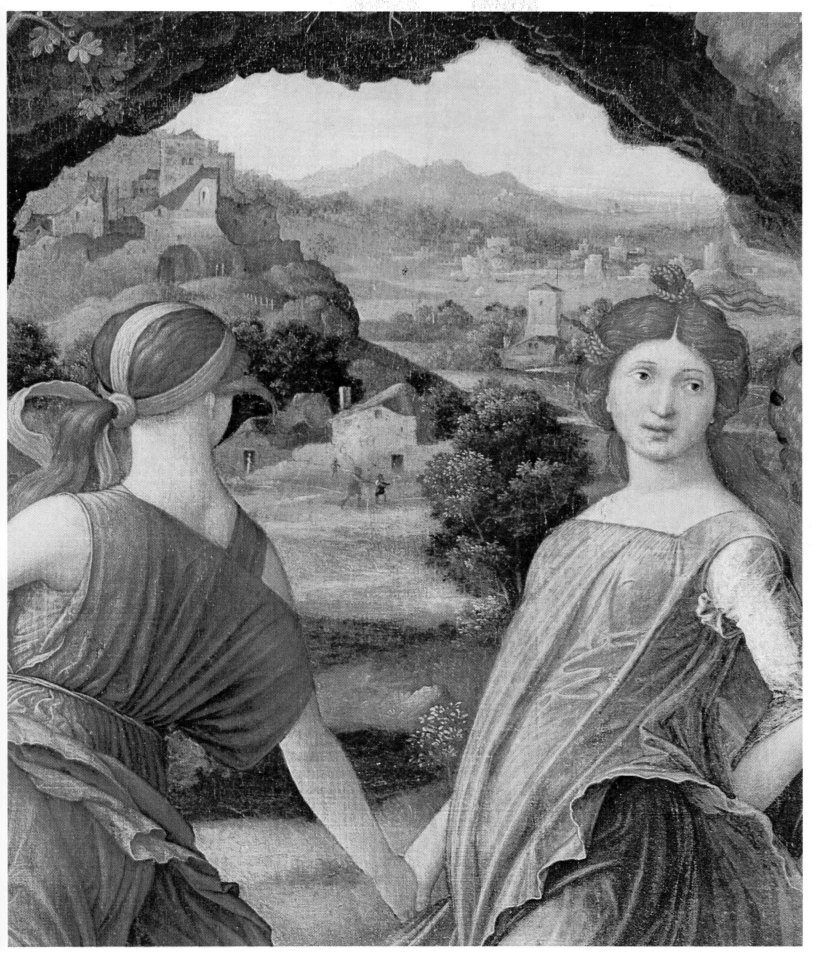

PLATE LXIII PARNASSUS Paris, Louvre
Detail (31 cm.)

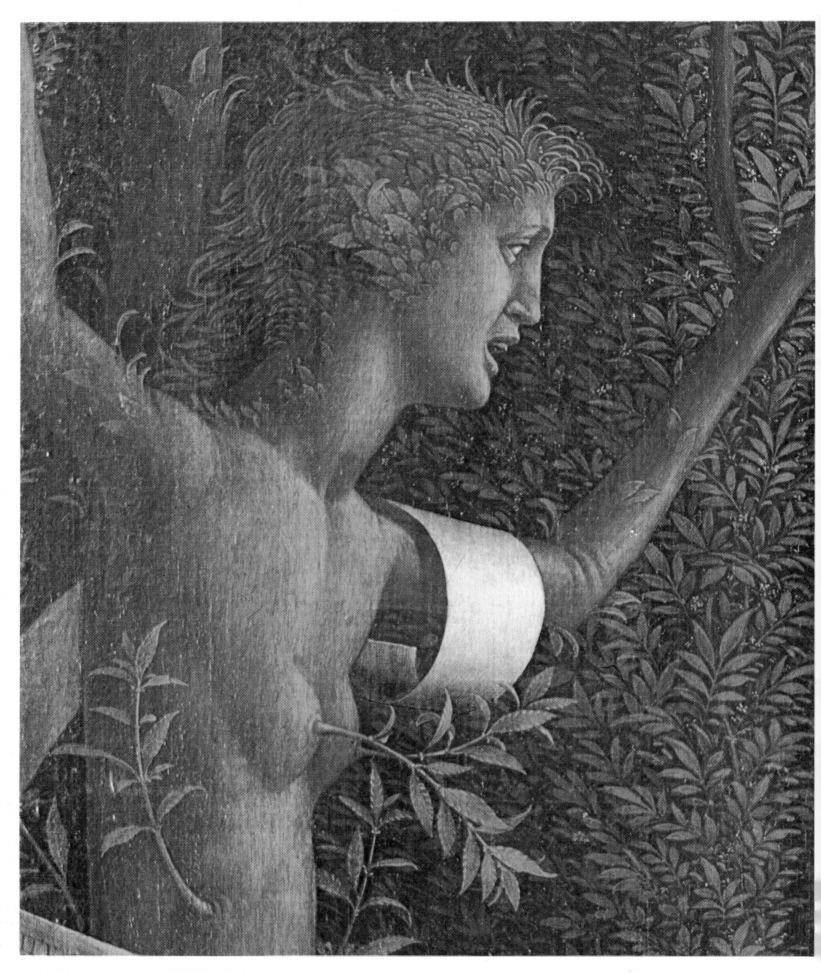

PLATE LXIV THE TRIUMPH OF VIRTUE Paris, Louvre
Detail (actual size)

The Works

Key to symbols used

In order to provide, in readily accessible form, a guide to the basic elements of each work, all items of the Catalogue are preceded by a number (which refers to the chronological position of the work in the painter's activity, and is used throughout this volume for purposes of identification), and by a series of symbols denoting the following: 1) execution of the work: i.e., to what extent it is the artist's own work; 2) medium; 3) base; 4) location; 5) other information such as: whether the work is signed or dated; whether it is now complete; whether it was originally finished. The remaining numerals denote respectively the size, in centimetres, of the painting (height x width) and the date. These figures are preceded or followed by an asterisk in all cases in which the information given is only approximate. All such data are based on the general consensus of opinion and any further relevant data are discussed in the text.

Execution

⊞ Autograph

⊞ With assistance

⊞ With collaboration

⊞ With extensive collaboration

⊞ From the workshop

⊞ Currently attributed

⊞ Currently rejected

⊞ Traditionally attributed

⊞ Recently attributed

Technique

⊕ Oil

⊕ Fresco

⊕ Tempera

Support

⊕ Wood

⊕ Plaster

⊕ Canvas

Whereabouts

⠿ Public Collection

⠿ Private Collection

⠿ Unknown

⠿ Lost

Additional Data

▤ Signed

▤ Dated

▤ Incomplete or fragment

▤ Unfinished

Symbols given in the text

Bibliography

The works of G. VASARI (Le vite, Florence, 1550 and 1568), M. A. MICHIEL (Notizie d'opere del disegno, 1523–43), B. SCARDEONE (De antiquitate urbis Patavii, Basle, 1560), I. DONESMONDI (Dell'istoria ecclesiastica di Mantova, Mantua, 1612–16) and G. CAMPORI (Raccolta di cataloghi . . ., Modena, 1870) provide the early source material concerning Mantegna's works. In addition, the following should be consulted: V. LAZZARINI (and A. MOSCHETTI) (NAV [for this and the other abbreviations please see the list of abbreviations printed below], 1908), E. RIGONI (AIV, 1927–28; AV, 1948) for his activity in Padua; C. D'ARCO (Delle arti e degli artefici di Mantova, Mantua, 1857), A. BASCHET (GBA, 1866), W. BRAGHIROLLI (GEA, 1872; Lettere inedite di artisti del sec. XV cavate dall'Archivio Gonzaga, Mantua, 1878), C. BRUN (ZK, 1876), A. LUZIO (E, 1899; La galleria dei Gonzaga venduta all'Inghilterra nel 1627–28, Milan, 1931), G. GEROLA (AIV 1908–09) and A. LUZIO – E. PARIBENI (Il Trionfo di Cesare di Andrea Mantegna, Rome, 1940) for his acitivity in Mantua.

The following works provide a general study of the artist or of his painting in particular: G. A. MOSCHINI (Della origine e delle vicende della pittura in Padova, Venice, 1826); (J. A. CROWE and) G. B. CAVALCASELLE (A History of Painting in North Italy, London, 1871); B. BERENSON (Italian Painters of the Renaissance, New York – London 1897 and Oxford 1953); C. YRIARTE (GBA, 1895); P. KRISTELLER (Andrea Mantegna, London, 1901 and Berlin – Leipzig, 1902; RDA, 1909); F. KNAPP (Andrea Mantegna, Stuttgart – Leipzig, 1910); A. VENTURI (Storia dell'arte italiana, VII 3, Milan 1914); G. FIOCCO (L'arte di Andrea Mantegna, Bologna, 1927 [in fact 1926] and Venice, 1959; Mantegna, Milan, 1937; La Cappella Ovetari, Milan, 1953); R. LONGHI (VA, 1926; "Pan" 1934; P, 1962); C. L. RAGGHIANTI (CA, 1937 and 1962); V. MOSCHINI (Gli affreschi del Mantegna agli Eremitani, Bergamo, 1946); L. VERTOVA (Mantegna, Florence, 1950); M. DAVIES (National Gallery Catalogue – The Earlier Italian Schools, London 1951 and 1961[2]); L. COLETTI (La pittura veneta del '400, Novara, 1953); E. TIETZE-CONRAT (Mantegna, London 1955 and Florence 1955); R. CIPRIANI (Tutta la pittura del Mantegna, Milan, 1956 and 1962[3]); R. PALLUCCHINI (La pittura veneta del '400, Padua, 1956–57); L. COLETTI – E. CAMESASCA (La Camera degli Sposi del Mantegna a Mantova, Milan, 1959); G. PACCAGNINI – A. MEZZETTI (Andrea Mantegna [Mantua Exhibition Catalogue], Venice, 1961); E. ARSLAN (C, 1961); S. BOTTARI (AV, 1961); G. CASTELFRANCO (BA, 1962); C. GILBERT (BA, 1962); G. PACCAGNINI (Andrea Mantegna, Milan, 1962) and E. CAMESASCA (Mantegna, Milan, 1964).

The more notable works which discuss Mantegna's other activities are as follows: A. BARTSCH (Le Peintre-Graveur, XIII, 1811); K. CLARK (BM, 1932); A. M. HIND (Early Italian Engraving, London, 1948; 1948); A. E. POPHAM – P. POUNCEY (Italian Drawings in the Department of Prints and Drawings in the British Museum, London, 1950); L. GRASSI (Il disegno italiano, Rome, 1956);

1956); A. MEZZETTI (BA, 1958). Other relevant works include those by FIOCCO (1937), E. TIETZE-CONRAT (1955), A. MEZZETTI (1961), LONGHI (1962), RAGGHIANTI (1962) and CAMESASCA (1964), all of which discuss Mantegna's engraving. His activity as a sculptor is dealt with by G. FIOCCO (RA, 1940) and G. PACCAGNINI (BA, 1961) as also by KRISTELLER (1902), FIOCCO (1937), RAGGHIANTI (1962) and CAMESASCA (1964); the principal works on his architectural activities are C. YRIARTE (CO, 1897), E. MARANI (in Mantova – Le arti, Mantua, 1961) and E. E. ROSENTHAL (GBA, 1962), though FIOCCO (1937) and RAGGHIANTI (1962) may also be consulted. Mantegna's "minor" works are discussed by A. BOVERO (BM, 1957) M. MEISS (Andrea Mantegna as Illuminator, New York, 1957) and G. FIOCCO (P, 1958), as also in the work by E. TIETZE-CONRAT (1955) already mentioned. Finally, the question of Mantegna's culture, his dependence on classical art, the problems of perspective and the interpretation of his symbolic representations are raised and discussed in the following works: E. TIETZE-CONRAT (JKS, 1917; AB, 1948); E. PANOFSKY (Perspektive als symbolische Form, Leipzig – Berlin, 1927; FF); A. MOSCHETTI (AIV, 1929–30); I. BLUM (Andrea Mantegna und die Antike, Strasbourg, 1936); F. HARTT (AB, 1940; GBA, 1952); E. WIND (AB, 1949); A. M. TAMASSIA (RPA, 1955–56); J. WHITE (The Birth and Rebirth of Pictorial Space, London, 1957); P. D. KNABENSHE (AB, 1959); M. MEISS (AB, 1960) and G. L. MELLINI – A. C. QUINTAVALLE (CA, 1962).

List of abbreviations

A: Apollo (Rome – New York)
AA: Art in America (Springfield – New York)
AAM: Arte antica e moderna (Bologna)
AAV: Atti dell'Accademia virgiliana (Mantua)
AB: The Art Bulletin (Washington – Providence)
AIV: Atti del R. Istituto veneto di scienze, lettere ed arti (Venice)
AQ: Art Quarterly (Detroit)
ASA: Archivio storico dell'arte (Rome)
ASL: Archivio storico lombardo (Milan)
AV: Arte veneta (Venice)
BA: Bollettino d'arte (Rome)
BCM: Bulletin of Cincinnati Museum (Cincinnati)
BEM: Berliner Museen (Berlin)
BM: The Burlington Magazine (London)
BMP: Bollettino del Museo civico di Padova (Padua)

C: Commentari (Rome)
CA: La critica d'arte (Florence)
CI: Civiltà (Milan)
CO: Cosmopolis (Paris)
D: Dedalo (Milan)
E: Emporium (Bergamo)
FF: Festschrift für M. J. Friedländer (Leipzig, 1927)
GBA: Gazette des Beaux-Arts (Paris)
GEA: Giornale di erudizione artistica (Perugia)
JCD: Jahrbuch der central Commission für Denkmalpflege (Vienna)
JKS: Jahrbuch der kunsthistorischen Sammlungen in Wien (Vienna)
JPK: Jahrbuch der preussischen Kunstsammlungen (Berlin)
JWCI: Journal of the Warburg and Courtauld Institute (London)
K: Kunstchronik (Munich – Nuremburg)
L: L'arte (Rome – Turin – Milan)
LA: Les Arts (Paris)

MA: Masterpieces of Art (Washington)
MK: Monatshefte für Kunstwissenschaft (Leipzig)
N: Napoli nobilissima (Naples)
NAV: Nuovo archivio veneto (Venice)
OMD: Old Masters' Drawings (London)
P: Paragone (Florence)
PA: Pantheon (Munich)
RA: Rivista d'arte (Florence)
RDA: Rassegna d'arte (Milan)
RPA: Rendiconti della pontificia Accademia romana di archeologia (Rome)
S: Il Santo (Padua)
V: Vittorino da Feltre (Brescia)
VA: Vita artistica (Rome)
ZK: Zeitschrift für bildende Kunst (Leipzig).

Outline biography

1430 or 1431 Most modern scholars give one or other of these years (usually the second) as Andrea Mantegna's date of birth. Their source for this information is the inscription which the painter is believed to have made on the altarpiece (now destroyed — cf. the entry for the year 1448 and section 1 of the *Catalogue*) for the Church of S. Sofia in Padua and which Scardeone reproduced as follows: "Andrea Mantinea Pat(avinus) an(nos) septem et decem natus, sua manu pinxit MCCCCXLVIII". He is generally believed to have been born in the same place as his older brother, Tommaso, namely Isola di Carturo, a suburb of Piazzola sul Brenta, now in the province of Padua but at that time under the jurisdiction of Vicenza, a detail which explains the designation of Mantegna as Andrea "de Vicentia" to be found in some Paduan documents. As regards his family, it is known that his father, Biagio, was a carpenter; this fact would seem to rule out absolutely any possibility of the peasant origin claimed for him by Vasari (1550 and 1568).

1441 6 NOVEMBER – **1445**. Between these dates, he was registered in the guild of painters in Padua as the "fiuilo" (adopted son) of Francesco Squarcione (1397–1468) "depentore" (painter): hence the name "Andrea Squarcione" used to identify Mantegna by some of his contemporaries. The documents relating to the legal action which was taken later (cf. the entry for the year 1448) reveal that the adoption had taken place at some time prior to 1443.

1447 Mantegna was in Venice with Squarcione. Though the date is very uncertain, it may have been in this year that the notary Ulisse Aleotti wrote a sonnet in his honour (manuscript in the Biblioteca Estense in Modena).

1448 By virtue of an agreement with his "stepfather" drawn up in Venice and dated 26 January, Mantegna secured his independence and the right to pocket his own earnings (cf. also the entries for the years 1445 and 1456). Most scholars connect the artist's success in this legal action and the esteem in which he was already held in Padua with the execution — almost certainly by himself — of the S. Sofia altarpiece, and the tone of the inscription on it: "sua manu pinxit" (cf. also the year 1430). On 16 May 1448, Mantegna and his "partner" Niccolò Pizolo (c. 1421–1453) undertook to decorate part of the Ovetari Chapel in the Eremitani (Augustinian) Church in Padua (cf. no. 14 of the *Catalogue*); this fact provides further notable proof of the fame already enjoyed by the artist in the town and so does the task (entrusted to him on 15 September) of assessing the work of Pietro da Milano in S. Giacomo, since the expert appointed to represent the other party in the dispute was none other than Squarcione himself. On 16 October, he received a payment for the S. Sofia altarpiece.

1449 There is evidence that he was in Ferrara on 23 May. By virtue of a ruling given by Pietro Morosini, acting as arbitrator and dated 27 September, the partnership

between Pizolo and Mantegna for the decoration of the Ovetari Chapel was dissolved (cf. no. 14 of the *Catalogue* for this and all subsequent references to this particular cycle).

1450 Death of Giovanni d'Alemagna who, with his brother-in-law Antonio Vivarini, had undertaken to carry out part of the decoration of the Ovetari Chapel.

1451 On 30 July, Bono da Ferrara received payment for a "cycle" in the Ovetari Chapel. At some time prior to 28 November, Antonio Vivarini had given up the decoration of the chapel, and the remainder of the work which he had undertaken to do in conjunction with Giovanni d'Alemagna was entrusted to a new partnership formed (prior to 30 October) between Mantegna and Ansuino da Forlì.

1452 21 JULY. This date was recorded in the lunette originally over the main entrance of the Basilica del Santo in Padua (*Catalogue*, no. 16).

1453 On 25 February, Iacopo Bellini received a series of advance payments in respect of the fee due to him from the Scuola di S. Giovanni Evangelista in Venice to enable him to provide part of the dowry for his daughter Nicolosia who was either about to marry or had just married Mantegna. On 1 August, Mantegna was commissioned to execute the polyptych now at the Brera (*Catalogue*, no. 17) for the monks of Santa Giustina in Padua. Pizolo died before the end of the year and the portions of the Ovetari Chapel which had been assigned to him for decoration were entrusted to his ex-partner.

1454 This date was recorded on the *St Euphemia* in Naples (*Catalogue*, no. 18). On 25 February, Iacopo Bellini received a further payment from the Scuola di S. Giovanni Evangelista and this too went towards his daughter's dowry. In February, too, Squarcione and Storlato valued the work done by Pizolo in the Ovetari Chapel. The balance of the fee for the Brera polyptych was paid in November (cf. 1453).

1455 On 28 November, Andrea Mantegna appealed to the Court of Padua for help in compelling Squarcione to pay him for work he had done while under his tutelage to the value, according to Mantegna, of "four hundred ducats and more". The court ruled through an arbitrator that Mantegna was entitled to receive the sum of two hundred ducats, but Squarcione contested this.

 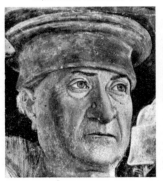 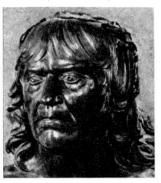

(from left to right). Presumed self-portrait of Mantegna as a young man: detail from Presentation in the Temple *now in Berlin (no. 38); probable self-portrait in the Camera degli Sposi (no. 51 C); bronze bust of Mantegna (possibly modelled by himself) in the memorial chapel in the church of S. Andrea in Mantua.*

1456 On 2 January, the Criminal Magistrature in Venice admitted the validity of Mantegna's claims against Squarcione and declared that the conditions imposed by the latter in the agreement of 1448 were null and void. The dispute dragged on and on between the two men until 1457. At some time in the course of this year Ludovico III Gonzaga, Marquess of Mantua, may have invited Mantegna to enter his service as court artist; the invitation was accepted (cf. 1457).

1457 On 5 January, Ludovico Gonzaga wrote to Mantegna to say how pleased he was that the artist had decided to come to Mantua and granted him leave to finish the altarpiece for the church of S. Zeno in Verona (*Catalogue*, no. 23), which must therefore have been commissioned at least in the previous year. On 14

February, Pietro da Milano signed in Mantegna's favour the valuation certificate in respect of the *Assumption* in the Ovetari Chapel (cf. *Catalogue*, no. 14 M); once again Squarcione was acting for the other side (as we learn from a document signed by him on 15 February). In a letter dated 27 November, the Marquess asked the Abbot of S. Zeno whether the above-mentioned altarpiece was finished.

1458 Before the end of this year (and not earlier than 1454), the humanist Iano Pannonio (who was the Hungarian bishop Csezmicei) wrote an ode to celebrate the portrait of himself and Galeotto Marzio (*Catalogue*, no. 13) by Mantegna and dedicated it to the artist. On 15 April, Ludovico III stipulated the terms for Mantegna's move to Mantua. These were: fifteen ducats per annum; a place to

live; enough grain for six people and payment of the cost of moving his household goods from Padua. Because of the artist's delays, the Marquess approached a number of others (including, possibly, Michele Pannonio in Ferrara); however, on 26 December, he again appealed to Mantegna who, in October, had taken on an apprentice in Padua for a period of six years. and had moreover bought a house there in November.

1459 On 30 January, Ludovico Gonzaga authorised Mantegna to use one of his own heraldic emblems (with the motto: *per un sol desir* [with one desire/aim] — cf. *Catalogue*, no. 49 B); on 2 February and 14 March, he agreed to further delays on the part of the artist (the second extension in March arose out of a letter written to the Marquess himself by the Podestà of Padua, I. A. Marcello, asking that Mantegna be allowed to finish "a little thing" for him. This "little thing" has often been identified as the *St Sebastian* now in Vienna (*Catalogue*, no. 43). It is quite probable, however, that the artist went to Mantua immediately afterwards in order to make arrangements for the move and for his new job for, on 4 May, the Marquess wrote to him in Padua to tell him that the chapel in Castel S. Giorgio had been "arranged as requested" (*Catalogue*, no. 34). He again wrote urging him to join him on 29 June. The S. Zeno altarpiece was finished before the end of the year.

Signatures in paintings by Mantegna: (top left) from the Agony in the Garden *now in London (no. 22); (bottom left) from*

Christ on the Tomb *now in Copenhagen (no. 69) and (right) from* Sacra Conversazione (Trivulzio Madonna) *in Milan (no. 94).*

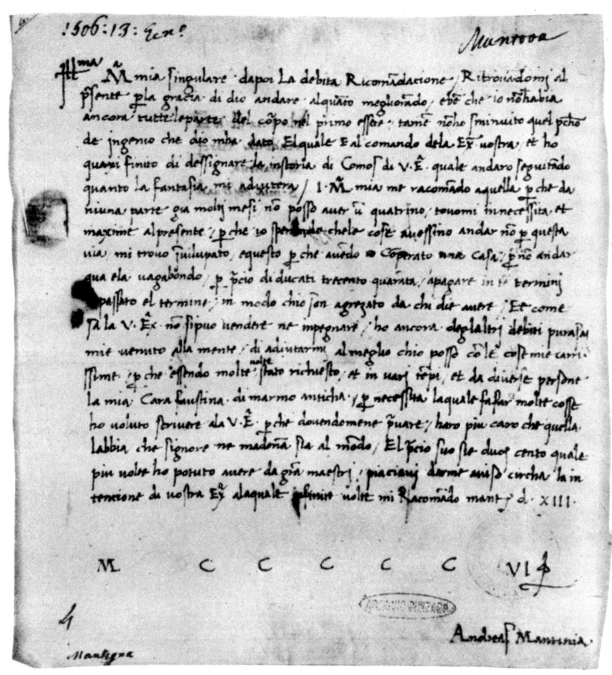

!506:13: ꞵ~

Mantoua

M C C C C C VI

Mantegna

Andreaſ Mantinia

Original of letter sent by Mantegna to the Marchioness Isabella d'Este Gonzaga on 13 January 1506 (Archivio di Stato, Mantua).

1460 Some time before July, F. Nuvolone dedicated to Mantegna a sonnet written in his honour (manuscript in Biblioteca Estense, Modena). He was in Mantua at least from 7 August onwards.

1461 By July, he was already back in Padua, where he apparently executed the *Lament over the Body of Gattamelata* (*Catalogue*, no. 25). He was back in Mantua by November; in the same year, F. Feliciano wrote a sonnet in his honour.

1463 On 13 January, this same Feliciano dedicated to Mantegna a collection of ancient epigraphs (manuscript in Biblioteca Capitolare, Verona). A letter dated 19 March reveals that Samuele da Tradate was then at work decorating the Gonzaga residence at Cavriana on the basis of designs by Mantegna (*Catalogue*, no. 35). In October, Mantegna started

work at another Gonzaga residence, at Goito (*Catalogue*, no. 36) and was still there in December.

1464 Documents dated 7 and 12 March provide evidence that work was going ahead at Cavriana (cf. 1463). On 26 April, the artist was at Goito and from here he wrote to Ludovico complaining that the frames were not yet ready for the "last" panels intended "for the little chapel" — the reference may well be to the chapel which had already been mentioned in 1459. On 23 and 24 September, Mantegna went with F. Feliciano, Samuele da Tradate and G. Antenoreo, the architect, on an excursion to Lake Garda during which the four companions, having assumed the rôles of imperator, procurator and consuls, wearing laurel garlands and singing to the accompaniment of a lyre, hunted for stones bearing Latin inscriptions and praised the Christian divinity

in pagan terms. Doubt as to the authenticity of this excursion, or at least to the accuracy of the account of it left by Feliciano (manuscript in the Biblioteca Capitolare, Treviso) has been cast by Tietze-Conrat, who is of the opinion that the whole thing is a nineteenth-century forgery or at most a purely literary fiction. Nevertheless, this kind of thing was a fairly common occurrence in the age of Humanism and the late Middle Ages generally (Camesasca).

1465 The date "1465. d. 16 iunii" appears in the window embrasure in the Camera degli Sposi (*Catalogue*, page 100). On 5 December, the Court of Mantua ordered the preparation of the materials for weaving a tapestry designed by Mantegna.

1466 On 1 March, Ludovico Gonzaga wrote to his wife, Barbara of Brandenburg, in-

structing her to arrange for Mantegna to copy a portrait, possibly of Bona of Savoy. On 5 July, Mantegna was in Florence where he is believed to have been giving advice on the chancel of the Church of the Santissima Annunziata, though there is no positive historical evidence for this. He was back in Mantua by December, where he urged the Marquess to subsidise the construction of "a little house".

1467 3 July. The artist was once again in Tuscany where he "had to finish painting" a work in the Camposanto in Pisa (*Catalogue*, no. 40).

1468 The whereabouts of the artist during the first half of this year is unknown. On 27 July he wrote, from Mantua, to inform Ludovico Gonzaga that he had started work on a "historia del Limbo" (but cf. *Catalogue*, no. 34 G).

1469 Ludovico III's secretary

wrote to tell the Marquess' wife, Barbara that it was Mantegna's ambition to be a count and this desire was fulfilled either then or at some later date (cf. 1490). On 11 July, Gonzaga asked Mantegna to draw two "Indian hens" (in other words, turkeys) for a tapestry.

1470 The documents connected with Mantegna begin to swell round about this time with letters, appeals, legal records and so on connected with real or imaginary petty thefts suffered by the artist, trouble caused by his neighbours, difficulties with his tailor and so on. The Marquess' replies always display great patience and he takes the artist's part even against some of his more prominent subjects who complain of Mantegna's thorny temperament.

1471 25 OCTOBER. Ludovico Gonzaga ordered "three weights of nut oil" to be sent to Mantegna. It is generally believed that this order was in connection with the decoration of the Camera degli Sposi.

1472 In April, Mantegna drew the Marquess' plans for the courtyard of the Castel S. Giorgio. On 18 July, Cardinal Francesco Gonzaga wrote to Ludovico (his father) to ask him to send Mantegna to Porretta, where the Cardinal was taking the waters, so that he could have a look at his collection of precious stones and bronzes. There is evidence that Mantegna was a guest of the Cardinal on 21 September. In a document dated 20 November, Ludovico III ordered the payment of a sum of eight hundred ducats to Mantegna for the purchase of a farm at Buscoldo (cf. also 1478).

1474 This is the year recorded in the dedicatory inscription in the Camera degli Sposi (but cf. *Catalogue*, no. 51 B).

1476 This date is recorded in the stone affixed by Mantegna (at some time between 1484 and 1502 [q.v.]) to his own house near S. Sebastiano in Mantua, as an acknowledgment of the plot of land given by Ludovico for its construction.

1477 On 6 July, Ludovico III asked Mantegna to paint the portraits of some absent members of his household. The artist's reply was: "You cannot produce a true likeness if you cannot see [the original]". It was in this year that Paola, the Marquess' daughter, married the Count of Gorizia. Four marriage chests were made for the occasion, all of which are thought to be based in varying degrees on drawings by Mantegna.

1478 A letter from Mantegna to Ludovico dated 13 May complained that the payment agreed on in 1472 (q.v.) had not yet been made in full. The Marquess explained that this was due to his own critical financial position. Ludovico died in October. Shortly afterwards, his heir, Federico, wrote to ask the artist to join him in Gonzaga. However, as Mantegna was ill at the time, he was unable to accept this invitation which was so pressing (as, indeed, were other gestures of the

Mantegna's house in Mantua, situated alongside the church of S. Sebastiano.

new Marquess) that we are left in no doubt as to the great esteem in which Mantegna was held at the Court of Mantua.

1479 21 MAY. During the war with Tuscany, Federico wrote to his wife from the battlefield to ask her to attend to urgent affairs including the question of Mantegna's fee.

1480 On May, the Marquess Federico wrote to the celebrated doctor Gerardo da Verona about one of Mantegna's sons who was seriously ill and who, in fact, died shortly afterwards. In June, when the Duchess of Milan wrote to the Gonzagas to ask them to get Mantegna to "copy a number of painted drawings", his uncompromising reply was that he "was not accustomed to painting small figures".

1481 On 24 April, Mantegna went to Marmirolo to give instructions to Antenoreo the architect, who was at work on the Gonzaga residence there. Before the end of the year, Chiara Gonzaga, another daughter of Ludovico III, married the Count of Montpensier; it is quite probable that she brought with her to Aigueperse the *St Sebastian* now at the Louvre (*Catalogue*, no. 56).

1483 In February, at the request of the Court of Mantua, Mantegna furnished G. M. Cavalli, the goldsmith and bronze artist, with a number of drawings for precious vases. Some time later, Lorenzo the Magnificent called on Mantegna and expressed his admiration for some of his work and for the archaeological "pieces" he had collected.

1484 A letter written on 25 February by Bishop Ludovico Gonzaga and addressed to the Prefect of Rome, Giovanni della Rovere, suggests that Mantegna was engaged in decorating an apartment in the Gonzaga Palace in Mantua (but cf. *Catalogue*, no. 55). On 26 August, the artist wrote to Lorenzo the Magnificent in Florence asking for financial help in the construction of a house near S. Sebastiano (cf. *1476*). On 6 November, Federico Gonzaga wrote to the Duchess of Ferrara to tell her that Mantegna was in the process of finishing "a Madonna with some other figures", the sketch for which the Duchess had seen and admired. A

number of attempts have been made to identify the work in question (*Catalogue*, nos. 19 and 62), which provoked a good many appeals to the artist to get on with it; on 15 December it was still unfinished. Federico Gonzaga died before the end of the year and was succeeded by his son, Francesco.

1486 26 AUGUST. Work was by this time in progress on the series of paintings featuring the *Triumph of Caesar* (*Catalogue*, no. 63).

1488 On 10 June, Francesco Gonzaga wrote a letter of introduction to Pope Innocent VIII for Mantegna who was about to go to Rome. The date 1488 has been found on one of the frescoes in the atrium of the Church of S. Andrea in Mantua (*Catalogue*, no. 64).

1489 On 31 January, Mantegna wrote from Rome to the Marquess Francesco asking him to look after the "pieces" of the *Triumph of Caesar* which had so far been finished and expressing the hope that he would be able to complete the series. In a further letter to the Marquess dated 15 June, Mantegna declared that he was getting enough to cover his expenses out of his work on the papal chapel (*Catalogue*, no. 65) and added that "the

work is a big one for just one man in search of honour, especially in Rome where there are so many judgments of men of worth". The letter goes on to describe Djem, the brother of the Turkish Sultan who was a papal hostage at the time. It is fairly clear that the artist was out to entertain his patron by embellishing the pen picture with exaggerated details which – so far as is known – did not apply to the unhappy prisoner. According to Mantegna he displays "a certain proud majesty, his gaze possesses a certain indefinable quality which is unquestionably ridiculous . . . and he walks like a man in love; on his head he wears sixty thousand metres of tulle" and it would seem that "Bacchus pays him frequent visits"; the artist adds that when he gets a suitable opportunity to draw him in peace, he will "send the drawing to Your Excellency"; indeed, he would have enclosed a drawing with the letter but "sometimes he looks one way and sometimes quite another, *just like* a man in love, so that I find it impossible to memorise his features". As Francesco Gonzaga was planning to marry Isabella d'Este, he wrote on 16 December asking Innocent VIII to authorise Mantegna to return to Mantua for the preparations for the wedding.

1490 The Pope's reply to this letter (dated 1 January) stated that Mantegna was ill and that it would be risky to expose "talem virum" to the rigours of the journey. In any case, the chapel in the Vatican was probably still unfinished, since it bears the date 1490 together with Mantegna's signature and the appellation "comes palatinus" (Count Palatine) (cf. *1469*). He returned to Mantua some time between September and 5 October, on which date there is definite evidence of his presence in the city.

1491 On 16 July, a number of Mantegna's assistants were engaged in the decoration of the Gonzaga residence at Marmirolo (*Catalogue*, no. 81). The date 1491 appears on the watercolour *Judith* at the Uffizi (cf. page 123).

Vault of Mantegna's memorial chapel in the church of Sant'Andrea in Mantua incorporating the family crest.

1492 14 FEBRUARY. The Marquess made over the Della Caccio wood to Mantegna in payment for his work on the Castel S. Giorgio chapel, the Camera degli Sposi and the *Triumph of Caesar*.

1493 On 12 January, the Marquess' wife Isabella commissioned the artist to paint her portrait, which she wished to send to the Countess of Acerra. However, she was not pleased with the result which she thought a poor likeness; she therefore wrote to the Countess (20 April) to say she would not send the portrait after all (*Catalogue*, no. 82).

1494 On 14 January, Isabella sent to the Countess of Acerra a portrait painted for her by Giovanni Santi, the father of

Stone erected by Mantegna outside his house in Mantua (cf. Outline biography, 1476).

Raphael. Meanwhile the work at Marmirolo went ahead (*Catalogue*, no. 81).

1495 31 JULY. Work began on the sketches for the *Madonna della Vittoria*, now at the Louvre (*Catalogue*, no. 93), to commemorate the battle of Fornovo which was fought on the 6 of the month.

1496 On 6 July, the first anniversary of the battle of Fornovo, the *Madonna della Vittoria* was solemnly unveiled in the chapel built especially to house it. There is evidence that work was in progress during this year on the altarpiece for the church of S. Maria in Organo in Verona – now in Milan (*Catalogue*, no. 94). Giovanni Bellini promised a painting to be hung in Isabella's studiolo, for which Mantegna was doing the so-called *Parnassus* now at the Louvre (*Catalogue*, no. 91 A).

1497 A letter dated 3 July by a court official to the Marchioness Isabella, who was in Ferrara,

contains the information that the *Parnassus* had been hung in the studiolo. The date 15 August, 1497, is recorded on the above-mentioned altarpiece executed for Verona.

1499 Mantegna went to Ferrara to value a number of paintings. During this year, he worked in Mantua on the designs for a monument to Virgil which Isabella wanted.

1500 Mantegna was approached by the Prior of Santa Maria in Vado who wanted him to paint either a *Madonna* or a *St Jerome*; the artist's reply was that he had no time.

1501 13 FEBRUARY. Sigismondo Cantelmo referred in a letter to the *Triumph of Caesar* which had been used together with the "*Trionfi*" of Petrarch (also by Mantegna) (*Catalogue*, no. 90) as part of the setting for a theatrical performance at the Court of Mantua.

1502 10 JANUARY. Mantegna made over to the Gonzagas the house near San Sebastiano in exchange for another one nearby.

1504 Mantegna made a will dated 1 March in which, among other things, he left two hundred ducats to be used in the decoration of his own memorial chapel in the church of S. Andrea in Mantua. On 6 July, Lorenzo da Pavia wrote to inform the Gonzagas that Giovanni Bellini had finished a painting which was to be hung with others by Mantegna, adding that the painting in question had been executed with great care "out of respect for Master Andrea".

1505 1 JANUARY. Bembo expressed his admiration for Mantegna in a letter to Isabella.

1506 On 13 January, having just recovered from an illness (which may have been an apoplectic fit) Mantegna sent to Isabella the letter reproduced on p. 84. In it he told her that he had almost finished sketching the *Myth of the God Comus* for her studiolo (*Catalogue*, no. 91 C), adding that, in view of his straitened circumstances, he was prepared to let her have a Roman bust of Annia Galeria Faustina (possibly the bust now at the Palazzo Ducale in Mantua) of which he was particularly fond. After prolonged and ungallant haggling on both sides, the bust finally changed hands on 4 August in return for the sum of one hundred ducats. The artist died on 13 September "at seven in the evening" according to a letter written two days later to the Marquess of Perugia by Mantegna's son, Francesco. On 2 October, another son, Ludovico, gave a list of the paintings left in his father's studio which included: "a foreshortened Christ; that work of Scipio Cornelius undertaken for mess(er) Francesco Cornaro; a St Sebastian and the two pictures for his chapel" (*Catalogue*, nos. 57, 96, 73, 108 and 109 [?]).

Catalogue of works

Scholars and critics are far from agreed concerning the evolution of Mantegna's artistic career, whether from the point of view of its origins, the question of which of his predecessors influenced him or the successive stages of his development; they are not even agreed on his stature as an artist (cf. introduction to the *Critical outline*).

Indeed, it is precisely those critics (or some of them) who tend to extoll every aspect and every stage of his career who have been responsible for attributing to Mantegna, in addition to the "corpus" of his work, all sorts of other paintings. Only rarely have these measured up (and all too often they have been far inferior) even to the poor opinion of his mature works held by other scholars who, on the whole, tend to contest these additional attributions.

The first point at issue concerning Mantegna's origins is the question of Francesco Squarcione. The early sources state that Mantegna's adopted father and master had been a painter since childhood. However, in the official records he is repeatedly referred to simply as "*sartor et recamator*" and there is no reference to his activity as a painter until 1429. The sources extoll his journeyings in Italy and Greece in search of good designs and archaeological remains; they record that he had no less than 137 pupils, all of whom are said to have been lovingly educated and many of them adopted; they attribute to him famous cycles of paintings — including the decoration of the Ovetari Chapel — in which, they say, he generously allowed his pupils to take a hand. The fact remains that the official records make no mention of any journey; the number of pupils attributed to him is at variance with the guild regulations at the time; the adoptions frequently resulted in disputes all of which seem to suggest that Squarcione was merely exploiting his adopted sons; finally, at least as regards the Ovetari Chapel, it is quite clear not only that he had nothing to do with its decoration but that he was openly hostile to the young Andrea. Even so, there is evidence to show that the ex-embroiderer did have a passion — though perhaps "craze" is the better word — for Antiquity, that he exercised an undoubted ascendancy over some of the keenest minds which were then coming to the fore in the artistic world of the Veneto and Emilia (which explains how Tura, Crivelli and Mantegna had more than one "theme" in common) and that the few extant paintings by him are not the second-rate efforts they were thought to be, but are

works of art "of very real quality" (Longhi), packed with witty and amusing Gothicisms.

A quite different problem is posed by the fact that such Tuscan artists as Andrea del Castagno and Paolo Uccello, Filippo Lippi and Donatello were all busily at work in Padua and Venice over the period from 1430 to 1460. All these, and particularly the latter two, are held to have influenced the young Mantegna (Fiocco, etc.). Indeed, there would seem to be no doubt that this is largely true, though due allowance must be made for the extent to which this influence was distilled to him through Pizolo. Before working with Mantegna on the Eremitani Church, Pizolo had helped Lippi with the Chapel of the Podestà in Padua, and Donatello in his work on the Basilica del Santo, at which time he very probably went with Donatello to Florence where he would have had an opportunity of studying his early sculptural work. The echoes that we get of this in Mantegna's own work would be inexplicable without the intervention of Pizolo (Camesasca). Moreover, the young Mantegna's trip to Ferrara in 1449 must have meant a great deal to him. In the course of it, he became acquainted with the samples of Flemish painting in the Este collections (and in particular with the work of Rogier van der Weyden) as also with the work of Piero della Francesca which was then to be seen in Ferrara. It should be emphasised that all this constitutes a consistent, positive and indeed indispensable key to much of Mantegna's early work. Nevertheless, it does not give the whole story unless due allowance is made for the fact that his work bore fruit from the seed sown by Squarcione.

Mantegna first came into contact with the Bellinis early in his career. The critics have attached a good deal of importance to the sketchbooks of classical themes drawn by the father, Iacopo. Much has been made, too, of the mutual influence exercised between Mantegna and Gentile and, to a greater extent, Giovanni. In the case of the latter, critics long held that he had been strongly influenced by his Paduan brother-in-law; subsequently, the opposite view held sway. A concept of "mutual influence", with all its implications of give and take, would seem to account most satisfactorily for the "softening" in style which even such an early critic as Cavalcaselle saw as occurring round about the time of Mantegna's marriage to Nicolosia Bellini and also for some, at any rate, of Giovanni's transitions from the

Byzantine to the Renaissance idiom.

The next stage in Mantegna's development is represented by his period in Mantua. Some critics maintain that he here encountered a truly vital culture. Others, who may be closer to the truth, believe that the atmosphere was largely provincial, though possibly tinged with a rather bookish type of antiquarian erudition, and probably influenced to some extent by the echoes of events which were still very much innovations in Venice, Urbino and Rimini but had long ceased to be so in Florence. Mantegna also came into direct contact with all this. In the past, various scholars have tended to attach a great deal of importance to the artist's trip to Tuscany where, it was held, he would have been able to study the entire artistic output not only in Florence itself but also in Pisa and possibly Arezzo. Moreover, he could then have seized the opportunity thus afforded him of bringing himself up to date with the work of Lippi, Castagno and Piero della Francesca and of acquainting himself with that of Botticelli. However, recent critics have come to the conclusion that, though Mantegna certainly studied the frescoes of Benozzo Gozzoli in Pisa, he did not pay a great deal of attention to much else, beyond a possible glance at some of Botticelli's work and not his most recent productions at that.

Next comes Rome. Critics are now more or less agreed that the artist was not greatly influenced by his visit to Rome since, by the time he made the trip, he already had some fairly set ideas with regard to Antiquity which he had developed from literary sources rather than from archaeological finds. This theory is confirmed by the cohesion between the sections of the *Triumph of Caesar* believed to have been executed before the Rome trip and those completed afterwards. Finally, in assessing his later works, some critics detect constant signs of a radical renewal (Fiocco; Coletti; Paccagnini, etc.). Others (including Longhi, Castelfranco, Camesasca and others) detect in them traces of a punctilious rejection of any outside influence. While recognizing that Leonardo, Giorgione, Michelangelo and Raphael had by this time attained the apex of their style (or were well on the way to doing so), it must be admitted that their temperaments differed too much from Mantegna's own for him to pay much attention to them. Nevertheless, it would be difficult to justify the view that Mantegna was seeing inspiration in

Perugino, then at his most weary and inferior.

In all instances, the critical assessment of Mantegna's extant works is rendered difficult by the absence of chronological information and in some cases also by the very poor state of

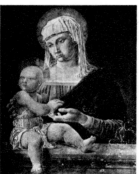

3

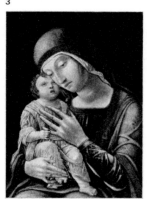

4

preservation of the works themselves. Apart from the regrettable destruction of most of the Ovetari frescoes and of the decorative work done by Mantegna in the Gonzaga residences at Cavriana, Marmirolo and elsewhere (which, if they had survived, might well have helped to offset the poor opinion of his works expressed by some critics by furnishing proof of his extraordinary inventiveness of which we have some evidence in the engravings executed on the basis of his ideas), and disregarding the damage which has been done in the Camera degli Sposi, most of the canvases and panels by Mantegna (but the canvases in particular) have peeled and show bare patches, principally on account of the very thin layer of colour originally applied which has not proved resistant to strong fixatives (or at least to such as were used in past centuries). Again, though there are a few occasions on which it is certain that Mantegna used oils, most of

his easel paintings appear to be in tempera, though it is possible that he in fact used the "mixed method". If so, the tempera predominated, resulting in the bare patches already mentioned. It has proved impossible to determine the medium used for some paintings, occasionally because no serious attempt has as yet been made to do so, so much so that some paintings believed to be in good condition have proved to have been touched up while others regarded as too mediocre to be attributed to Mantegna have also been found to have been retouched by other artists.

1 1448

Altarpiece
Formerly in the Church of S. Sofia in Padua.
This bore the inscription recorded by Scardeone (see *Outline biography*) and featured the Madonna "and some other figures", presumably saints. Mantegna was paid the sum of forty ducats for the work — which is also mentioned by Vasari — on 16 October 1448. It had already been destroyed by 1648.

2 1449?

Portrait of Lionello d'Este and Folco da Villafora
An entry for 24 May 1449, relating to the affairs of the Este Court (Campori, 1886), mentions a small panel portraying "Lionello d'Este on one side and Folco da Villafora (Chamberlain and a favourite of Lionello's) on the other" painted by "Andrea da Padova". Most critics agree that the reference is to Mantegna, though there is no absolute proof that this is so.

3 43×34

Madonna with Child
Basle, Private collection
This work bears the inscription "OPVS ANDREAE MANTEGNAE", though there are serious and legitimate doubts as to its authenticity. The picture was first mentioned by Fiocco (BM, 1949) as having been executed by Mantegna round about 1452. Tietze-Conrat regards it as a pastiche of features taken from a number of works.

4 48×34,5 1450*?

Madonna with Child
Boston, Museum of Fine Arts
This picture reached its present home in 1933 from "a castle in Brandenburg". Its attribution to Mantegna was endorsed by Fiocco who

saw in it some affinity with the cycle in the Eremitani church. Suida maintains that it was done by a pupil. Tietze-Conrat attributes it to a disciple and Cipriani to an imitator.

5 76×53

St Jerome in the Desert
Washington, National Gallery of Art (Mellon Collection)
This picture was attributed to Mantegna by Venturi (L, 1927) supported by Fiocco, who dated it about the time the artist was engaged on the Eremitani Church in Padua (no. 14). Longhi (P, 1934), Tietze-Conrat and Cipriani all reject it.

6 48×37 *1450*

St Jerome in the Desert
São Paulo, Museu de Arte
This work was attributed to Mantegna by Borenius (BM, 1936). It reached its present home after the Second World War. As early as 1937, Fiocco had attributed it to Marco Zoppo, a theory which was supported by Ragghianti (1937) and others. However, in 1952 Berenson once again attributed it to Mantegna and most modern critics, except Tietze-Conrat, accept this view. The question of its chronology has been largely by-passed. Cipriani dates it round about the year 1465. Camesasca detects in it certain features betokening a connection with North European painters, Piero della Francesca and Mantegna's own early work; he therefore dates it in 1449–50. It is well preserved except for some very slight restoration on the top left-hand side.

7 40×55,5 1449-50*

Adoration of the Shepherds
New York, Metropolitan Museum of Art
This work features the Madonna adoring the Child in the centre, surrounded by a host of cherubim. St Joseph is asleep, leaning against a tree. The two shepherds seen going on their knees to the right of the picture so closely resemble the damned in Rogier van der Weyden's *Last Judgment* in Beaune as to suggest that

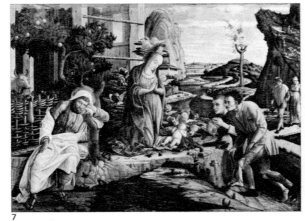
7

Mantegna was still strongly influenced by his recent trip to Ferrara (Camesasca) where some of the Flemish painter's work was to be found. The landscape, evocative of Piero della Francesca's style, is almost the same as that in the São Paulo *St Jerome* (idem), though somewhat better arranged. In the background is to be seen the pointed rock which was to appear in a number of Mantegna's other works. Only part of one of the two people seen approaching from the right is now visible; this would seem to confirm Tietze-Conrat's theory that the picture was cut down at some time, at least on that side. The Museum's catalogue claims that the picture originally formed part of a predella executed round about 1460, and this view is endorsed by Tietze-Conrat. A painting featuring this subject, together with other works by Mantegna, was among the pictures owned by Margherita Gonzaga, wife of Alfonso II d'Este. These were restored by Bastiano Filippi over the period 1586–88. The painting now under discussion was owned by A. Rouse-Boughton-Knight of Downton Castle (England). It was there that Cavalcaselle saw the painting and attributed its execution to an artist of the Mantegna school on the basis of a design by the Master. Kristeller, Schmarsow and Tietze-Conrat have rejected the attribution to Mantegna though most of the other critics rightly hold that

8

it is his work. It has been fairly reliably dated between the years 1449–50 (Fiocco; Camesasca). Cipriani, however, believes it to have been executed round about the same time as the S. Zeno Altarpiece (no. 23). The tempera has been transposed onto canvas from the original panel. Drawings connected with the painting (though most critics feel that they were not done by Mantegna) are to be found at the Uffizi and Windsor Castle.

8 24,6×15,8

Adoration of the Shepherds
Paris, Martin Le Roy Collection Formerly
The only information now available concerning this work is the illustration of it which appears in the catalogue for the Collection (A. Coupil, 1909), where it is described as a *bottega* work, closely resembling Mantegna's own style and in particular that of the *Adoration* now in New York (no. 7). Resuscitating a theory which had been hinted at in the catalogue, Lorenzetti (L, 1910) maintained that it was a partial copy of no. 7. Though conceding that the two paintings may originally have been the same size, Tietze-Conrat held that this one was really a replica with variations; in support of this view, she adduced a drawing at Windsor Castle which she felt was connected with this.

"INCLITA MAGNANIMI VE... EVANGELISTA. PAX TIBI... ANDREAE MANTEGNAE... O... LABOR". The saint is seen looking out of a window the perspective of which is handled with such evident delight as to invite a comparison with the arch featuring *St James with the devils* in the Eremitani Church in Padua (no. 14 F). On the window-sill rest an apple and the book of the Gospels, symbol of the Evangelist. Though he originally thought in terms of Pizolo (1927), Fiocco later concluded that the inscription was authentic and attributed the work to Mantegna, dating it round about the year 1454. This view was endorsed by

9 87×76

Madonna with Child
Invergarry (Scotland), W. V. Goodbody Collection
This picture reached its present home via Agnew's, London. It was first made known to the public by R. Fry as a Mantegna original inspired by reliefs by Donatello, a theory which is endorsed by Fiocco and Coletti but rejected by Tietze-Conrat and Cipriani, who bases her judgment on the painting as it is now and concludes that there is little ground for including it in the "corpus" of Mantegna's works.

9

10 67×43 1450*

Madonna with Child, St Jerome and St Louis
Paris, Musée Jacquemart-André
This work was acquired in Venice in 1887 by Guggenheim, the antiquarian. Kristeller and Venturi regarded it as a *bottega* effort, though Berenson and Fiocco thought it was done by Mantegna himself (Fiocco dated it in the Ovetari Chapel period — no. 14). Others maintain that it was done in the Bellini *bottega* by Mantegna himself with the possible collaboration of Gentile (Paccagnini) or Giovanni (Longhi, Ragghianti, Camesasca). Meiss, Arslan and Gilbert have detected the hand of an unknown artist, at least in the actual execution. The picture is in good condition.

10

11 47×37

Madonna with Child Asleep
Turin, Galleria Sabauda
This painting was first made known to the public by L. Venturi (1926) as a Mantegna original executed some time before the *S. Zeno Altarpiece* (no. 23). Tietze-Conrat (who believes it to be a derivation from Mantegna's own work by a Venetian artist), Cipriani and Paccagnini have all rejected the attribution to Mantegna. It is, in any case, difficult to give an opinion in view of the serious damage which has been done to the painting by cleaning and retouching operations.

11

12 82×63,5 1450*

St Mark
Frankfurt am Main, Städelsches Kunstinstitut
The inscription on the scroll at the base of the picture (which some critics believe to be apocryphal) runs:

5

6

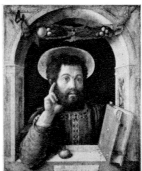
12 (plate I)

Berenson, Ragghianti, Longhi (1962) and Camesasca. Camesasca detected in it direct stylistic affinities with the *Head of a Giant*, also in the Eremitani Church (no. 14 D). Tietze-Conrat, however, maintains that it is by a painter with a Paduan background.

13 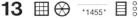 *1455*

Portrait of Iano Pannonio and Galeotto Marzio da Narni

The first of these two is the well-known Hungarian bishop and humanist, Csezmicei, who may well be the person who, according to Vasari, is depicted in the Ovetari Chapel (cf. no. 14 K). It is not clear whether the work in question comprised two separate likenesses or, as in the case of those of Lionello d'Este and Folco da Villafora (no. 2), a pair of portraits done on either side of a single support. The work is mentioned by Pannonio himself in an elegiac composition written in Mantegna's honour before the year 1458. We may therefore conclude that it was executed in Padua.

Frescoes in the Ovetari Chapel

This chapel (which has an overall height of 11·10 m. and a width of 8·85 m.) is part of the Eremitani Church in Padua. During the first half of the fifteenth century, it was renovated at the expense of Antonio Ovetari, a notary. Shortly afterwards, in his will dated 1443 and in a codicil dated 1446, he left a sum of seven hundred ducats to provide an altar for the chapel and to defray the cost of decorating it with a series of scenes from the lives of St James and St Christopher. On

right-hand wall (scenes from the life of St Christopher), the groin vault (figures of the Evangelists), the wall above the archway giving access to the chapel (scenes from the Passion), the archway intrados (figures of saints) and the frieze outside the chapel] was allocated to Giovanni d'Alemagna and Antonio Vivarini, both from Murano. The work was to be completed by the end of 1450 but a number of factors caused delay. To begin with, the agreement with Pizolo and Mantegna (both of whom would appear to have been of a rather touchy disposition) had not stipulated which sections were to be decorated by each artist. The dispute was settled on 27 September 1449, when Pietro Morosini, who had been called in as arbitrator, gave his decision, by virtue of which the "partnership" between the two painters was dissolved and it was stipulated that Pizolo should execute the altarpiece and paint the apse, the right-hand side of the arch and the last fresco of the life of St James (on the left-hand wall, near the altar) since he had already started work on the figures of God the Father and St James himself in two sections of the apse; Mantegna was to decorate the remaining three sections of the apse (comprising the figures of St Peter, St Paul and St Christopher) on which he was already engaged (no. 14 A–C), the left-hand side of the archway (no. 14 D) and the first five panels in the St James cycle. Morosini further stated that the ex-partners had already been paid more than was their due; he therefore ordered that they should finish the work, adding that, in the event of the death of one of the parties, the other should receive that portion of the fee representing the value of the work thus left undone. There was a further unforeseen hitch in 1450 when Giovanni d'Alemagna died,

Sketch illustrating the distribution of the panels comprising the decoration of the Ovetari Chapel (no. 14). The numbers followed by a capital letter indicate the frescoes by Mantegna in the order in which they are discussed in the Catalogue; *the small letters denote the following works: a – St James,* begun by Pizolo and finished by others; b – God the Father, *by Pizolo;* c – St Christopher before the King, *generally ascribed to Ansuino da Forli, but possibly by another artist;* d – St Christopher Refuses to Serve the Prince of Demons, *also believed to be by Ansuino or others,* e – St Christopher Carries the Child Jesus across the River, *generally believed to be by Bono da Ferrara;* f – Sermon by St Christopher, *also frequently attributed to Bono da Ferrara,* g – Altarpiece *modelled by Nicolò Pizolo.*

then allotted to Mantegna, who thus executed all the stories in the *St James* cycle (no. 14 F–J), in addition to the *Assumption* (no. 14 M) in the apse, the three saints (no. 14 A–C) and the left-hand side of the archway already mentioned as having been assigned to him. Mantegna also did the frescoes for the last two scenes in the life of St Christopher (no. 14 K and L) which had originally been allocated to the d'Alemagna-Vivarini partnership. However, Ansuino, Bono and one or two other painters whose identity is uncertain did the remaining frescoes in this series.
On 14 February 1457, Pietro da Milano, acting as arbitrator, declared that, although he had not supervised the work personally, he could detect Mantegna's hand in the execution of the frescoes on the left-hand wall and in the *Assumption* because, he stated, a painter's style, especially in the case of a "great master", can always be recognised by his colleagues. He went on to say that, in spite of Imperatrice Ovetari's protests, it would not have been possible to depict the twelve apostles at the feet of the Virgin without destroying the artistic effect. The next day, Squarcione, acting on behalf of Ovetari's widow, contended that there would have been plenty of room for all the apostles if Mantegna had taken the trouble to adapt their dimensions to the space available. Basing his remarks on a letter from Gerolamo Campagnola, Vasari maintains that the work in question had originally been allocated to Squarcione and that it was he who first brought his adopted son into the picture. However, the documents make it quite clear that the only connection between the old artist from Padua and the decoration of this chapel is the fact of his having acted as consultant on this occasion and, moreover, against Mantegna.
The actual order in which the

14 A
16 May 1448, Ovetari's widow, Imperatrice, signed an agreement with the painters Nicolò Pizolo and Andrea Mantegna (whose brother Tommaso signed on his behalf as he was still under age) for the execution of an altarpiece in relief and the frescoes on the left-hand wall. The remainder of the decoration [comprising the

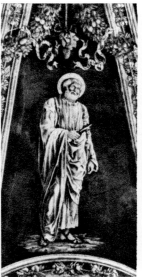

14 B
whereupon his partner Vivarini abandoned the project (1451). The work d'Alemagna and Vivarini had undertaken to do was therefore entrusted to Mantegna and Ansuino da Forli (both of whom were being paid fees as early as 1451) and to Bono da Ferrara. Further payments

14 C
were made in 1452 to Pizolo, who modelled the altarpiece and finished his figures in the apse; he also painted the four Fathers of the Church in the apse and completed the decoration of the portion of the archway assigned to him.
In 1453, he died from wounds received in a brawl. The remainder of his share was

14 D

various panels were executed was and still is hotly disputed. The whole question is not made any easier by the relative lack of documentary evidence, even in spite of Rigoni's notable finds (AIV, 1927–28 and AV 1948), though the principal difficulty is the fact that most of the cycle was destroyed in an air raid in March 1944, from which survive only the *Assumption*, the *Martyrdom of St Christopher* and the *Removal of his Body* (no. 14 K–M). In addition, there remain small fragments of the *Martyrdom of St James* (no. 14 J) and a few of his *Trial* (no. 14 H).
In the following survey of those portions of the cycle executed by Mantegna, no details are given concerning the position of the pictures as this is clearly shown in the sketch, in which the numbering is that of the relevant works in the Catalogue.

14 ▦ ⊕ *1449-50* 目 ⁰₀
A. St Christopher
The arbitration ruling given in 1449 (see above) stipulated that this and the next two figures were to be completed by Mantegna, who had already started work on them. Before the details of this ruling came to light (Rigoni, 1927), these paintings had mostly been attributed to Pizolo, though Venturi (1914) thought he detected signs of Mantegna's intervention at least in this panel and Longhi (1926) saw traces of his work all over the apse. Fiocco regarded the work as reminiscent of Andrea del Castagno. Camesasca propounds the theory that the Donatello-like style which is here so apparent, and which may be based on some of the great sculptor's work in Florence, filtered through to Mantegna from his companion Pizolo (who had worked with Donatello) who, in Camesasca's opinion, may well have been responsible for the overall design. All three panels are generally dated 1449 or 1450 at the latest.

14 ▦ ⊕ *1449-50* 目 ⁰₀
B. St Paul
See no. 14A.

14 ▦ ⊕ *1449-50* 目 ⁰₀
C. St Peter
See no. 14A.

14 ▦ ⊕ *1450* 目 ⁰₀
D. Head of a Giant
This was probably a self-portrait of Mantegna (matching one of Pizolo on the other side of the archway). It was located in the portion of the chapel entrusted to Mantegna by the arbitration ruling of 1449. This fact, together with certain stylistic features which betoken an acquaintanceship with the work of Ferrarese artists (probably dating from about May of the year 1449), would seem to endorse the view that the fresco was done round about 1450.

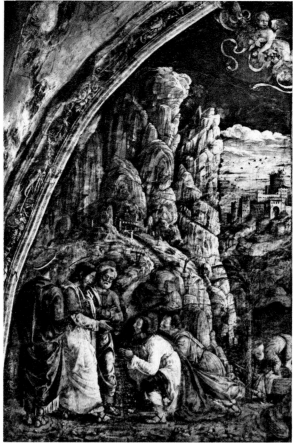

14 E

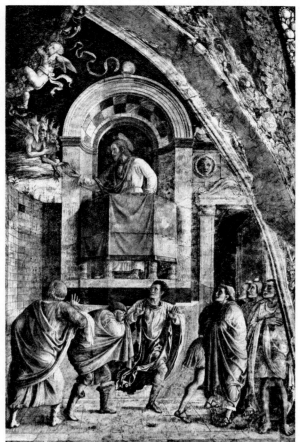

14 F

14 G

Detail of St James on Trial *(no. 14 H) before the raid in 1944, and as it is now.*

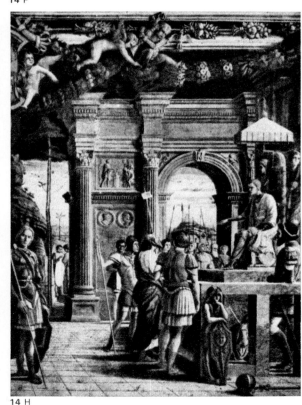

14 H

14 ▦ ⊕ base 330* *1450* 目 ⁰₀
E. Call of St James and St John

The scene depicted is that recorded in St Matthew's Gospel (IV, 21–22). Christ is pictured on the left between Peter and Andrew. The two new apostles are seen kneeling in the centre. Their father, Zebedee, is busy gathering in the nets in the boat on the right. The rocky background clearly displays the "almost geological relish" which was to be a recurrent feature in

Mantegna's work though the colour in this instance has none of his later work. Michiel attributed this panel and the other half of the lunette to Mantegna as early as 1523–24. This view was endorsed by Cavalcaselle, Kristeller and Longhi (1926) and was subsequently confirmed by the documents relating to the arbitration ruling of 1449. Venturi had been of the opinion that it was the work of Pizolo and thought that the picture was to some extent indebted to the corresponding cycle on the opposite wall, which he believed to

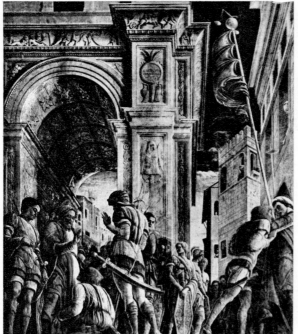

14 I

have been done by Ansuino da Forli. The pictorial idiom and the position of the two paintings – in the upper part of the wall – would seem to suggest that they were executed round about 1450.

14 ⊞ ⊕ base 330* *1450*

F. St James Speaking to the Demons

The idea for this panel is taken from the *Legenda aurea* by Iacopo da Varazze. St James is seen in a pulpit addressing the demons which have terrified some of the bystanders while others remain rooted to the spot. The door on the right is decorated with a mask and above it there is a statue of a half-reclining man which was to reappear in the *Triumph of Caesar* (63 D) (Tietze-Conrat). The cherub on the festoon, which matches the one in the previous painting, is here seen to share in the general terror. The third bystander from the left had one leg missing. This is likely to have been due to the fact that a portion of the picture done by the dry fresco method eventually came away. For questions of attribution, etc., cf. no. 14 E.

14 ⊞ ⊕ base 330* 1451*

G. St James Baptising Hermogenes

This scene, too, is taken from the *Legenda aurea*. Hermogenes, the magician, is converted to Christianity in full view of the public. The medallion on the end wall above the shop is said to have been derived from a classical relief (Moschetti, 1908). The perspective demands that this and the neighbouring panel be viewed as a whole since the vanishing point which is common to both is located on the chandelier which was to divide them (Castelfranco). The remarkably low position chosen for this vanishing point would seem to have been suggested by the reliefs executed by Donatello for the Basilica del Santo in Padua (1447) (cf. L. Grassi, 1958). The elongated shape of the figures has been taken by Fiocco as a first indication of the influence of Iacopo Bellini on Mantegna, apparent also in the inclusion of children

and the classical details. The lighting in the picture is gentle, rather after the manner of Piero della Francesca, but the latter's underlying vitality is absent (Cipriani). The attribution to Mantegna has never been denied. Camesasca believed it to be connected with the payments made to the artist in 1451 (cf. Rigoni, 1948) and therefore executed some time earlier. Most scholars, however, date it a few years later.

14 ⊞ ⊕ base 330* 1451*

H. St James on Trial

The Saint is standing facing Herod Agrippa, who gives sentence from his throne. At the foot of the throne, a small boy wearing a soldier's helmet and leaning on a shield, seems to be playing at being Herod's equerry. The arch in the background is adorned with a relief depicting a pagan sacrifice (which Blum maintains is connected symbolically with the martyrdom of St James), two medallions and a tablet bearing the inscription: "T. PVLLIO . . .". Marcanova mentioned a stone bearing this inscription and two medallions at Monte Buso, near Este

14 J

(cf. Mommsen, *Inscriptiones Galliae Cisalpinae*, I, no. 2528). The inclusion of a number of minor details – such as the child in the foreground, the two men talking to the left of the archway and the flying birds above their heads – relieves the overall tension of the scene, which is a good deal more awkwardly arranged than the *Baptism* (14 C) and brings to mind the unfavourable opinion expressed by Squarcione and recorded for us by Vasari, namely that these figures seem more like "ancient statues" than "real people". It would seem that the artist had come to a kind of halt. Venturi commented that "his love for Antiquity" predominated. The remarks in the commentary on no. 14 G concerning attribution and chronology apply equally to this work. Only a few fragments of the figure believed to be a centurion in the right foreground now remain after the bombing in 1944.

14 ⊞ ⊕ base 330* post 1453

I. St James Led to Martyrdom

The theme is based on one of the miracles which, according

to the *Legenda aurea*, St James performed as he was led out to martyrdom. Most critics are of the opinion that it represents the cure of a lame man, though Fiocco maintains that it shows the saint blessing one of his jailers who has been converted to Christianity. On the right, a man is seen to be thrusting a standard bearer out of the way. It is difficult to fit this incident into the general theme, though it can easily be accounted for by the artist's need to balance the composition (Cipriani). There is a "bewildering vista" (Camesasca) of houses in the background, with onlookers gazing from the windows. The magnificent triumphal arch has the following inscription on the pillar: "L. VITRVVIVS/ CERDO ARC/HITETVS", which would seem to have been taken direct from the *Arco dei Gavi* in Verona (demolished in 1805). The soldier in the centre with his hands on his shield is quite clearly reminiscent of Donatello's *St George* (Bargello, Florence). Camesasca points out that this figure is missing in the drawing at Donnington Priory (Hardy Collection: 165 × 254 mm.) which most critics attribute to Mantegna. (The

exceptions are Colvin (1907), who thought it was Donatello's own and Fiocco (1949) who attributes it to Giovanni Bellini.) Mantegna may have drawn his inspiration from some of the classical drawings in Iacopo Bellini's well-known "sketch-books". The carefully planned relationship of architectural elements and human figures which themselves have an architectural quality, produces a perfectly balanced composition. However, the possibility that the fresco may have been influenced by Iacopo Bellini does not seem to provide sufficient grounds for dating it after 1454, which was very probably the year in which Mantegna married the Venetian artist's daughter. Nevertheless, most scholars agree that some time elapsed between the execution of the previous panels and this one, though opinions are divided as to Mantegna's probable activities in the meantime. The majority of critics (Eisler; Ragghianti, 1937; Rigoni; Tietze-Conrat; Arslan, etc.) believe he then worked on the *Martyrdom of St Christopher* while Camesasca, who dates the pictures now under discussion to 1453 or thereabouts, thinks that the *St Christopher* was painted at the same time. There are a number of copies of this and of other panels in the cycle. Cavalcaselle spoke of a copy of this fresco and of the *Martyrdom* – on canvas – as being in the possession of the Marquis Dondi dell'Orologio in Padua. Another very much older copy, which may even be as old as the original, is at the Musée Jacquemart-André in Paris (tempera on wood now transferred to canvas; 51× 53 cm. – cf. commentary on no. 14 K). A third copy is in the Schickler Collection in Paris.

14 ⊞ ⊕ base 330* 1453-57

J. Martyrdom of St James

Vasari states that a number of the figures in this panel were painted from life. It is more likely that the studies from life are to be found in the *Martyrdom* and *Removal of the Body of St Christopher* (cf. nos. 14 K & L) which Vasari may have got confused

14 K

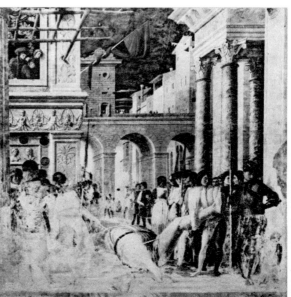

14 L

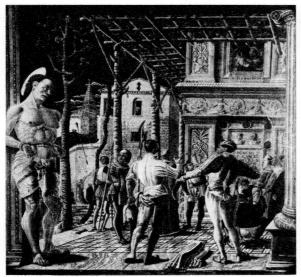

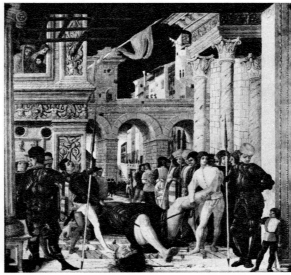

Copies of nos. 14 K and 14 L (Musée Jacquemart-André, Paris); they are in tempera, now transferred to canvas (51 × 51 cm. each) from the original panel and quite by chance put together with a copy of no. 14 I. They may be the copies mentioned by Michiel as being in Padua and Venice, or those said by

Cavalcaselle to be in Padua. Kristeller hazarded a guess that they were the work of Benaglio. However, they are more likely to have been done by the disciples of Parentino or Domenico Morone; in any case, they were executed only very shortly after the original frescoes they reproduce.

14 base 332*
1452

L. Removal of the Beheaded Body of St Christopher

The Saint's head is seen resting on a dish in the foreground. The bottom left-hand portion of the picture has been badly affected by discolouring. For further details, cf. no. 14 K.

14 base 238
1456

M. Assumption of the Virgin
The arbitrary lengthening of this picture (now eliminated) in the last century had effectively concealed the figures of the apostles behind the altar which was moved to the back of the small apse. Evidence of the original proportions is provided by an engraving by F. Novelli from a drawing by L. Brida executed before the picture was detached from the wall in 1865, which is when the lengthening just mentioned also occurred; (in BMP, 1931, Moschetti denied that the

with the panel now under discussion. Even so, some modern critics have tended to endorse the identifications suggested by Vasari. Tietze-Conrat, in particular, declares that the man on horseback on the extreme right of the picture is a portrait of "messer Bonramino cavaliere" (possibly Antonio Borromeo, the lawyer and theologian). It should be added that Vasari's identification of the "executioner" as Marsilio de' Pazzi can only be a reference to this painting. The arbitration ruling of 1449 assigned its execution to Pizolo but it was actually painted by Mantegna after the death of his ex-partner, probably in 1453, but at any rate before 1457 (for the chronology, cf. nos. 14 I and L). Camesasca accounts for the difference in setting between this and the companion picture (14 I) by suggesting that Pizolo had already secured the Ovetaris' approval for the design as we now have it and that Mantegna had to conform to it. It should nevertheless be pointed out that this kind of layout is quite common in Mantegna's own work. Cavalcaselle, and later Venturi, thought that the saint's head had been painted by an assistant but this theory is out of keeping with the general practice at the time. It may well be that the saint's head, and other parts of the picture, were touched up at some later date, though there is now no opportunity of checking this directly since the fresco was destroyed in 1944, although the minute fragments which were salvaged have now been laid on a photographic reproduction in which the colours are more subdued than those of the original.

14 base 332*
1452

K. Martyrdom of St Christopher

This scene is very closely tied up with the next one which carries the same setting beyond the pillar that has been inserted here in place of the frames used to separate the other panels in the cycle. In the *Martyrdom*, the huge figure of

the saint (now almost invisible) is seen towering at the extreme left of the picture, leaning up against the embrasure of the simulated doorpost from which both the compositions are viewed. According to the account in the *Legenda aurea*, the archers (in the centre) were amazed when the arrows they had aimed at the martyr flew in other directions and one struck the eye of the tyrant, who was watching from a window. In the left background there is a bell tower not unlike that of S. Marco in Venice. The other buildings are such as one would see in any fifteenth-century city, though some classicising elements and intarsia work typical of the Renaissance have been included. Neither the inscription beneath the two busts (". . . PONENVS/. . .") nor the figures themselves have been identified archaeologically. Vasari, who may be referring to this picture (but cf. no. 14 J) identifies Squarcione in "a corpulent figure with sword and lance in hand": except for the sword, this description might well apply to the second archer, who is seen from the rear.

Luca Brida (drawing) and Francesco Novelli (engraving): engraved copy of no. 14 M (c. 1865).

Vasari further identifies the portraits of "Noferi (Onofrio) di m(esser) Palla Strozzi the Florentine" (who was in Padua towards the end of his

life), "Girolamo dalla Valle, a most worthy physician" and also the celebrated orator and Latin poet "Bonifazio Fuzimeliga (Frugimelica) doctor of law" of Padua, "Niccolò, goldsmith to Pope Innocent VIII and Baldassare da Leccio". Neither of these individuals is known. Like the others, they are apparently portrayed among the figures clad in "splendid gleaming armour" (in other words soldiers such as are depicted also in the next fresco). In addition, Vasari records the portrayal of "m(esser) Bonramino cavaliere" (cf. no. 14 J), "a certain bishop from Hungary" (probably the well-known humanist Csezmicei [or Iano Pannonio — cf. the commentary to no. 13]), "Marsilio Pazzo (de' Pazzi)" (cf. also no. 14 J) and the artist himself. It may well be that in some cases the reference is to the *Removal of the Body of St Christopher* (no. 14 L). Cavalcaselle commented on a softening in style which he attributed to the influence of the Bellinis and he suggested that the three figures seen in profile beneath the window had been executed by Gentile Bellini. Cipriani thought the theory an interesting one, but it has not been further developed. Davies dates the picture as late as 1459, an opinion which is supported by Fiocco and apparently also by Paccagnini. Most recent critics, however, are inclined to date it as early as 1451 (Rigoni) or at any rate before the end of 1453 (Camesasca) (cf. also the commentary on no. 14 I). Since this and the companion picture were detached from the wall in 1865, both escaped destruction. Unfortunately they are in poor condition: this particular panel is very faded towards the bottom and on the left-hand side, so much so that it is only possible to identify the saint from the copy in the Musée Jacquemart-André in Paris, which may have been executed not long after the original by a painter who is believed by some critics to have been from Verona and by others from Padua. A further copy of this and the next picture is at the Pinacoteca in Parma.

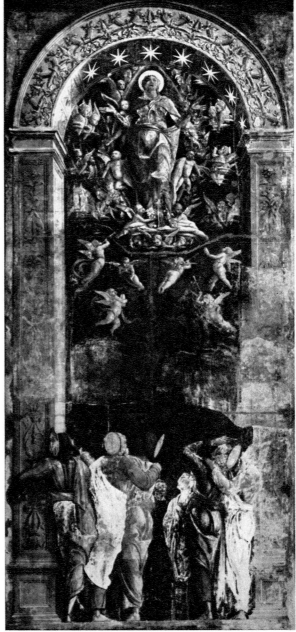

14 M (plates II–III)

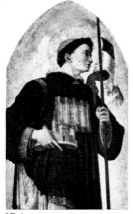

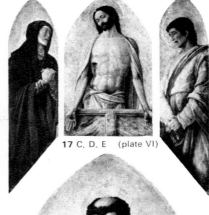

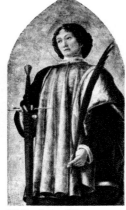

17 C, D, E (plate VI)

17 A **17** B **17** F **17** G (plate VI)

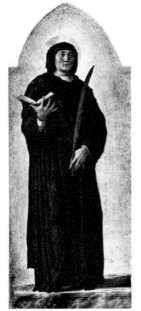
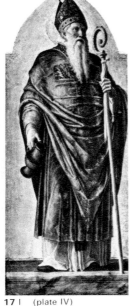
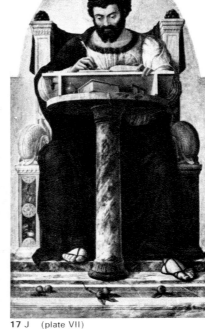
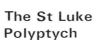

17 H (plate IV) **17** I (plate IV) **17** J (plate VII) **17** K (plate V) **17** L (plate V)

picture had, in fact, been lengthened). In 1523–24, Michiel had attributed the painting to Pizolo and as a result most scholars held this view until Rigoni (1927) published the documents from the archives relating to the chapel. Even so, Cavalcaselle judged that Mantegna must at least have had a hand in the execution; Kristeller had commented on the presence in the painting of some very pronounced features of Mantegna's style. The current theory is that Pizolo had begun work on some of the angels at the top. The fact that the picture portrayed only eight of the apostles gave rise to a dispute with the Ovetaris which resulted in the ruling given by Pietro da Milano in February 1457 (cf. preliminary remarks concerning the chapel). There can be no doubt that the picture had then only just been finished. Mantegna, at any rate, cannot have started work on it until after the death of Pizolo (1453). Fiocco maintains that the elongated form of the Madonna may be due to the influence of Byzantine work elsewhere in the Eremitani church. The picture is in poor condition owing to fading and falls of plaster, particularly at the bottom.

15 80×48

Archer
Padua, Museo Civico
This is a fragment of a fresco which may have been torn down in the residence of Dondi dell'Orologio in Padua (De Toni, BMP, 1898).

Venturi attributed it to Mantegna or to his immediate circle; all later critics have rejected it.

16 base 316 1452

Monogram of Christ, with St Anthony of Padua and St Bernardine
Padua, Museo Antoniano
This work was originally located over the main entrance to the Basilica del Santo in Padua. It was detached from the wall during the First World War and replaced by a copy. The circular inscription reads: "IN NOMINE IESV OMNE GENVFLECTATVR CELESTIVM TERESTRIVM ET INFERNORVM"; the one at the bottom on the marble support on which the lunette rested runs: "ANDREAS MANTEGNA OPTIMO FAVENTE NVMINE PERFECIT

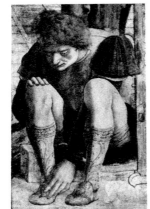

15

MCCCCLII XI KAL. SEXTIL". Since the restoration carried out in the seventeenth century by Liberi and later on by Zanon (1769), only the figure of St Bernardine retains something of the original painting. It is therefore only possible to appreciate the general layout which is remarkable for the harmony which links the figures.

The St Luke Polyptych

This work (measuring 178×227 cm.) is now at the Pinacoteca di Brera in Milan. It consists of twelve figures set in a modern frame. According to a tradition recorded by Moschini, the original frame was destroyed in the seventeenth century when struck by lightning. Scardeone claimed that Mantegna's signature had been "fancifully" inscribed on this frame but that it had been made by a "maestro Guglielmo" who received payment for his work in 1454. The painting itself was originally commissioned on 10 August 1453, and the last instalment of the fee was paid to the artist before 19 February 1454. It was intended for the Church of S. Giustina in Padua. It was the French authorities who moved it from the chapel dedicated to St Luke in St Justina, to its present abode in 1797. Tietze-Conrat has commented on the archaic quality of the layout, though Cipriani believes this to have been stipulated by those commissioning the painting. Tietze-Conrat adds

that the colouring is evocative of Piero della Francesca, while Cipriani comes nearer the mark in adducing affinities with the Bellini *bottega*. We may accept Fiocco's view that the original frame probably fused into a more homogeneous whole the various elements, each of which now seems to be set in a kind of vacuum. Nevertheless, in the individual figures, one is struck by the sureness of touch with which perspective is handled, in perfect cohesion with the gradations of colour and tone, many of the passages being very fine. The complexity of the drawing already foreshadows part of the *S. Zeno Altarpiece* (no. 23). All critics agree in attributing the work to Mantegna and dating it to the years 1453–54; the only point at issue is the identity of some of the saints portrayed in the polyptych.

17 66×37 1453–54

A. St Daniel of Padua
Although the traditional symbols of St Daniel are a basin and a cloth, whereas the figure here depicted is carrying a castle and a flag, the fact that he is dressed as a deacon and has a tonsure is regarded as sufficient grounds for the identification, coupled with the fact that the painting was originally in Padua, of which St Daniel is one of the principal patrons.

17 66×37 1453–54

B. St Jerome in the Desert
The stone in the saint's left hand and the gesture made by his right are sufficient grounds for the identification.

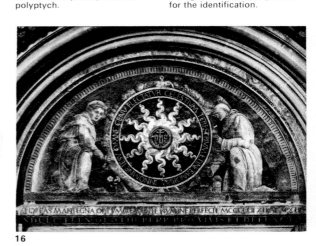

16

17 ⊞ ⊘ 1453-54 📋 ⋮

C. Madonna Addolorata (Mater Dolorosa)
This and the next two sections together constitute a *Pietà* and all three have been executed on a single panel.

17 ⊞ ⊘ 1453-54 📋 ⋮

D. Christ in Pietà
See commentary on no. 17 C above.

17 ⊞ ⊘ 1453-54 📋 ⋮

E. St John the Evangelist
See commentary on no. 17 C above. This panel rounds off the rather strained convergence of the *Pietà* group. The picture is much damaged and has been considerably retouched, particularly the background.

17 ⊞ ⊘ 66×37 1453-54 📋 ⋮

F. St Augustine (?)
The symbols of a bishop's vestments and a book might well be used for a number of other saints; nevertheless, the identification is unanimous.

17 ⊞ ⊘ 66×37 1453-54 📋 ⋮

G. St Sebastian (?)
Although identified as St Sebastian, the two-handed sword seems more appropriate to St Achilleus, Nereus or Pancras.

17 ⊞ ⊘ 97×37 1453-54 📋 ⋮

H. St Scholastica
The book, palm and clothing constitute insufficient grounds for identification. However, the fact that she is depicted in conjunction with St Benedict and St Justina (no. 17 K and L) and that she is one of the patrons of Padua make it

17 ⊞ ⊘ 97×37 1453-54 📋 ⋮

I. St Prosdecimus
This figure can be positively identified from his bishop's attire, the crook in his hand, the fact that he is depicted alongside St Scholastica and more especially St Justina.

17 ⊞ ⊘ 119×61 1453-54 📋 ⋮

J. St Luke (?)
The identification of this figure as St Luke has been questioned principally because the fact that he is seen at a writing desk is not of itself a sufficient indication without some more positive suggestion of his activity as an artist; his symbol — the ox — is missing. In view of all this, it has been suggested that the figure is St Matthew, to whom there is a specific reference in the deed commissioning the painting. Nevertheless, the fact that the painting came from the chapel dedicated to St Luke makes the current identification the more likely one.

17 ⊞ ⊘ 97×37 1453-54 📋 ⋮

K. St Benedict
The monk's habit and the book, the fact that St Benedict is one of the patrons of Padua and that he is depicted in conjunction with St Scholastica (17 H) are all factors which serve to identify the Saint.

17 ⊞ ⊘ 97×37 1453-54 📋 ⋮

L. St Justina of Padua
The identification of this figure as the saint to whom the church for which the work was intended is dedicated, and who is a patron of Padua, is confirmed by the martyr's

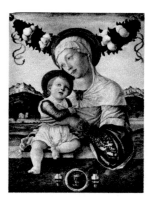

Painting belonging to the Kress Foundation and on show at Tulsa (Oklahoma); connected with no. 20.

palm, the book and the sword (which is embedded in her heart); a further positive factor is her portrayal alongside St Prosdecimus and St Scholastica (no. 17 I and H).

18 ⊞ ⊘ 174×79 1454 📋 ⋮

St Euphemia
Naples, Gallerie Nazionali di Capodimonte
The scroll beneath the saint's feet bears the inscription (which is authentic, in spite of Morelli's questionings in 1880): "OPVS ANDREAE MANTEGNAE — MCCCCLIIII"; the saint's name is featured over her head in large capitals: "SANTA EVFEMIA". She is depicted with a lion, a reference to her martyrdom.
In the eighteenth century it was seriously damaged in a fire which charred almost the whole of the original thin canvas, which was then clumsily coated and impregnated with oil. Restoration work was carried out in 1960; the colours, particularly in the upper half, were found to gleam with something of the splendour of the *S. Zeno Altarpiece* (no. 23).

19 ⊞ ⊘ 43,7×28,6 1454? 📋 ⋮

Madonna with Child and Seraphim (Butler Madonna)
New York, Metropolitan Museum of Art
This work is usually referred to as the *Madonna of the Cherubim*, but the angels depicted in it are, in fact, seraphim. It would seem at one time to have belonged to Doctor Fusaro of Padua, for Cavalcaselle records that he saw in his possession "the most Mantegna-like of all the works attributed to the master in the city". Following the doubts cast by Kristeller on some at least of the execution, Venturi, Knapp and Tietze-Conrat adopted the view that it, together with the identical theme in Berlin (no. 20), was derived from a lost original by Mantegna. Yriarte, Bode, Berenson, Fiocco, van Marle, Suida and G. M. Richter (A, 1939) all hold that it is by Mantegna himself. Mason-Perkins maintains that it closely resembles his style but is not his work. Paccagnini believes it to be the fruit of collaboration between

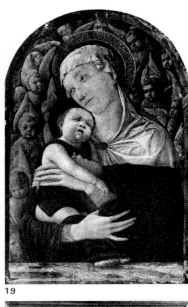

Mantegna and the Bellinis, and Camesasca elaborates this theory by suggesting that the general layout is Mantegna's, and in particular the handling of the Child who, with his feet planted on the window-sill, gives depth and realism to the perspective. Richter dates the work 1450; Fiocco's dating 1454 is the more likely one. The picture is in poor condition as it has been painted over several times.

20 ⊞ ⊘ 79×67 📋 ⋮

Madonna with Child and six Angels Bearing Symbols of the Passion
Berlin, Staatliche Museen
Critics have repeatedly linked this work with the *Madonna with Child and Seraphim* in New York (no. 19) owing to the marked iconographic affinity between them. Kristeller and Cavalcaselle believed it to be Mantegna's own work. Sandberg-Vavalà adduced reasonable grounds for attributing it to Lazzaro Bastiani, a theory which was supported by Collobi (CA, 1949), Longhi (1962) and others. After this, Berenson listed it as a copy of an early work by Mantegna. Coletti considers that it closely resembles the group of works which may be attributed to Bastiani, though also to Quirizio da Murano, Bartolomeo Vivarini or their disciples. Fiocco claims that the original composition was designed by Iacopo Bellini. In spite of all this, the work was exhibited at Schaffhausen in 1951 as an early work by Mantegna.
There is a panel (71× 52 cm.) from the S. H. Kress Foundation now at the Philbrook Art Center in Tulsa (Oklahoma) featuring the same Madonna and Child group. The Kress catalogue has attributed this work to Mantegna, though it is more likely to be an early effort by Correggio who is known to have worked with Mantegna or in his immediate circle.

21 ⊞ ⊘ —— 📋 ⋮

Heads of Roman Emperors, Putti and Floral Motifs
Venice, Church of Santa Maria Gloriosa dei Frari
This monochrome frieze is located above a carved angel on the tomb of Federico Cornaro (who died in 1380). Fiocco first propounded and then defended the view that the work was executed by

18

19

20

21

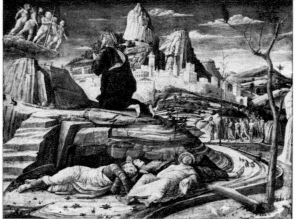

22 (plates XIV–XVII)

the youthful Mantegna during his possible though undocumented stay in Venice in 1454, principally on the ground that Sansovino (*Venetia . . . descritta*, 1604) attributes the statue to "Jacomo Padovano" but also because the work bears some affinity with the decoration in the Ovetari chapel (no. 14). This attribution was rightly rejected by Longhi (Pan, 1934) and by other later critics (Tietze-Conrat, Cipriani, etc.).

22 ⊞ ⊗ 63×80 *1455* ▤ ⋮

Agony in the Garden
London, National Gallery
One of the rocks bears the signature: "OPVS ANDREAE MANTEGNA". Peter, James and John are fast asleep in the foreground. The kneeling figure of Christ dominates the picture. A group of angels, top left, is seen showing Him the symbols of the Passion instead of the traditional chalice. The group of soldiers led by Judas

is seen approaching from the right along a sharply winding road. Bare mountains frown down on the city, the walls of which are seen to have been rebuilt in places as if to repair the ravages of war; the buildings featured are reminiscent of the Colosseum in Rome, the campanile of S. Marco in Venice, etc. At one time, the painting was owned by the Aldobrandinis in Rome; it was then acquired by Cardinal Fesch (1845) and then by the Northbrook Collection (1894) from which it finally reached its present abode. Cavalcaselle and others identified it as a work executed in 1459 for Antonio Marcello; Kristeller, Venturi and some modern critics have endorsed this view. Knapp thought it should be dated after 1464. Davies pointed out that from 1470–75 onwards Mantegna used to latinise his name to "Mantinia" and so put the date round about this period. Fiocco used the fact that the picture had belonged to the Aldobrandinis to argue that it was executed during Mantegna's stay in Rome but in our view this dates it much too late. Tietze-Conrat and Camesasca have opted for 1450. This work and the one featuring the same theme by Giovanni Bellini (also in London) have been studied in conjunction with

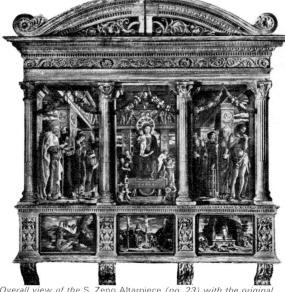

Overall view of the S. Zeno Altarpiece *(no. 23) with the original frame in which, however, the original paintings forming the predella (panels 23 D, E and F) have been replaced by nineteenth-century copies.*

the analogous composition in Iacopo Bellini's sketchbooks (Goloubew, *Les Dessins de Jacopo Bellini*, 1908–12). Comparing this picture with the same subject as depicted in the S. Zeno Altarpiece (no. 23 D), one notices in the latter an elaboration of the subject matter which seems to indicate that it is of later date; though that is not to say that

it is the better picture of the two, since the rather harsh restraint which might even seem like hardness in the London picture, imparts a highly dramatic sense of urgency which is lacking in the predella one. All critics accept the attribution to Mantegna. The picture has recently been cleaned and found to be in good condition.

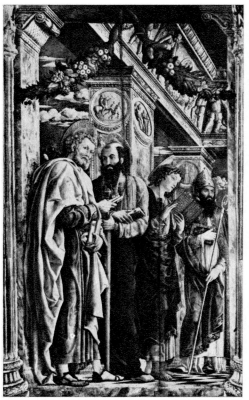

23 A (plates XX–XXI and XXII)

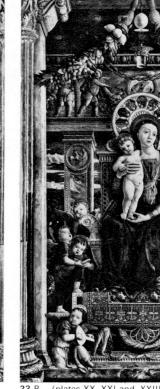

23 B (plates XX–XXI and XXIII–XXV)

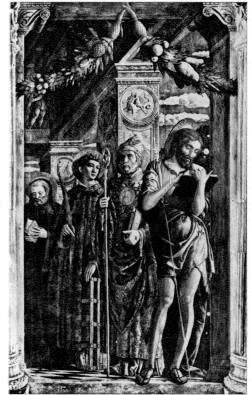

23 C (plates XX–XXI and XXVI)

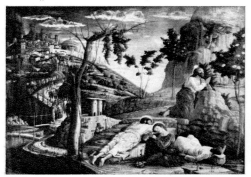

23 D

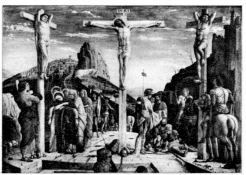

23 E (plates XVIII–XIX)

23 F

The S. Zeno Altarpiece

This work was commissioned by the Prothonotary Gregorio Correr, Abbot of S. Zeno in Verona, for the high altar in the basilica. Mantegna may well have been approached in 1456, because the work is mentioned in a letter to him from Ludovico Gonzaga dated 5 January 1457 (cf. *Outline biography* for this and all subsequent chronological data). It might still have been unfinished in June 1459, though it must have been completed early in 1460. Mantegna also designed the frame (480×450 cm.) in which the six panels of the polyptych (see below) are still set. In this connection, Tietze-Conrat comments on the "truth" of the space achieved by the combination of the architectural features painted in the actual panels (particularly the pillars) and those incorporated in the wood of the frame; if anything, it might be said that the pillars in the frame are rather overdone and create a sense of confusion. Recent investigations have shown that Mantegna had devised an independent setting for the monks' choir in the sanctuary of the church and that the altarpiece, located on the altar, was intended to provide the finishing architectural touch. It further appears that he had a window made in the right-hand wall so that the real source of light was identical with that suggested in the painting (Mellini and Quintavalle, CA, 1962). It was Kristeller who first drew a parallel with the polyptychs of Vivarini as regards the overall "triptych" layout of the three main panels (cf. in particular that dated 1446 and signed by Giovanni d'Alemagna and Antonio Vivarini portraying the Madonna enthroned with four angels supporting a *baldacchino* and four saints, in the Accademia in Venice). However, critics from Knapp and Venturi onwards have been more inclined to stress the affinity of this work with the three-dimensional structure conceived by Donatello for the high altar of the Basilica del Santo in Padua. The connection has been further confirmed by the reconstruction of this altar as proposed by Fiocco and Sirtori (S, 1961). The polyptych remained intact until 1797 when it was taken to France with Napoleon's other spoils. Only the main "triptych" was returned in 1815. The predella was kept in France and was divided up between Paris and Tours. Copies of the originals were then inserted into the original frame. The critics agree in attributing the whole of at least the upper panels to Mantegna (though some minor details may have been executed in the *bottega*). No great effort has been made to establish the order of execution, apart from the obvious conclusion that the predella was done towards the end. Gregorietti cleaned the parts of the original still in the frame in 1947.

23 ⊞ ◔ 220×115 *1457-59

A. St Peter, St Paul, St John the Evangelist and St Zeno
Verona, S. Zeno
These figures were identified by Hourticq (GBA, 1922); although St Zeno is without his most distinctive emblem, a fish, the identification may safely be accepted in view of his bishop's robes and the location of the painting. The *Sacra Conversazione* featured in the main triptych is set in a marble portico with reliefs in the classical style. Across the top, half-hidden by festoons of foliage and fruit, runs a frieze of *putti* (alternating with palm trees and medallions) supporting an enormous cornucopia; the ceiling is trabeated. Other medallions featuring mythological scenes have been used to decorate the tops of the pillars. Those visible in this panel have not been identified. Between the pillars and beyond a rose trellis, there are glimpses of a "high mountain" sky with clouds scudding across it. There are signs of vertical cracks, particularly in the centre towards the top of the picture.

23 ⊞ ◔ 220×115 *1457-59

B. Madonna with Child Enthroned and nine Angels
Verona, S. Zeno
A lamp hangs down from the point at which the two festoons meet at the very top of the picture. The throne rests on a platform covered with an oriental rug and supported by a rose ornament and two marble putti whose lower limbs only are visible. The two medallions on the pillars (for general setting, cf. no. 23 A) perhaps feature the feats of Hercules: at any rate, a centaur and an armed man may be seen in the one on the left, a horse and trainer in the other. The painted surface is covered with a spider's web of cracks, particularly in the darker areas.

23 ⊞ ◔ 220×115 *1457-59

C. St Benedict, St Laurence St Gregory and St John the Baptist
Verona, S. Zeno
St Benedict may be satisfactorily identified by comparing this figure with that in the *St Luke Polyptych* (no. 17 K). The identity of the other saints can be deduced fairly accurately from their traditional emblems. Two figures which cannot be identified with certainty are discernible in the medallion on the pillar at the back (for general setting, etc., cf. no. 23 A); a further two appear in the medallion above the head of St Laurence, while the third medallion features a merman and a nymph: this is a theme which Mantegna re-elaborated later (no. 55).

23 ⊞ ◔ 70×92 1459-60

D. The Agony in the Garden
Tours, Musée des Beaux-Arts
On the left of the picture, the band of soldiers led by Judas is seen approaching from Jerusalem. There is a very marked similarity of composition between this work and the picture on the same theme in the National Gallery, London (no. 22). Although most critics consider the work to be Mantegna's own, Tietze-

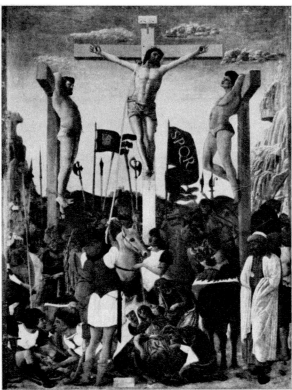

24

Conrat maintains that the actual execution shows signs of a good deal of collaboration, and we would endorse this view.

23 ⊞ ◔ 67×93 1459-60

E. The Crucifixion
Paris, Louvre
The group of mourners is on the left, that of the soldiers casting lots for Christ's clothes on the right. Castelfranco pointed out that the horse between the two crosses is based on the monument to Niccolò III in Ferrara, the design for which was submitted by the sculptor Baroncelli in 1443. Camesasca sees the influence of North European artists in the two figures just coming into view in the centre and so effectively emphasising the foreshortening of the bare height on which the crosses stand. Of the many artists who have copied this picture, mention should at least be made of Degas.

23 ⊞ ◔ 70×92 1459-60

F. The Resurrection
Tours, Musée des Beaux-Arts
In Tietze-Conrat's view, the rules of perspective have here been broken because the vanishing point for the tomb differs from that for the ground. Tietze-Conrat, followed by Meiss (1957), believes the panel to have been executed entirely in the *bottega*, though the figure of the Risen Christ may have been derived from an idea of Mantegna's. We certainly endorse this view as far as the actual painting is concerned. Fiocco has here detected Flemish details and affinities with the work of Andrea del Castagno, though there is perhaps greater affinity with that of Piero della

Francesca, particularly in the case of the figure on the extreme right.

24 ⊞ ◔ 83,5×58,2 *1459*

The Crucifixion
New York, Historical Society
This work had always been traditionally ascribed to Mantegna until Berenson (GBA, 1896) suggested, though with some misgiving, that it was the work of Iacopo da Montagnana. Later, Suida again attributed it to Mantegna (AA, 1946) and dated it after the *S. Zeno Altarpiece* (no. 23). Tietze-Conrat rejects this view and points out that there are no examples of Mantegna's work featuring a disordered crowd in a setting in which there is so little co-ordination, and with a rather romantic portrayal of armour and a series of disjointed flags and standards such as we have here. However, she concludes that the work resembles some of Mantegna's own early efforts, though it was not executed until the end of the fifteenth century. Cipriani contends that there is really very little affinity with similar themes handled by Mantegna.

25 ⊞ ◔ 1457*

Lament over the Body of Gattamelata
According to Scardeone (1560), this theme was depicted by Mantegna over the fireplace of a residence "in the district of S. Lucia" in Padua, where he owned a house until 1472. Giovio (1524) provides the same information. Both statements would seem to be borne out by a drawing which now forms part of the Wallace Collection in London. A copy of this, engraved by Prestel in 1777, bears the inscription: "Gattamelata de Narni . . . mort en 1440 (but it was 1443) et pleuré par le peuple, gravé d'après le dessin de même grandeur de Andrea Mantegna . . ." What is more, the composition was engraved by a "Maestro A. C." in a print produced in 1555, though on this occasion it was set between pillars similar to those which were later used to separate the various panels of the *Triumph of Caesar* (no. 63) Tietze-Conrat (BM, 1935) recognised that it was difficult to trace the original of the drawings mentioned here back to Mantegna, as they would seem rather to have been derived from Pollaiuolo. This view was shared in part by Berenson, van Marle (*The Development . . . XI*) and others, though Fiocco believes the drawing in the Wallace Collection to be the work of Mantegna himself.

26 ⊞ ◔ 44×33 *1459*

Portrait of Cardinal Ludovico Mezzarota
Berlin, Staatliche Museen
This work was at one time in Padua in the possession of Francesco Leone, who inherited the property of the Ovetaris. In view of the very close affinity of expression between this painting and the *Gattamelata* by Donatello, Tietze-Conrat (and Paccagnini) dates it to Mantegna's Paduan period. However, there is no reason to suppose that Mantegna abandoned entirely the style of this period once he had moved to Mantua, a line of reasoning which provides good grounds for the view held by many scholars that the painting was executed at some time during the Church Council which Pius II convened in Mantua (May 1458 – February 1460) and at which Cardinal Mezzarota was present. The identity of the subject has been established from a medal portraying the Cardinal in question and an

Drawing in the Wallace Collection, London, connected with the painting discussed in section 25 of the Catalogue.

engraving taken from the painting itself, though with some alteration to the dress (Tietze-Conrat), which was published in Romasino's *Illustrum virorum elogia* (1630). The picture is reasonably well preserved though there are some vertical cracks and the background (which may originally have been dark green) has been altered.

27 ⊞ ⊕ 71,5×62 *1460? ▤ ⁞

Portrait of Duke Francesco Sforza
Washington, National Gallery of Art (Widener Collection)
This picture bears the inscription: "AN. MANTINIA PINX. ANNO MCCCCLV"; Berenson adduced sound reasons for believing this to be false. Morelli had ascribed the work to F. Bonsignori, a view which was supported by Berenson himself. Shapley (AQ, 1945) — who was responsible for identifying the subject on the basis of a number of chiaroscuro sketches which had at one time belonged to the descendants of this same Bonsignori — suggested that the work was a copy by Bonsignori from an original probably executed by Mantegna shortly before 1460 (in view of the analogies with the Mezzarota portrait — no. 26). This opinion is shared by most recent scholars.

26

27

28 ⊞ ⊕ 385×220 1460? ▤ ⁞

St Bernardine
Milan, Pinacoteca di Brera
The words "HVIVS LINGVA SALVS HOMINVM" are inscribed on the architrave; the scroll at the bottom of the picture records a date which is generally given as "1460" but which Fiocco maintains should be read as "1468" and Tietze-Conrat as "1469". The saint, who is flanked by angels, is holding a monogram of Christ and is portrayed standing on a platform covered with an oriental carpet.

The background, which simulates marble intarsia work, is reminiscent of Donatello's background for the high altar of the Basilica del Santo in Padua and of the one featured in the *Court Scene* (no. 50). Most critics regard it as a *bottega* work or even of the Mantegna school. Fiocco believes it to be by Mantegna himself, strongly influenced by Donatello, while Longhi and Camesasca attribute to him the design and part, at least, of the execution.

29 ⊞ ⊕ 33×25 1460* ▤ ⁞

Man in Profile
Milan, Museo Poldi Pezzoli
It is not known how this work was acquired. Morassi (1936) and others have attributed it to artists of the Ferrara school. Most other critics are inclined to accept Berenson's view (1894) that it is by Francesco Bonsignori; the exception is Coletti (1953) who ascribes it to Gentile Bellini. It affords unmistakable evidence of Mantegna's own touch (Suida, AA, 1946; Longhi, 1962; Camesasca, 1964), particularly in view of its affinity of style with the *St Bernardine* in the Brera (no. 28).

30 ⊞ ⊕ 65,5×57 ▤ ⁞

Female Saint (or Madonna) with Hands Joined
San Diego (California), Fine arts Museum
The work bears the signature "Andreas Pat." which may well be false. Tietze-Conrat suggests that it may be due to an error in copying the original signature. The background features a landscape similar to that in the *St George* in Venice (no. 41). It was first made public as a work by Mantegna dating from about 1460 by Suida (AA, 1946) and this opinion was endorsed by Fiocco (BM, 1949) and also by Gronau and Morassi. Tietze-Conrat believes it to be much later, possibly the work of Antonio da Pavia, who normally signed himself "Ant(us) Papien(sis)". Cipriani, too, rejects the attribution of Mantegna.

31 ⊞ ⊕ 25,5×18 1461? ▤ ⁞

Portrait of a Prelate of the Gonzaga Family
Naples, Gallerie Nazionali di Capodimonte
Frizzoni (N, 1895) identified the subject as Francesco Gonzaga, second son of the Marquess Ludovico III, who received the cardinal's hat in 1461, at the age of sixteen. Most later critics have accepted this view, except Fiocco who believes the portrait to be that

29

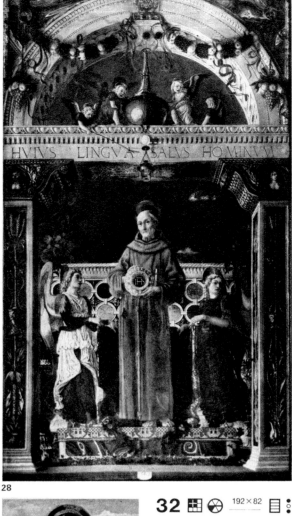

28

30

of Ludovico Gonzaga, younger brother of Cardinal Francesco, who was made a bishop in 1468 at the age of nine. This latter theory has been questioned by Cipriani who reverts to Frizzoni's view and on this basis dates the work in 1462 or shortly thereafter. The traditional attribution to Mantegna has been rejected by Tietze-Conrat, Meiss, Arslan and Gilbert, all of whom maintain that it is a copy of a larger original now lost. The other critics accept the work as a Mantegna original. The picture is impaired by dirt and clumsy attempts at retouching.

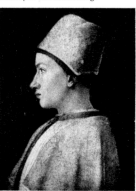

31 (plate XXXIX)

32 ⊞ ⊕ 192×82 ▤ ⁞

Madonna Enthroned with Child
Milan, Gallarati Scotti Collection
This work is signed: "Andrea Mantinea p.p. 1461", but this is certainly false. Cavalcaselle attributed it to Liberale da Verona and Kristeller named Bernardino Butinone, a view accepted by later critics, who mostly tend to date it 1470 or thereabouts

33 ⊞ ⊕ *1464 ▤ ○○○

Altarpiece
This work was intended for the chapel of the Palazzo Ducale in Mantua. A letter from Mantegna himself seems to suggest that it was wholly or partially completed in 1464. Most scholars believe the Uffizi "triptych" to be the work in question (no. 34; q.v. for further details), but Tietze-Conrat questions this view.

The Uffizi "Triptych"

This "Triptych", mounted in a nineteenth-century frame, is now at the Uffizi Gallery in Florence. In 1632 it was broken up into three parts, of which the central panel (no. 34 B) was attributed to Botticelli and the other two to Mantegna. All three panels were not attributed to Mantegna until the inventory of 1784. Kristeller and Yriarte had identified this work as being the "little panel (*tavoletta*) with various scenes in which the figures, though not very big, are extremely beautiful" which Vasari (1565) stated he had seen in the chapel of the

Palazzo Ducale in Mantua. It has therefore been dated in 1464, the year in which (cf. *Outline biography*) Mantegna mentioned in a letter the painting of a "panel" for this chapel. Because Scannelli (*Microcosmo della pittura*, 1657) reported the existence of works by Mantegna in this chapel, Fiocco argued that there were no grounds for the identification with the "Triptych" in Florence. However, apart from the fact that there must have been a good many more than three works by Mantegna for the chapel in question, it should be borne in mind that Scannelli was reporting hearsay (Tietze-Conrat). Fiocco, however, suggested that the "Triptych" had been executed for one of the Medici while Mantegna was in Tuscany (1466–67). Longhi rightly contested this view (*Pan*, 1934) pointing out that the grouping of the panels in the Uffizi lacks coherence, so much so as to make it doubtful whether the panels were originally designed to be grouped in this way and to suggest that they had been intended by the artist for some other purpose, namely the palace chapel. In propounding this theory, Longhi also suggested an ideal reconstruction for the *Death of the Madonna* (no. 34 D and E) which would give a picture the same size as the panels of the Uffizi "Triptych". In particular, he pointed out that

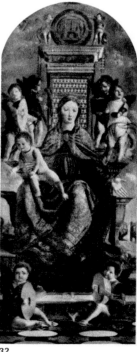

32

there was a much closer stylistic link between the *Death of the Madonna* and the Uffizi *Ascension* (no. 34 A), than between the *Ascension* and the other two sections of the "Triptych" as it stands. Moreover, in confirmation of these differences in style, Longhi has shown that the execution of these pictures was protracted over a long period. He suggests that "external" factors may also have been responsible for this; for instance, the *Death of the Madonna* could have been designed as a companion panel for the *Ascension* and

then rejected when it was perhaps decided to depict only scenes from the life of Christ, at which point it could have been replaced by the *Circumcision* (no. 34 C). Fiocco and, to some extent, Tietze-Conrat (see below) have rejected this theory which has nevertheless been accepted by the remaining critics. Although there is still strictly speaking no conclusive proof of the connection between the Uffizi "Triptych" and the cycle of paintings executed for the palace chapel in Mantua, we will give the remaining details about the latter here. Tietze-Conrat, who holds that the two works are not identical, points out that Vasari also describes as a "*piccola tavoletta*" Titian's altarpiece in the sacristy of the church of the Salute in Venice, which is nearly three metres high. She therefore argues that the altarpiece for the Gonzaga chapel must have been quite a respectable size. She further bases her reasoning (GBA, 1943) on the three engravings of the Mantegna school depicting the *Deposition from the Cross* (463 × 361 mm.; Bartsch, no. 4), the *Laying in the Sepulchre* (id.; Id., no. 2) and the *Descent into Limbo* (446 × 348 mm.; Id., no. 5) which, in her view, are reproductions of the paintings in the chapel. She also states that, if the originals were in fact painted on wood, the *Descent into Limbo* cannot have been started before 1468 (cf. no. 34 F).

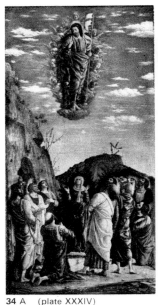

34 A (plate XXXIV)

34 B (plate XXXIII)

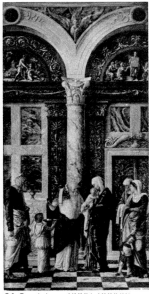

34 C (plates XXXV–XXXVII)

34 ⊞ ◕ 86 × 42.5 1460*

A. The Ascension
The landscape is reminiscent of that featured in the Louvre *Crucifixion* (no. 23 E). Most critics agree that the work is among the early ones executed by Mantegna in Mantua (the only exception is Fiocco, cf. above).
The Fogg Art Museum has a drawing on grey-green paper heightened in white (290 × 218 mm.) featuring the group of apostles on the right. Some scholars believe this to be a preliminary study or cartoon (Mongan – Sachs, *Drawings in the Fogg Museum* 1940; etc.) though there is a wider measure of agreement on the view that it is a copy and not an original drawing by Mantegna (Popham, OMD, 1932; Tietze-Conrat, etc.). The comments as regards technique concerning the Hamburg drawing (cf. no. 34 C) could apply equally.

34 ⊞ ◕ 76 × 76.5 1462*

B. Adoration of the Magi
This panel has a concave support. Kristeller was of the opinion that this was in order to fit it into a niche in the palace chapel in Mantua (see above). Tietze-Conrat maintains that the only reason for it was to furnish an opportunity for perspective acrobatics. Critics are agreed in relating the picture to Mantegna's early activities in Mantua (though actual dates mentioned vary from 1462 to 1464 or thereabouts). The only divergent opinion is that of Fiocco (see above). When the work was restored recently, it was found that a

fairly large section on the left-hand side was missing and painted over.

34 ⊞ ◕ 86 × 42.5 1464-70*

C. The Circumcision
Although the theme seems self-evident, Saxl (JWCI, 1938–39) questioned whether the scene portrayed was

the Presentation in the Temple. He based this view principally on the ground that the lunettes at the top of the picture feature the Sacrifice of Abraham and Moses presenting the Tables of the Law to the Israelites, both of which events are regarded as presaging the Presentation of the Child Jesus in the Temple. In addition to the Holy Family, there is the priest with his assistant and, on the right, a little boy with a doughnut who may be intended to be John the Baptist with his family. Tietze-Conrat has seen an affinity between the architectural setting in this panel and that designed by Laurana (who was working in Mantua in 1465) for the Cappella del Perdono in Urbino. In any

case, it certainly resembles the setting (now ruined featured in the Vienna *St Sebastian* (no. 43). Longhi established that this panel must have been finished by 1473, when the setting used here served as a basis for a page illuminated by the miniaturist Liberale da Verona. Since Longhi has further adduced reasonable grounds for supposing that the background as it now stands

in fact represents a revision of the original concept, the actual disposition of the figures may well go back to 1464 (Camesasca) or possibly even earlier. A good deal of the repainting and touching-up was removed in the course of the restoration of the Uffizi "Triptych" undertaken recently. The result has been not only to confirm the difference in style between this and the other two panels but further to emphasise the disparity between them. Fiocco, Tietze-Conrat and Ragghianti (1962) all believe the fine drawing of the Madonna and Child in the Hamburg Kunstalle (ink and white lead on grey-green paper; 281 × 99 mm.) to have been taken from this

Circumcision. Others, however (Pauli, *Museum Catalogue*, 1927; Popham, 1930; Baniel and Clark, 1931; Mezzetti, 1961) believe the drawing to be an original *modello* by Mantegna for the painting, a theory which is supported by postulating a similarity in colour between the drawing and the "verdaccio" compounds used in the fifteenth century.

34 ⊞ ◕ 27.5 × 17.5 1461*

D. Christ with the Soul of the Virgin
Ferrara, M. Baldi Collection
This work passed from the collection of G. Barbianti to that of E. Vendeghini (both in Ferrara) during the latter half of the nineteenth century. It was recently acquired by the Baldi Collection. The figure of Christ is damaged but has been carefully restored. For further details, cf. no. 34 E.

34 ⊞ ◕ 54 × 42 1461*

E. Death of the Virgin
Madrid, Prado
This work was severed at the top – probably in order to eliminate a portion of the painting in poor condition – and then cut down to match the Boston *Sacra Conversazione* in size (cf. no. 34 F for the latter's subsequent history) while it was in Ferrara (1586–88). The catalogue for the sale of the property of Charles I of England describes it as follows: "Death of the Virgin, water colours, Mantignia". As already pointed (cf. Uffizi "Triptych"), it was Longhi (*Pan*, 1934) who identified the *Christ with the Soul of the Virgin* (no. 34 D) as being part of the upper portion which had been cut away. His ideal reconstruction of the original has been accepted by most critics, except for one or two doubts expressed by Fiocco. The critics are also agreed in attributing the work to Mantegna himself, the only discordant voice being raised by Venturi (who had, in fact, originally accepted the attribution [*Storia* . . . 1914, VII, 3] but later revised his view and attributed it instead to Giovanni Bellini.

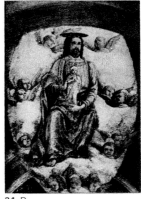

34 D

Sketch illustrating proposed reconstruction of paintings nos. 34 D and 34 E (shown shaded in grey).

The general belief is that the scene depicted is the Mincio with the Ponte S. Giorgio (which linked the two castles in Mantua) running across it (Kristeller). In practice, this would be a view from the Camera degli Sposi (Coletti, 1959); or else the Mincio and the Molini bridge on the other side of the city (Hendy, *Isabella Stewart Gardner Museum Catalogue.*

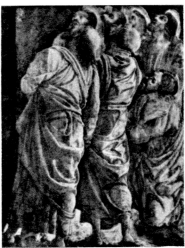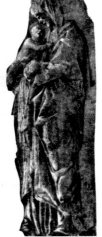

Brush drawing heightened with white lead on grey-green paper (290 × 218 mm., Fogg Art Museum, Cambridge [Mass.]), which a number of critics have connected with the lower portion of painting no. 34 A. Silverpoint drawing heightened with white lead on grey-green paper (281 × 99 mm., Kunsthalle, Hamburg) probably connected with the figure of the Virgin in no. 34 C.

1931); it may even be the Mincio crossed by the dyke between Porta Pusterla and Ceresca which the Marquess Ludovico III had rebuilt (Tietze-Conrat). We may add that Tietze-Conrat's theory that the theme is not a *Dormitio Virginis* is an unlikely one: the Madonna would appear to be well and truly dead and not simply asleep and the Apostles certainly seem to be reciting the Office of the Dead since they are carrying candles and a thurible. Moreover, Longhi's reconstruction of the original gives us all the typical features of a *Dormitio* (including, in particular, the portrayal of Christ with the soul of the Madonna). The

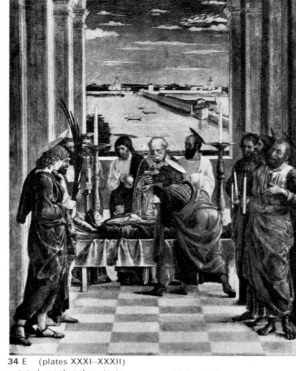

34 E (plates XXXI–XXXII)

34 ⊞ ⊗ 56×43 ▤ ⦙

F. Sacra Conversazione
Boston, Isabella Stewart Gardner Museum
The words "ANDREVS MANTINA" (sic) appear in the bottom right-hand corner and Fiocco is very probably right in saying that they were added at some later date. On the left of the Madonna, who is holding the Child facing the boy Baptist, are the figures of St Elizabeth and St Mary Magdalen. There is no clue to the identity of the other figures in the group. On the rocky ledge overhead, St Francis, attended by Fra Leone, is seen receiving the stigmata. St Jerome doing penance is depicted at the mouth of the cave below. The background also includes, on the right, the figure of St Christopher wading across the river with the Child Jesus; behind him, St George is attacking the dragon and further back there is a city with buildings in the classical style. The history of the finished painting has been reconstructed by Hendy (*Isabella Stewart Gardner Museum Catalogue*, 1931). When the picture was in London it was with the *Death of the Madonna* now at the Prado (no. 34 E), a consideration which led Hendy to connect the two works, claiming that both this and the other work had certainly been executed in Mantua and that they typified the artist's style in the year 1460 or thereabouts. This opinion has, however, been rightly rejected by Tietze-Conrat, who has

pointed out that there is, in fact, no documentary evidence for this work at Mantua. She believes that it may well have been this picture – together with the above-mentioned *Death of the Madonna* and the New York *Adoration* (no. 7) – that was cleaned in 1586–88 by B. Filippi (who was presumably responsible for cutting it down to its present size) when they were in the possession of Margherita Gonzaga, the wife of Alfonso II d'Este. This identification is confirmed by the similarity in the subsequent history of all three paintings. There has, in any case, always been considerable doubt as to whether the *Sacra Conversazione* was, in fact, executed by Mantegna. Kristeller and Frizzoni ruled out the possibility completely. Fiocco suspended judgment on account of the poor state of preservation of the panel. Berenson believed the work to be Mantegna's, though with some collaboration. Longhi (1934) at first attributed it to Mantegna but later (1962) appeared to restrict this attribution to the design only. Tietze-Conrat holds that it is the work of a Ferrarese artist round about 1480; Cipriani is uncertain. As to dating, Fiocco suggests the years 1483–95 and Longhi possibly even later. It is difficult to say quite

which technique was used: the work may be in tempera with a good deal of retouching in oil.

34 ⊞ ⊗ 71×55,5 ▤ ⦿ 1500*

G. The Descent into Limbo
Asolo, Formerly in the Valier Collection
It is fairly clear from the engravings discussed below that the picture depicts the entry of Christ into Limbo. This work was made public by Fiocco as incorporating a late original by Mantegna, this attribution being restricted to the lower portion of the picture only. A second version, but only of the portion of the picture including the figures, has been published by Tietze-Conrat (panel, 40× 43 cm.; Stephen Courtauld Collection, Taynauilt [Argyll]) and seems to be of better quality, insofar as this can be judged from the photographs; a third version, in poor condition, is in the Pinacoteca in Bologna. A letter written by Mantegna to Ludovico Gonzaga on 28 June 1468, makes it clear that the artist had begun work on "a scene of limbo". However, apart from the fact that this reading of the manuscript is doubtful (the words "del limbo" [of Limbo] have

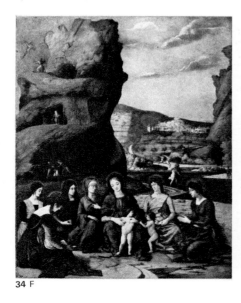

34 F

34 G

been interpreted as "del libro" [of the book], the artist would seem to be referring to a larger work. Moreover, further doubt on the possible identity of the two works is thrown by chronological considerations, for all three of the engravings mentioned seem to reflect the kind of design Mantegna tended to use towards the end of his life. Most recent critics seem to share this view (but see below) and all are equally agreed in rejecting the attribution to Mantegna. There are a number of reproductions which should be mentioned: in particular there is an engraving of the Mantegna school (already discussed in the introduction to the Uffizi "Triptych"; then there is a drawing of the figure of Christ (no. 622, Kupferstichkabinett, Berlin; 284×202 mm.) which was said to be a copy (cf. Mezzetti, 1961), though its connection with Mantegna himself is proved by an eighteenth-century engraved replica which bears the artist's initials and the date 1492; finally, there is yet another drawing (no. 189, Ecole Nationale Supérieure des Beaux-Arts, Paris; 172×280 mm.) which most scholars attribute to Giovanni Bellini and which is dated 1472 – a factor which reopens the whole question of the date of execution of the original work from which all these copies are derived.

35 ⊞ ⊗ 1463-64* ▤ ⦿

Decorative work
(Mantua), Formerly in the Castle at Cavriana
There is evidence that the work of decorating the castle at Cavriana – of which almost nothing now remains – was already in progress on 19 February 1463, and we know that Samuele da Tradate was engaged in executing what were probably frescoes in a number of the rooms (Sala d'Ercole, Sala del Sole, etc.) on the basis of designs by Mantegna. The work was still unfinished in March 1464. Some critics (Kristeller and others down to Camesasca) have attributed to the Cavriana or Goito cycles such scenes as *Bacchanalia with Silenus* and *Bacchanalia with Vat* which are known to us through prints (measuring 307×445 and 305×433 mm. respectively) for which Mantegna himself is said to have prepared the plates (Vasari; other critics down to Mezzetti, etc.); another view is that the plates were made under his supervision (Tietze-Conrat, etc.). The actual execution has been dated over a period ranging from 1465–70 (at least as regards the design [Tietze-Conrat] which all critics ascribe in any case to Mantegna) to 1490 or thereabouts (Hind) since there is a copy of the *Bacchanalia with Silenus* engraved by Dürer in 1494; a date in the region of 1470 would seem to be the more correct view (Mezzetti, etc.). In discussing the actual subject-matter, Tietze-Conrat has detected a vague affinity with the chapter in Boccaccio's *Filostrato* on the Andriani, but most scholars hold that the scenes are derived from classical sarcophagi.

36 ⊞ ⊗ 1464* ▤ ⦿

Decorative work
(Mantua), Formerly in the Castle at Goito
Only a few ruins of this building now remain. In April 1464, (see *Outline biography*) Mantegna had already been at work in the castle for several months. (For the theme of the decoration and other details, cf. no. 35).

37 ⊞ ⊗ 70,2×35 ▤ ⦿ 1465*

Christ the Child Blessing
Washington, National Gallery of Art (Kress Collection)
The Child's clothes closely resemble those of the child

(from top to bottom) Engraving (446×348 mm.) generally attributed to Mantegna's bottega in connection with no. 34 G. Brown ink drawing (372 × 280 mm.) normally attributed to Giovanni Bellini and connected with no. 34 G. Pen and watercolour drawing heightened with white lead on blue paper (284 × 202 mm.) generally believed to be by Mantegna and connected with no. 34 G.

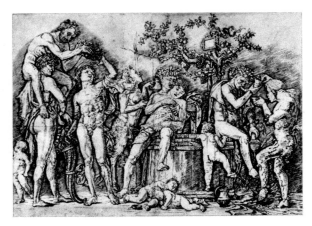

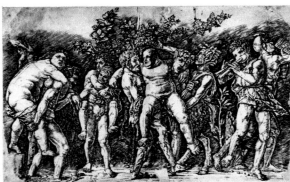

(top of page). Bacchanalia with vat (305 × 433 mm.) and (above) Bacchanalia with Silenus (307 × 445 mm.): engravings which are sometimes linked by critics with the decorative work, now lost, discussed in sections 35 and 36 of the Catalogue.

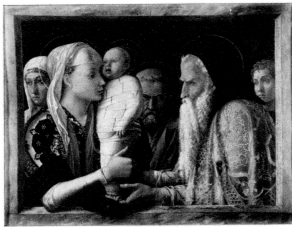

38 (plates VIII–IX)

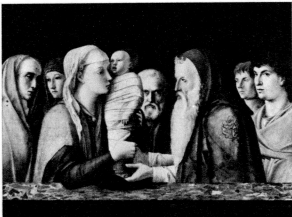

Presentation in the Temple *(panel, 80 × 105 cm.; Fondazione Querini Stampalia, Venice) by Giovanni Bellini (see no. 38).*

featured in the foreground of *St James Baptising Hermogenes* (no. 14 G). The picture's attribution to Mantegna, which is widely accepted by scholars and critics, was questioned by Kristeller and Borenius (1913). Longhi and Cipriani believe it to be an early work, while Camesasca dates it in the 1460s. Fiocco and Tietze-Conrat hold that it is a very mature work, while Camesasca dates it in the period 1475–80. Tietze-Conrat suggests that the reference to a "little child clothed, 20 inches high and 10 inches wide by Mantegna" in the Gonzaga inventory prepared by Novellara (Campori) may well be a description of this picture; she thinks it must have been a "copy of a New Year gift sent to relatives by the Duke of Mantua".

38 ⊞ ⊕ 67 × 86 1465–66* ▤ ⦙

Presentation in the Temple
Berlin, Staatliche Museen
In the foreground are the figures of the Madonna and Child with the priest. The figure on the extreme right is said to be a self-portrait of Mantegna, whose wife, Nicolosia Bellini, is portrayed in the female figure on the extreme left (Prinz, BEM, 1962). The picture was at one time owned by the Gradenigos of Padua. It found its way into the Solly Collection in Berlin and thence to the museum. The Querini Stampalia Foundation in Venice has a painting of the same subject which is now attributed to Bellini. All critics from Cavalcaselle onwards are in any case agreed that the Berlin canvas is Mantegna's work. Opinions differ widely as to which artist was responsible for the original design. The work now in Venice was at one time regarded as a tribute to Mantegna by Bellini; recent critics are rather more inclined to reverse the relationship but even so there seems to be no doubt that the Child, so clearly evocative of Donatello and planted so firmly on the windowsill to convey an impression of depth, is the product of Mantegna's mind. Mantegna's touch (indeed we might say Squarcione's touch) is further apparent in the figure of the priest and in the fact that the artist has confined the scene rigidly within a marble frame, reminiscent of Alberti, perhaps (Camesasca). However, the inclusion of two further figures in Bellini's work suggests that Giovanni Bellini made a decisive contribution to the whole. Most critics, arguing chiefly from their particular opinion as to whether Mantegna or Bellini originally conceived the design, maintain that the picture dates from Mantegna's early days in Mantua, namely round about 1454, which is the date most generally accepted for Bellini's picture (Kristeller; Posse; Fiocco; Tietze-Conrat; Cipriani; Prinz); Longhi, Camesasca and Paccagnini date it to 1465 or 1466. Yet another composition which is almost identical and which is believed to be by Mantegna and his son Francesco is in the collection of the Marquess of Northampton. The picture has been so heavily repainted that it is very difficult to give any positive opinion about it.

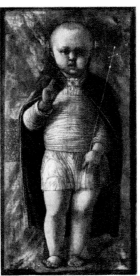

37

39 ⊞ ⊕ 40.5 × 29,5 1466 ▤ ⦙

Portrait of Cardinal Carlo de' Medici
Florence, Uffizi
The portrait was at one time believed to be of a member of the Gonzaga family and was still listed as such in the Gonzaga Exhibition held in Mantua in 1937, although the true identity of the subject had even then been established for some time by Schaeffer (MK, 1912). Kristeller regarded the portrait as a poor copy of a lost sixteenth-century original. The other critics agree in attributing it to Mantegna except for Tietze-Conrat whose doubts are occasioned principally by its poor state of preservation. It seems reasonable to accept the dating of the work in 1466 endorsed by most scholars, in consideration of Mantegna's trip to Florence in that year and the fact that he disliked doing portraits other than from life. The work has in common with the portrait of Mezzarota (no. 26) a diffused kind of light which is subtly fused with the drawing (Gilbert).

40 ⊞ ⊕ *1467 ▤ ⦙

Subject matter unknown
Pisa, formerly (?) at the Camposanto
There is evidence that during his stay in Tuscany Mantegna was in Pisa at the beginning of July 1467, where he had "to finish painting at the Campo Santo (Cemetery)". It is possible that traces of his work may be found on the wall in the left wing of the building.

41 ⊞ ⊕ 66 × 32 1467* ▤ ⦙

St George
Venice, Gallerie dell'Accademia
The saint is depicted with the dragon. Tietze-Conrat suggests that the picture may originally have formed the left-hand panel of an altarpiece, in view of the set of his head and the direction of his gaze. Most critics believe it to have been executed immediately after Mantegna's trip to Tuscany, though Cavalcaselle had connected it with the beginning of his stay in Mantua. Venturi believed it to have been painted concurrently with the S. Zeno Altarpiece (no. 23) while Tietze-Conrat

and Cipriani consider that it should be dated at the same time as the *Martyrdom of St James* in the Eremitani church (no. 14 J). The early scholars were very taken with it: Kristeller saw in it the incarnation of the Renaissance spirit. Even after Pellicioli had cleaned it, the work of restorers was still visible in several places while the original paint had peeled off in others. It may well be, therefore, that the clear light, soft brushwork and breadth of execution which have been extoled by some critics were in fact largely the various efforts at retouching.

42 ⊞ ⊕ 24 × 19 1470* ▤ ⦙

Portrait of a Man
Washington, National Gallery of Art (Kress Collection)
Adducing in support of his argument the fact that this picture had at one time been

39 (plate XXXVIII)

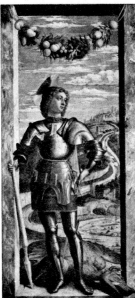

41 (plate X)

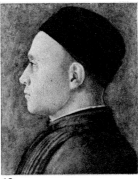

42

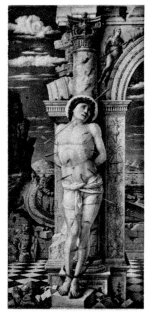

43 (plates XI–XIII)

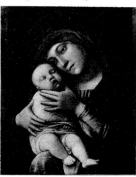

44

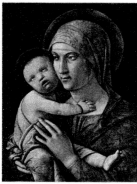

45

in Hungary (cf. below). Frankfurter (MA, 1939) suggested that the subject of the portrait was the Hungarian humanist, Bishop Csezmicei, better known as Iano Pannonio (cf. also no. 14 K), who is known to have been painted, together with Galeotto da Narni, by Mantegna in Padua in 1458. However, at that time the Bishop was only twenty-four, a fact which would seem to rule out the identification. In It became part of the Kress Collection in New York in 1950. The attribution to Mantegna, mooted by Suida in about 1926 (AA, 1946) has been endorsed by most modern critics; Meiss alone believes it to be a work of the Mantegna school. As regards dating, we may accept the view of Cipriani and Camesasca that it is connected with the period when Mantegna was working on the Camera degli Sposi

43 68×30 / 1470*

St Sebastian
Vienna, Kunsthistorisches Museum
The Greek inscription carved in the stone to the left of the Saint reads: "Work by Andrea". According to Kristeller, the cloud in the upper left-hand portion of the picture reproduces a portrait of King Theodoric on horseback taken from a bas-relief on the façade of the church of S. Zeno in Verona, while the city itself is depicted in the background. (In fact, we may identify the Arena, though it is difficult to see any resemblance between the lake and the river Adige). Bottari maintained that the chequered pavement was reminiscent of Piero della Francesca. The saint is resting against an architectural structure similar to that featured in the *Circumcision* at the Uffizi (no. 34 C).
In 1902, Berenson retracted the doubts he had expressed concerning its execution by Mantegna, and thereafter critics have unanimously attributed it to him, mostly dating it in the year 1450. Tietze-Conrat, followed by Pallucchini (1961), Cipriani and others, has identified it as the "little work" commissioned by Antonio Marcello, *Podestà* of Padua, from Mantegna who asked to be allowed to delay his move to Mantua (see *Outline biography*, 1459) in order to finish it. Tietze-Conrat points out that plague was rife in Padua in 1456–57 and that St Sebastian was one of the most popular saints whose intercession was sought in such circumstances. Longhi dates it about 1470, while Camesasca seems to advocate an even later dating.

44 43×35 / 1470*

Madonna with Child
Milan, Museo Poldi Pezzoli
The original coloring was much impaired by G. Molteni, the restorer, in 1860, making it impossible to give any definite opinion concerning this picture. Most critics, with the exception of Venturi, Tietze-Conrat, Cipriani and Camesasca, regard it as an early work. In fact, however, although the style is reminiscent of both Filippo Lippi and Donatello, it would seem to be one of the artist's more mature works. An identical composition is owned by T. Spano in Venice. Coletti and Fiocco maintain that this second picture is also by Mantegna, was executed before the Milan Madonna we are now discussing and is a finer work. No other critics appear to have expressed an opinion on this point.

45 43×31 / 1470*

Madonna with Child
Bergamo, Accademia Carrara
Nineteenth-century scholars ascribed it to Mantegna's Paduan period, though Cavalcaselle believed it to have been executed after the *Triumph of Caesar* (no. 63). Kristeller, Fiocco and Tietze-Conrat have all dated it among Mantegna's early works in Mantua; Longhi, Cipriani and Camesasca believe it to have been painted later. Camesasca comments that the technique – consisting of a very thin layer of tempera – is typical of Mantegna's mature works.

Camera degli Sposi

The room in question is, in effect, a cube (each side measuring 805 cm.) and occupies the first floor of the north tower of the Castel S. Giorgio, which is itself part of the Palazzo Ducale (or "Reggia") of the Gonzaga family in Mantua. It may well be the room described as *"camera magna turris versus lacum de medio"* in a document in the Gonzaga archives dated 1462 (in fact, on the north side the room looks out onto the Lago di Mezzo, one of the three lakes formed by the Mincio). A letter written thirty years later certainly refers to it as a *"camera depincta"*, a fact which justifies its identification with the *"camera magna picta"* referred to in a document dated 1475; yet another description of the room in question is *"camera picta"*. The references just quoted and others of the same period seem to suggest that the room was regarded as a very special reception room, and so to rule out the probability of its having been used as a bedroom. In any case, the phrase *"camera detta degli Sposi"* ("room known as the Bridal Chamber") which is used for the first time by Ridolfi (1648) does not necessarily imply that it was ever used for that purpose, since it may well be that the phrase "Bridal Chamber" was suggested by the dedicatory inscription (cf. no. 51 B).
The room was probably already being used to house works of art and precious objects in 1506, and this may still have been its function in the early eighteenth century. A century later it was known as the "room commonly referred to as Mantegna's" and at that time it housed part of the notarial records which continued to be kept in it until about 1880. Its artistic importance was not recognised until 1915.
The overall design is as follows: the central feature of the ceiling is the celebrated "oculus" (no. 46) set in a floral garland of flowing ribbons and clusters of fruit and foliage (which also abound all over the rest of the ceiling); the garland is itself set in a square stucco frame from which run eight caissons or compartments with a medallion supported by a *putto* in each (no. 47 A–H). The caissons form the framework for twelve triangular sections featuring mythological scenes (no. 48 A–L). These are separated from each other by segments of the stucco frame running down to the corbels (these and the stucco frame are among the few items in the room which do, in fact, feature real relief work) at the top of each of the two piers and two pilasters (all of which are simulated in the paintwork), which divide each wall into three equal parts, with a lunette surmounting each (no. 49 A–H). Finally, the piers appear to rest on a dado which is decorated in the same way as the background wall in the *Court Scene* (no. 50) and, incidentally, the base of Donatello's altar in the Basilica del Santo in Padua. The corbels "support" the (painted) runners for (painted)

gold-embossed leather curtains lined in blue. The curtains hang full length on the east and south walls, while elsewhere they are drawn back in various ways to "reveal" the paintings which are the room's chief claim to fame (nos. 50 and 51 A–C). The overall effect is to create the illusion of an open-air pavilion and the ceiling, which is in fact only slightly concave, is made to seem both high and vaulted. This illusion s not unduly marred by the existence of two real windows (in the north and east walls), by the two doorways (north and west walls) or by the fireplace and small recess (north and south walls). The framework round the fireplace and the recess, together with that round the two doors constitute the only other elements in the room which are, in fact, in relief; all the other architectural features which seem to be in relief are an illusion created by the artist. The general layout has been linked by the critics with the ideas of Brunelleschi (Fiocco, etc.). This would

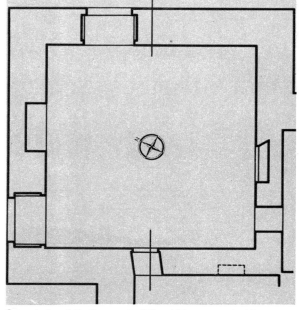

Ground plan of the Camera degli Sposi (the area marked by a dotted line in the west wall represents an opening which may have been the original doorway in place of the existing one in the same wall).

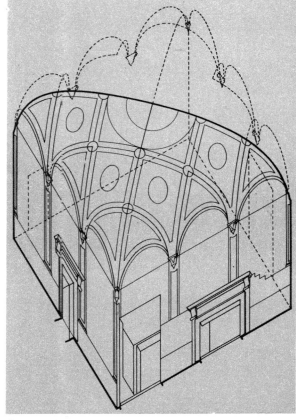

Axonometric projection of the Camera degli Sposi as simulated in the decoration (drawn by G. Alessi for the treatise published by Coletti and Camesasca in 1959).

seem to be the most convincing theory, although some connection with Francesco di Giorgio Martini, or with Laurana (Tietze-Conrat) and Alberti (Coletti, etc.) cannot be ruled out absolutely. Although the critics agree in attributing the work to Mantegna (and there is plenty of evidence for this) they are by no means equally agreed on the question of chronology. The principal point at issue is the date on which the work was begun. A number of scholars from Kristeller onwards have mentioned the year 1471, for it was on 25 October in that year that the Marquess Ludovico ordered "three weights of nut oil for the work on that room of ours". Some critics (Luzio, 1913; and down to Mezzetti, 1958) interpret this as an indication that the work was already under way; (Camesasca has pointed out (1964) that the use of nut oil was not incompatible with the technique of wall decoration if the evidence of the well-known treatise by Cennini is to be accepted). Other critics incline to the view that the work had been begun even earlier; they mention: 1467, immediately after Mantegna's return from Tuscany (Tamassia, 1955–56); 1465, which is the date carved in the embrasure to the left of the window in the north wall (Pérate, *Michel*, III, 1907; and Giannantoni, *Palazzo Ducale*, 1929). Since the cycle was completed in 1474 – or so it would seem from the date in the dedicatory inscription (no. 51 B) – the work must have been protracted over a period of from four to ten years, depending on which of the above theories concerning the starting date is accepted. Milanesi (in *Vasari*, III, 1874) maintained that the decade devoted by the artist to the work ended in 1484, the year in which he would appear to have been engaged in decorating a room in the Castel S. Giorgio (see *Outline biography*) (even Cavalcaselle had taken this as a reference to some room other than the Camera degli Sposi), and, moreover, the year which, according to Brandolese, is in fact the date recorded in the dedicatory inscription (*Testimonianze intorno alla patavinità di A. Mantegna*, 1805). Without commiting himself as to when the work was started, Moschini asserted that Mantegna was still at work on the cycle in 1488, when he went to Rome; however, he declared that Mantegna himself finished it when he returned to Mantua, adding that he found unacceptable the view expressed by "some" (we do not know to whom he was referring) that the vault (which would, in any case, be the first part of any room to be decorated) was finished by his sons after his death. Recent critics mostly share the view expressed by Tietze-Conrat, namely that the work was done in the years 1473 and 1474. Latterly, Camesasca has outlined a theory which could really only be confirmed by the kind of examination of the originals which cannot now be made owing to the condition of the cycle. He has suggested that the cycle was executed in two stages: to begin with, possibly in 1465 (but see above) Mantegna did the *Court Scene* (no. 50) as

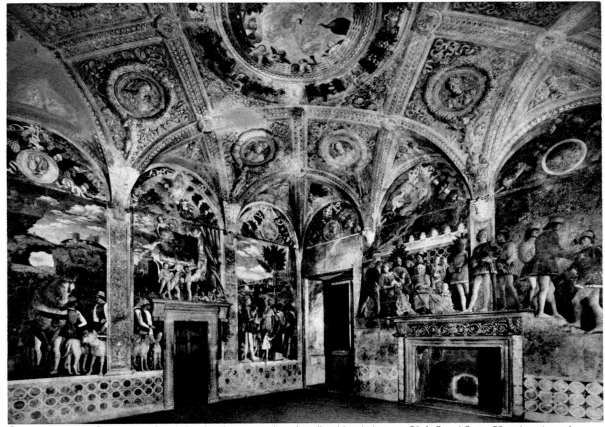

General view of the Camera degli Sposi showing the west and north walls with paintings no. 51 A, B and C, no. 50 and portions of the ceiling.

an entirely independent work, and at the same time the rest of the room was painted to simulate green marble, traces of which are still to be found in the window embrasures. Later, some time before 1474, he executed the rest of the decoration (comprising the ceiling, the panels on the west wall and the other simulated decorative features which are still visible today) within the space of a few months. At this point, he also altered the *Court Scene* considerably to bring it into line with the rest of the room. This theory is borne out by considerations of both design and technique. As regards design, it is important to note that in the *Meeting* (51 C), a series of harmonic proportions have been established between the pictorial and architectural features; this fact indicates that the artist deliberately set out to co-ordinate the picture with the decoration of the remainder of the room in a way that is by no means apparent in the *Court Scene*. Indeed, in the latter, the steps to the right are at variance with the overall perspective framework, and the figures in front of the piers have nothing to stand on (which seems to indicate that the piers were not there to begin with, particularly since, to the left of the second pier – over the fireplace – may be seen the edge of a sleeve which does not belong to any of the gentlemen in view and was presumably

part of another figure which was eliminated when the pier was added). Moreover, although the general style of the *Court Scene* seems to be akin to Mantegna's other work of the Padua period (e.g. the Donatello touch in the background wall and in the arrangement of the lighting), the whole feel of the *Meeting* suggests the influence of Benozzo Gozzoli. There is an undeniable affinity with the latter's *Construction of the Tower of Babel* fresco in the Camposanto in Pisa and Camesasca maintains that Gozzoli constituted the principal attraction that induced Mantegna to go to Tuscany. The examinations of the actual paintwork carried out by Mauro Pellicioli have revealed that the technique used for the *Court Scene*, the lunettes and the garland surrounding the oculus is *tempera a secco* (dry tempera) and not fresco, which was used for the rest of the room. It is conceivable that the artist used the dry tempera method a great deal for the *Court Scene*, but only over an initial layer of fresco; this would confirm the view that the picture was altered to bring it into line with the rest of the decoration (and not very successfully in view of such features as the steps out of perspective and the sleeve showing, which have already been mentioned). The paintings and decoration generally have been considerably impaired both by

wilful damage and attempts a restoration, so that it is now impossible to pronounce absolutely concerning the various theories and views expressed. The first essay at "improvement" dates back to 1506 when, on 22 September, a few days after Mantegna's death, Isabella d'Este ordered his sons to "repair" one or two places – not otherwise specified – in the room. During the sack of Mantua in 1630, the palace was invaded by the imperial troops, and it was probably then that the shots were fired of which we find traces in the figure of the dwarf in the *Court Scene*. It was certainly on this occasion that the paintings were defaced by captions extolling Luther and so on. In 1790, when the paintings had already been in a "deplorable" condition for some considerable time (Cadioli, *Descrizione . . . di Mantova*, 1763), the Austrian government commissioned M. Knoller to restore them. By great good fortune, he appears to have restricted his activities to the worst of the damage perpetrated during the sack of 1630 (Intra, *Mantova*, 1883) and by the subsequent occupants of the palace. The "mess" made by Knoller, at any rate on the wall featuring the *Meeting*, was removed by Cavenaghi in 1876. In the following year, G. Bianchi, the celebrated "retoucher" of the Giotto frescoes in Santa Croce in Florence, took a hand in repairing the *Court Scene* but he, too, would seem merely to have done a little re-touching "here and there" (Id.). Further minor attempts at restoration were undertaken in 1894. Finally, Pellicioli worked on the room from 1938 to 1941 and it is to him that we owe the consolidation of the painted surfaces and the elimination (not, unfortunately, complete) of the previous attempts at retouching; Pellicioli also filled in a number of blank areas in the paintings. It was

originally the custom to drape leather curtains round the two undecorated walls. The design of these curtains may well have been somewhat in the style of those painted by the artist into the decoration of the wall. The pictorial sections of the decoration are discussed individually below: as far as possible, they have been taken in order starting with the north wall (or the corresponding portion of the ceiling) and moving round the room clockwise. As regards dimensions, the overall width measured inside the frame or framework, if any, is quoted.

The Ceiling

The general structure of the ceiling has already been discussed. The alternation of periods of humidity and periods of great dryness has caused considerable discolouring, and falls of paint both in the areas done a fresco and a secco. There have been partial falls of stucco. The remaining stucco was fixed in position during the recent restoration work.

The Oculus

46 ▦ ⊕ diam. 270* 1473* ▤ ⋮

The Oculus
Eight winged *putti* with a peacock in their midst are seen to be either resting against or peeping through a balustrade, which repeats the Donatello-inspired pattern of the background wall in the *Court Scene* (no. 50). In addition, two groups of women are leaning over the balustrade on either side of a tub of citrus fruit. Venturi thought the woman next to the negress was none other than Barbara of Brandenburg (cf. no. 50), though it is more likely to be a portrait of a maid-servant. The artist's

Date inscribed in the window embrasure in the north wall.

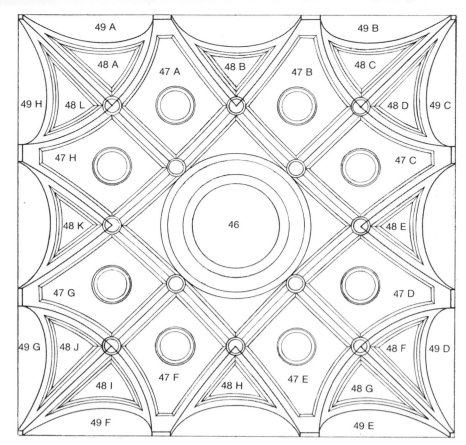

Plane diagram of ceiling of the Camera degli Sposi: the numbers denote the various portions of the decoration (including the lunettes) in the order in which they are discussed in the Catalogue.

is a good deal less bony than in the customary classical iconographic representation of him. Tamassia maintains that he resembles the effigy of Augustus in the next caisson. She further claims that the *putto* beneath is very much akin to one of the cupids with the attributes of Mars in the Capitoline Museum in Rome. There has been collaboration particularly in the execution of this *putto* whose head is much discoloured.

47 ⊞ ⊕ 250* / 1473* ▤ ⁝

B. Augustus
"OCTAVIAN(us)/AVGVSTVS". The emperor has been

Diagram showing relief-pattern of stucco rib in roof.

portrayed somewhat older than was traditional (Blum), though the likeness is fairly close. For details concerning the *putto* and the collaboration of other artists, cf. the commentary on no. 47 A.

47 ⊞ ⊕ 250* / 1473* ▤ ⁝

C. Tiberius
"TIBERIVS/CAESAR". According to Blum, the mouth is rather larger than in other likenesses of the emperor. Tamassia adds that the artist took as his model an antique piece in the Mantua Archaeological Museum. As regards collaboration, cf. no. 47 A.

47 ⊞ ⊕ 250* / 1473* ▤ ⁝

D. Caligula
"CAIVS. G.(ermanicus)/IMPER (ator)". According to Blum, this is a likeness of Augustus as a young man taken (Tamassia) from an antique group in the Mantua Archaeological Museum. Both the *putto* and the emperor seem to be executed by a collaborator (Camesasca).

47 ⊞ ⊕ 250* / 1473* ▤ ⁝

E. Claudius
All that is left of the inscription is ". . . VS/CA . . ." (Claudius Caesar?); however, the figure can be identified from his position in the series. There is a resemblance to Augustus (Tamassia). The comments in no. 47 A above apply equally to the *putto*.

47 ⊞ ⊕ 250* / 1473* ▤ ⁝

F. Nero
The inscription has disappeared, but the identity can be deduced from the position of the figure, and also from the actual physiognomy which closely resembles the traditional likeness of this emperor (Blum). Tamassia believes it to have been copied from a coin. The panel is discoloured from the mid-point on the left side down to the bottom.

finishing touches, done *a secco*, have presumably fallen off.

The Caissons

Some of the old guides (Antoldi, *Palazzo di Mantova*, 1813; Soresina, *Mantova*, 1851) unaccountably list twelve caissons and not eight. Each one features the head and shoulders of a Roman emperor — Caesar and his first seven successors (who may be identified from the inscriptions which have mostly been retouched, but are probably original) — painted so as to appear framed in a marble (or stucco) medallion against a (painted) mosaic background in gold tesserae surrounded by a garland in simulated relief; the garland is supported by a *putto* — also in mock relief — standing on a

vase or some other classical decorative motif which, in turn, rests on some architectural feature (a vase, floral trophy, etc.) handled in various ways, but identical in each pair of caissons and all made to resemble marble relief work. The state of preservation is poor on account of extensive repainting and gaps where the original paint is now missing. Although there must have been a good deal of collaboration by other artists in this area, the state of the various panels makes any accurate assessment difficult, and collaborators have been named only where fairly reliable evidence was available.

47 ⊞ ⊕ 250* / 1473* ▤ ⁝

A. Julius Caesar
The inscription reads: "IVLIVS/CAESAR". Blum has pointed out that the dictator

46 (plates XLVIII–XLIX)

47 A

47 B

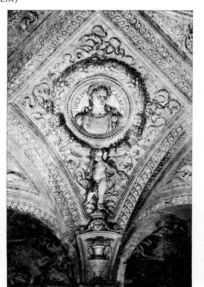
47 C

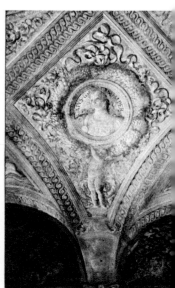
47 D

47 ⊞ ⊕ 250* 1473* ▤ ⋮

G. Galba
"GALBA/IMPER (ator)". The classical iconographic representation has been faithfully reproduced (Blum). Apart from one or two lacunae towards the bottom and slight retouching, the panel is reasonably well preserved: this may be one reason why critics are inclined to attribute its execution to Mantegna himself.

47 ⊞ ⊕ 250* 1473* ▤ ⋮

H. Otto
"OTHO/IMPER.(ator) C.(aesar)". According to Tamassia, the emperor's likeness was taken from a coin. For derivation of the *putto* cf. no. 47 A.

The Cells

Of the twelve triangular sections in the room, the eight in the corners are in pairs, thus forming four corbels. Each section features

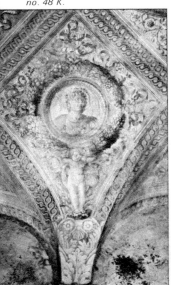

Hercules and Antaeus *(drawing done in brown, blue and white lead on brown paper; 264×164 mm.; Uffizi, Florence)* attributed to Mantegna (c. 1471) by Mezzetti who identified it and drew the parallel with no. 48 K.

48 A

48 B

48 C

48 D

48 E

48 F

48 G

48 H

48 I

48 K

48 L

a mythological scene executed against the same gold mosaic background used for the Roman emperors and, moreover, foreshortened from the bottom upwards to heighten the illusion of a vaulted ceiling. Blum maintains that the scenes depict Christian allegories. Coletti believes that the sections featuring Orpheus and Arion denote some connection with music, and perhaps even that the intention had been to use the room for concerts.

48 ⊞ ⊕ 180* 1473* ▤ ⋮

A. Spell Cast by Orpheus's Music
Orpheus is seen playing his lyre to an audience of two women (the one on the left holding a bow may be an allusion to the power of music to tame even the wildest spirits; the lion and the citrus fruit tree depicted on the right-hand side close to the two women would seem to

denote the power exercised by Orpheus over the animal and vegetable kingdoms, as well as over human beings. According to Mezzetti (1958), neither the execution (which is particularly weak) nor the design, which betrays "a ridiculous and childish rigidity", can be attributed to Mantegna, but may perhaps be the work of Mocetto. However, she stresses that this is only a tentative opinion in view of the state of preservation of the panel.

48 ⊞ ⊕ 180* 1473* ▤ ⋮

B. Orpheus Taming Cerberus and an Erinys
The theme is the descent of Orpheus to the underworld. Damage has impaired the fine, close-knit composition in which there seem to be fewer signs of the work of other artists than in the rest of the cycle.

48 ⊞ ⊕ 180* 1473* ▤ ⋮

C. Death of Orpheus
Orpheus lies prostrate and is done to death by the women of Thessaly. It should be noted that the god's lyre is missing, although it had always been a traditional feature of representations of this episode and is, in fact, visible in a design by Mantegna featuring the same theme and known to us through a drawing by Dürer (1494; Kunsthalle, Hamburg) and also through a later

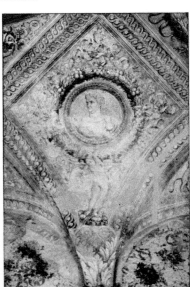

47 F

47 G

47 H

Italian print. There is a folio by an anonymous fifteenth-century artist (preserved in the Rosebery "Book" in the British Museum) featuring figures very like those in this panel which Tietze-Conrat (BA, 1958) has identified as the death of Pentheus precisely because there was no musical instrument; in spite of this, nobody has questioned the connection between this panel and the legend of Orpheus. Coletti has pointed out that the "fleshy and ferocious hags" are clad in light tunics which seem to waft in the breeze very much after the style of Filippo Lippi (and later of Botticelli), whose influence is further evident here in the tendency displayed by Mantegna — normally so "austerely constructional" — to yield to a temptation to amuse himself with decoration. Not only is the whole thing reminiscent of Lippi but, according to Coletti, it is even more so than was Mantegna's work in Padua several decades earlier at the beginning of his career.

48 ▦ ✦ 180° 1473° ▤ ⁝

D. Arion and the Pirates
The seventh-century BC Greek poet and musician who had been thrown into the sea by pirates (whose ship is seen disappearing in the distance) manages to attract a dolphin by his music and save himself by riding on its back (no. 48 E).

48 ▦ ✦ 180° 1473° ▤ ⁝

E. Arion on the Dolphin
The theme is outlined in the previous commentary; this panel too is defaced by cracks and other damage.

48 ▦ ✦ 180° 1473° ▤ ⁝

F. Periander and the Wicked Sailors
Periander, ruler of Corinth (625–585 B C), who was known as one of the seven wise men of Antiquity, declares the sailors guilty of trafficking in slaves. The composition seems to be derived from a classical sarcophagus in the Camposanto at Pisa (Tamassia). The panel is very much discoloured.

48 ▦ ✦ 180° 1473° ▤ ⁝

G. Hercules Shooting an Arrow
The theme really occupies two panels, since the next one portrays Hercules' target: the centaur Nessus with his captive Dejanira.

48 ▦ ✦ 180° 1473° ▤ ⁝

H. Dejanira and Nessus
For theme, see previous commentary. The composition is akin to that featured on an antique sarcophagus in the Maffei Museum in Verona (Tamassia). While making due allowances for the poor state of preservation of the panel (discolouring, stains, cracks and, possibly, considerable re-touching), of all the cells in

the cycle this one would seem to be the farthest removed from the work of Mantegna.

48 ▦ ✦ 180° 1473° ▤ ⁝

I. Hercules and the Nemean Lion
The theme features the first of the celebrated labours of Hercules. The arrangement somewhat resembles the classical handling of the same theme. A considerable portion of the plaster is missing; the remainder of the cell is much discolored; no opinion as to the possibility of Mantegna's workmanship can therefore be expressed.

48 ▦ ✦ 180° 1473° ▤ ⁝

J. Hercules and the Hydra (?)
The painting has disappeared almost entirely (so no attempt has been made to reproduce it in this *Catalogue*).

48 ▦ ✦ 180° 1473° ▤ ⁝

K. Hercules Strangling Antaeus
According to Mezzetti (1958), the general setting is derived from a Hellenistic group featuring the same theme. She has further identified a drawing of the same theme at the Uffizi in Florence which may be ascribed to Mantegna, thus constituting the only known drawing by him in connection with the Camera degli Sposi. The drawing includes variations which would seem to indicate that it had not been designed for execution within a triangular frame; it may even date back to the time when the artist was working on the *Martyrdom of St Christopher* in the Eremitani Church (no. 14 K) or on the S. Zeno Altarpiece (no. 23). With specific reference to this cell, Mezzetti rules out the possibility of its execution by Mantegna himself, as also of his having had any direct hand in the design.

48 ▦ ✦ 180° 1473° ▤ ⁝

L. Hercules Capturing Cerberus
This is the last of the labours of Hercules. The painting has been impaired by discolouring, cracks, falls of plaster and attempts at restoration.

The Lunettes

The lunettes are really part of the wall. However, for the purposes of this description also in view of the fact that the decoration creates the illusion that they form part of the ceiling, and that the altered colour now marks them off from the rest of the wall, it is more convenient to consider them separately. We have seen that there are three per wall. In each, the sky serves as a background against which two festoons of leaves and fruit are depicted. In the eight lunettes in the corners of the

49 A

49 B

49 F

49 G

One of the central lunettes on each wall (in this case the west wall) in which the decoration consists entirely of festoons of greenery against a background of blue sky, with a decorative centrepiece hanging from the point at which the two festoons meet.

room, a shield portraying some heraldic emblem of the Gonzaga family seems to hang on elegantly looped ribbons from the point at which the two festoons meet. This *Catalogue* includes only a description of the lunettes featuring details from the Gonzaga arms, the chief features of which have in each case been used to give a title to the relevant lunette. In view of the very poor condition of all the lunettes it is impossible to say whether any represent Mantegna's own work (though it is fairly obvious that there was a great deal of collaboration). For this reason, the symbols denoting execution, medium and so on are given for the first lunette only, it being understood that they refer equally to the others. As has already been pointed out in the general introduction to the Camera degli Sposi, Pellicioli believes the lunettes to have been executed *a secco*.

49 ▦ ✦ 240° 1473-74 ▤ ⁝

A. Dove and Log
It has only been possible to recognise the emblem — a turtle dove perched on a dry log in swirling waters, accompanied by the motto *"Vrai amour ne se cange"* — because there is other evidence for identifying it; without this, it would be quite impossible to decipher the painting.

B. Sun
The blazing sun was one of the most common of the Gonzaga heraldic emblems. It was usually accompanied by the motto *"Per un desir"* to give the phrase *"Per un sol desir"*. The motto was adopted by Ludovico III and he gave Mantegna the right to use it.

C. Hind
Although the four-footed animal — passant on a red field in which may be detected a scroll with fragments of Gothic lettering ("B . . . /er/ craf") — is now headless, there is every justification for recognising it as the emblem of a hind gazing at the sun, accompanied by the motto *"Bider Craft"* in old German (Against Force) which would seem to be an appeal for peace made by the Gonzagas to their powerful neighbours (Magnaguti, V, 1957).

D. Tower
A grey tower with double-pointed (as opposed to square) crenellations, set on a white field (which, however, may originally have been red). The tower itself appears to be either pentagonal or hexagonal. Such a tower, flanked by two very leafy trees was a very common Gonzaga emblem.

E. Subject matter unknown
The picture has disappeared; only very tentatively may one hazard a guess at the emblem: this may be an illusion created not so much by the very few traces of the original paintwork that now remain as by the stains left by discolouring.

F. Wolf Hound

Owing to discolouring, all that is now visible is the outline of a dog couchant and re-guardant, on a ground which may originally have been grey, and against a field which may once have been red. This is the unleashed wolfhound which was usually accompanied by the motto "Si l'aire ne me faut", an emblem which was adopted by Gianfrancesco Gonzaga before 1432.

G. Wings and Ring

There are now only a few traces of the red which must have been used for the field and framework of this emblem, comprising the two wings of a falcon with talons, bells and a ring, which Ludovico III also had engraved on some coins.

H. Salamander

All that is now visible is a kind of dragon with a curled up tail on a yellow rock, set against a field which was probably

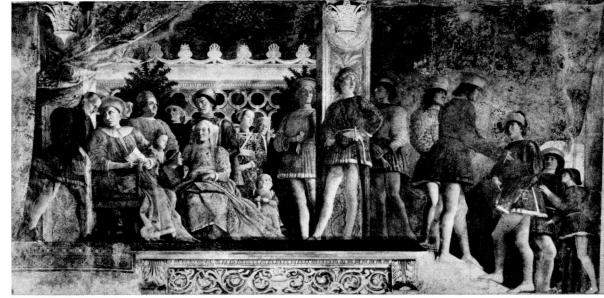

50 (plates XLIV—XLVII)

Cross-section and front elevation of the north wall (drawing by G. Alessi); the number refers to the Court Scene depicted on this wall.

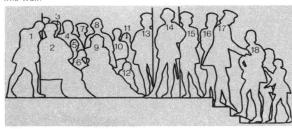

Sketch giving key to the identity of the figures in no. 50 as indicated in the relevant section of the Catalogue.

Photograph of the central portion of fresco no. 50 showing its general condition prior to the restoration done by G. Bianchi in 1877. The surface appears to be both worn away and damaged by the deliberate slashing perpetrated in the seventeenth century.

originally red. It is therefore more by a process of deduction than direct observation that the emblem is identified as that of the salamander, which was usually depicted with the motto "Quod huic deest me torquet".

The Walls

The North Wall

The left-hand panel is taken up entirely with the window. In the second panel and to some extent the third, the continuity of the dado (see preliminary description) is broken by the fireplace. There is a portion of the decoration beside the fireplace where the execution is so very robust in spite of the flowing brush-work that there are good grounds for believing it to be Mantegna's own work. The rest of the wall is taken up with the painting described below.

50 ⊞ ⊕ 600* ·1474? ▤ ⦂

Court Scene

The heavy curtain, which is mostly drawn back on the left-hand side, seems to hang down over the greater part of the other side, though it gives a glimpse of a man moving in the sun "outside". There are rich oriental rugs on the floor; they may even be Turkish rugs of the so-called "Holbein" type. Some of the figures can be identified with certainty (see details below). Even so, it has so far proved impossible to determine the occasion which the artist intended to portray. Chronological considerations suggest that there is no question of a straightforward "portrait". A great many theories have been formulated concerning the "event" depicted. Equicola (*Commentarii mantovani*, 1521) sees in it the grand reception arranged by the Court of Mantua for the Emperor Frederick III and the King of Denmark (this would be Christian I) — but no such high-ranking dignitaries seem to be included among those

Diagram showing relief-pattern and cross-section of the frame round the fireplace (north wall).

on the wall. Gionta's theory (*Fioretto delle cronache di Mantova*, 1574) that the scene represents the return of Federico, eldest son of Ludovico III, after his flight to Naples to avoid having to marry Margaret of Bavaria would seem to be equally untenable. In fact, Federico does not seem to be portrayed in the picture at all. Gionta's theory has never-theless been supported and followed up by some critics (Intra, ASL, 1879 and *Guida di Mantova*, 1912; Brinton, *The Gonzagas*, 1927). By seeing a connection between this

Detail of one of the small imitation piers by the fireplace (north wall) showing "painted ornamentation" of particularly high quality.

The gloved hand of the Marchioness Barbara (no. 50) before the restoration of 1938—41 (note signs of the stucco coming away or having already disappeared) and (right) as it is today.

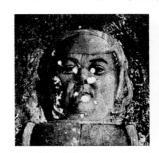 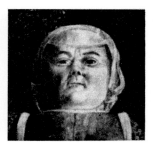

Dwarf (no. 50) showing how the pitting (possibly caused by shot in 1630) had been filled in with plaster in the course of the early restoration work and (right) as it is today.

Front elevation of the east wall which (like the south wall) features only the imitation leather curtaining.

Front elevation of the south wall (beside the door there is a small recess in the wall covered over with a shutter).

Febo, illegitimate son of Gianfrancesco Gonzaga (Camesasca); 6. Paola Gonzaga, youngest daughter of Ludovico III; or else one of his other daughters: Dorotea (Brinton); Cecilia or Barbara or Chiara (Pacchioni) (it is impossible to recognise any of these from coins known to bear their likenesses (Camesasca); 7. possibly Bartolomeo Manfredi (Davari and other critics down to Camesasca); Francesco Prendilacqua (Bellonci, etc.); Vittorino da Feltre (?) (Luzio); 8. possibly Rodolfo Gonzaga, fourth son of Ludovico III; Gianfrancesco (Davari down to Paccagnini) or Federico (Fiocco) Gonzaga; 9. Barbara Hohenzollern, wife of Ludovico III (there is a likeness with identified portraits); 10. possibly Barbara Gonzaga, last but one

(above and below) Two details of the imitation leather curtaining on the east and south walls; the thistle motif (above) has been used in the central panel on the east wall and the second motif below in the two side panels; this arrangement has been reversed on the south wall.

painting and the *Meeting* (no. 51 C), Venturi and Pacchioni (*Palazzo Ducale di Mantova*, 1921 and 1928) have identified the scene as depicting the arrival of the messenger bearing the papal brief announcing that Ludovico's second son, Francesco, had been made a cardinal or, alternatively, Francesco's own arrival in Mantua either immediately after being made a cardinal or on some other occasion (but see commentary on the *Meeting* – 51 C). Yet other critics maintain that, having devoted the west wall to celebrating the links between the Gonzagas and the Church, the artist used this wall to illustrate the family's connections with the Emperor, by commemorating the betrothal of Federico to Margaret of Bavaria (Rescasio, E, 1941). Some critics will commit themselves no further than to state that the scene depicts the arrival of foreign ambassadors, without saying which (Cruttwell, *A. Mantegna*, 1908), but this view is not borne out by the fact that all the figures are wearing red and white stockings, and these were the Gonzaga colours (Camesasca, 1959). In view of the impossibility of identifying the scene, recent scholars have reverted to the view that it constitutes a "family portrait" (Bellonci, etc.) (without, however, ruling out the possibility that some action or event is in fact portrayed, though its nature cannot now be identified) and that the portrait has been executed with a relentless realism which shows up humps, double chins, prominent foreheads and protruding jaws, limp and spindly arms and legs: in fact, all the well-known physical defects of the Gonzagas. In the light of these interpretations, the various figures may be identified as follows (the numbers refer to those marked on the sketch on page 105, in each case, the first identification given is the most probable or the most current one; those based on undoubted misinterpretations have in most cases been omitted):
1. Marsilio Andreasi, secretary to Ludovico III; bearer of the papal brief (Venturi, etc.);
2. Ludovico III Gonzaga (likeness may be compared with those featured on coins and other equally reliable evidence); 3. unknown man; Giovanni da Gargnano the physician (Davari); Alessandro Gonzaga, brother of Ludovico

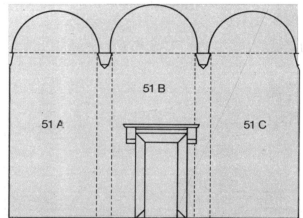

Front elevation of the west wall: the numbers refer to those used in the Catalogue to distinguish the various sections of the decoration.

51 B
51 A
51 C

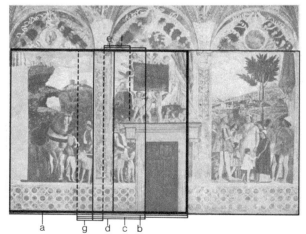

Vertical harmonic divisions on the west wall (illustrated by G. Alessi); note the harmonic proportions between the real architectural features (e.g. the jamb of the doorway) and those which are painted in (e.g. the pier); an even closer scrutiny (not illustrated here) reveals a corresponding harmony of proportion between these simulated architectural features and other details in the painting (as, for instance, the Marquis Ludovico's sword in no 51 C). The letters denote the extent of the series of harmonic divisions here identified starting from a, relating to the entire wall (and coinciding with one jamb of the door).

III (Magnaguti, V, 1947);
4. Gianfrancesco Gonzaga, third son of Ludovico III (may be compared with modelled effigies, etc.) (Camesasca); Federico Gonzaga, eldest son of Ludovico III (Davari; Venturi, etc.); Cardinal Francesco Gonzaga (Brinton); Carlo Gonzaga, brother of Ludovico III (Luzio); 5. Prothonotary Ludovico Gonzaga; possibly

daughter of Ludovico III (Bellonci etc.); Susanna (Intra) or Dorotea (Luzio) Gonzaga, daughters of Ludovico III; Margaret of Bavaria (Brinton etc.); Gentilia Gonzaga (?) youngest daughter of Carlo (Bellonci etc.); Susanna (Intra) woman (Paccagnini); 11. An unknown woman; Cecilia (?) or Margherita (?) Gonzaga, sisters of Ludovico III (Camesasca); a nurse (Davari

The principal coat of arms of the house of Gonzaga done in fresco over the doorway in the south wall on a portion of plaster which may very well have been used in place of the original plaster.

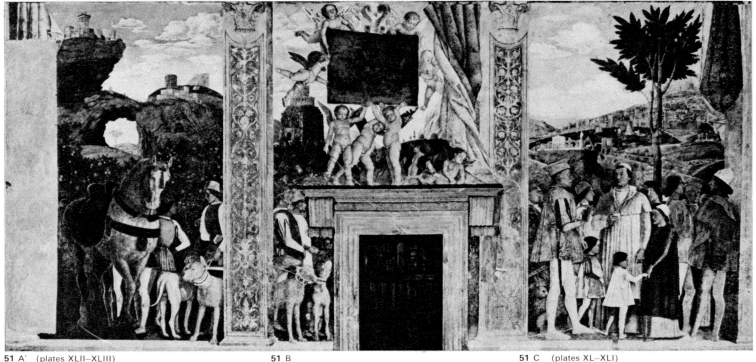

51 A' (plates XLII–XLIII) 51 B 51 C (plates XL–XLI)

etc.); a nun (A. Venturi); 12. a dwarf; Cecilia (Intra) or Paola (Brinton) Gonzaga, daughters of Ludovico III; 13. a courtier (?) or Giovanpietro Gonzaga (?), cousin and counsellor of Ludovico III (Camesasca); Mantegna himself (Milanesi, in *Vasari*, 1874); Gianfrancesco Gonzaga di Novellari (Davari); 14. Ugolotto Gonzaga, son of Carlo (ditto etc.); Rodolfo Gonzaga, fourth son of Ludovico III (Pacchioni etc.); 15. an unknown member of the Gonzaga household;

Evangelista, natural son of Carlo Gonzaga (Davari) (in the photograph of the painting taken in 1875, this figure has a marked resemblance to Francesco Sforza [see no. 27]); 16. unknown member of the Gonzaga household; 17. Ludovico III (?) (Milanesi); Federico Gonzaga (?) (Bellonci etc.); a courtier (?) (Camesasca); 18. an unknown member or page of the Gonzaga household; a follower of Federico Gonzaga (Milanesi); Federico Gonzaga

(Intra, Bellonci etc.); Francesco Gonzaga (afterwards a cardinal) (A. Venturi etc.). For further information, see the introduction to the Camera degli Sposi.

The East Wall

Except for the area occupied by the window, this wall is covered by the gold-embossed leather curtains.

The South Wall

Here too, with the exception of the two apertures, the painted curtains are "drawn" across the wall. In addition, the Gonzaga coat of arms surrounded by winged cupids, clumsily copied from those on the west wall (no. 51 B), has been painted onto a plastered area which has replaced the original wall surface (which may well also have been covered at this point by the painted curtain).

The West Wall

This wall features three separate panels which are linked by means of the landscape depicted in each. Basing his theory on the discovery of traces of an old doorway to the extreme left of the wall (1959), Camesasca suggested in 1964 that Mantegna himself had had the original door filled in and a new one made to make it possible to establish harmonic proportions between the real architectural features in the room and those portrayed in the paintings.

Diagram showing relief-pattern and cross-section of the frame round the doorway in the west wall.

Ludovico III; the castle on the left may conceivably resemble the Gonzaga residence at Goito which no longer exists (Brinton); the building surrounded by scaffolding may be intended to represent the "great palace" which in 1468 Ludovico III began building at Bondanello, near Gonzaga. Most scholars are inclined to see in the natural archway in the rock a portrayal of the Veia Bridge in Verona (Giannantoni; etc.). Nothing is known of the origin of the

Detail of painting no. 51 B showing the text of the dedicatory panel and the date, which shows clear signs of having been interfered with as a result of the various attempts at retouching.

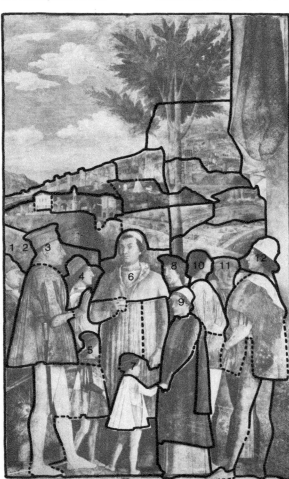

Sketch illustrating the pattern of execution of fresco no. 51 C and the area painted each day. The sketch also provides a key to the identity of the various figures portrayed in the fresco, in conjunction with the information given in the text.

51 ⊞ ⊕ 235* •1474 ▯ ⋮

A. Servants with Horse and Dogs
Both this and the next panel have at times been given the title *Return from the Hunt* (Intra; Pescasio; Brinton; etc.) though there would seem to be no justification for this. There is no means of identifying the figures portrayed, beyond the general statements that they are members of the Gonzaga household staff. The horse is presumed to belong to

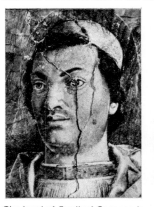
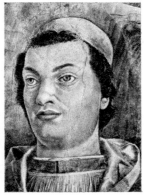

The head of Cardinal Gonzaga in painting no. 51 C before and after the restoration carried out in 1938–41. The photograph on the left shows the extent to which the plaster repairs done in the nineteenth century had worked loose.

blank area on the extreme left where the picture has been painted over in such a way as to leave visible the hand and pointing finger of a figure which has otherwise been eliminated.

51 ⊞ ⊕ 230* 1474 ▤ ⦂

B. Servants, Dogs and Cupids
No attempt has been made to identify the two figures on the left beyond recognising in them members of the Gonzaga household staff.
The building depicted over the doorway resembles the mausolea of Augustus and Hadrian in Rome. Moschetti maintains that, of the nine winged cupids, the three beneath the dedicatory panel are derived from fragments of the Throne of Saturninus in Venice and from an altar of Bacchus in the Maffei Museum in Verona. Tamassia, however, suggests that they were inspired by examples of classical sculpture in Mantua, Venice and Verona as also by a fragment of the Throne of Jupiter in Florence; she further points to an affinity between the recumbent cupid on the right and a piece of a classical throne in Ravenna. The inscription itself runs as follows: "ILL. LODOVICO II M. M./PRINCIPI OPTIMO AC/FIDE INVICTISSIMO/ET ILL. BARBARAE EJVS/CONIVGI MVLIERVM GLOR./INCOMPARIBILI/SVVS ANDREAS MANTINIA/PATAVVS OPVS HOC TENVE/AD EORV DECVS ABSOLVIT/ANNO MCCCCLXXIIII" ("To the illustrious Ludovico, second Marquess of Mantua, most excellent prince of unparalleled faith and to the illustrious Barbara, his consort, incomparable glory of womankind; their Andrea Mantegna, of Padua, completed this modest work in their honour in the year 1474"). The heads of the two servants, the cupids and the inscription itself (particularly the date) have all been considerably altered and/or impaired by restorers.

51 ⊞ ⊕ 235* *1474 ▤ ⦂

C. The Meeting
We may complete the remarks made so far concerning the subject matter of this panel (cf. general introduction and the commentary on no. 51 A) by adding that recent critics are mostly inclined to see in it a portrayal of the reception of Cardinal Francesco Gonzaga, second son of Ludovico III, on one of the occasions when he returned to Mantua. The chronicler Schivenoglia (1445–84) dwells in particular on the Cardinal's visit to Mantua in December 1461, immediately after he had received the red hat, and on another visit in August 1472 when he took possession of his titular church of S. Andrea. Apart from the fact that the landscape is anything but a wintry one, the portrayal of the children (some of whom were not yet born in 1461) would seem to argue strongly in favour of the second of these occasions, when the Cardinal was received at Bondanello (Cavalcaselle, etc.) (but see no. 51 A). What is more, on this second occasion, the Cardinal presumably came from Rome and, with a little good will, Rome can be identified as the

city depicted in the background. At any rate, it is a city featuring the Aurelian Walls with the Arch of Titus, the Colosseum (a curious brown colour), the Domus Flavia in ruins, the Pyramid of Caius Cestius, the Ponte Nomentano, the Aqueduct of Claudius, the Theatre of Marcellus and a mixture of the *Athlete* in the Vatican and some *Hercules* or other (Tamassia) in the statue. However, so much licence has been taken with the originals, that the most satisfactory solution would seem to be to define it as a "humanistic city" as Coletti does. Some mention should be made of the white building in the background to the left of the picture. Coletti had defined it as a Palladian edifice, though pre-Palladian in time; Bottari saw in it a foreshadowing of the Palazzo Chiericati in Vicenza. One further comment: during his visit to Mantua in 1472, Cardinal Francesco Gonzaga was accompanied by some members of the household of Pico della Mirandola (though Cardinal Giovanni Pico della Mirandola who headed the party does not seem to be depicted here), and his arrival coincided with the construction of the church of Sant'Andrea, designed by Alberti. In the case of the *Meeting* as in that of the *Court Scene*, a great many opinions have been expressed concerning the identity of the various figures. These are summarised below according to the same criteria used for the *Court Scene* (50).
1. Unknown man; a Pico della Mirandola (Intra); Carlo Gonzaga (Luzio, etc.); 2. as no. 1; 3. Marquess Ludovico III Gonzaga (see no. 2 in the commentary on the *Court Scene*); 4. probably a Gonzaga in view of the resemblance to Ludovico III (Camesasca); a Pico della Mirandola (Intra); Dorotea (Brinton) or Gianfrancesco Gonzaga (Fiocco); 5. the future Marquess Francesco II Gonzaga, eldest son of Federico I (likeness may be compared with known portraits of the Marquess, though of a later date); 6. Cardinal Francesco Gonzaga (ditto); 7. the future Cardinal Sigismondo Gonzaga, third son of Federico I (ditto); 8. possibly Bernardino, Mantegna's son (Camesasca); Leon Battista Alberti (Intra); Mantegna himself (Patricolo); 9. Prothonotary Ludovico Gonzaga, youngest son of Ludovico III (may be compared with known likenesses); Giovanni Pico della Mirandola (Tietze-Conrat); 10. Giambattista Alberti (?) (Camesasca) (may be compared with fairly reliable likenesses); Poliziano (Intra, etc.); a Pico della Mirandola or Evangelista Gonzaga (Bellonci); 11. Mantegna (may be compared with known likenesses); 12. the future Marquess Federico I, eldest son of Ludovico III (ditto)·
The numerous figures in the background include some men quarrying, to which Hartt has attached hidden meanings: in particular, he suggests that the pillar in front of the cave (on the extreme right) symbolises the sexual life which the prelate has abandoned; he even attaches to the mountains — so typical of Mantegna's repertoire — an allegorical meaning by seeing in them a reference to the Gonzaga motto: "*Ad montem duc nos*".

Engraving at the British Museum connected with no. 52.

52 ⊞ ⊕ 70×102 ▤ ⦂

Portraits of Ludovico III Gonzaga and Barbara of Brandenburg
The two portraits constituted a single picture. However, in view of the fact that both the figures were portrayed looking in the same direction, we may accept the view expressed by Tietze-Contrat that the portraits had originally been separate works which were then arbitrarily placed in a single frame. Moreover, the portrait of the Marchioness reproduced her likeness as depicted in the Camera degli Sposi (no. 50) whereas Ludovico is portrayed as a young man. The "diptych" may have been in the possession of the Flemish painter Nicolas Renier in Venice, whose collection was broken up in 1666; in fact, among the items in the collection, there is a mention (Segarizzi, NAV, 1914) of two portraits such as these on wood, measuring 3 × 4 *quarti* (corresponding to the measurements given above). Kristeller pronounced them to be, in all probability, copies of lost originals, adducing in support of this theory a late engraving reproducing them at the British Museum, as well as two letters from the Gonzaga archives, one of which (dated 2 August 1471) mentions "two portraits" and nothing more, while the other (written by Mantegna to the Marquess and dated 16 July 1477) explicitly refers to a portrait of Ludovico and possibly also to one of his wife. A further consideration is the reference by Campori to a "Portrait of the Marquis Lodovico of Mantua painted life-size, that is the head, on wood measuring four *quarti* and a third by three *quarti* and a third in width". Campori attributes the work to Mantegna but does not say where it is.

53 ⊞ ⊕ 10,7×8,2 ▤ ⦂

Portrait of a Man (Rodolfo Gonzaga ?)
New York, Metropolitan Museum of Art
The catalogue of the Bache Collection in New York (1937) — to which this work at one time belonged — listed it as a portrait of Gianfrancesco II Gonzaga and described it as a Mantegna original. Berenson endorsed both the identification and the attribution to Mantegna. Fiocco denied both and his view has been shared by Cipriani (who, however, suggests tentatively that the portrait is of Francesco

Gonzaga) and by Tietze-Conrat, who is more inclined to identify the subject as Rodolfo Gonzaga in view of the resemblance to the portrait in the Ambras series.

54 ⊞ ⊕ 42×32 *1475* ▤ ⦂

Madonna with Child
Berlin, Staatliche Museen
All critics are agreed in ascribing it to Mantegna himself. As regards chronology, Kristeller (and later Arslan) connected it with the *St Euphemia* in Naples (no. 18). Fiocco holds that it dates from the beginning of the artist's career in Mantua. Tietze-Conrat, supported by Pallucchini, believes it to be an early work in view of the marked Donatello features. Paccagnini and Gilbert believe it to have been executed after the artist's return from Tuscany, while Longhi and Camesasca regard it as a late work. It has been slightly and inadequately restored.

55 ⊞ ⊕ 1478* ▤ ⦂

Decorative motifs (?)
Formerly (?) in the Castle at Gonzaga (Mantua).
A number of rather vague allusions relating to a period

53

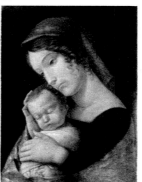

54

between 1468 and 1478 may conceivably be in connection with work executed by Mantegna in this residence owned by the rulers of Mantua and constructed in Bondanello (see no. 51 A) at the behest of Ludovico III in the years following 1468. It would appear (Kristeller) that some ten years later, Mantegna supervised, among other things, the execution of a frieze featuring the four Elements which may well be connected (id.) with the pair of prints constituting the *Battle of the Sea Gods* (307 × 415 and 258 × 393 mm.). The remarks concerning the attribution of the *Bacchanalia* (no. 35) apply equally in this case. One scholar (Förster, JPK, 1902) has seen a connection between the theme of the *Battle of the Sea Gods* and the ichthyophagi described by Diodoro Siculo in his *Biblioteca*. Wind (JWCI, 1938–1939) is more inclined to the view that the theme is derived from Lucian; Delaborde (*La gravure en Italie*, 1877) followed by as recent a critic as Petrucci (D, 1930–31) maintained that the theme was taken from a terracotta bas-relief discovered in Ravenna, though Rubbiani (ASA, 1895 has shown that the discovery was made later (c. 1500). As regards chronology, Zani (*Materiali* . . ., 1802) thought he could decipher the date 1481 beneath the word "INVID" in the scroll held by the old hag. Petrucci reads "1461" though the characters would appear to be a transcription in Greek or Hebrew of the word "envy" (Tietze-Conrat). It is known that this work cannot have been executed after 1494, when Dürer engraved a copy of it. We may legitimately hold that the original design by Mantegna goes back to some fifteen years earlier at least.

56 ⊞ ⊕ 275×142 *1480* ▤ ⦂

St Sebastian (St Sebastian of Aigueperse)
Paris, Louvre.
The martyr is depicted bound to a half-demolished pillar as in the Vienna *St Sebastian* (no. 43); the background features a mixture of ancient buildings in ruins and contemporary dwellings. The busts of the two archers are clearly reminiscent of the work of Rogier van der Weyden. The work was acquired by the museum from the church of Notre-Dame in Aigueperse to which it was presumably presented by Chiara Gonzaga when, in 1481, she married Count Gilbert of Bourbon Montpensier. Fiocco and Coletti hold that it was executed prior to the S. Zeno Altarpiece (no. 23) but is more or less contemporary with the *Adoration of the Shepherds* now in New York (no. 7). Tietze-Conrat and Cipriani connect it with the period when the artist was at work on the Camera degli Sposi. The other critics are inclined to date it in 1480 or thereabouts. There is a copy by the Paduan school at Buckingham Palace, London.

57 ⊞ ⊕ 66×81 *1480* ▤ ⦂

Dead Christ
Milan, Pinacoteca di Brera
The Madonna and St John the Evangelist are depicted on the left of the picture. In a letter to

Marquess Gonzaga dated 2 October 1506 (see *Outline biography*), Ludovico Mantegna listed a "fore-shortened Christ" among the works left by his father; moreover, it is known that the picture was bought by Cardinal Sigismondo. The subsequent history of the painting is not at all clear. It does seem, however, that, possibly as a result of the sack of Mantua (1630), the picture finished up in Rome, where it is mentioned by Félibien (second

it during his stay in Paris. It was acquired by the Brera in 1824 together with the rest of the property of Giuseppe Bossi. However, Yriarte maintains that it had been in Venice before that — a claim which would seem to confirm the existence of at least two versions of the work. In fact, an inventory of the property of the Aldobrandinis in Rome, compiled in 1611 and published by Della Pergola (AAM, 1960), lists "a fore-shortened picture of Christ

Della Pergola herself, who wondered whether the Aldobrandini picture was a replica or a copy. There can in any case be no doubt that the picture was in Rome, as Yriarte maintained; his theory is that, having found its way to Paris, it was subsequently lost. Tietze-Conrat declares that Summonte (1524) records the existence of another version of this work in the church of San Domenico in Naples, but Bologna has shown (P, 1956) that this work, which is now lost, was connected with Mantegna's print of the *Deposition in the Sepulchre*. The picture's history is clearly a complex one. Nevertheless, no doubts have been expressed as to the Brera work being a Mantegna original, though the critics differ considerably over the question of dating. Yriarte maintains that it has all the features typical of Mantegna's Paduan period. Fiocco and Berenson and many others believe it to be a late work. Pallucchini (1956—57) suggested that Mantegna designed it after his trip to Tuscany. Longhi (1962) feels it cannot have been painted later than 1490. Arslan and Ragghianti (1962), reverting to the views expressed by Thode and Kristeller, date it in 1475 or at any rate some time during the 1480s. Camesasca believes it was begun between the years 1478 and 1485. Tietze-Conrat, whose view is contested by Cipriani but supported by Bottari, maintains that the figures of the two mourners were added later, thus, in a sense, confirming an opinion expressed by Marangoni *(Saper vedere)* to the effect that they were stylistically out of keeping with the rest of the picture. It is almost superfluous to mention how popular the picture has been on account of the clever trick of perspective which makes it seem that the face of Christ "follows" the onlooker whatever his position in relation to the picture. Camesasca suggests that the picture was prompted by the same order of ideas that produced the foreshortened drawing of the oculus in the Camera degli Sposi in Mantua (no. 46). Recent critics are rather more inclined to point to the "livid, half-lit tone" as being the picture's most authentic merit (Cipriani). For details of the De Navarro version, see no. 58.

58 ⊞ ⊗ —— 65×75 ▤ ⦙

Dead Christ
Glen Head (New York), De Navarro Collection
The existence of this work was made known by H. Tietze (AA, 1941) when it was at the

Jacob M. Heimann Gallery in New York, from which it has since been moved to its present home. Tietze believes that it is the genuine *modello* — dating from Mantegna's Paduan period — for the Brera painting (no. 57), which was the one mentioned by Ludovico Mantegna as being among his father's effects. While endorsing the attribution to Mantegna (as does Fiocco), Tietze-Conrat held that it dated from the period after Mantegna's return from Tuscany. No other critics have expressed themselves in favour of the direct attribution of the work to Mantegna. On the contrary, the theory has been seriously questioned, particularly by Cipriani, Camesasca and Longhi who declared that the De Navarro version was a "very poor partial copy, probably executed about a century after the original" at the Brera.
The critics have evinced equally little enthusiasm for a panel in oil of the same theme (65·5× 73·5 cm.), which appeared at a Milanese auction in 1963.

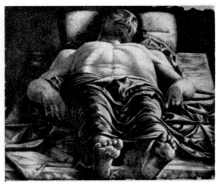

56 (plates XXVII—XXX)

59 ⊞ ⊗ —— 1483 ▤ ⦙

Decoration of a room
Mantua, Formerly (?) at Palazzo Ducale
In a letter dated February 1483 (see *Outline biography*), Bishop Ludovico Gonzaga informed the prefect Giovanni della Rovere that Mantegna was not free to go to Rome as he was engaged in decorating a room for the rulers of Mantua. This remark has been interpreted by some scholars as a reference to the Camera degli Sposi, but even such an early critic as Cavalcaselle rightly questioned this. However, in the absence of any further information, it is impossible to identify any other room in the palace to which the Bishop may have been referring.

60 ⊞ ⊗ —— *1484 ▤ ⦙

Judith
An inventory of the property of Lorenzo the Magnificent compiled in 1492 lists "one

(above, top and centre) The two parts (307 × 415 and 285 × 393 mm.) of the engraving featuring the Battle of the Sea Gods *(cf. no. 55). The first one (Gabinetto delle Stampe, Rome) shows signs of retouching which Kristeller attributed to Mantegna himself; there are two extant versions of the second part, in each of which the vegetation has been handled differently. (bottom). Ink drawing (245×353 mm.; Duke of Devonshire Collection, Chatsworth) connected with the first of the two parts of the* Battle of the Sea Gods *and believed by most critics to be by Mantegna.*

half of the seventeenth century) as part of the collection of Cardinal Mazarin. Not long afterwards, the same picture may have been acquired by Camillo Pamphili, who offered it to Louis XIV, in whose possession Bernini saw

lying dead on a slab with two women weeping, done by Andrea Mantegna". Without going into the question of the "two women", we are still left with the problem of the difference in the support or base; a problem which was raised by

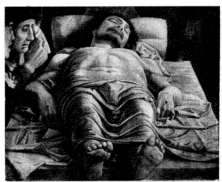

57 (plates LX—LXI)

58

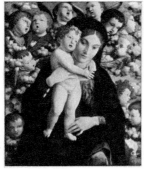

62 (plate LI)

small panel (of Judith), the work of Andrea Squarcione" (Müntz, 1888) (see *Outline biography*, 1441). There seems little ground for identifying this work with the painting in Washington (no. 74), in view of the style, which is that of a period too long before 1484, the year in which the painting was in all likelihood sent to Lorenzo the Magnificent (see *Outline biography*). Tietze-Conrat believes that evidence may be gleaned from the engravings of *Judith* executed by Zoan Andrea and by Mocetto. However, both of

these appear to be connected with the paintings now in Washington (no. 74) and Dublin (no. 75).

61 1484*?

Archer and Squire
Mantua, Formerly (?) at Palazzo Ducale
Cavalcaselle describes a painting on the ceiling of the Carving-room in Mantua depicting a "man accompanied by a boy holding his arrows, an undoubted indication of Mantegna's activity some ten years after his completion of the Camera degli Sposi".

62 89×71 1485*

Madonna with Child and Cherubim
Milan, Pinacoteca di Brera
This work is frequently identified with the "picture painted on wood with the Madonna and Child and Seraphim" listed in an inventory compiled in 1493 of the property of the Este family (Campori, 1870); however, the description of the angels as seraphim and not

cherubim calls for some care in making the identification (Camesasca). The attempt to identify it with a painting said by Vasari to be in the possession of the Abbot Matteo Bosso, a friend of Mantegna's, in Fiesole, seems to have been definitely ruled out (*Catalogue of the Exhibition of Ferrarese Painting*, 1933). Until 1808, the picture now under discussion was in the church of S. Maria Maggiore in Venice and Sansovino's "a picture of the Madonna most excellently painted" (*Venetia descritta*, 1604) is presumably a reference to it. Sansovino had grouped it with two other Madonnas by Giovanni Bellini, and all three were attributed to him until Cavenaghi did his restoration in 1885, after which it was recognised that this picture was in fact the work of Mantegna. On the basis of the identification of the work with that known to have been in Ferrara in 1493, it is generally believed to have been executed in 1485 for Eleanora of Aragon, the wife of Ercole I d'Este, as may be deduced from letters published by Baschet and Braghirolli. Tietze-Conrat has emphasised the agreement between the date, 1485, and the style of the painting. Some more recent critics such as Middeldorf (Camesasca, 1964) and Camesasca himself are now rather more inclined to connect the work once again with Giovanni Bellini. The picture is in a poor state of preservation. Longhi rightly pointed out that the panel had very probably been cut down, especially towards the bottom.

The Triumph of Caesar

The series of nine canvases (all the same size) is now at Hampton Court. Vasari states that the cycle was executed for Ludovico III Gonzaga, but this is probably untrue since the Marquess died in 1478 and the cycle is likely to have been begun a couple of years later — if Tietze-Conrat's theory is correct — though there is no definite evidence prior to 1486 when (see *Outline biography* for this and all further chronological data) Guidobaldo d'Urbino reported that he had seen the *Triumph* which Mantegna "is painting"; moreover, in a letter written in 1489, Mantegna himself declared that only some "pieces" were finished while others were still in hand at the Palazzo Ducale. The deed of gift drawn up in 1492 makes it clear that the beneficiary was then still at work on the series and in fact the cycle was probably never finished. A letter written in 1494 refers to two missing "pieces" which writers from Kristeller onwards have identified with the *Triumph of Caesar* although there is no evidence for this link. The length of time taken to do these pictures has been interpreted as a sign that Mantegna's interest in Antiquity had waned following his trip to Rome. The theory is a questionable one even though, unlike Tietze-Conrat who maintains that Mantegna's stay in Rome must have had a positive influence on the way in which he handled the cycle,

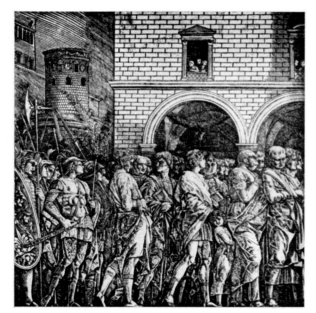

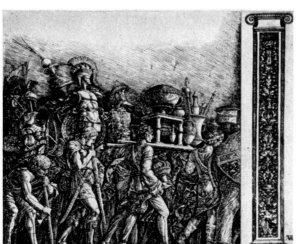

(*above, top*) *The print known as the* Senators *(282 × 262 mm.; Bartsch, no. 11), which may have been derived from a design by Mantegna for the* Triumph of Caesar *which he never executed.* (*above*) *Engraved copy of no. 63 F with a pillar added.*

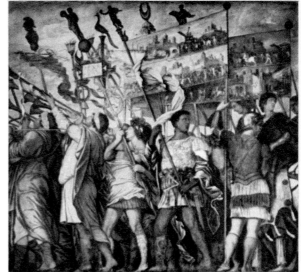

63 A

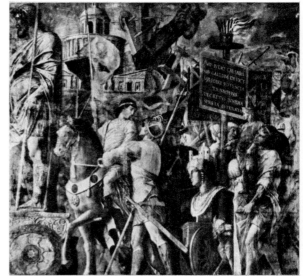

63 B

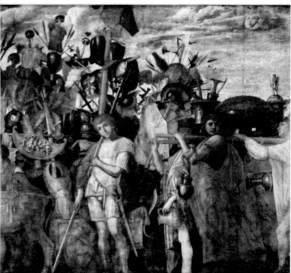

63 C

a number of critics deny that any development in style resulted directly from the Roman trip. In any case Kristeller, following Giehlow (JKS, 1915) has rightly stressed the literary source of inspiration for the cycle, as having derived from Valturio's *De re militari*, published in Verona in 1472. On the other hand, just as critics (Camesasca) have ruled out the possibility of the artist's having been influenced by the "triumphs" which it was the custom to present in Italian *piazze* on all sorts of occasions

ranging from formal receptions to carnivals and funerals, so they are inclined to minimise (Tietze-Conrat, etc.) the importance of such ancient works in Rome as the frieze from the Temple of Vespasian, and the bas-reliefs on Trajan's Column and on the Arches of Constantine and Titus adduced by Giehlow, Blum and Paribeni (1940) as possible sources of inspiration. Even so, as Cipriani points out, there does not seem to be much in the complicated hypothesis outlined by Giehlow and endorsed by Tietze-Conrat

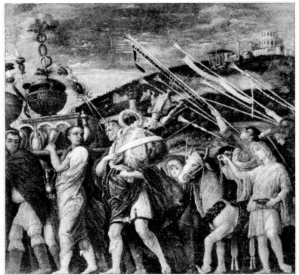

63 D

63 G

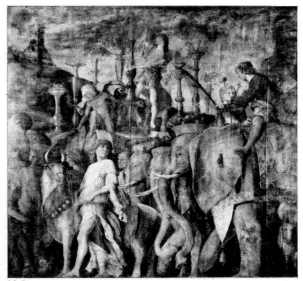

63 E

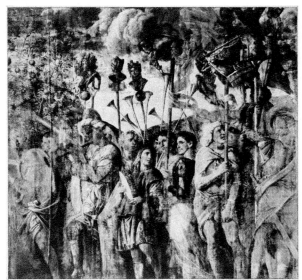

63 H

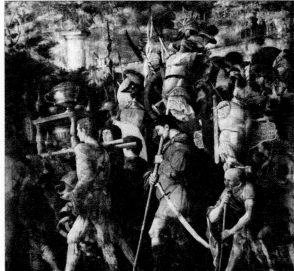

63 F

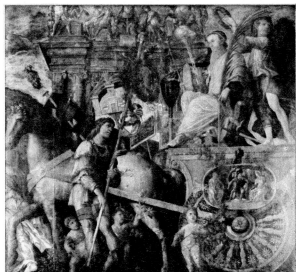

63 I

according to which the use of such classical motifs as festoons, members of the human body, skulls of animals and so on, transmuted through Mantegna's elaborations and combinations, resulted in the production of a set of symbols (which are quite erroneously looked upon today as mere ornamentation), devised as pictorial features on the basis of what Alberti believed to have been the criterion adopted by the Romans in respect of Egyptian hieroglyphics.
Another equally unconvincing theory, formulated by Fiocco, attempts to prove a predominantly "Mantuan" genesis for the cycle; he claims that a "prelude" to the *Triumph* has been executed on the front of a chest which features, in panels done in *gesso* and paint, the *Justice of Trajan* (now at the Landesmuseum in Klagenfurt), and he believes this to be an example of Mantegna's use of plastic media (though it has quite rightly been omitted from the works generally attributed to him). Although it is obvious that there must have been collaborators to help in the

execution of an undertaking on this scale, it should be noted that work on it appears to have stopped while Mantegna himself was in Rome, a fact which may well be interpreted as an indication that he was directly involved or that he was at least supervising the work personally. As early as 1497, Bishop Ludovico Gonzaga was planning to use the various sections of the cycle for the decoration of an outdoor courtyard, and an official wrote to the Marquess (14 January) with advice on how to protect the panels from the effects of inclement weather. In 1501, the panels were certainly used for a theatrical performance in Mantua. In 1506, shortly after Mantegna's death, they were erected in the house which he had had built for himself at Porta Pusterla, close to the church of S. Sebastiano. Their arrangement in the courtyard in the spaces between the various piers constituting the arcade must have created the illusion of a single unbroken work and this was very probably the effect which the artist himself had hoped to achieve. (The connection between the panels and the architectural setting would seem to be confirmed by an engraving done in Mantegna's *bottega*, reproducing no. 63 F alongside a pier). The pictures were brought back to the Palazzo Ducale in the early 1600s; shortly afterwards, they were made over to Charles I of England. The pictures were clumsily restored at the beginning of the eighteenth century, when Laguerre embarked on large-scale repainting as a result of which the original tempera was disastrously buried beneath coats of oil and gum. In 1919, R. Fry advocated their restoration, but an inspection of the first panel produced such disconcerting results that he abandoned the project. K. North made another attempt in 1931–34, but without achieving satisfactory results. We do not know whether Rubens actually saw this cycle when it was still in the house near S. Sebastiano; he was certainly so much impressed by it that he paraphrased it in his own *Triumphs*. Nor was he the only one to have been so impressed, since various copies of the cycle are in existence: one such copy, comprising four of the panels, executed in oil on copper and measuring 21 × 19 cm. each, is at the Pinacoteca in Siena; another consisting of nine frescoes now mounted on canvas and measuring 160 × 150 cm. originated from a house in Mantua and is now at the Palazzo Ducale in Mantua; a third set is in the Alte Pinakothek in Munich. In addition, we have definite evidence of further sets copied from the original cycle (one such set may actually have been executed at Marmirolo under the supervision of Mantegna himself [no. 81]); various drawings and engravings of the series have also survived. It was these, and particularly the set executed by A. Andreani in 1599, which were largely responsible for the renown enjoyed by the cycle.
The various panels are here discussed separately. In view of their precarious state of preservation, it is impossible to say in what order they were executed. The symbols denoting execution, medium

and so on are therefore given for the first panel only, but apply equally to the remaining eight.

63 ⊞ ⊕ 274 × 274 ▤ ⁝
1480–95

A. Trumpets and Standard Bearers
Giehlow made a painstaking study of the symbols portrayed on the standards on the right of the panel and of every other feature of the composition. However, his conclusions were so unreliable in the case of this and the remaining panels, that there is no need to reproduce them here.

B. Triumphal Chariot, Trophies and Weapons of War
The writing on the banner attached to the torch pole refers in particular to the victories of Caesar in Gaul.

C. Chariot with Trophies and Men Carrying Booty
In the clouds there is a round object with a man's face,

which is perhaps the moon. The continuity between this panel and the preceding and following ones is marked.

D. Men Carrying Booty, Sacrificial Bulls and Trumpets
The banners on the trumpets bear inscriptions referring to the various offices held by Julius Caesar. The background in this and subsequent panels features buildings which appear to be closer and closer to the beholder from one panel to the next.

E. Sacrificial Bulls and Elephants
There is no doubt as to the connection between this panel and the preceding one. According to Giehlow, the torches are derived from a row of lictors' fasces featured in a relief on the Arch of Titus.

F. Men Carrying Booty and Trophies
The change in perspective as compared with the previous panel may be accounted for by the fact that the series was intended to stand between the piers of a square courtyard, this panel occupying a corner position, thus necessitating an adjustment in the viewpoint.

G. Prisoners and Standard Bearers

H. Musicians and Standard Bearers

I. Julius Caesar in the Triumphal Chariot
According to Giehlow, the man in the centre is a personification of Rome.

S. Andrea Sinopie and Frescoes

These are connected with the façade of the Basilica of S. Andrea in Mantua. They were first mentioned by Donesmondi (*Historia ecclesiastica di Mantova*, 1612–16), who attributed the three *tondi* in the atrium (*Ascension* [no. 64 B–C]; *Holy Family* and *Deposition*) to the young Correggio. Local art historians echoed this opinion until the beginning of the nineteenth century when it faded into oblivion, all the more so since the paintings, much impaired, were covered over with a layer of plaster onto which they were crudely repainted. In 1915, Venturi recognised in the nineteenth century copies the general composition of the works described by Donesmondi and steps were taken to bring the originals to light. Venturi and Pacchioni (1916) then confirmed the attribution of the latter two to Correggio, but ascribed the first to a disciple of Mantegna. Recently, the frescoes have been lifted from the wall together with a fourth *tondo* (*St Andrew and St Longinus*, no. 64 A) which was on the pediment and was not mentioned by Donesmondi.

The Risen Christ between St Andrew and St Longinus: *engraving (392×325 mm.; British Museum, London) connected icono-graphically with painting no. 64 B and generally considered a Mantegna original.*

64 diam. 200* 1488

A. St Andrew and St Longinus
This panel was discovered beneath a layer of "neo-classical" plaster over which the picture had been repainted, in the same way as the other *tondi* in the series (see introductory remarks). It is dated: "MCCCCLXXXVIII." The figures had already almost disappeared in 1818 when Susani, in ascribing them to Mantegna, commented that "now little more than the heads remains". Since then, one of the two heads has been lost so that now, to quote Paccagnini (1961), there only remains, "irremediably damaged, part of the painted surface of the head of St Andrew, of the cross and one of the sacred vessels", though he added that "the paint used for the colours is of exceptional chromatic strength and the composition of the head possesses a breadth and a powerfulness of construction that one associates with the works painted by Mantegna in the last decades of the century".

64 diam. 245 1488*

B. The Ascension
This was discovered beneath the picture described in the next section (64 C). The man who brought it to light, Paccagnini, described it as "one of the most forceful and free of Mantegna's drawings" though, as he pointed out, there are many of the same blank areas here as in the corresponding fresco. He believes it to be a *sinopia*, but taken by transfer from a cartoon: this is not in itself a guarantee that the work is by Mantegna's own hand. In fact, after Longhi had expressed the opinion in 1962 that the work in question was "almost weaker than the fresco", Camesasca argued that Mantegna had not executed it himself but had "dictated" it before leaving for Rome; he suggested a comparison between this figure of the Redeemer and the similar one in the engraving featuring the risen Christ between St Andrew and St Longinus (392 × 325 mm.) (Bartsch, no. 6). Certainly, such a comparison reveals that none of the restrained compactness of the print is to be found in the *sinopia-spolvero*. As regards the engraving, it should be pointed out that Kristeller was almost tempted to see in it

evidence that it was a drawing for a work of sculpture. Tietze-Conrat countered this theory by claiming that it seemed rather to reproduce the composition for a fresco situated high up over a door.

64 diam. 245 1488*

C. The Ascension
Full details of the various events connected with this picture and former con-jectures as to the identity of the artist are given in the introductory remarks above. Mention should be made of the following rather confused comment by Ridolfi (1648): "On the outside (of the Church of Sant'Andrea, Mantegna) also painted the apostles standing watching the Lord going up to heaven". Although Paccagnini held that Mantegna had been responsible for the fresco, he recognised that, in spite of their "robust and lively colouring", the cherubim could have been executed by an assistant. In discussing the figure of Christ, he said that "the strength of the colour, and the very precise plastic structure of the huge body and of the folds of the vigorously modelled robe are unmistakable signs of Mantegna's own work". This opinion was rejected absolutely by Longhi (1962) and by Camesasca, who adduced the inferior quality of fresco as compared even with the *sinopia* (see no. 64 B for this and other details). Three "days" were devoted to the execution of the figure of Christ. The fresco is in a very poor state of preservation.

65 *1490

Decoration of the chapel of Innocent VIII
The artist may have begun work on this chapel in 1488; he was certainly engaged on it in June of the following year (see *Outline biography*) and it was completed either in 1490 or at any rate before October, 1491. The room in question, in the Vatican, Rome, was destroyed in 1780 in order to make way for the Museo Pio Clementino. The only informa-tion we now have about the Mantegna cycle is the description left of it by A. Taja (*Descrizione del Palazzo Apostolico*, 1750) and by G. P. Chattard (*Nuova descrizione del Vaticano*, 1762–67), from which the following notes are taken. In fact, the decoration was not restricted to the chapel

itself, but extended also to an adjoining room which served as a vestibule. This was embellished with painted piers, distributed round the room in the same way as the similar piers in the Camera degli Sposi. In the spaces between the piers, and apparently set in small recesses, there were "chalices, pyxes, crucifixes, candlesticks and other sacred vessels", while "a gold-embossed Chinese

Innocent VIII *(paper on panel; 12 × 9.8 cm.; Schloss Ambras, Innsbruck), reproduced here in connection with no. 65.*

decorative motif" and imitation stucco work linked the various features into a cohesive whole. A window with an iron grille looking out on a country scene was painted on the wall facing the doorway. The arms of the Pope who had commissioned the work formed the centre-piece of a complicated pattern of imitation bas-reliefs on a blue background executed on the ceiling. The chapel itself was square and was "decorated in each corner with a pier" which was made to look as if it were "supporting the cornice" from which sprang the four arches which carried the vault. The altar was on the right, set against a wall covered entirely with frescoes ("John the Precursor baptising Christ, who is surrounded by angels holding his clothes, with two other figures at the side, one of whom is seated and pretending to take off his shoes, with a smiling landscape and a city in the distance", above "the Holy Spirit painted beneath two festoons of fruit from the centre of which hangs a golden scroll"). On the opposite wall there was a window like that already described; in the embrasures there were "some *putti* on a blue background" holding an oval frame with the inscription: "Innocent VIII P.M. dedicated (this chapel) to St John the Baptist, the Precursor, in the year 1490". On one side of the window, there appears the signature: "Andreas Mantinia comes palatinus eques auratae militiae pinxit" ("Painted by Andrea Mantegna, Count Palatine, Knight of the Golden Army"); above, "the Virgin of the Annunciation with the angel and the Holy Spirit against the same background". The wall facing the entrance featured the beheading of John the Baptist, surrounded by soldiers. The saint "is shown patiently awaiting the blow of an uplifted sabre". Higher up, over a painted cornice, was "Herod's supper with a great many figures all busy preparing the tables for the feast in a royal garden, decorated with much greenery and, in the middle, a magnificent side-board bearing golden platters".

64 B

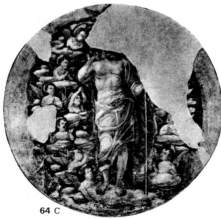

64 C

On either side of the door were the "half-figures of St Anthony and St Paul the Hermit on one side and St Stephen and St Laurence on the other"; the last two were surmounted by an *Epiphany* scene, and the other two by a corresponding *Nativity*. Over the doorway there was a large fresco of the "Virgin with the Child in her arms and St Paul, St John and St Catherine of Alexandria on her right and St Peter and St Andrew on her left"; the Pope who commissioned the work is seen kneeling with "other virgin saints behind him". Three of the four lunettes formed by the arches of the vault featured a round window of which "only one, above the altar, let in the light"; the fourth lunette had "the Sacrifice of Abraham done in chiaroscuro on a gold background". Allegories of the virtues were portrayed on either side of each of these windows: "Faith, Hope, Charity, Discretion depicted as and old woman" and

67 Saints, Sphinxes, Cupids and Floral Motifs

Rome, Palazzo Venezia (Map Room)
These figures all form part of a complex pattern not dissimilar in taste to Mantegna's, but undoubtedly of later date. There are, in any case, no grounds for attributing them to Mantegna himself, as Hermanin did (D, 1930–31), connecting them with the artist's stay in Rome. The attribution was rejected by Fiocco and later critics, though, curiously enough, it has recently been revived by Mariacher (*Ambienti italiani del '500*, 1962).

68 29×21,5 *1489* Madonna with Child (Madonna of the Stone-cutters; Madonna of the Cave)

Uffizi, Florence
This Madonna, seated on a rock with the Child half asleep on her lap, is the only one by

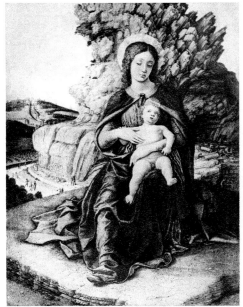

68 (plate L)

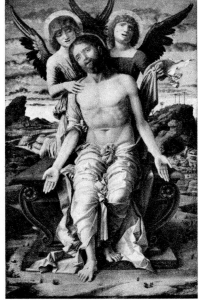

69 (plate LIV)

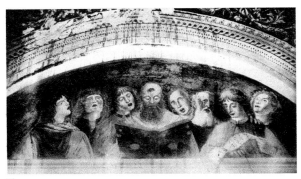

66

"Prudence, Justice, Temperance and Fortitude". The four Evangelists "well coloured and depicted against the sky" appeared on the corbels of the vault. Finally, the vault itself was decorated with "a number of interconnected *tondi* forming a kind of grating, interspersed with fifteen *putti* holding festoons, the cornice being in imitation stucco; the whole serves to support a centrepiece featuring the arms of Innocent VIII"; in addition, the heads of cherubim appeared "here and there". In fact, it is evident that the entire repertoire of the Camera degli Sposi appeared again in the decoration of this chapel, expressed with Mantegna's customary "dogged dexterity" (Camesasca), if we are to believe Vasari, who speaks of walls which "looked more like a page illuminated with miniature work than fresco".

66 base 330 Eight Men Singing

Rome, Vatican (Palazzetto di Innocenzo VIII)
Because of a certain resemblance – though it is more in the nature of a caricature – to Mantegna's work and of the picture's location in the Palazzetto belonging to Mantegna's Roman patron, Cecchelli maintained that the fresco in this lunette was by Mantegna. The theory was rejected by Fiocco and Cipriani; other critics do not mention it. The picture is not in good condition as there are a number of bald patches and it is discoloured.

Mantegna in which her head is uncovered and her hair hangs loosely (Hartt); behind her, an enormous rock which seems about to explode gives off a curious reddish light; for once, the landscape does not seem to be strewn with classical remains but features, instead, scenes of everyday life. Towards the horizon, the green of the earth seems to merge into the pale sky. Knapp has

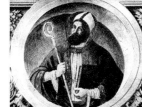

Details of frieze in the Map Room in Palazzo Venezia, Rome (no. 67). (top): medallions with the image of St Ambrose and St Gregory the Great. Below the medallions: sphinxes and other decorative motifs which serve as a general framework for the various medallions featuring saints.

seen in the quarry men on the right a reference to the quarries of Carrara (though the colour of the rock does not seem to bear out this theory). Kristeller pointed out that since the rock appeared to be basaltic, the landscape could be identified as Mount Bolca between Vicenza and Verona. Note the small stones – almost like gems – scattered about in the foreground at the Madonna's feet. Hartt has worked out a detailed interpretation of the various iconographic features: according to him, the picture constitutes an allegory of the Redemption, since to the right of the Child the landscape is shrouded in darkness, there is no vegetation and the line of the rock is jagged and tortuous while, on the other side, the rock face is almost sheer, the city is bathed in the light of the noonday sun, the fields are full of waving corn and the shepherds quietly tend their flocks. In particular, he goes on, the sarcophagus and pillar on which the quarry men are

69 83×51 *1489* Christ on Tomb Supported by two Angels (Pietà)

Copenhagen, Statens Museum for Kunst
This work is signed "ANDREAS MANTINIA" in letters of gold on the corner of the base of the sarcophagus in the bottom right-hand corner of the picture. The city of Jerusalem is in the background to the left and on the road running from it may be seen the figures of two women – possibly the holy women – more or less level with some shepherds who are playing musical instruments. On the other side, at the foot of the hill of Calvary, there is a quarry with stonemasons at work on a column, a statue and other things. Panofsky (FF) and Hartt (AB, 1940) believe the work to be an *Imago Pietatis*. A picture featuring the same theme is listed in the Gonzaga Castle inventory compiled in 1627, though the work now under discussion

working are symbols of the Passion. Though the theory is an attractive one, it is not altogether convincing. Yriarte, Venturi, Cipriani, Longhi, Camesasca and others all accept as true Vasari's statement that he saw the work in the home of Don Francesco de' Medici. Vasari further stated that the picture had been painted in Rome (1488–90). Knapp and Fiocco believe it to date from Mantegna's Florentine period (1466); so do Kristeller and Paccagnini who, however, put the date of execution two years later and connect it with the *St George* in Venice (no. 41). Tietze-Conrat interprets a letter written by Mantegna to Lorenzo de' Medici on 26 August 1484, in which he mentions the dispatch of "a few little works" as referring to the picture under discussion; however, it should be noted that there is no mention of it in the inventory of Medici property compiled in 1492. Tietze-Conrat has in any case herself shown that it was only towards the end of the fifteenth century that artists began to depict the Madonna without the traditional attributes of majesty.

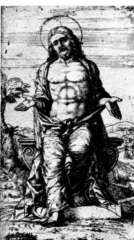

Engraving (208 × 112 mm.) generally attributed to an artist of Mantegna's immediate circle and connected iconographically with painting no. 69.

came (eighteenth century) from the collection of Cardinal Valenti, secretary to Benedict XIV. Krohn (*Italienische Bilder in Dänmark*, 1910) thought in terms of an early work but linked it with the Vienna *St Sebastian* (no. 43.), while the other critics are agreed in assigning it to Mantegna's Roman period. Tietze-Conrat would go further and date it in 1490. In her commentary, Cipriani has drawn attention to Mantegna's change of tone: his customary smooth presentation of the subject is here shattered and becomes instead "an energetic affirmation, proclaimed with something approaching bitterness, in which the grief is conveyed by a consistent puckering of the outlines". It is probably an oil painting and is in good condition.
Borenius mentions two prints (listed by Bartsch: *Mantegna*, no. 7 and *Zoan Andrea*, no. 4) which may mean that there are a number of versions of this composition. However, the connection which Kristeller believed to exist between this work and another painted version available on the London market in his day has

70

71

catalogue of the works of art owned by Charles I of England compiled by Vanderdoort also mentioned a *Judith* which it attributed to Raphael and which was given to Lord Pembroke in exchange for a Parmigianino Finally, Caval-caselle and Kristeller saw this work at Wilton House, a Pembroke property.
Both scholars rejected the attribution to Mantegna and postulated instead its execution by late imitators of the master. In addition to Kristeller, Borenius (Crowe and Cavalcaselle) Berenson (1896) and Cruttwell stated that the work was not by Mantegna. Later, however, Berenson himself revised his opinion (AA, 1918), whereupon most critics accepted his view and

Andrea at the Albertina) executed by someone else.

75 ⊞ ⊗ 46×36 1490*

Judith
Dublin, National Gallery of Ireland
This monochrome composition on a grey marble-like back-ground veined with ochre is almost the same as the one featuring the same theme now in Montreal (no. 76) and, indeed, also resembles a corresponding engraving by Zoan Andrea. According to Duncan, (BM, 1906), it is part of a series featuring famous and notorious women. Berenson (1910), Schwabe (BM, 1927) and Fiocco hold that it is by Mantegna but of very poor quality; Paccagnini and Camesasca regard it as being largely his work. Tietze-Conrat agrees that the con-ception is undoubtedly Mantegna's, dating from 1490 or thereabouts, but does not commit herself as to its execution. Venturi, followed by Cipriani, held that the work was done in the *bottega*.

76 ⊞ ⊗ 64×30'

Judith
Montreal, Art Association
This work is done in mono-chrome heightened with golden-yellow on a background simulating grey marble. The theme is the same as that of the corresponding works in Washington and Dublin (nos. 74 and 75) and of a number of drawings by Mantegna and his immediate circle. Like its companion picture featuring *Dido* (no. 77), the work was acquired from the collection of J. E. Taylor in London. Kristeller identified the two pictures with items listed in the inventory of the contents of the *studiolo* of Isabella d'Este (1542), but his identification may not be reliable. He concluded that both had been executed in the *bottega*, an opinion which has been endorsed by Tietze-Conrat, Paccagnini and others. Berenson, Fiocco and Cipriani hold that they were done by Mantegna. Cipriani has compared the Montreal *Judith*



proved to be unfounded, since the second work was in fact Carpaccio's *Meditation on the Passion*, now in the Metro-politan Museum, New York.

70 ◇ ⊗ 52×65

Christ Carrying His Cross
Verona, Museo di Castelvecchio
Berenson held that it was either a copy of a lost original by Mantegna or was in fact a Mantegna original much impaired by retouching. Fiocco, basing his opinion on a comparison with another work said to be by Mantegna, such as the similar picture now in Oxford (no. 71) declared that it was definitely a Mantegna original, though much deteriorated. Tietze-Conrat does not list it among the works which are definitely by Mantegna, but adds that it certainly resembles the Copen-hagen *Christ* (no. 69) more closely than any other. Cipriani is doubtful; Paccagnini attributes it to Francesco Mantegna. The poor state of preservation makes it impossible to make any fresh assessment.

71 ⊞ ⊗ 62×77,2

Way of the Cross
Oxford, Christ Church College
The composition resembles that of the *Christ Carrying His Cross* in Verona (no. 70). The picture was listed in the Gonzaga

inventory compiled in 1627. Immediately after this, it was acquired by Charles I of England together with the other works purchased by him in Mantua; it was later in the collection of General J. Guise. It was originally ascribed to Mantegna himself but critics generally (Fiocco and others) have long held the view that it was a *bottega* work or else ignored it completely.

72 ⊞ ⊗ *1490

Portrait of Maddalena Sforza
"The head of the illustrious M. Maddalena done by Mantegna in profile": so runs an item in the inventory (Biblioteca Oliveriana, Pesaro) of the contents of the library of Giovanni Sforza in Pesaro, compiled on 21 October 1500 (Camesasca). As the subject of the portrait died on 8 August 1490, the picture may have been painted before that date. There seems to be no further record of the painting.

73 ⊞ ⊗ 210×91 1490*

St Sebastian
Venice, Ca' d'Oro
The inscription on the scroll round the candle in the bottom right-hand corner of the picture reads: "NIHIL NISI DIVINVM STABILE EST. COETERA FVMVS". ("Only the divine is stable. The rest is

smoke"). After Mantegna's death, his son Ludovico listed this picture among the works left in the *bottega*, together with others (including nos. 57 and 96). It had apparently been intended for Bishop Ludovico Gonzaga (see *Outline biography*, 1506). It was later owned by Cardinal Bembo, in Padua. Most critics hold that it is one of the last works executed by Mantegna. Pallucchini (1946) specified the end of the fifteenth century; Tietze-Conrat thought it might have been executed somewhat earlier, round about the same time as the *Triumph of Caesar* (no. 63). Camesasca has pointed out that any true attempt at dating is difficult since the picture has been extensively repainted over (possibly by one of Mantegna's sons) in addition to being partially repainted to put the loin-cloth on. However, he is inclined to accept the dating of the work in 1490, though he believes it may well have been designed several years earlier.

74 ⊞ ⊗ 30,5×18 *1490*

Judith
Washington, National Gallery of Art (Widener Collection)
The inscription "An. Mantegna" appears on the back. There was a small painting of the same theme among the effects of Lorenzo the Magnificent in Florence in 1492. The

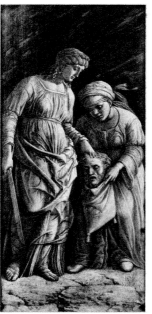

73

dated it among the master's very last works (Fiocco). The exceptions are R. Schwabe (1927) and Tietze-Conrat who believes the picture to represent a conception by Mantegna himself or one of his immediate followers (as may be seen from a print by Zoan

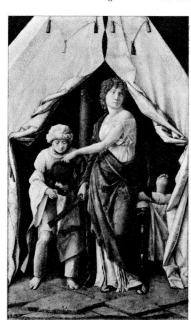

74

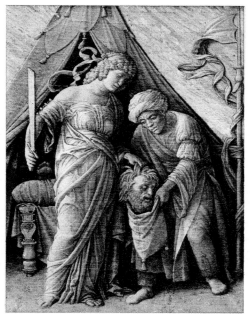

75

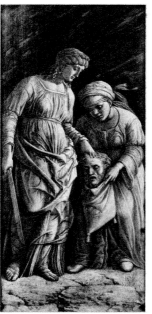

76

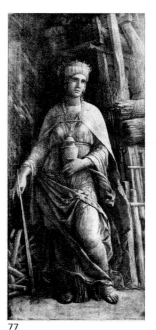

77

with the same composition in the Mantegna chapel in the Church of S. Andrea in Mantua. No data concerning the technique are available.

77 ⊞ ⊗ 64×30 ▤ ⋮
Dido
Montreal, Art Association
The Queen of Carthage is depicted standing beside her own funeral pyre. For all other details, see no. 76.

78 ⊞ ⊗ 40,8×34 1490-1500 ▤ ⋮
Mucius Scaevola
Munich, Staatliche Graphische Sammlung
This is a greyish-brown monochrome on a pale brown background with the light areas sharply emphasized. Michiel (1512) saw a small monochrome featuring this theme at the Zio residence in Venice; Vertue (1757) spoke of one in the collection of Charles I of England. Tietze-Conrat has suggested convincingly that the original was larger and that the missing portion, featuring King Porsenna, is referred to in the description of a painting depicting "a man seated on a throne surrounded by courtiers, done in watercolour with the light areas heightened" ascribed to Mantegna in an inventory of Gonzaga property in Novellara (Campori). Kristeller, Tietze-Conrat and Paccagnini have all held that Mantegna was not directly responsible for the Munich work. Berenson, followed by Fiocco and Camesasca, attributed to him, though with some collaboration. Fiocco and Camesasca date it at the end of the century. The picture is in a poor state of preservation.

79 ⊞ ⊗ 48,5×36,5 ▤ ⋮
The Sacrifice of Isaac
Vienna, Kunsthistorisches Museum
This is a monochrome work executed to create an impression of marble figures against a green stone background. Both this picture and *David* (no. 80) were included in the Palazzo Ducale inventory of 1627; later (1659) both were listed as works by Mantegna in the collection of the Archduke Leopold William of Austria. Kristeller (JKS, 1912), Berenson and Oberhammer (1960) believe them to be by Mantegna. So too does Fiocco, though he holds that there was a good deal of collaboration in their execution, which he dates immediately after 1490. Tietze-Conrat maintains that it is a *bottega* work, possibly based on drawings by Mantegna.

80 ⊞ ⊗ 48,5×36,5 ▤ ⋮
David
Vienna, Kunsthistorisches Museum
This, too, is a monochrome work, though the background in this case is made to resemble stone the colour of old gold. Cf. the commentary on no. 79.

81 ⊞ ⊗ •1481-94• ▤ °°
Decorative work
Mantua, Formerly in the Castle at Marmirolo
As early as April 1481 (see *Outline biography*).

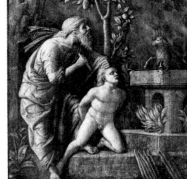

78

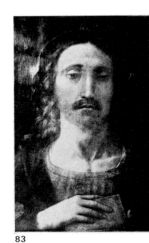

79

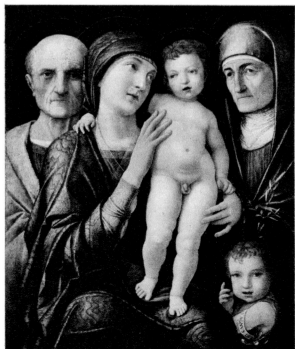

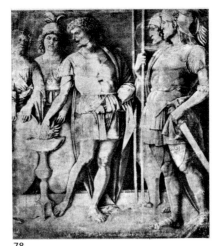

Engraving by an artist in Mantegna's circle, connected with no. 74.

Detail of frescoed decoration of the Mantegna memorial chapel in the church of S. Andrea in Mantua (cf. no. 76). The cycle was executed after Mantegna's death by his sons and other artists on the basis of his own designs.

Pen and charcoal drawing (350×200 mm.; National Gallery, Washington); see no. 76.

Mantegna was making trips to Marmirolo in connection with the decoration of the Gonzaga residence there, of which only a few ruins now remain. From a series of letters sent to the ruler of Mantua between 1491 and 1494 we learn that the artist's son Francesco, F. Bonsignori and two other individuals named Benesella and Tondo were working at the castle under Mantegna's supervision. At that time, the team was engaged on the "Horse", "Map" and "City" rooms as well as on another referred to as the "Greek" room. The decoration of this last room included representations of Constantinople, Adrianople Gallipoli, Vlonë, Rhodes (featuring the siege by the Turks), and another theme which is not expressed very clearly but which was also connected with the Turks and over which were to appear the words (1494): "ET BACHANALIA VIVVNT". It is quite probable that the picture of "a number of Turkish women going bathing and other figures (seated) at the mosque" said to have been executed by Tondo as also that of "the head of the Turkish ambassador" done by Bonsignori were located in this room. It is also known that, possibly in connection with one of these "cycles", Francesco Mantegna had done a portrait of the King of France with which, however, the client was not satisfied. Furthermore, the records speak of a "picture" by Tondo, though this might have been a fresco; there is mention of a "picture of Brescia" – evidently in the "Cities" room. Finally, from 1491 onwards, there were artists at work executing some "Triumphs" on canvas "as Andrea Mantegna has done". It is a reasonable assumption that the reference is to a replica of the *Triumph of Caesar* or of the "*Trionfi*" of Petrarch (no. 63 and no. 90).

82 ⊞ ⊗ 1493 ▤ °°
Portrait of Isabella d'Este Gonzaga
This portrait was commissioned from Mantegna in January, 1493. Isabella intended to send it to the Countess of Acerra. On 20 April 1493, she wrote to the Countess to apologise for not having sent the portrait yet, adding by way of explanation that the artist had not produced a satisfactory likeness. She was therefore

forced, she said, to try another artist (she chose Giovanni Santi, the father of Raphael). Writing in 1913, Luzio denied that the first and unnamed artist was Mantegna. On the other hand – as Tietze-Conrat has pointed out – if, in fact, Isabella is not depicted in the *Madonna della Vittoria* (no. 93), this may well be on account of her dissatisfaction with the portrait under discussion.

83

83 ⊞ ⊗ 53×43 1493 ▤ ⋮
Christ the Redeemer Blessing
Correggio, Congregazione di Carità
There is an inscription running vertically down the left-hand side of the picture (and most scholars tend to copy it wrongly): "MOMORDITE VOSMET IPSOS ANTE EFIGIEM VVLTVS MEI" ("Grieve yourselves – or: Let you too grieve – before the image of my face"); lower down, underneath another inscription visible on the cover of the book the following may be deciphered: "JA P. C. S. D. D. MCCCCLXXXXIII – DV JA", which Frizzoni (L, 1916) interpreted as follows: "(Mantin)IA P(inxit) C(um) S(uis) [or: C(haritate) S(ua)] D(ono) D(edit) [or D(omino) D(icavit)— 1493 D(ie) V (fifth) JA(nuarii)". Most critics have agreed in attributing it to Mantegna, though Berenson does not mention it and Tietze-Conrat is rather doubtful. Restoration work carried out in 1959 successfully removed the earlier attempts at repainting; the very thin layer of colour makes it clear that the picture had already been cleaned at some time in the past.

84

84 🏛 ⊕ 75,5×61,5 *1495* 📋 ⁞

Sacra Conversazione
Dresden, Staatliche
Gemäldegalerie
There is no positive means of
identifying the two saints.
behind the Madonna with the
Child and St John the Baptist.
Kristeller thought they were
Joseph and Elizabeth, though
other critics hold that they are
Joachim and Anne. The boy
Baptist (who, in Cipriani's
view, is somewhat in the style
of Leonardo) has a scroll round
his arm with the words "... CE
AGNVS DEI ..." Ridolfi's
description (1648) of a work
with "the half figures of the
Madonna with Child, a saint
on either side and the young
Baptist" which he saw at the
residence of Bernardo Giusti in
Venice, may be a reference
to this picture.
Cavalcaselle, Yriarte and others
thought it may well have been
the picture executed in 1485
for Eleonora d'Este, though
most critics believe the latter to
have been the Brera Madonna

85

(see no. 62); Paccagnini
suggests that it may be one of
the works which the Gonzagas
were in the habit of sending to
their friends, as we learn from
a letter written in 1491. What-
ever the truth of the matter, it
is thought to have been
executed between 1495 and
1500 and is regarded as one
of the finest compositions
produced by Mantegna during
this period. According to
Tietze-Conrat, the Child is a
variation of the one featured in
the *Madonna della Vittoria*
(no. 93)

85 🏛 ⊕ 71×50,5 *1495* ? 📋 ⁞

**The Holy Family and the
Boy Baptist
(Imperator Mundi)**
London, National Gallery
Against the customary back-
ground of citrus fruits, the
Child is depicted as lord of the
universe with a globe and an
olive branch in his hand.
Behind him stands the boy
Baptist holding a long scroll
with the end of an inscription:
"... DEI", together with
St Joseph and the Madonna,
apparently sewing. Kristeller
suggested that the semi-
circular parapet surrounding
the Madonna was the mystical
well ("fountain sealed") in the
"garden enclosed" of the
Song of Songs. However,
Davies (1951) commented on
the inappropriateness of
depicting the Madonna in a
well. Kurz (1910) thought that
the originality of the com-
position (at least as regards the
well) was a reflection of the
version in the Petit Palais in
Paris (which was quite
unfoundedly also ascribed to
Mantegna). The picture was in
the collection of Cavalier

Andrea Monga of Verona in
1856. J. P. Richter acquired it
in 1885; he subsequently
parted with it to L. Mond, who
left it to the National Gallery.
Davies, Cipriani and others
accept the traditional attribu-
tion of the work to Mantegna.
Tietze-Conrat believes that only
the idea was his; in view of its
poor state of preservation,
there does not seem to be any
point in mentioning the full
range of suggested attributions
In 1930, the extensive
repainting done by Colnaghi
was removed (among other
things, he had placed a book
in the hands of the Madonna)

86 🏛 ⊕ 46,5×37 *1495* 📋 ⁞

Judgment of Solomon
Paris, Louvre
This is a monochrome work
made to resemble relief work
in grey stone against a wine-
coloured marble-like back-
ground (not reddish green as
Tietze-Conrat says).
Camesasca has commented on
the affinity between this work
and the *St Christopher before
the King* painted by Ansuino or
other artists in the Ovetari
chapel (see p. 88). It may
perhaps be the painting listed
in an inventory of the works of
art owned by Bishop
Coccapani of Reggio Emilia,
together with a drawing of the
same subject (Campori). The
traditional attribution of the
work to Mantegna was denied
by Berenson (1901), but he
later revised his opinion and
dated it towards the end of the
artist's life. Kristeller and Fiocco
point to evidence of collabora-
tion; so too do Paccagnini and
Camesasca. Tietze-Conrat

*Painted copy, with variations,
of no. 85 (Petit Palais, Paris).*

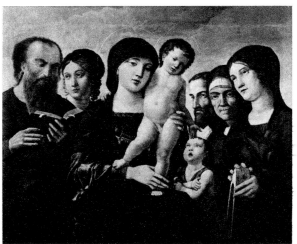

88

maintains that it was executed
entirely by assistants, to a
drawing by Mantegna. All
critics date it 1495 or
thereabouts. Camesasca
thought that the background
might well have been entirely
repainted.

87 🏛 ⊕ 168×146 *1495* ? 📋 ⁞

Occasio et Poenitentia
Mantua, Palazzo Ducale
This picture was originally in
the Palazzo Biondi in Mantua,
where it served as decoration
over a fireplace. Various
attempts have been made to
interpret the allegory, notably
by van Marle (*Iconographie de
l'art profane*, II), Warburg
(*Gesammelte Schriften*, I) and
Wittkower (JWCI, 1937–8).
Most scholars regard it as a
work of the Mantegna school,
possibly by Antonio da Pavia
(Kristeller). The conception,
which is rather fine, would
certainly seem to be
Mantegna's own though,
according to Fiocco, he was
unable to complete the execu-
tion (his touch may possibly be
discerned in the head of the
figure of the penitent).
Paccagnini maintains that
Mantegna never even started it.

88 🏛 ⊕ 61,5×87,5 *1495* 📋 ⁞

**Madonna with Child, the
Boy Baptist and five other
Saints**
Turin, Galleria Sabauda
The last saint on the right-hand
side can be identified as
St Catherine of Alexandria on
account of the wheel. The
picture came from the Royal
Palace in Turin. Kristeller,
whose opinion has been
endorsed by other critics, felt
that this was a *bottega* work.
However, even Cavalcaselle
had attributed it to Mantegna,
probably with the collaboration
of Caroto. Most critics are now
inclined to the view that it is a
Mantegna work. All except
Fiocco agree in dating it
towards the end of the artist's
life. The picture was impaired
by extensive retouching, much
of which was removed when it
was cleaned recently. Even so,
the upper left-hand portion
proves to have been entirely
redone.

89 🏛 ⊕ — *1500* 📋 ⁞

**Cardinal Georges
d'Amboise of Rouen
Venerating the Baptist**
This picture, described as a
work by Mantegna, was given
to the subject of the portrait by
the Marchioness Isabella

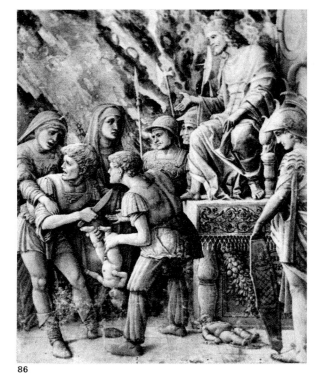

86

87

Gonzaga in the year 1500.
Tietze-Conrat thought
the artist may have copied the
Cardinal's likeness from a
medal, of which there exists
also a carved panel, now in
the Metropolitan Museum,
New York (AQ, 1945).

90 🏛 ⊕ — *1501* 📋 ⁞

The "Trionfi" of Petrarch
From the description of a
theatrical performance
presented in Mantua in 1501
given in a letter by Cantelmo
(D'Ancona, *Origini . . .* II,
1891), we learn that the
Triumph of Caesar (no. 63)
was used as the stage set
while the front stage was
decorated with a further series
of *Trionfi* painted by Mantegna
using Petrarch as his source.
Several attempts have been
made to adduce as further
evidence of this the six small
panels (51 × 53.8 cm.)
acquired by the National
Gallery (Kress Collection) in
Washington, and
universally attributed to the
Mantegna school by recent
critics. Venturi asserts that
there is evidence for a plastic
transposition of these *Trionfi*
in the ivory reliefs on two
chests in Graz cathedral
(which Fiocco, too, is inclined
to believe are derived from
designs by Mantegna). This
theory is much debated by
recent critics.

Paintings for the studiolo of Isabella d'Este Gonzaga

In accordance with the
humanist custom of the time,
Isabella d'Este Gonzaga wanted
to have an apartment where
she could study and reflect.
The scheme probably dates
from the year 1495 or so.
Kristeller says that the
"program" of subjects for the
paintings which were to
decorate the apartment was
prepared by Isabella herself in
consultation with her erudite
friends, including Paride
Cesarara in particular. Tietze-
Conrat questions the existence
of any such "program", since
in any case such "ideas"
would have had to be adapted
to circumstances and to the
particular bent of the artists
called in to do the work. The
fact remains, however, that the
extant commission agreement
signed with Perugino in 1503
contains a meticulously
detailed description of the
theme for decoration. More-
over, when Giovanni Bellini
was approached with a view to
executing one canvas in the
series (1501), he tried in vain
to secure for himself a free
hand in its execution and
ultimately turned down the

commission (1506). Although the original frames for the paintings – for which Mantegna himself submitted suggestions – are still in one of the rooms of the palace in Mantua, it is not known quite how the pictures were first arranged. We do know that the series included not only the three paintings by Mantegna discussed below but also an *Allegory* by Lorenzo Costa and the *Battle between Love and Chastity* by Perugino, all of which are now at the Louvre in Paris. The full story of their "adventures" is still somewhat obscure in spite of the efforts made by Camesasca to clarify them (*Tutta la pittura del Perugino*, 1959). The five pictures were left in the suite even after the death of Isabella; they were certainly transferred to what was known as the "Paradise Suite" (in the same palace) in 1605. They were acquired by Cardinal Richelieu at some subsequent date, certainly before 1627; they remained in the Château

Du Plessis until 1801 when they were earmarked for the Louvre.

91 160×192 *1497

A. Parnassus
Although this picture has consistently been given the title *Parnassus*, a Gonzaga palace inventory compiled in 1542 gives a more appropriate description: "Mars and Venus fondle each other, with Vulcan, Orpheus playing and nine Nymphs dancing". There is no mention of Apollo, without whom no representation of Parnassus would be complete. Moreover, the identification of the figure on the left as Orpheus would seem to be reliable; if it were Apollo, he would surely be portrayed in a dominant position among the Muses. The fact that the artist did indeed intend to depict the nine Muses would seem to be confirmed not only by their

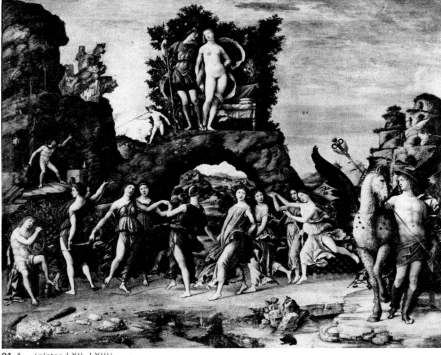

91 A (plates LXII–LXIII)

number but also by the detail of the crumbling mountains at the top left-hand side, in accordance with the tradition that their singing caused volcanic eruptions which were then stayed by Pegasus stamping his hoof on the ground (Wind, AB, 1949). The winged horse, just about to stamp his hoof, is on the right beside Mercury, who is known for the protection which he and Apollo afforded to the intrigue between Venus and Mars. Vulcan, the faithless goddess's legitimate consort, is visible on the left at the mouth of the cave which serves him as forge and where the tools of his trade are to be seen. There is no need to comment on the gesture he is making to the lovers on the rock, standing as they are in front of a bed which speaks for itself. Even so, the critics are by no means agreed as to the correct interpretation of this work. Förster (JPK, 1901) thought the Muses seemed to disapprove of the illegitimate union between Mars and Venus. Citing the epithalamium composed by A. M. Salimbeni in 1487 for Isabella Gonzaga's sister, Tietze-Conrat pointed out that the association was by no means frowned upon by men of letters at the Court of Mantua. Wind elaborated a highly complicated interpretation of the painting, based on the works of Homer, which were circulating from 1488 onwards in translations done by such humanist figures as Lorenzo Valla and Raffaele da Volterra. However, he concluded that the tone of the Greek source has here been interpreted as a kind of "burlesque heroism" and, by forcing the poses of the dancers somewhat, he deduced a pornographic meaning. This conclusion was vigorously rejected by Tietze-Conrat, who argued that nowhere in either classical or Renaissance literature is there any hint of frivolity on the part of the Muses. In discussing the aesthetic and philological side of the work, Fiocco – followed by Paccagnini – thought he saw in it some presage of the chromatic discoveries which were to be made in Venice at the beginning of the sixteenth century. He further suggested a comparison between this Venus by Mantegna and Botticelli's

Birth of Venus now at the Uffizi, but it should at least be remembered that Botticelli had produced his own "mythology" some twenty years earlier. The picture has been extensively painted over; one such attempt – positively identified by Camesasca – was responsible for the unusual lightness of the Muses, an

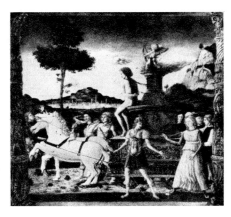
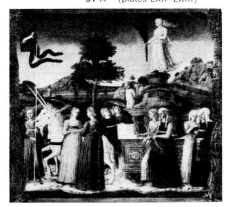

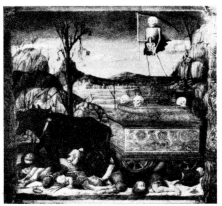
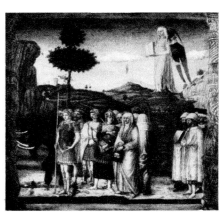

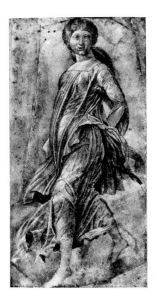

The "Trionfi" of Petrarch, *now in Washington (no. 90). (from top to bottom and from left to right)* Love; Chastity; Death; Glory; Time; God the Father (or Eternity). *This order (which is in no way suggested by the paintings) is that given in Petrarch's* Trionfi *on which they are based.*

Drawings (now in Graphische Sammlung, Munich and Kupferstichkabinett, Berlin, respectively) connected with painting no. 91.

117

91 B (plate LXIV)

91 C

impression which has been created because one of the would-be restorers misjudged the placing of the ground beneath their feet. All critics agree in attributing the work to Mantegna and in regarding it as the first panel in the series. Two important drawings are connected with this painting. Both are characterised by the fact that the figures they portray (the first and fourth Muses from the right) correspond exactly to those in the painting. So, too, does the technique: pen and watercolour heightened in white. One of these drawings (Staatliche Graphische Sammlung, Munich) was believed by Morelli (1880) and Kristeller to be a *bottega* copy, but was later said to be a Mantegna original by such critics as Berenson (1900–1), Clark (1930) and Popham (1931); this view was again rejected by Fiocco and Tietze-Conrat, though re-advocated by Degenhart (1958) who held that Mantegna had himself cut the figure from the full cartoon for the painting in order to use it as a *spolvero* (in fact, the outline of the figure is partially perforated), as also by Möhle (1959) and A. Mezzetti. However, Ragghianti (1962) upheld the theory that the drawing had been done by a

disciple of Mantegna. The second drawing (Kupferstich-kabinett, Berlin — acquired from the collection of A. von Beckerath in Berlin) was unknown to "standard" Mantegna scholars, but was linked with the Munich one, as regards both origin and quality, by Degenhart, Möhle and Mezzetti. Möhle drew attention to the evidence of retouching which he attributed to Mantegna himself, though Camesasca suggests that it was done later.

91 ⊞ ⊕ 160×192 *1504* ▤ ⦂

B. The Triumph of Virtue
Förster (JPK, 1901) identified the theme as Minerva driving Venus and the Vices from the garden of Virtue, as indicated in the long scroll wound around the *Mater Virtutum* (on the left), who is imprisoned in an olive tree and is seen invoking the cardinal Virtues (which appear framed in clouds in the sky to the right). Though the colouring of the mountain is that of the Dolomites, there is a darker strip of colour just above the level of the foliage which can only be satisfactorily explained by supposing the picture to have been painted over. It is

suggested that the literary sources used by the artist were the *Hypnerotomachia Poliphili* (Venice, 1472) and *De genealogia deorum gentilium* by Boccaccio. Most critics agree that the picture constituted the second "panel" in the series, and date it in 1502 or thereabouts. It provides a kind of anthology of Mantegna's most usual motifs; the figures are squashed in uncomfortably and the rhythm is lost because the group is foreshortened in a Bosch-like "anxiety to reach the pre-arranged apex within the triangular foreground scheme". The foliage, which may have been done in the *bottega*, is lifeless. On the other hand, the sky is dazzling and already "foreshadows the heroic-cum-sentimental lyricism of Altdorfer" (Camesasca).

91 ⊞ ⊕ 160×238 *1505* ▤ ⦂

C. Myth of the God Comus
This is the third "panel" in the series. It was begun by Mantegna and finished, after his death, by Lorenzo Costa. From a letter written by Calandra to the Marchioness Isabella (15 July 1506) we learn that "Master Andrea" had executed (on the left of the

picture) the figure of Comus, the god of joy, seated on a throne between *amorini* and two "Venuses", one naked and the other clad in a robe, and beyond the gateway three figures which are said to be about to fly. The inscription "Comes" on the gateway and the symbolic elements in the composition were analysed by Wind (*Bellini's Feast of the Gods*, 1948) and by Tietze-Conrat, though they came to conflicting conclusions. The painting would seem to be a portrayal of the god Comus in connection with the marriage of Bacchus and Ariadne, though it is precisely over the identity of the main protagonists that critics are at variance. All agree that it is now impossible to pinpoint the sections executed by Mantegna: this is partly because Costa may well have repainted the whole thing, (possibly altering the original composition in the process), but partly also because Mantegna himself may have been painting with the intention of imitating Perugino.

92 ▦ ⊕ 54×42 *1495-1500* ▤ ⦂

Ecce Homo
Paris, Musée Jacquemart-André
The two scrolls at the top convey visually the howls of the crowd against Christ. The figures on either side of Christ (usually believed to be two in number, though, in fact, there are at least four), one of whom has a Hebrew text on his head, have been variously interpreted as soldiers or, alternatively, personifications of the Jews and the Gentiles. According to Fiocco, the picture was acquired from Bardini, the Florentine antiquarian. Nearly all critics (down to Tietze-Conrat, etc.) have attributed the work to the Mantegna school: Kristeller thought it resembled the work of Liberale da Verona; Venturi suggested that it was done by Francesco Mantegna. Cipriani has rightly commented on its "very high quality, closely akin to the style of Andrea himself towards the turn of the century".

93 ▦ ⊕ 280×160 1496 ▤ ⦂

Sacra Conversazione (Madonna della Vittoria)
Paris, Louvre
The Madonna, with the Child on her lap and the boy Baptist (holding a cross and a scroll with the traditional inscription) on the right, leans from her throne to bless the Marquess Francesco Gonzaga, who is portrayed kneeling on the left of the picture, behind him stand the figures of St Michael and St Andrew, with St Longinus and St George (with a broken lance as in the Venice painting – no. 41) in the corresponding position on the other side. In front of these latter is the kneeling figure of a woman whom Vasari took to be St Elizabeth and others St Anne, while modern scholars believe her to be either the Marchioness Isabella (though the figure is depicted with a small halo) or a woman called Osanna, who was then living in Mantua and was popularly regarded as a saint. The small rose ornament in the base of the throne bears an invocation and alleluia to the Madonna. The support on

which the throne rests features a work in relief portraying the original sin, in reference to the redemption of Christ. Tietze-Conrat maintains that a similar reference is to be deduced from the string of coral hanging down from above. The Marquess Francesco himself offered the altarpiece to the Cappella della Vittoria in Mantua in thanksgiving for the slender victory he had secured over the French at Fornovo on 6 July 1495. In 1493, a Jew named Daniele de Norsa bought a house in Mantua which contained a frescoed picture of a *Madonna and Saints*. Although the local ecclesiastical authorities, led by Sigismondo Gonzaga who held the office of vicar at the time, had authorised the removal of the picture, it nevertheless caused an uproar which resulted in de Norsa being ordered to pay a fine of one hundred and ten ducats. It was decided to use this sum to pay Mantegna for painting a new picture which was to be donated to the above-mentioned chapel, then only recently built. The original plan was for a Madonna della Misericordia, who was to be depicted sheltering the victorious Marquess and his brothers beneath her cloak on one side and his wife on the other. A few weeks later, it was agreed that St George and St Michael (to whose company St Andrew and St Longinus were later added) should be shown holding the Madonna's cloak. Wind (*Bellini's Feast of the Gods*, 1948) maintains that the general composition of the altarpiece was dictated by Isabella. If so, one might well wonder why she was, apparently, excluded from the picture: Tietze-Conrat suggests that it was because Mantegna had failed to produce a satisfactory portrait of his patron (but see no. 82). On the first anniversary of the Battle of Fornovo (6 July 1496), the picture was solemnly carried to the position it was intended to

92

occupy (which, according to Vasari, had been prepared by Mantegna himself though Luzio names B. Ghisolfi as the person responsible), amid scenes of wild rejoicing. The work remained in this position until the French took it to France with the rest of Napoleon's spoils in 1797. According to Tietze-Conrat, the Madonna's gesture is derived from Leonardo's *Virgin of the Rocks*; she makes the same claim for the pergola structure in the background. This, with its glimpses of the sky, is said to reflect some of the tricks already used by Mantegna in the chapel of Innocent VIII in Rome (no. 65) (Paccagnini).

Taken as a whole, the work, which such an early critic as Lanzi had lauded for its mellowness of design, provides evidence of Mantegna's "extraordinary capacity for renewal". Cavalcaselle, on the other hand, commented on the lack of proportion between the various figures and a certain hardness of execution for which he held the artist's collaborators responsible. These considerations have induced recent critics too to express reservations (Longhi, 1962; etc.). Nevertheless, Camesasca points out that this "colossal miniature" may well have been absolutely appropriate in its original setting particularly if this was, in fact, designed by Mantegna himself who, according to Bettinelli (*Delle lettere ... mantovane*, 1774) certainly

Drawing done in white on dark paper (273×166 cm.) connected by a number of critics with painting no. 93.

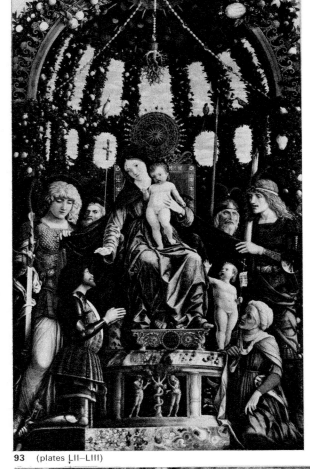

93 (plates LII–LIII)

designed the frame, which was subsequently lost. The picture is in a good state of preservation.
There is at the Palazzo Ducale in Mantua a brush drawing done in white on a dark background; it is the same size as this *Sacra Conversazione* except that there is a section missing at the bottom, so that its measurements are 273× 166 cm. It is an exact copy of the Louvre painting. Ozzola (CI, 1942) published it as a Mantegna cartoon, which he suggested might have been executed for submission to the Marquess Francesco for approval, since the latter was in Venice at the time. Fiocco (RA, 1941 and BM, 1949) declared that it was a tracing done when the altarpiece was taken to Paris. Tietze-Conrat is of the opinion that the drawing was connected with the preparations for the painting, though she is unable to account for the fact that it was not used (it would have had to be perforated in order to transfer the design to the support and this would almost certainly have destroyed it completely). Cipriani and Camesasca endorse Fiocco's views.

94 287×214 *1497*

Sacra Conversazione (Trivulzio Madonna) Milan, Museo del Castello Sforzesco
One of the three singers at the bottom of the picture is holding in his hand a document bearing the artist's signature and the date: "A. Mantinea pi. an. gracie 1497 15 augusti". There is a second inscription, relating to the Baptist, on the scroll wound round the citrus tree on the left. The various figures, in addition to the Madonna and Child surrounded by cherubim are generally believed to represent: St John the Baptist and St Gregory the Great, St Benedict and St Jerome. Below are the three singing angels already mentioned. The work was originally on the high altar in the church of S. Maria in Organo in Verona (St Jerome is said to be holding a wooden model of this church: Mellini-Quintavalle), for which it was painted (as we learn, indirectly, from a letter written in 1496 [see *Outline biography*] by the monks attached to the church). Tietze-Conrat says that the pose of the Baptist is akin to that of a figure engraved by Schongauer (Bartsch, no. 54) which may well have been known to Mantegna. The altarpiece was recently cleaned and restored by Pellicioli so that it is now possible to see not only the "harsh contrapuntal range that

is unavoidable with very dry tempera" (Cipriani) but also a number of rather sugary colour passages.

95 47×37 *1495*

Samson and Delilah
London, National Gallery
This is a monochrome work made to simulate a marble bas-relief against a background of black, red and yellow stone. On the trunk of the tree appear the words: "FOEMINA / DIABOLO TRIBVS / ASSIBVS EST / MALA PEIOR" ("A bad woman is three times worse than the devil") a saying which was already current in the Middle Ages, principally in books of magic. Tietze-Conrat sees a satirical comment on the words in the contrast between the vine growing round the tree and the spring water. The

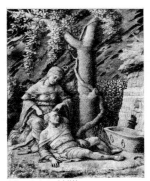

95 (plate LVII)

representation is the traditional one of the moment when Delilah cuts the hair of the Jewish Hercules while he is asleep. Knapp is the only critic who has questioned the attribution to Mantegna; the others are all agreed that the painting was done by him towards the end of his life, possibly round about 1495, though Camesasca is inclined to date it a few years earlier. Both Cipriani and Camesasca regard it as the best "piece" in the series of monochrome works of more or less the same size now in various museums in Dublin, Vienna and Paris.

96 73.5×268 *1500*

Introduction of the Cult of Cybele to Rome (The Triumph of Scipio)
London, National Gallery
This is a brown monochrome simulating a bas-relief against a variegated background. Both the standard in the centre and the cloak of the musician on the extreme right bear the letters "SPQR"; in the background to the left, over the two tombs, there appear the inscriptions: "SPQR / GN SCYPIO/NI CORNELI/VS F(ilius) P.(osuit)" and "P SCYPIONIS / EX HYSPANIENSI / BELLO / RELIQVIAE"; yet another inscription runs along the base of the picture: "S HOSPES NVMINIS IDAEI C". This latter is a reference to Cybele, the great mother of the

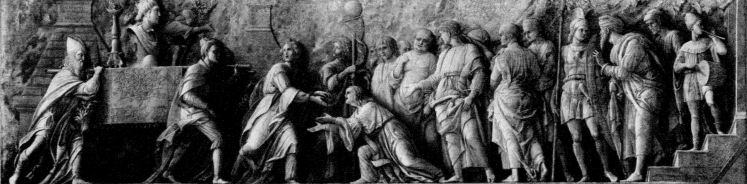

96 (plates LVIII–LIX)

97 98

99

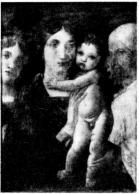

100

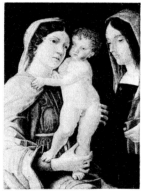

101

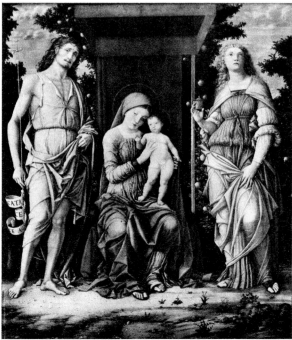

102

S. H. Kress Foundation Collection in New York). This theory was endorsed by Cipriani and others but has been rejected by Tietze-Conrat and, implicitly, by Fiocco who maintains that it was painted immediately after Mantegna's return from Rome (1490). (In any case, the letter written by Bembo to Isabella Gonzaga in 1505, which has been used as a basis for deducing that the picture was commissioned in 1504, in fact says that the dispute between the artist and the client over the fee had occurred "some time ago".) Camesasca tends to be very harsh in his appreciation of Mantegna's later work, he has drawn attention here, as also in the case of *Tucia* and *Sophonisba,* to a high quality in the work due to the "lucidity of the overall composition which has been convincingly set out and rounded off". Davies (1951) made a careful technical study of the painting which enabled him to pinpoint a number of places which have been somewhat damaged (the left-hand bearer in particular is "much defaced") as also traces of *pentimenti* on the part of the artist. Even so, he found it impossible to say with certainty whether the support used was in fact canvas or in what way the colour had been applied. Finally, he concluded that the triangular piece on the bottom right (the sides of which measure 205 × 15 cm.) was spurious.

97 ⊞ ◷ 72,5×23 *1500*

Tucia
London, National Gallery
Monochrome simulating marble relief work against a background made to look like agate. There is an inscription on the reverse side: "Antonio (sic) Mantegna" (Davies) (though other critics have read it as "ANDREA MANTEGNA"). The picture is of the vestal virgin, Tucia, who was accused of incontinence but proved her innocence by successfully carrying water from the Tiber to the temple in a sieve. The painting has sometimes been taken to be an allegory of summer. According to Longhi (1926), it was originally part of a series which also included *Sophonisba* and the *Triumph of Scipio* (nos. 98 and 96, q.v.), though this theory is rejected by Tietze-Conrat. Frizzoni (1891) and Morelli (1893) believed it to be a forgery; Kristeller and Tietze-Conrat attribute it to the Mantegna school and Davies to a disciple. Venturi rightly emphasised the fine quality of the picture and concluded that it was by Mantegna himself. This opinion has been shared by a number of recent critics, who date it in the latter years of the artist's life.

98 ⊞ ◷ 72,5×23 *1500*

Sophonisba
London, National Gallery
Queen Sophonisba is depicted drinking poison in order to escape being taken as a prisoner to Rome. Possibly an allegory of autumn. It forms a pair with *Tucia* (no. 97, q.v.) and the tale of its peregrinations, attributions, etc. is the same.

99 ⊞ ◷ 58×48 *1500*

Tarquinius and the Sibyl
Cincinnati, Art Museum
Monochrome heightened in gold on a brown background. The title as given here is the one by which the picture is known traditionally. However, according to Landsberger (BCM, 1953), it really portrays Esther and Mordecai. The museum acquired it from the Duke of Buccleuch's collection. Most critics regard it as a late work by Mantegna though Kristeller and Venturi regarded it as a *bottega* work and Tietze-Conrat held that only the design was certainly Mantegna's own. She thought it might have been cut down.

100 ⊞ ◷ 57×42 *1500*

Madonna with Child, two Male Saints and one Female Saint
Paris, Musée Jacquemart-André
The figures on either side of the Madonna cannot be identified. Cavalcaselle thought it might correspond to (but could not be identified with) the *Madonna* painted by Mantegna in 1485 for Eleanora of Aragon. Berenson felt it was either a *bottega* work or had been badly overpainted. Fiocco thought it was a late work by Mantegna himself. Tietze-Conrat attributed it to a disciple and Cipriani simply ruled out its execution by Mantegna.

101 ⊞ ◷ 75×55

Madonna with Child and a Female Martyr
Verona, Museo di Castelvecchio
The martyr may possibly be St Juliana. Berenson regarded the work as a copy of an unknown original. Fiocco held that it was by a Mantegna-style painter in Verona. Cipriani merely ruled out Mantegna as the artist and the work is not mentioned by other critics.

102 ⊞ ◷ 139×116,5 *1500*

Madonna with Child between St John the Baptist and St Mary Magdalen
London, National Gallery
The scroll around the cross held by the Baptist reads: "(ec) CE AGNV(s Dei ec) CE Q(ui tollit pec)CATA M(un) DI". At the top, also on the scroll, is the artist's signature: "Andreas Mantinia C.P.F." These three letters are generally believed to stand for C(ivis) P(atavinus) F(ecit) although Davies (1951) is inclined to accept an older interpretation: C(omes) P(alatinus) etc. — being a reference to the title of Count conferred on Mantegna (see *Outline biography*, 1490). The picture was in the possession of Cardinal Cesare Monti,

gods, whose image may be seen on the litter on the left. The composition refers to an episode which occurred in the year 204 B C during the Punic Wars : Hannibal had landed in Italy and the books of the Sibyls had revealed that he could only be prevailed upon to depart if the bust of the goddess kept at Pergamum were present in Rome; moreover, the oracle of Delos had further stipulated that the bust was to be received by the worthiest citizen and Publius Cornelius Scipio had been selected for the task; furthermore, the arrival of the image provided an opportunity for the matron, Claudia Quinta, to prove her chastity which had been questioned (see Livy, *History,* XXIX ; Ovid, *Fasti* IV, etc.). Claudia is taken to be the woman kneeling in the centre, and Cornelius Scipio is presumably the figure standing

immediately behind her. The presence of Cornelius and the various other references to Cornelius may be accounted for by the fact that the work had been commissioned from Mantegna (1504) by a certain Francesco Cornaro of Venice, whose family believed that it was descended from Cornelius. Owing to a dispute about the fee, the work was left on Francesco Mantegna's hands after his father's death. It was later owned by Cardinal Sigismondo Gonzaga and subsequently found its way to the Palazzo Cornaro in S. Polo di Venezia. It was Longhi (1927) who first suggested that the picture had originally been designed as part of a series which was to include also *Tucia* and *Sophonisba* (nos. 97 and 98) and the *Continence of Scipio* executed by Giovanni Bellini after Mantegna's death (now in the

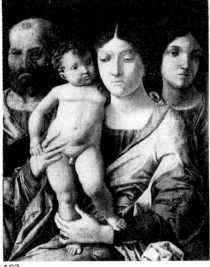

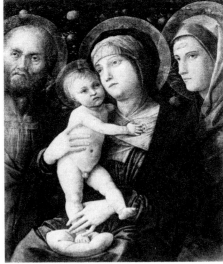

103

104

Archbishop of Milan, in 1650. Cavalcaselle, Fiocco, Tietze-Conrat and Camesasca have all detected signs of a *bottega* work in it, which they believe accounts for the hardness of execution, though Cipriani maintains that this is, in fact, a feature of Mantegna's last works. Other critics believe it to be entirely Mantegna's work. Venturi thought it must have been executed prior to the *Madonna della Vittoria* (no. 93), though Tietze-Conrat probably comes nearer to the mark in dating it round about 1500. Cipriani has rightly seen in this Madonna the prototype of Correggio's.

apparent that the quality of the Madonna was certainly worthy of Mantegna in his last period (Pallucchini, 1946; Cipriani, etc.). The general composition resembles that of similar works now in Dresden (no. 84), Paris (no. 100) and New York (no. 105).

104 ⊞ ⊗ 56×41 ▤ ⋮

Madonna Feeding the Child
Washington, National Gallery of Art (Kress Collection)
First made known to the public by Monod (CBA, 1910) as a work of the Mantegna school; later it was ascribed to

the ageing Mantegna by Fiocco, Berenson, Richter (A, 1939), Suida (PA, 1940) and others. In his *Correggio* (1930), Ricci propounded the very much more convincing theory that it was by the young Correggio, strongly influenced by Mantegna, and this view was shared by Longhi (private communication, 1938), Richter (id.) and Suida (id.) and a number of other experts in the work of both Correggio and Mantegna. Tietze-Conrat has attributed it to an unknown artist working in Mantegna's style.

105 ⊞ ⊗ 57×45,5 *1500*? ▤ ⋮

Holy Family and Female Saint
New York, Metropolitan Museum of Art
The saint has been identified as Mary Magdalen. Bode (K, 1904) suggested that it had been executed by Mantegna round about the year 1495, and this view was endorsed by Woermann, de Ricci (LA, 1912) (who also suggested that Boschini's description of a canvas at the church of the Incurabili in Venice (*Ricche minere*, 1674) was a reference to this picture), Berenson and Fiocco. The attribution to Mantegna was promptly rejected by Knapp and Venturi, who thought the work might conceivably have been by

Francesco Mantegna. Cipriani appears to accept this theory, which seems the more likely one.

106 ⊞ ⊗ 54,5×71 1500-05*? ▤ ⋮

Adoration of the Magi
Northampton, Collection of the Marquess of Northampton
There are at least eight extant versions of this composition (cf. Kristeller) of which this is the best example (cf. also below). Kristeller declares it to have been executed by Mantegna prior to 1457; Berenson regards it as a late work; Fiocco and Tietze-Conrat do not rule out the possibility of its being a Mantegna original though Knapp does, at least as regards the actual execution. According to Venturi, whose view is partly shared by Cipriani, the picture is by Francesco Mantegna. Of the various extant versions of this composition, special mention should be made of the one on canvas (50.9×68.3 cm.) in the collection of J. G. Johnson of Philadelphia, which was made known to the public by R. Fry (BM, 1905) as being by Mantegna himself; later, it was more accurately described as a copy (cf. *Catalogue of the Collection*, 1941). Yet another version which was published as an authentic Mantegna (L, 1941) and described as a genuine portrait dating from the time of the Brera *Christ* (no. 57) consisted of the head only of the black king (canvas, 39×28 cm.; privately owned, Milan [?]). Another partial version, depicting the Madonna and Child only, was acquired from the Brivio Collection by the Pinacoteca Ambrosiana in Milan.

107 ⊞ ⊗ 51×40,5 ▤ ⋮

Madonna with Child and the Boy Baptist
Princeton, (New Jersey), Museum of Historic Art
This picture has come from the Cannon Collection; in the manuscript catalogue for the collection — compiled by J. P.

104

107

108 ⊞ ⊗ 26×33 ▤ ⋮

Nymph Discovered by Satyrs
Private collection
This monochrome work was made known to the public as a Mantegna original (together with the next two pictures — nos. 109 and 110) by Zimmermann (PA 1965), who adduced in support of his view an item in the inventory of the property of Isabella d'Este (no. 121) which fits this work. Zimmermann suggests that it was executed during the last ten years of the artist's life. It would seem unlikely that Mantegna was responsible either for this picture or for the other two depicting *Neptune* (no. 109) and *Mars* (no. 110) which are discussed below.

Cleaning operations carried out in 1957 have revealed that the work is almost intact and made it possible to detect traces of a *pentimento* in the figure of the Baptist. Even so, there was no positive indication of the technique used, or at any rate nothing has been said on this score since the picture was cleaned.

103 ⊞ ⊗ 72×55 1500* ▤ ⋮

Holy Family and Female Saint
Verona, Museo di Castelvecchio
There is no means of identifying the saint. The picture appears to have changed hands at an early date. Early critics (Thode, Knapp, Frizzoni, Venturi, etc.) held that it was the work of a Mantegna disciple; this opinion is shared by Tietze-Conrat, who has thought in terms of F. Bonsignori. Nevertheless, even Morelli ascribed it to Mantegna himself, and this was the view of Berenson and Fiocco. The picture was restored for the exhibition of "Masterpieces from Venetian Museums" held in Venice in 1946, when it became

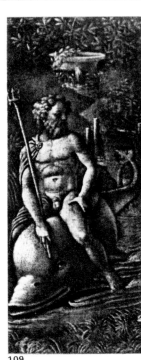
109

110

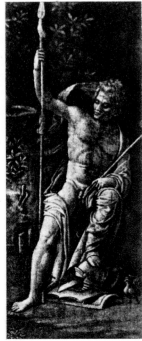
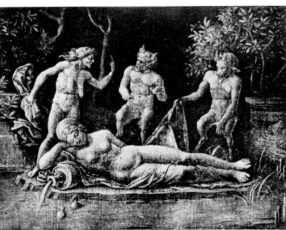
108

Richter (Princeton, 1926) — it is ascribed to the Mantegna school. F. J. Mather, jr. (AA, 1943) maintained that it was a Mantegna original, adding that the work was part of a larger composition which had featured a number of saints and the donor on the left-hand side. No other critic has developed this view.

109 ⊞ ⊗ 33×13,6 ▤ ⋮

Neptune
Private collection
This picture forms a pair with *Mars* (no. 110). Zimmermann suggests an affinity between the dolphin and the portrayal of Arion in the Camera degli Sposi (no. 48 D and E).

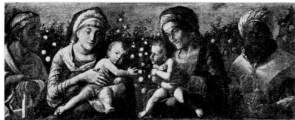

111

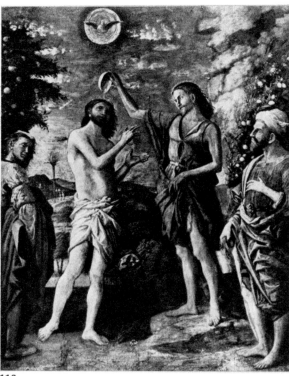

112

110 🏁 ⊕ 33×13,6 📋 ⦂

Mars
Private collection
This work was published with
the two previous ones (q.v.).
Zimmermann has commented
on the affinity with the draw-
ing of *Diana, Mars and Venus*
(?) in the British Museum
(see page 124).

111 🏁 ⊕ 40×169
1505 📋 ⦂

**Holy Family and Family of
John the Baptist**
Mantua, Basilica of
S. Andrea, Mantegna
Memorial Chapel
In the centre are the figures of
the Madonna and St Elizabeth.
St Joseph is on the left of the
picture and, although
Kristeller believed the figure on
the right to be the black king,
it would seem more logical to
accept the view (Tietze-Conrat)
that it is Zacharias, since
he is in fact holding a thurible,
the symbol of his office.
It is thought that Mantegna
had intended the picture for
his own memorial chapel (see
Outline biography, 1504)
where it now is. However, it
was still unfinished when he
died, as we learn from a
letter written by his son
Ludovico on 20 October 1506.
Kristeller, Yriarte and Berenson
believe it to be by Mantegna;
Fiocco regards it as a *bottega*
work and this view is shared by
Camesasca, who detects
undoubted signs of Mantegna's
own work in the Madonna and
Child and in the figures of
Joseph and Elizabeth. Venturi
and Cipriani maintain that it

was executed by Francesco
Mantegna on the basis of one
of his father's ideas. Venturi –
and likewise Paccagnini – has
further detected evidence that
Correggio was concerned with
the painting. It seems
unlikely that Correggio was
responsible for the over-
painting in oil of most of the
surface of the picture
(Camesasca).

112 🏁 ⊕ 228×175 📋 ⦂

The Baptism of Christ
Mantua, Basilica of
S. Andrea, Mantegna
Memorial Chapel
No attempts appear to have
been made to identify the two
figures on either side nor the
two visible in the background
to the left of Christ. It is
suggested that the work is one
which was still unfinished in
the *bottega* when Mantegna
died, and which he had
intended for the decoration of
his own memorial chapel,
together with the *Holy Family*
(no. 111, q.v.). Most critics
agree that the design
was probably his, though much
altered during the course of
execution by Antonio da Pavia
(Kristeller), Francesco
Mantegna (Yriarte), or others of
Mantegna's disciples
(Berenson, Fiocco). Tietze-
Conrat even rules out the
possibility of Mantegna's being
responsible for the design and
Paccagnini would seem to
share this view.
Camesasca reverts to the view
that the setting at least was
Mantegna's.

Other works mentioned by the early commentators

*Brief details are given below of
the other works attributed to
Mantegna by the early
commentators which, however,
could not be included in the
Catalogue owing to the
vague or unreliable nature of
the source. The works are
discussed in the alphabetical
order of geographical location;
where a number of works are
in the same place, these have
been considered in
chronological order.*

Bassano

**113. Subject matter
unknown**
A painting by Mantegna,
probably on a wall, is said by
Lanzi (*Storia*, 1795–6) to be
in the church of San
Bernardino.

Berlin

114. The Flagellation
Mention is made of such a
picture in the Royal Castle,
with the information that it was
gift of Barbara of Brandenburg
to the Queen of Prussia,
(*Mémoires de l'Académie
Royale de Sciences et Belles
Lettres*, Berlin, 1805).

Ferrara

115. The Marys
An inventory of the contents of
the Este "dressing room"
(1493) mentions "a picture
painted on wood with the
Marys, done by Andrea
Mantegna".
The same inventory also lists a
"picture painted on wood with
the Madonna and Child and
seraphim, executed by the
above-mentioned Mantegna";
this is usually identified as the
Brera panel (no. 62).

**116. Christ among the
Doctors**
This is mentioned in a
document covering the years
1586–8 (Campori, 1886) as
belonging to the chapel of the
Margherita Gonzaga d'Este.

**117. Subject matter
unknown**
Mentioned with the previous
work: the reference could be
to the *Sacra Conversazione*
now in Boston (no. 34 F).
The same inventory also lists a
Nativity and a *Death of the
Virgin*, which are generally
identified as pictures no. 7
and no. 34 E.

118. Melancholy
An inventory compiled in 1685
of the property of Cesare
Ignazio d'Este in Ferrara
(Campori) includes: "A
picture ... done by Mantegna
with 16 children playing
musical instruments and
dancing, with, at the top, the
title Melancholy, in a gilt frame,
14 inches high and 20 inches
and a half wide". Tietze-Conrat
thinks a work by Cranach (in
Panofsky – Saxl, *Melencolia I*,
plate XL) might well fit this
description; Sidorow (in
Tietze, *Kritisches Verzeichnis
der Werk Dürers*, no. 86) took
this view and connected the
work with a drawing by Dürer
featuring dancing *amorini*,
now in Moscow.

Fiesole

**119. Madonna with Child
and Angels Singing**
This work was praised by
Vasari ("A half figure of the
Madonna with the Child in her
arms and the heads of a
number of angels singing,
executed with wonderful
grace") who added that it had
been done for "an abbot of the
abbey of Fiesole", who may be
identified as Matteo Bossi (see
no. 146). Attempts have been
made to match this description
with the Brera *Madonna* (no.
62, q.v.) or with the Berlin
Madonna (no. 20).

Mantua

**120. Christ and the
Samaritan Woman**
In a letter dated November
1549, addressed to Cardinal
Ercole Gonzaga (Gonzaga
Archives, Mantua), Timoteo
de' Giusti referred to a painting
featuring this theme.

121. Four Figures
An inventory of the property of
Isabella d'Este Gonzaga
compiled *c.* 1550
(D'Arco, 1857) lists "a picture
simulating bronze ... by
Andrea Mantegna with four
figures".

122. Ship with Figures
This same inventory also

mentions: "another picture
simulating bronze ... by the
said Mantegna, featuring a
ship with a number of figures
on board and one falling into
the water".

123. Dead Christ
An inventory for the Palazzo
Ducale drawn up in 1612
(D'Arco) mentions a "Christ on
the tomb foreshortened with
gold-embellished frames" by
Mantegna.

**124. Tobias – Esther –
Abraham – Moses**
The same inventory also lists
"four pictures done in gouache
by Andrea Mantegna,
portraying Tobias, then Esther,
then Abraham and in the
fourth one Moses, with black
frames embellished with gold".

**125. Christ and the Woman
taken in Adultery**
The inventory goes on to
mention "a canvas painting
showing Our Lord and the
woman (head and shoulders
alone) taken in adultery,
without a frame, by Mantegna".

126. A Dance
This work ("a dance by Andrea
Mantegna") is listed together
with the others.

127. St Louis of France
Mentioned by Ridolfi (1648)
as having been executed by
Mantegna "over the pulpit" of
the church of S. Francesco.

128. Wall decoration (?)
Ridolfi further mentions that
Mantegna had decorated his
own house "located alongside
the church of S. Sebastiano
... but the paintings were
destroyed by the Germans
(1630?)".

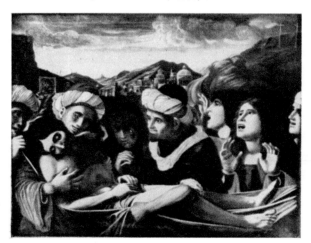

*(above) Two paintings believed to be copies of no. 131 (now in
the M. Gismondi Collection in Sanremo and the Church of the
Annunziata, Angri, respectively). The lower picture is attributed to
an unknown south Italian painter and believed to have been
executed in 1515 or thereabouts.*

129. The Flight into Egypt
A "Christ going into Egypt, an original by Andrea Mantegna" is mentioned in an inventory (1665) of the property of Duke Carlo II Gonzaga (D'Arco).

130. Portrait
A "portrait done by Mantegna" is recorded (measuring "un braccio") in an inventory for the palace compiled in about the year 1700 (D'Arco).

131. The Descent into Limbo
This work is listed together with no. 130, though smaller in size, as follows: "A smaller (painting) of Christ going into Limbo, by Mantegna".

Naples

132. Deposition from the Cross
A "Christ taken down from the cross and wrapped in a winding sheet" located in the church of S. Domenico is mentioned in a letter sent by Summonte to Michiel in 1524. Bologna (P, 1956) maintained that copies of the altarpiece in question exist in the shape of a painting in the church of the Annunziata in Angri and another, now privately owned, in Sanremo.

Novellara

133. A Triumph
An inventory for the Palazzo Ducale compiled at some time during the eighteenth century (Campori) mentions: "A water-colour triumph, 14 inches high and 8 inches wide, by Mantegna".
Listed together with it are "a puttino clothed" which might well be the painting now in Washington (no. 37) and a "Lord seated on throne surrounded by courtiers" which could refer to the Mucius Scaevola in Munich (no. 78).

Padua

134. St Benedict
Work "on canvas" said by Michiel (c. 1525) to be in the church of S. Benedetto.

135. Portrait of Gerolamo della Valle
This is mentioned by Scardeone (1560): it might be a reference to one of the figures in the panels of the Ovetari cycle.

136. Mission to the Apostles
A "Saviour sending the Apostles to preach throughout the world" is mentioned by Ridolfi (1648) as being by Mantegna and located in the church of S. Spirito.

Parma

137. Susanna and the Elders (?).
An entry in the inventory of the Palazzo del Giardino compiled round about 1680: "A picture 1 br(accio) and 6 on(ce) high and 1 br(accio) and 3 on(ce) wide (i.e. approx. 82 × 74.5 cm.) on canvas over wood, a woman said to be Susanna with two elders, now damaged; ascribed to Mantegna".

138. Nocturne (?)
The same inventory also mentions: "A picture 1 br(accio) 4 on(ce) high and 11 on(ce) wide (approx. 76 × 33 cm.): a man with candle in hand climbing a staircase, near which there are other figures"; ascribed to Mantegna.

Reggio Emilia

139. Head of a Man
A "man's head" is listed in an inventory of the Coccapani property compiled round about 1640 (Campori).
The same inventory also mentions a *Judgment of Solomon* which may be identified as the painting now at the Louvre (no. 86).

Rome
140. "Legends" of St Bassiano
A list of the property owned by Queen Christina of Sweden drawn up round about 1689 includes the following: "Seven panels on stands featuring the life, miracles and martyrdom of St Bassiano, well painted and preserved, with the figures measuring a little less than two *palmi*＊ (approx. 46 cm.), architectural structures and landscape respectively by Mantegna, all the same size, 3 *palmi* and a quarter high and two *palmi* and a quarter wide (approx. 78 × 46 cm.) with smooth round frames to go with them."

Venice

141. Martyrdom of St Christopher (?)
Michiel (1543) speaks of a "small coloured portrait from the St Christopher cycle which Mantegna painted in the Eremitani church in Padua, done by the said Mantegna, a very fine piece of work" as being at the residence of Michele Contarini. This may well have been a copy of the Ovetari fresco (no. 14 K).

142. St Jerome
"A picture showing the head of St Jerome, with white frames" is apparently also mentioned by Michiel (Cicogna, AIV, 1860) and, coupled with it, a *Christ Carrying His Cross*, which may be a reference to the painting in Verona (no. 70).

Verona

143. Subject matter unknown
Vasari mentions a panel "for the altar of St Christopher and St Anthony" though this information makes it impossible to determine to which church he was referring. Deducing that the panel in fact portrayed the figures of St Christopher and St Anthony, Tietze-Conrat has suggested that Dürer may have copied the former.

144. Portrait of Lawyer
An inventory of the Curtoni estate, compiled in 1662 (Campori) lists a "Portrait of a lawyer" by Mantegna.

145. Wall decoration
Ridolfi (1648) refers to the decoration of the front wall of a house "overlooking the lake square" or (a more satisfactory rendering) "near the 'lake fishing ground'" – to quote the description given by Dal Pozzo (*Vite*, 1718).

146. Portrait of Matteo Bossi
Maffei mentions a likeness of Matteo Bossi, who was abbot of Fiesole (see no. 119) in his *Verona illustrata*, 1731).

Appendix

Mantegna's other artistic activities

No discussion of Mantegna's activity as an artist would be in any sense complete if it did not include some reference to his work as an engraver. Mention has already been made in the *Catalogue* itself of a number of drawings and engravings. These engravings reveal a power of invention far beyond that suggested by his extant paintings alone. The critics are by no means agreed as to which of them can be attributed directly to Mantegna himself. Recent critics seem generally inclined to reject the arguments put forward by Tietze-Conrat in support of her theory that he had never, in fact, been an engraver but had been content to supervise the actual engraving by others, on the basis of his own designs. However, the critics are not agreed as to when Mantegna first became involved in this field. We may legitimately believe, with Fiocco, that it was the trip to Tuscany in 1466 that first aroused in Mantegna a passion for engraving; in fact, echoes of the *Battle of the Sea Gods* would certainly seem to have found their way into the miniatures of a Pliny (Biblioteca Reale, Turin), possibly dating from 1460–70 (Mezzetti). In the eighteenth century, over fifty prints were attributed to Mantegna; of these only seven are now held to be Mantegna originals and of these seven, six are mentioned by Vasari. The most reliable order of execution is as follows: the two *Bacchanalia* and the two pieces constituting the *Battle of the Sea Gods* (*Catalogue*, nos. 35 and 55), prior to 1470; the *Deposition* (page 124) and the *Madonna* (resembling the Poldi Pezzoli *Madonna* – no. 44) in the year 1475 or thereabouts; the *Risen Christ between St Andrew and St Longinus* (no. 64 B), in the year 1488 or so.
An essay written in honour of G. B. Spagnuoli the humanist (1502) compares Mantegna to Phidias and

Death of the Virgin *(mosaic; Mascoli Chapel, Basilica di S. Marco, Venice). In spite of the mosaic's affinities with the work now at the Prado (cf. Catalogue, no. 34 E), Thode (1898) thought it by Andrea del Castagno; Fiocco, by Mantegna and Iacopo Bellini; Longhi, by a disciple of Mantegna influenced by Castagno.*

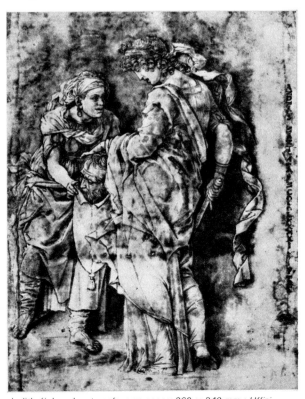

Judith *(ink and watercolour on paper; 360 × 240 mm.; Uffizi, Florence). The signature and the date 1491 are recorded down the right-hand side. In spite of the reservations expressed by Berenson and Tietze-Conrat, it is generally identified as being the drawing which Vasari owned (1568); it is in any case universally attributed to Mantegna and the critics are further agreed in regarding it as one of his finest works on account of the vitality with which he has constructed the figure of Judith and the harmonious formal relationships between the two figures.*

Bird Catching Fly *(pen drawing, 128×88 mm.; British Museum, London). Variously attributed to Donatello (Colvin) and to Giovanni Bellini (Fiocco) but the long-standing attribution of it to the youthful Mantegna (Kristeller) now seems to be accepted by most critics.*

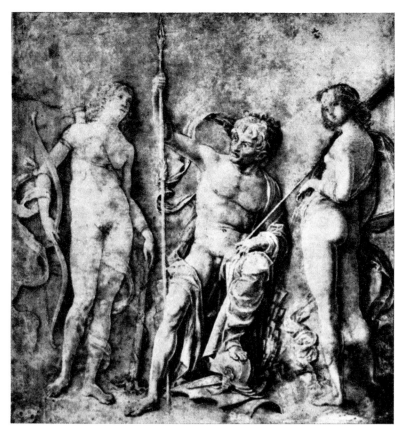

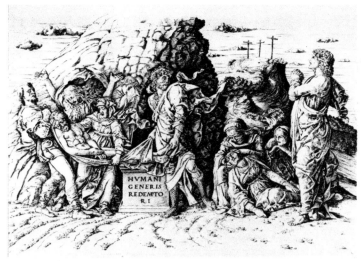

Deposition in the Sepulchre *(engraving; 332×468 mm.). Hind maintains that the design for this print dated from 1456–59; Tietze-Conrat is rather more inclined to date it later, towards the end of the century, a view which she substantiates by maintaining that it presents in Christian terms the same "heroic vibration" which causes the Triumph of Caesar to thrill with life. However, once it is realised that the composition closely resembles the work of Donatello (it is essentially a variation of the Death of Meleager as portrayed on the ancient Montalvo sarcophagus which is now in the G. Torno Collection in Milan but which Donatello could have studied in Florence), it seems probable that the design was, in fact, produced not later than 1475 and possibly a good deal earlier. (Left). Pen and watercolour drawing on brownish paper (364 × 317 mm.; British Museum, London – formerly in the J. Strange, C. M. Metz and J. Heywood Collections) portraying a scene which cannot be identified with certainty. It is generally believed to represent Mars between Venus and Diana, though Tietze-Conrat maintains that the theme is allegorical rather than mythological. Most critics are agreed in attributing it to Mantegna.*

Drawings for jewellery *(each measuring 87 × 85 mm.; Städelsches Kunstinstitut, Frankfurt). These and three similar drawings were first published as Mantegna's work by K. Clark, who suggested that they had been executed about 1465–70 for use in niello work; Tietze-Conrat felt that only the design and not the actual drawing could be attributed to Mantegna. (Below). The Annunciation (tapestry: M. A. Ryerson Collection, Art Institute, Chicago). Mantegna is known to have provided drawings for tapestries. However, as Tietze-Conrat rightly points out, in this particular tapestry there is nothing to suggest the work of Mantegna except the Gonzaga arms and a certain vague affinity with his style.*

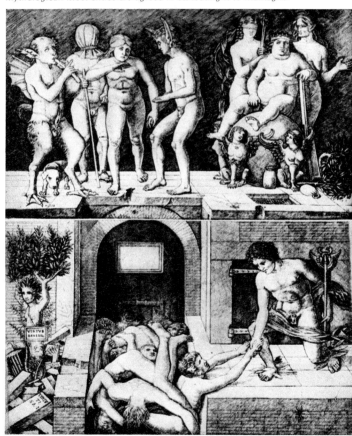

Symbolical composition consisting of two engravings *(298×425 and 299×425 mm.). The fat woman at the top is presumably Ignorance; under her influence Envy (the old woman with long ears) and Fate (the young girl blindfolded) hold sway and, in their struggle for wealth, men allow themselves to be carried away by Folly (the young man with an ass's ears) and Luxury (the satyr musician), while they ignore Virtue, who perishes on the pyre beneath the human laurel bush, and so fall into the pit, from which only Mercury, the god of Knowledge (on the right) can rescue them (Förster). A drawing of the upper portion (British Museum, London) may well have been executed by Mantegna himself.*

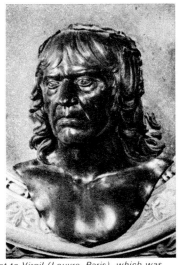

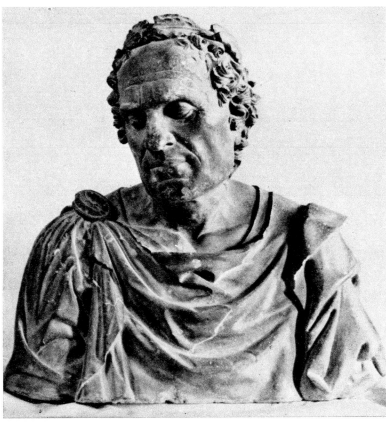

(above, left) Pen drawing for a monument to Virgil (Louvre, Paris), which was at one time believed to have been done by Mantegna and thought to be connected with a letter written by Iacopo d'Atri to Isabella d'Este (17 March 1499), although this seems to refer to a rather different monument; in any case, the quality of the drawing is very much inferior to Mantegna's normal standard. (above, centre) Bronze bust of Mantegna in his memorial chapel in the church of S. Andrea in Mantua; the modelling, which even such an early critic as Venturi had attributed to him, may well in fact have been done by him (even if the actual casting was done by others) and probably dates from the period 1480–90, judging from the features. (right) Bust of Virgil (terracotta; 74 cm. high; Palazzo Ducale, Mantua): this bust has come from the Fiera residence in Mantua, together with two others (one of the Marquess Francesco Gonzaga and the other of G. B. Spagnuoli), though the Virgil is the best. It was not executed by Mantegna but by an unknown sixteenth-century sculptor working, in all probability, from an original modelled by Mantegna, judging by the affinity between this bust and the figures of the Caesars in the Camera degli Sposi.

Policlitus as a sculptor. Kristeller was the first to attempt a reconstruction of Mantegna's activities as a sculptor. Fiocco thought he might have been concerned in the execution of the altarpiece for the Ovetari Chapel and for the Cornaro Tomb in the Frari in Venice; he further definitely attributed to Mantegna a bas-relief with the *Blood of Christ* and a bust of Francesco II Gonzaga in the Palazzo Ducale in Mantua, in addition to the probable *Self-portrait* in bronze in the church of S. Andrea, also in Mantua, and the chests for Paola Gonzaga in Klagenfurt. Finally, Paccagnini attributed to Mantegna five large pieces in terracotta recovered from the frieze of a house in Mantua. The *Self-portrait* is the only one among these works which the critics are more or less agreed in attributing to Mantegna.

Turning now to architecture, it is known that Mantegna provided Ludovico Gonzaga with the design for the courtyard in the castle in Mantua (1472), and that he took part in the competition arranged in 1482 for the memorial tomb for the Marchioness Barbara. In addition, some critics attribute to him the design for his own house in Mantua near the church of S. Sebastiano (but see the caption bottom right).

Finally, in his capacity as court painter, Mantegna supplied sketches for tapestries (see *Outline biography*, 1465 and 1469) as also for jewellery (ibid. 1483) and caskets. It is less likely that Mantegna should have done any miniature work, in spite of the fact that Berenson and, more recently, Meiss attributed a number of works in this field to him (Biblioteca Universitaria, Turin; Bibliothèque de l'Arsenal, Paris).

(above) Courtyard of Mantegna's house in Mantua, the construction of which was begun in 1476 or thereabouts and completed before the end of 1496. The structure of the house (but cf. also page 85) is notable for the incorporation of a cylindrical courtyard in a rectangular edifice. The courtyard itself may have been covered by a cupola based on that of the Pantheon in Rome and it was probably surrounded by open arcades. Modern critics are inclined to attribute the design to Luca Fancelli, who was architect to the Gonzagas, though he probably used as a basis an idea devised by Mantegna influenced by Alberti. A similar scheme was described in the treatise published by Francesco di Giorgio in 1482. (left, from top to bottom) Three Evangelists and the Angel and Madonna of the Annunciation (terracotta figures, each approximately 180 cm. high; Palazzo Ducale, Mantua). They were originally located in niches in the outer wall of a fifteenth-century house in Mantua, from which they were removed recently. Paccagnini exhibited them as Mantegna's work at the Mantegna Exhibition in 1961.

Indexes

Subject Index

Index of Titles

*An asterisk to the right of the
reference number indicates
that replicas or copies of the
same subject are discussed in
that particular section of the
Catalogue.*

Index of Locations

(Indicating churches, museums,
etc. where works may be seen).